MONA LISA

The People and the Painting

Mona Lisa

The People and the Painting

by

MARTIN KEMP
& GIUSEPPE PALLANTI

OXFORD
UNIVERSITY PRESS

OXFORD
UNIVERSITY PRESS

Great Clarendon Street, Oxford, OX2 6DP,
United Kingdom

Oxford University Press is a department of the University of Oxford.
It furthers the University's objective of excellence in research, scholarship,
and education by publishing worldwide. Oxford is a registered trade mark of
Oxford University Press in the UK and in certain other countries

Published in the United States of America by Oxford University Press
198 Madison Avenue, New York, NY 10016, United States of America

British Library Cataloguing in Publication Data
Data available

Library of Congress Control Number: 2016961206

ISBN 978-0-19-874990-5

Printed in Italy by
L.E.G.O. S.p.A.

Contents

List of Illustrations

Acknowledgements

This book embraces two different modes of research: the archival which allows us to reconstruct human lives and circumstances that are both shared with ours and crucially different; and the art-historical which draws upon a range of cultural sources, written and visual, to gain some sense of what went into a work of art and what might be drawn out of it, then and now. The historical understanding of the *Mona Lisa*, no less than any other work of art, relies upon both. What is unusual here in a book on a painting is the depth and quantity of documentation relating the participants' lives in their civic and family contexts.

It will not be too difficult to work out which of the authors possesses the necessary archival skills and which specializes in the cultural sources. We do however share full responsibility for both facets of the book, via a harmonious collaboration that has been a sustained pleasure. In a number of crucial areas, the *desiderata* for archival searches were agreed and the results were analysed in close liaison.

A third person has played an integral role, Maria Pavlova of the University of Oxford. She has with considerable acumen translated Giuseppe Pallanti's texts, skilfully retaining their tone and meaning. She has also provided Martin Kemp with crucial support in grappling with the poetry of the period, in which she is expert.

Oxford University Press has been supportive, patient, and creative at all stages in the process from contract to publication and publicity. Matthew Cotton provided the open door through which we have passed, always benefiting from his enthusiasm and high professionalism. Jonathan Bargus has designed the book with his customary elegance, Kizzy Taylor-Richelieu, and Lisa Eaton have skilfully shepherded the book through the stages of production and into the public domain. Deborah Protheroe has correlated work on the illustrations with exemplary care. Sandra Assersohn has battled heroically through the mire of obtaining pictures and permissions from those who claim

copyright. The key task of copy editing was undertaken by Jeremy Langworthy with notable assiduity.

Caroline Dawnay of United Agents has amply demonstrated why she was Agent of the Year in 2014, ably assisted by Sophie Scard. Judd Flogdell, Martin Kemp's personal assistant has played many crucial roles, without which this book would have struggled to see the light of day, culminating in her heroic provision of the very complex index.

Martin Kemp's debts over the years in the ever-extending field of Leonardo studies are beyond comprehensive listing. The researcher most intimately involved with the material in the book has been Pascal Cotte of Lumière Technology in Paris. He has shared his scientific research with us in a notable spirit of openness and generosity, and has recently published a remarkable study on the painting. We have agreed to disagree about some aspects of his interpretation, but have never lost sight of the fact that we are part of the same quest. In the long build up to this book Martin Kemp has benefited from key exchanges in various ways with Carmen Bambach, David Allan Brown, Juliana Barone, John Brewer, Noah Charney, the late André Chastel, Margaret Dalivalle, Vincent Delieuvin, Claire Farago, Francesca Fiorani, Cecilia Frosinini, Bill Gates, Matt Landrus, Bruno Mottin, the late Romano Nanni, the late Henry Pulitzer, Jehane Ragai, Ashok Roy, Fred Schroder, Monica Taddei, Thereza Wells, Curtis Wong. The interpretative framework for the book was first aired in 2013 at the Rowe lecture (endowed by David Rowe) at the University of Oxford, which was arranged by Martin McLaughlin, and in the keynote talk at the 2015 conference held in conjunction with the major Leonardo exhibition in Milan, masterminded by Maria Theresa Fiorio and Pietro Marani. It is always salutary to have cherished ideas exposed to scrutiny. Martin Kemp's family and valued circle of personal friends deserve unlimited thanks for enduring his impolite periods of monasticism.

Giuseppe Pallanti's researches are indebted to the teachings of Carlo Maria Cipolla and to the example of masters of archival research such as Gabriella Battista, Alessandro Cecchi, Anthony Molho, and Rab Hatfield.

All the staff of the State Archive of Florence and of the other archives cited in the notes and abbreviations have unfailingly supported the investigations and offered enthusiastic assistance. Special thanks are due to Monsignor Renato Bellini of the Church of the Parish of Vinci, who has generously opened the archive and house so that our inquiries could be pursued to best effect.

Giuseppe Pallanti's friends have always been close and they have helped him in various crucial ways. In particular, he would like to thank Angelo Romeo,

who has generously made available his excellent cartographic skills to provide lucid maps of key properties and locations.

Last but not least, Giuseppe would like to thank his family: his wife, Patrizia, who has patiently endured his periods of sustained research, supporting and participating actively throughout, above all during the writing of the draft text; and his children, Guido and Francesca, have been close to him in every moment, although at times it must have seemed as if he was offering them a heavy burden.

Introduction

We know for certain that Leonardo had begun to paint a portrait of Lisa del Giocondo in 1503. This is the foundation of everything that follows. But this is not simply a book about the world's most famous painting. It is also about the realities of the people who were involved: the subject of the portrait, Lisa Gherardini; her husband, Francesco del Giocondo; Leonardo's father, Ser Piero da Vinci; and Leonardo himself. Leonardo's mother also makes her first definite appearance. The first half of the book is about families of the kind who rarely attract sustained research. These were not the great families of high wealth and political muscle; nor were they picturesque peasants. They were of the upper middling kind, living reasonably favoured lives, isolated from extreme monetary heights and depths, though they were subject to the political and military dramas of their times. They were not in positions to exercise the kinds of power that attracts contemporary comment and eager historians. Leonardo, Ser Piero's son, is obviously another matter, internationally famed in his lifetime, but he too lived in the realities of the same ambience when he was in Vinci and Florence as a boy and young man.

We are aiming to capture the whiff of reality for the participants in the story of the portrait. We seek to convey something of the complex texture of the participants' lives, the reality of their families, their income and expenditure, their residences, their pleasures and problems. This has its own interest and value independently of the painting. We make no apology for the documentary detail that this narrative requires. Obviously, we would not be writing about them without the portrait. However, documenting their lives has its

own fascination, not least for those of us who negotiate our own middle-class lives today.

The rich vein of documentation gives a real sense of how Florentines of their class lived—moving home a good deal, often renting rather than buying in the city, moving to better areas, building networks, creating big families, seeking advantageous marriages for very young brides (with correspondingly high levels of mortality for mothers and babies), placing surplus daughters in convents, acquiring productive land whenever possible, lending money at high rates of interest if they had spare cash, navigating minefields of factional interests, currying favour judiciously, maintaining face and appearance, climbing socially or at least not slipping visibly. Upward mobility was most readily achieved in Florence through trade and/or finance. Francesco del Giocondo's family did both. Marrying upwards financially or socially was an important tactic. Impoverished gentry and the newly rich forged judicious unions. Being able to afford female slaves, as Francesco del Giocondo did, was a sign of status, and a commonplace source of illegitimate children—though the idea that Leonardo's mother was a slave can be dismissed, as we will see. Leonardo's ambitious father achieved his social mobility through his rise within the cadres of lawyers in Florence.

The documentation of sales and inheritance provides precious insights into the lives and homes of well-off citizens and those who aspired to keep up appearances. The exceptionally detailed inventory of the possessions of Leonardo's father in the Appendix gives a clear idea of the stylish life that someone of taste and means could achieve in Florence. The same bodies of documentation also bear witness to the many litigious disputes between the heirs of well-off men, with their widows scrambling for rights in competition with their plentiful children. The dispersal of an estate, or, as in the case of Francesco del Giocondo, of a business, could result in a mess from which no one benefited, apart from the lawyers. The impression is that Florentine citizens had frequent recourse to lawyers and that the profession of Leonardo's father was thriving.

We will gain detailed insights into the functioning of major ecclesiastical institutions in Florence, which were vibrant centres for religious and many secular activities. Leonardo banked with Santa Maria Nuova, which was a large hospital and facilitated the most famous of his anatomical dissections. Santissima Annunziata provided Leonardo with accommodation after his return to Florence in 1500 and provided a hub for the relationship between

Leonardo, his father, and Lisa's husband. He was meant to paint panels for an altarpiece there, but failed to do so. We will also see how convents such as Sant'Orsola served as genteel and comfortable refuges for women of good breeding and wealth.

In provincial Vinci we will encounter a different kind of reality in a society in which almost 70 per cent of the population lived in poverty and no more than 4 per cent could consider themselves well off. The tax records convey a picture of poorly built and crumbling dwellings both in Vinci itself and in the countryside. Residents often had to sell modest plots of land to Florentine owners of estates or wealthy local people. The family into which Leonardo was born counted itself amongst the privileged, but he would have been aware of the daily reality of those crammed into the small town as he grew up in his grandfather's residence below the castle. And his very young mother came from the very bottom of the economic pile.

We are deliberately asserting the documented detail of real lives in the face of a legendary picture that has become separated from the grit of daily occurrences. When we write directly about the picture, we aim to look at the documentation with a straight stare that does not actively seek the kinds of picturesque and tenuous diversions that feed the apparently insatiable need for some kind of mystery or secret. We believe that this firm foundation will allow us to see the picture as even more remarkable than if we assign it extraordinary and incredible origins.

The picture is in fact exceptionally well documented, not least for a portrait of someone who otherwise would have left no mark on history. The central current of the documentation leads to the conclusion that the painting in the Louvre is the same as the portrait of Lisa del Giocondo which was underway in 1503. Ambiguities in some of the early accounts have been overplayed, often using absence or incompleteness of information in a way that ignores the functions and limitations of the documents in question. It is into these peripheral spaces of ambiguity that alternative identifications of the sitter are inserted, generally with supporting evidence that circumstantially adheres to the preferred identification but not to the core documentation.

The need to overthrow the traditional interpretations has proved very powerful over the years. There are two main motivations. The first is the apparently insatiable desire to believe that such a famed and fascinating image must have originated in extraordinary circumstances. A secret or a more overtly fascinating sitter obviously helps to satisfy such desires. The second is the recurrent

need to come up with something new. For the historian or other investigators there is a big incentive to generate a new theory of some kind, both for personal satisfaction and to get noticed. Exposure is more or less guaranteed for anyone who argues that they possess the real *Mona Lisa*; that they are in possession of a 'first version' showing the sitter when younger; that she is Leonardo in drag (or his rascally assistant, Salaì, in drag); that she is a 'lady of the night'; that she is mother of an illegitimate child to one of the Medici; that she is smiling with her mouth closed because her teeth were blackened by mercury treatment for venereal disease; that the painting is by Titian; that she is the Egyptian goddess, Isis; that she is a vehicle for secret messages of a heretical or metaphysical nature; that she suffered from high cholesterol; that the Louvre picture and the Prado copy were to be viewed side-by-side stereoscopically. Some of the theories are seriously and systematically developed. Others are speculative nonsense. But none of them are *necessary*.

The advent of digitized pictures has released an alarming slew of new possibilities. Images, frequently of poor quality and low resolution, can now be enlarged, spliced, collaged, and otherwise manipulated to disclose hidden images of alligators, mysterious numbers, oriental scripts, sexual allusions, and much else besides. Mirroring and collaging the whole or parts of the digital images is said to disclose the actual location of the landscape. Techniques and magnifications not available to Leonardo are used to help him inform us of some secret 500 years later.

At one stage we envisaged a chapter on the 'Leonardo lunacies', but our historical task has already proved more than large enough, and there are other authors who have assembled and will continue to assemble anthologies of the varied and often hilarious theories and spoofs, visual and written.

As the research for this book was being pursued, the most notable tranches of new evidence came from scientific examinations, which increasingly revealed that the painting evolved substantially over a longish period. All evidence from scientific examinations—X-rays, infrared, multispectral scanning, and so on—requires judicious and cautious interpretation. The images are often very slippery. This is particularly the case with the most recent techniques, in which we are definitely seeing new things, although we are not clear at this stage precisely how the visible effects are generated and what they actually represent. As with all evidence, we tend to see what we *want* to see. For our part, we aspire to look at the science through the lens of carefully researched art history.

We are inserting our somewhat unusual book into a literary territory that is already heavily overpopulated. There is of course no book about Leonardo that does not devote sustained attention to the *Mona Lisa*. The major Leonardo specialists have all weighed in with serious contributions. In chapter VII we look at some of the major literary steps in her rise to fame before the twentieth century. In the twentieth century, giants of art history were irresistibly drawn to the *Mona Lisa*. We are thinking of figures of the stature of André Chastel and Kenneth Clark. The later part of the century was characterized by intense research by Carlo Pedretti and Augusto Marinoni, both great masters of Leonardo documentation and of his written and drawn legacy; by Pietro Marani and Frank Zöllner working in the Italian and German traditions respectively; by Carmen Bambach, whose command of Leonardo's drawings is unrivalled; by David Allan Brown whose insights into portraiture are of considerable moment; and Claire Farago, particularly for her insights into Leonardo's art theory; and, as is conventionally said, many others too numerous to mention here. For the documentation of the life of Leonardo and those associated with him, which is a central feature of our book, we should acknowledge the revised anthology of documents by Eduardo Villata; the Florentine archival exhibition of documents in 2005, *La Vera Immagine*; and the richly informative biography by Carlo Vecce. Monographs on the *Mona Lisa* of varied intent continue to emerge, some with genuinely new information like Josephine Rogers Mariotti and Rab Hatfield. Of the many books that look at the *fortuna* of Lisa's portrait over the ages, Donald Sassoon's remains the most substantial. There are printed and online anthologies of the endless reworkings and parodies of the enigmatic lady across every area of visual culture. Novelists have not been slow to fill the mysterious gaps. The most beguiling of the recent novels has been Lucille Turner's *Gioconda*. We should not be sniffy about artists in fiction. Not infrequently it seems as if historians of the portrait have been writing fiction under the veil of historical terminology.

We have done our best to include a good and representative range of material in our bibliography, but have no doubt missed contributions that we should have included. Leonardo is a nightmare for a bibliographer. The Raccolta Vinciana in Milan and Bibliotheca Vinciana in Vinci both do excellent jobs in trying to keep up.

The first half of our book deals, as the title suggests, with the people without whom there would have been no Lisa, no Leonardo, and no portrait. We want to evoke the look of their lives in the realities of the periods and places. The

documents we cite extensively present a vivid sense of the period voice. The two main locations, Florence and Vinci, were and are locations with their own very distinctive feel, much changed but with an enduring core of distinctiveness. The circumstances in which the Giocondo and Gherardini families came together in a marriage allegiance are the subject of the first chapter. We see how a family with a good name came together with a merchant who was making money. We will trace the sitter and her husband back to their paternal grandfathers—one a landed gentleman with limited funds, and the other a barrel-maker who made a great deal of money. We then look at how Francesco and Lisa managed their lives with increasing wealth, property, and numbers of children. Although he cannot be counted as a great patron, Francesco was involved with leading artists and commissioned an altarpiece for his family chapel. The story is not all of sweet success. Francesco created antagonisms. Lisa (like most mothers at that time) experienced child bereavement and was the subject of a strange story about her 'honour'. One of her daughters prominently participated in something of an orgy in the convent of San Domenico. Lisa herself was later to pass her widowhood in the convent of Sant'Orsola, and she was to be buried there—surprisingly not in the family vault in Santissima Annunziata. Had she suffered a rift with Francesco?

The Servite monastery of Santissima Annunziata was a locus for the convergence of Francesco, Leonardo's father, Ser Piero, and Leonardo himself in 1500. We witness the rise of Ser Piero as a leading lawyer in the city, poised in his office outside the palace in which justice was administered to pick up important business. Francesco was one of his clients. Ser Piero led a long, stylish, productive, and fertile life, as the notably informative posthumous inventory of his possessions shows.

While Ser Piero was forging his Florentine career, his illegitimate son was being nurtured in the family home in Vinci under the watchful eye of his grandfather, Antonio. Piero's first son was welcomed into a family that lived well—at least by the country standards of rural Tuscany. The identity of his mother, Caterina, has been the subject of much fantasy, including the idea that he was the son of a slave. A far better and more realistic candidate is Caterina Lippi, an orphan without independent means, for whom the family promoted a decent marriage soon after Leonardo's birth. Her story, which we can piece together, is not so much uniquely sad as typical. Was she the Caterina who travelled to Milan to spend the last year of her life with her prodigiously talented son?

The second part of the book sustains the documentary mode into Leonardo's return to Florence in 1500 where he faced the challenge to re-establish himself and to justify his reputation. The great battle scene he began to paint for the new Council Hall of the Florentine republic would have been the prime vehicle for his claim to fame, and even in its unfinished state it was regarded as a marvel. It is from the humanist clerk, Agostino Vespucci, who wrote the account of the battle at Anghiari for Leonardo, that we learn of Leonardo having made a start on his portrait of Lisa del Giocondo. The subsequent trail of documentation is quite rich, involving a visit by the Cardinal of Aragon to the aged Leonardo when he was housed near Amboise by the French king, and a list of paintings owed by Salaì on his death in 1524. The painting was, from the first, regarded as special, as sixteenth-century testimony confirms.

Although there are times when its fame dimmed, there are enough laudatory accounts of the picture from important observers in the seventeenth and eighteenth centuries to indicate that it could still cast its spell. In the nineteenth century we witness Lisa's romantic rise to the status of the ultimate *femme fatale* for those of a literary and artistic bent, fuelled in part by the first effective reproductions. For the opportunist thief Vincenzo Peruggia in 1911, the *Mona Lisa* was the obvious painting to steal from the Louvre for repatriation to Italy. We let the protagonists in the theft and recovery speak for themselves in their characteristic ways.

We then look intensively at the picture itself, asking which interpretative strategies might best help us understand how it works. As a picture that is poetic in the general sense, we refine this proposition by showing how it works with the tropes of the all-pervasive love poetry of the Renaissance from Dante and Petrarch to Leonardo's day. Leonardo works with and surpasses the poet's recurrent images of the irresistible eyes and sweet smiles of their beloved ladies. He in turn was the subject of poetic effusions in a reciprocal manner. We create an unrivalled anthology of poems about Leonardo.

Alongside the poetry lies Leonardo's sciences—in this case, the science of how we see, the science of the dissected human body, and the science of ancient transformations in the body of the earth. All these are deeply infused into the image of Lisa. We show how what began as a portrait assumes the guise of a 'universal picture', in which Leonardo strove for his ultimate remaking of nature through his imagination—the *fantasia* that Dante prized as the means to transform knowledge into a poetic vision.

Science, modern science, is the subject of the final chapter. We look at a series of scientific examinations, concentrating on the most recent, to see what lies beneath the surface of Leonardo's masterpiece. The results are complicated and by no means certain, but we can see enough to support our idea that the portrait became universalized into a picture that conveys deep meanings about nature and the human condition in nature.

In all this we aim to be straightforward, founding everything on the record of Leonardo undertaking a portrait of Lisa del Giocondo in 1503. Lisa in the Louvre was the wife of somebody. This is our starting point.

CHAPTER I

Old Gentry and New Money

Lisa's family

Lisa Gherardini, the famed subject of a portrait by Leonardo, was born in inauspicious circumstances in Florence on Tuesday, 15 June 1479.[1] Her parents were living on the corner of Via Maggio and 'Chiasso Guazzacoglie', now known as Via Sguazza, a narrow and insalubrious lane where the waters seeping from the nearby Boboli hill tended to stagnate. Her parents were renting from Giovanbattista Corbinelli, a wealthy merchant who had converted the property from a wool workshop, long since closed. In the morning, we may imagine, the young woman pulled herself together, faced the last wave of pain and gave birth to a baby girl (fig. 1): her mother was called Lucrezia and her father Antonmaria.

THE GHERARDINI FAMILY
NOLDO'S DESCENDANTS
(XV–XVI centuries)

Noldo

Lucia	**Antonmaria**	Giovangualberto	Ginevra
	1441		

LISA	Noldo	Camilla	Giovangualberto	Francesco	Ginevra	Alessandra
1479	1480	1481	1483	1486	1488	1489

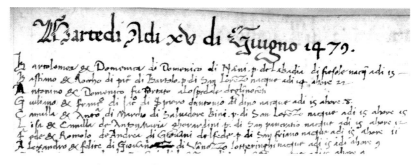

Fig. 1. *Baptism of Lisa Camilla, daughter of Antonmaria Gherardini, 15 June 1479 (sixth line).*

Lisa's parents were descended from well-known Florentine families: Lucrezia was the daughter of Piera Spinelli and Galeotto del Caccia, while Antonmaria was the son of Lisa Casciani and Noldo Gherardini. The Spinelli were wool merchants who lived in an unostentatious stone palace in Borgo Santa Croce, next to the church of the same name. The Del Caccia may not have been as wealthy as the Spinelli, but they too had their own business; they owned some farmland in the Chianti region and a palace in Florence on the corner of Via Ghibellina and Via de' Buonfanti (now the Via de' Pepi). Lisa and her family moved next door in 1494.

As for Antonmaria, he belonged to one of many branches of the once grand Gherardini family. Of feudal origin, the Gherardini had their strongholds in Chianti, and became landowners in the Valdelsa and Valdigreve campaigns. Subsequently, some of them moved to Florence, lived near Ponte Vecchio, and became protagonists of political life. Antonmaria instead came from a family who had lived on their properties near San Donato in Poggio and only recently moved to the city.

In June 1479 Antonmaria was about 40 years old and in his third marriage. The first two had ended in the kind of tragedy that was all too common at this time: in 1465 he had married Lisa Carducci, and in 1473 Caterina Rucellai, both of whom had died during childbirth. In 1476 he married Lucrezia del Caccia, who was 25 years old and now was in her second pregnancy.[2] Her husband would have perhaps preferred a boy. In any event, neither could have imagined the fame that the birth would bring to their family.

Lisa would have been washed and swaddled tightly, as it was widely believed that this helped children grow better. She would then have been dressed for baptism, and on that very afternoon her father, accompanied by relatives and

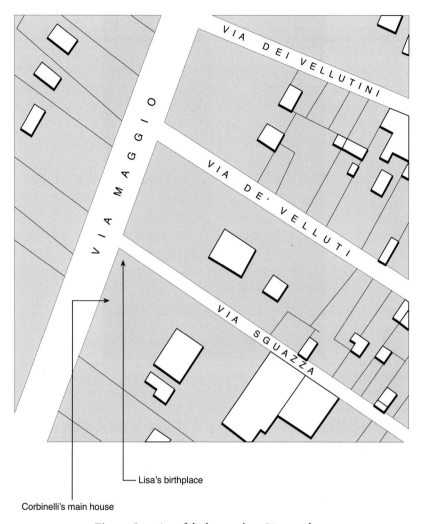

Corbinelli's main house

Lisa's birthplace

Fig. 2. *Location of the house where Lisa was born.*

friends, carried her to the baptistery. The little procession would have set out from the house at the corner of Via Sguazza and Via Maggio, turned into Borgo San Iacopo, crossed the Arno over the Ponte Vecchio, and walked into Via Por Santa Maria, where the Del Giocondo brothers' workshop was located. Lisa's future husband, Francesco, was 14 at the time and worked there as an apprentice. Together with another seven new-born babies, she

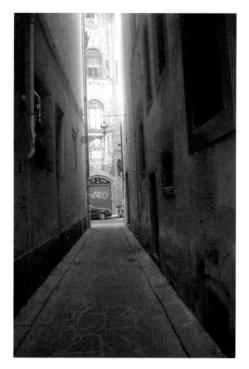

Fig. 3. *View along the Via Sguazza towards the Via Maggio, with the location of Lisa's birthplace at the corner on the left.*

received the first Sacrament of the Church in the baptistery of the cathedral. As was then the custom, she was given two names, Lisa and Camilla.

The actual house where Lisa was born has not been preserved, but local property taxation documents allow us to pinpoint its location (figs. 2 and 3). At the end of the fifteenth century the building stood to the left of what the documents describe as the 'main residence' of Giovanbattista Corbinelli (the Gherardini's landlord) in Via Maggio, a main north–south thoroughfare on the south of the Arno. There were two buildings: the larger one overlooked Via Maggio and was bordered on the right side by the palace of the Ridolfi; the other, where Lisa was born, was located to the left of the first house, spanning the corner and continuing into the Via Sguazza.[3] In the second half of the sixteenth century, they were both sold and demolished in order to make space for a new building. The new owner of the properties hired one of the best painter-architects, Santi di Tito, to prepare the plans and build on the site of the Corbinellis' old houses. This palace survives, largely unaltered.[4] Visiting the

corner plot today presents a grander and more sanitary impression than would have been the case at the time of Lisa's birth.

Lisa was born during a war, at a critical time for the Florentine Republic. A year earlier, on 26 April 1478, a violent conspiracy had been mounted, in which factions opposed to the Medici plotted to remove the family from their position of dominance in Florence. The rebels succeeded in assassinating Giuliano de' Medici in the cathedral. Lorenzo, the elder brother, was wounded but managed to escape with the help of supporters. The attempted coup had been planned in the Vatican under Pope Sixtus IV. Although it had failed, the Pope was unwilling to admit defeat. As determined as ever to overthrow the Medici, he mediated a secret alliance between the King of Naples and the city-state of Siena against Florence. Between August and September 1478 the Aragonese soldiers invaded the Chianti region, crushing the Florentine troops and ravaging the Valdelsa countryside, including Antonmaria's estates. In June of the following year, the invading army halted its advance and camped out in the hills south of Florence, precisely when Lisa was being born. When the city was on the brink of surrender, Lorenzo saved it with a bold move. He travelled to Naples and, after a long wait, met King Ferdinand of Aragon and negotiated peace on honourable terms, securing the return of the occupied lands. The fluctuating fortunes of the Medici family were to play a conspicuous role in the lives of Lisa's husband and Leonardo. A later Giuliano de' Medici is to feature in the story of Leonardo's portrait.

Lisa was given the name of her paternal grandmother who had passed away several years earlier. Lisa's grandfather Noldo was born at the beginning of the century, the son and grandson of Antonio and Arnoldo di Ugolino. Ugolino was the founder of this branch of the family which was based in the village of Cortine. The family's other branches had settled in the Chianti countryside where one of their most beautiful landholdings was Vignamaggio, girdled by a magnificent amphitheatre of hills, already famous for its vineyards. In 1422 the Gherardini sold Vignamaggio to the Gherardi who, from their houses in Via Ghibellina, traded and insured ships in the Mediterranean and in the northern seas.[5] Vignamaggio survives as a large and gracious villa above Greve in Chianti, producing fine wines and providing accommodation for paying guests. In both activities, the owners make the most of the Gherardini associations with Leonardo's portrait.

In 1427, Noldo was 25 years old and still resided in Chianti with his older brother Piero. Both were bachelors; they did not work, living off private means.

From their father they had inherited the properties in Cortine, including 'a land-owner's house [*una casa da Signore*]' which was their home, a mill, several nearby houses, an estate in Valdarno, and another one in Valdigreve. Later the two brothers went their separate ways; Noldo was married and received two estates as his wife's dowry, one of which he sold, buying three more in San Donato.[6]

In 1458 another tax survey was conducted, and Noldo stated that he was married, had four children—Lucia, Ginevra, Antonmaria (Lisa's father), and Giovangualberto—and lived in Florence in Via Santo Spirito. Noldo died shortly before the birth of Lisa. Sadly, he did not die in his bed, in the comfort of his home, but in the hospital of Santa Maria Nuova, one of the most sophisticated in Europe at the time. The hospital specialized in caring for the poor in communal halls, but also set aside private rooms for the more affluent.[7] The hospital was also an important financial centre: it accepted deposits of money and owned large quantities of land, which served as collateral and sources of income. This was where Leonardo banked his money, stored his books, and conducted his most important human dissection. Michelangelo also banked there. We do not know how an old man of Noldo's standing could end his days in the hospital with limited privacy and a high risk of contracting an infectious disease. He made a testament and left his possessions to his firstborn son Antonmaria, Lisa's father.

In 1480, Antonmaria already lived in Via Maggio and was not engaged in any business activities, or at least so he said; he was married to Lucrezia and he had a 1-year-old daughter, Lisa, without a dowry—that is to say, without a monetary deposit for her future marriage. A girl without a dowry could only have come from a family without much in the way of financial liquidity. Usually even less well-off families made deposits in the Monte delle Doti (dowry bank) in the name of their new-born daughters. The initial investment grew over time and after fifteen or twenty years became a solid amount which could guarantee a good marriage.[8]

The dowry bank was to feature in one of Leonardo's earliest commissions. His complex agreement with San Donato a Scopeto for his altarpiece of the *Adoration of the Magi* included his receipt of a parcel of land and a requirement that he make a payment of 150 florins into the Monte delle Doti on behalf of the commissioner.[9] The odd arrangement may have been promoted by his father, Ser Piero, who was procurator for the monastery. In any event, it was a payment on which the young painter seems to have defaulted—and he did not finish the painting.

Antonmaria's main income came from his landholdings in Chianti, but the raids of the Aragonese troops in 1478–9 took a heavy toll, affecting harvests for several years. Antonmaria described them as reduced to utter desolation: 'For the love of war [he stated sarcastically] I did not get anything out of them.' His estate in Cortine was laid waste and the other two were also badly damaged with ravaged fields, burnt houses, and peasants and cattle missing.[10] Antonmaria did not wallow in self-pity: instead he rented—cheaply—four landholdings belonging to the hospital of Santa Maria Nuova, which too had been pillaged by the soldiers. The largest of them had a huge stone tower which by that time had lost its military function, becoming a 'house for the landlord and his tenant farmer'. It lay in the heart of the Chianti region, in the neighbourhood of Panzano, and it was called 'Casa in Pesa'—'the house over the Pesa river'— because of the imposing bulk of the building overlooking the course of the river of the same name.[11] Surrounded by pines and cypresses, it hangs over the wide valley below, blessed with a panoramic view of the embracing scenery, as if from an elevated balcony. A network of white roads criss-crosses the slopes of the nearby hills, with spectacular climbs and descents cutting through fields and woods, connecting houses and villas, small villages, and old parish churches—a landscape moulded (and, thankfully, preserved) by man.

Together with the landholdings in Panzano, Antonmaria ran six estates in Chianti, all of them rented to tenant farmers. They produced marketable wheat, wine, and oil, obviously more than he needed to feed his household. His main occupation was to manage his country properties and his primary source of income was what he earned from selling agricultural products and livestock. However, some documents suggest that he had another source of revenue: he knew several notaries and from time to time acted as an 'arbitrator and a friendly mediator' in civil litigations, receiving monetary rewards for his services. It was a sporadic activity, a way of supplementing his income, which was perhaps just enough to guarantee an honourable existence to a man of his standing, somebody who was referred to as 'a gentleman' in the legal documents when acting as a witness or as an arbitrator.[12] Life in the city was expensive, and Antonmaria's finances became very stretched. To give one example, while the dowry of a farmer's daughter could be around 10 florins, the dowry of a Florentine girl from a well-off family needed to be at least 500 florins or more. Antonmaria's liquid assets were limited, and when he married off his daughter Lisa, he was forced to cede to her husband his largest estate, the one in San Silvestro.[13]

San Silvestro is situated on the ridge of the hills that separate the Florentine and Sienese zones of the Chianti region. Picturesque as it may be, this is a challenging place; the terrain is steep and stony, difficult to manage and cultivate. Only vines and olive trees grow well there. The surrounding hills are covered with woods; below there are fields, vineyards, and cubic farmhouses that are often located in places difficult of access. Yet this did not deter some of

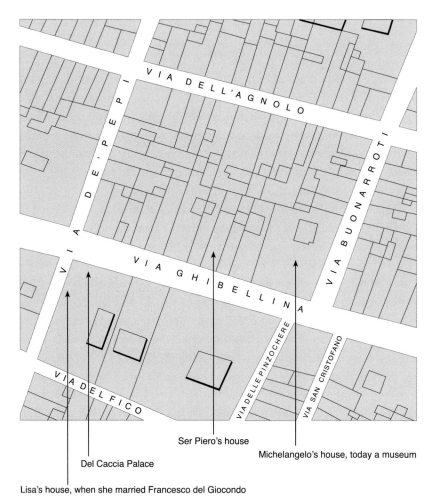

Ser Piero's house

Del Caccia Palace

Michelangelo's house, today a museum

Lisa's house, when she married Francesco del Giocondo

Fig. 4. *Lisa's house in Via de' Pepi, Ser Piero da Vinci's house, and the later houses of Michelangelo in Via Ghibellina.*

the most well-known Florentine families from wanting to own property in that countryside. Land was more trustworthy than banks.

Artists with cash to spare typically invested in farmland. In the middle of the sixteenth century, Michelangelo Buonarroti instructed his nephew to purchase as soon as possible, and at whatever price, two estates—'la Torre' and 'Casavecchia'—situated in places that were not exactly easy to reach. The nephew carried out his uncle's request, and the artist became the owner of two farmhouses and a stern stone tower that marked the entrance to his land-holding.[14] Leonardo's documented landholding was his 'vineyard' on the out-skirts of Milan, on which his assistant Salaì constructed a house.

While Lisa was growing up, Antonmaria and his wife Lucrezia had six more children: Noldo, Camilla, Giovangualberto, Francesco, Ginevra, and Alessandra.[15] Like Lisa herself, her first four siblings were born in Via Maggio, while the last two, Ginevra and Alessandra, were born in a nearby house. As we shall see, Antonmaria often moved house: for about ten years he lived in Via Maggio, then in the neighbourhood of Porta Romana, and in 1494 he crossed the Arno and moved to Via de' Pepi, next door to the palace of his in-laws, on the corner with Via Ghibellina (figs. 4 and 5). The reason behind his last move remains a mystery; we do not know why the Gherardini left Via Sguazza. It could be that the state of the house and of the street it faced was particularly depressing, but it is possible that Antonmaria was not punctual with payments and that the Corbinelli did not renew his rental agreement. At that point, his father-in-law, Galeotto, probably intervened and tried to find a new dwelling for the family, asking an immediate neighbour to house them, at least temporarily. The neighbour in question was Leonardo Busini, an old cloth merchant who lived on his own. He eventually obliged Galeotto and agreed to share his house with the Gherardini family. We do not know, however, whether he did so out of compassion or to earn money. In his tax return he stated that he had let them live with him because 'they did not have a house', and yet he charged them a biting rent and was quick to add—bluntly and with a note of regret— that they made him very 'uncomfortable'.[16]

In 1495, at the time of her wedding with Francesco del Giocondo, Lisa still resided in the Via de' Pepi, next to the palace of her maternal grandparents. On the other side of Via Ghibellina lived a man who was well-known in Florence: the notary Ser Piero da Vinci, Leonardo's father. Ser Piero's family had settled there fifteen years earlier, and their presence was very evident in that part of the street, both because of his high reputation and, as we may imagine, from the

Fig. 5. *The Gherardini residence at the corner (on the left) of Via Ghibellina and Via de' Pepi.*

noisy activities of his very numerous children swarming down Via de' Pepi into Piazza Santa Croce. Ser Piero was one of the most influential Florentine notaries and it is not by chance that his 'legal office' was located in a strategic place for his profession—that is 'in front of the gates of the Palagio del Podestà', now called the Bargello, which in those days was the seat of the legal offices of the city (fig. 19).[17]

Ser Piero certainly knew Antonmaria's father-in-law, Galeotto del Caccia, who occupied the house opposite him, and also the Gherardini who lived in the next house along the road. After her wedding, Lisa was to move again, but this time her new dwelling was an affluent house owned by the merchant, Francesco del Giocondo. It was however still located in a largely working-class area. His palace stood at the end of Via della Stufa, close to the convent of Sant'Orsola, immersed in the narrow streets of the parish of San Lorenzo, which were busy with many small shops in the daytime and with the world's oldest profession at night.

Francesco's family

THE DEL GIOCONDO FAMILY
IACOPO'S DESCENDANTS

Iacopo
*c.*1357

Zanobi
*c.*1389

Domenico	Antonio	**Bartolomeo**	Amadio	Giovangualberto
		*c.*1424		
Giocondo, 1457		Alessandra, 1459		Caterina, 1460
Giuliano, 1461		Gherardesca, 1463		**Francesco, 1465**
Lisa, 1468(?)		Margherita, 1470		Marietta, 1477 (?)

Lisa's and Marietta's dates of birth are deduced from their father's 1480 tax return, and are uncertain. The other children's dates of birth are taken from the Baptismal Registers.

Francesco del Giocondo was born in Florence on 19 March 1465 in Via della Stufa, in the house which his father Bartolomeo had bought and refurbished two years earlier (fig. 6).[18] Unlike the Gherardini, who were proud of their illustrious past and who could live off a private income, the Del Giocondo came from obscure and humble origins and had grown wealthy first as artisans and then as merchants.

Their forefather was a certain Iacopo di Bartolo, known as Iacopo del Giocondo, who made wine barrels. He had spent his life in the workshop he had rented in the neighbourhood of Via Vecchietti, between the cathedral and Santa Maria Novella, toiling with his adze and hammer, shaping staves and binding them together with metal hoops. In 1427, Iacopo was 70 years old and lived with his wife, their two children, and seven grandchildren in his house in Via dell'Alloro. His wife was Tommasa, and she was fourteen years younger than he. His sons, Zanobi and Paolo, were 38 and 26 years old. Zanobi was married to Piera, who at the age of 25 had already given birth to six children, including Bartolomeo, who was to be Francesco's father. Paolo, the younger brother, was not married but had an 8-month-old daughter, Sandra, who was welcomed into the fold of the family by her grandparents. Another member of this large and thriving household was a 22-year-old slave called Caterina.[19]

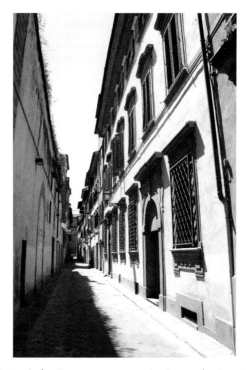

Fig. 6. *Via della Stufa (with San Lorenzo in the distance). The Del Giocondo house was on the right, with the garden wall of the Palazzo Taddei on the left.*

Iacopo's work was hard yet very profitable, at least judging by the wealth he was able to amass over the course of his life. He bought two houses in the city, one in Via dell'Alloro in which he lived and another in the vicinity of Via Faenza which he regularly rented out. He also became the owner of a beautiful country estate near Florence, in the plain of Badia a Settimo, complete with a landlord's house and a tenant farmer's house.

Zanobi and Paolo decided not to follow in their father's footsteps; sensing opportunities in the textile sector, they founded their own trading company. In 1427 they had a surplus of over 5,000 florins in the form of cash and goods in the storehouse, whole pieces of fabric and strips, as they stated in the tax declaration that they submitted jointly with their father. The two brothers showed a flair for entrepreneurship and their company grew, becoming one of the most important in Florence.

After the marriages of his sons and the birth of his grandchildren, Iacopo's house in Via dell'Alloro became too small, and Zanobi looked for a larger

dwelling. He learnt that the Alberti had put their houses in Via dell'Amore (today Via Sant'Antonino) up for sale, and he promptly bought them, together with an adjacent house, joining them into one single palace for himself and for his brother, Paolo. Zanobi died shortly after the mid-century, leaving his properties and the company to his sons Antonio, Bartolomeo, Amadio, and Giovangualberto, born in quick succession. In 1458 they were aged between 30 and 35; they were all married and they lived together, forming an extended family in their father's house in Via dell'Amore. For many years they had employed a slave named Sofia and they had recently acquired another called Chiara. Sofia had a son by the oldest brother, and it is easy to imagine that Chiara ran the same risk. In those days illegitimate children were not a rare sight even in the best families: the extended Corbinelli family, to give just one example, included five illegitimate children, and Giovanbattista, the owner of Antonmaria's house in Via Maggio, had two.[20] This is worth bearing in mind when we think about Leonardo's illegitimate status.

Judging by their achievements, Zanobi's sons were good businessmen: the number of customers grew and so did the company. In 1450 they bought a workshop in Por Santa Maria; in 1456 they rented another one, and in 1482 a third.[21] All three were located near Ponte Vecchio. The premises were used for the weaving and storage of silk, and for selling a variety of fabrics— damasks, satins, velvets, and brocades. These were luxury goods for customers who were wealthy and hard to please. Florentine silks were of excellent quality and much sought after abroad, as they were produced with great skill, in conformity with the strict guidelines imposed by the Arte della Seta (Silk Guild).

In the second half of the fifteenth century the textile sector retained its leading position in Florence. Workshops for wool were the most numerous and generated the largest turnover.[22] They were followed—albeit at a distance—by silk workshops, including those owned by the Del Giocondo brothers. In their premises in Por Santa Maria, then the 'silk road' of Florence, they produced and sold both wholesale and retail exquisite fabrics for buyers in Italy and abroad. They were suppliers or clients of the most prominent Florentine merchants, such as the Medici, the Frescobaldi, the Quaratesi, the Rucellai, and especially the Strozzi, to whom they lent significant amounts of money. They had established a thriving business with a high volume of international transactions and they became active players on the money and exchange market jointly with Francesco Cambini's company.[23]

Antonio, Bartolomeo, Amadio, and Giovangualberto were entrepreneurial family men. Following the birth of their children and eventually of their grandchildren, the house in Via dell'Amore had become too small, and one of the brothers decided to move out and live by himself. Between October 1458 and January 1459, Bartolomeo bought 'three small houses' in the parish of San Lorenzo, two of which overlooked Borgo la Noce and the remaining one on the parallel Via della Stufa. Shortly after the contracts had been signed, there ensued a long dispute over the transfer of ownership, which was resolved only four years later. Having taken possession of the 'three small houses', Bartolomeo immediately started refurbishing them: he turned them into one palace and moved the front door from the Borgo la Noce to the Via della Stufa. Bartolomeo was about 40 years old when he moved into this new house; he was married to Piera and he had four children: Giocondo, Alessandra, Giuliano, and Gherardesca. His fifth child, our Francesco, would be born the following year, in 1465.

Bartolomeo always gave priority to commercial investments, but like many Florentine citizens, he loved the countryside and, as soon as he could afford it, he purchased a beautiful property close to home. He bought two estates on the Montughi hill, not far outside the city walls.[24] Though not particularly big, the estates were located in an exclusive place and included 'a landowner's house' where he would stay when he wanted to relax, go hunting, or retreat during the hot summer months. Florence lies at the foot of Montughi, and his villa offered a sweeping view of the surrounding hills and the city below, with the graceful tower of Palazzo Vecchio and the airy dome of the cathedral as the focus of the panorama (figs. 7 and 8).

In the spring of 1480 tax assessments were carried out again, and the Del Giocondo brothers registered essentially the same properties that they had owned ten years earlier. Of the four families, three resided in Via Sant'Antonino, while Bartolomeo's family lived in Via della Stufa. Bartolomeo was 56 years old and his wife Piera was 43; they now had nine children: three sons, including Francesco who was aged 15, and six daughters all of whom had substantial dowries that would guarantee them advantageous marriages.[25]

Judging by their tax return, the Del Giocondo brothers were shrewd managers. They preserved their patrimony and the shares of their company, which, after a period of robust growth during the reign of Cosimo de' Medici from 1434 to 1464, continued to flourish during Lorenzo's era. Unfortunately the company's books do not survive, with the exception of two small registers that

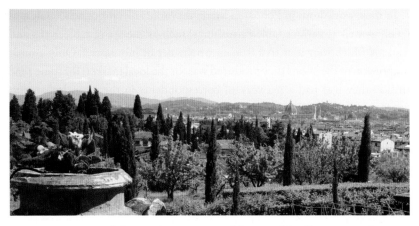

Fig. 7. *View of Florence from Francesco del Giocondo's villa in Montughi.*

offer a limited insight into the firm's activity. For their economic transactions and payments the Del Giocondo brothers used a number of large banks, such as the Medici bank in Rome and those owned by Luca da Panzano and Piero Mascalzoni in Florence.

Their trade was international. In April 1490, just to give an example, they sold some rolls of fabric to a certain 'Gilar Bay, a Turk and a servant of the Granturco' who lived in Rome and who paid for the goods by depositing the money at the Banco Medici, which in turn credited the amount to the account of the Florentine company. They used Lorenzo de' Medici's bank in Rome mostly for foreign trade operations, usually involving large-value payments.

The brothers' economic relationship with the Medici must have been more complex than the available sources reveal; it probably was not limited to cashing bills of exchange or making payment transactions at their bank. From the few surviving records it emerges that the Del Giocondo enjoyed business relations with both 'Lorenzo son of Piero dei Medici and Partners, wool merchants' and 'Piero son of Lorenzo dei Medici and Partners, silk merchants'. In other words, they were clients and suppliers of the two main Medicean companies in the wool and silk sector. Such dealings were part of a long-term relationship rather than merely sporadic, so much so that when Lorenzo died in 1492, leaving many debts, among his main creditors were the Del Giocondo brothers, who had to go to considerable lengths to recover their 4,000 florins from his son Piero.

In their workshops in Por Santa Maria they sold silk fabrics, wholesale and retail, as well as various table furnishings, such as the set of tablecloths and napkins which they sent to a Roman wholesaler in July 1492.[26] Only a small proportion of the goods they produced was for the local market; for some time already they had had a network of correspondents in the main Italian and European market towns, especially in France. It was in Lyon that at the end of October 1492 that the Del Giocondo brothers founded a new silk trading company. Without distinguishing between the sacred and the profane, they invoked the 'immortal and omnipotent God, his glorious ever-virgin Mother Mary and all the Saints so that the enterprise may have a good beginning, a better middle and an excellent end'. The share capital was set at 8,000 florins, with three-quarters of this sum supplied by the signatories. 'The governing body of the company' was based in Florence and in Lyon, and the managers had to act 'in the company's interest' and to serve it 'day and night', abstaining from any form of competition. They exercised a strong presence not only in Florence and in Lyon, but also in Rome, where they conducted business with the Roman Curia and where in 1494 Francesco's cousins founded a company which combined trading with financial operations.[27]

The year in which the Del Giocondo established their firm in Lyon, Florence witnessed an event that changed its history. The death of Lorenzo il Magnifico was followed by a rapid decline of his family and their eventual exile. The flight of the Medici from the city in November 1494, in the face of the invading French and a revolt of citizens, marked the beginning of a turbulent era. There were regular clashes between the supporters of the Medici and the followers of the Dominican prior of San Marco, Gerolamo Savonarola, who railed loudly against the corruption of the Church and the tyranny of the Medicean regime. Savonarola became the de facto ruler of the newly republican city. He carried considerable political weight and exercised a compelling influence over Florentine citizens. Citing apocalyptic visions, he never tired of inveighing against corrupt clergymen and venal rulers. Unsurprisingly, he ran foul of the ecclesiastical elite, and, having openly defied the Pope, was excommunicated. His political project in Florence began to fail. In 1498, Savonarola and two fellow monks were charged with heresy, arrested, tried, condemned, and hanged. The monks' limply hanging bodies were burnt at the stake in the great piazza in front of the Palazzo de' Signori.

The republican government did not immediately fall. It constructed a great new Council Hall for meetings of franchised citizens. It was for this new hall

that Leonardo was commissioned to paint the *Battle of Anghiari*, alongside Michelangelo, whose subject was to be the *Battle of Cascina*. Leonardo also worked for the republic as a military and civil engineer, above all on the doomed scheme to divert the River Arno around Pisa, the city that had taken advantage of the French invasion to declare its independence from Florence. Along the way, Leonardo also began his portrait of Lisa, as reported by the Florentine chancellery clerk (and sometime secretary to Niccolò Machiavelli) Agostino Vespucci, who supplied Leonardo with a written account of the battle he was required to paint in celebration of the republican regime. His mural was to be placed above the loggia of the 'Twelve Noblemen [*Dodici Buonomini*]', a body on which generations of the Del Giocondo family served, including Francesco.

It was symptomatic of the weak position of the Florentines that they were forced to cede Michelangelo's services to Pope Julius II in Rome, and eventually yielded Leonardo to the French rulers of Milan. Torn by factions, the republican regime ultimately proved to be incapable of fortifying the weak position of the small Florentine state. Having spent eighteen years in exile, the Medici, helped by Pope Julius II, returned to power at the beginning of September 1512.

The Del Giocondo family proved to be astute politicians. They avoided taking sides openly, and manoeuvred through these tumultuous years without apparent detriment to their business. They belonged to one of the major guilds, the Silk Guild, and they could therefore hold the highest offices of the Florentine state. From the mid-fifteenth century until the beginning of the sixteenth century, almost eighty members of the family were elected to various governing bodies, either as Priors of the Signoria, the executive body, or as members of the consultative body, the *Dodici Buonomini*. They were particularly active in the period between 1480 and 1520, when, despite the political changes, they supplied more than forty representatives to the governing bodies. They managed to remain on good terms both with the Medici family and their enemies. They refused to be dragged deeply into the sterile struggles between factions, continuing to be appointed to public offices, all the while keeping their company afloat.

When Bartolomeo died in 1484, his place was taken by his third-born son Francesco, perhaps because he resembled his father in personality and in business acumen to a greater degree than the other sons.[28] The other two brothers, Giocondo and Giuliano, took different paths: Giocondo became a priest,

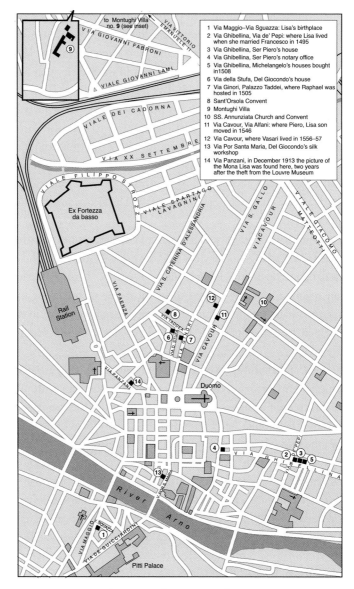

1 Via Maggio–Via Sguazza: Lisa's birthplace
2 Via Ghibellina, Via de' Pepi: where Lisa lived
 when she married Francesco in 1495
3 Via Ghibellina, Ser Piero's house
4 Via Ghibellina, Ser Piero's notary office
5 Via Ghibellina, Michelangelo's houses bought
 in 1508
6 Via della Stufa, Del Giocondo's house
7 Via Ginori, Palazzo Taddei, where Raphael was
 hosted in 1505
8 Sant'Orsola Convent
9 Montughi Villa
10 SS. Annunziata Church and Convent
11 Via Cavour, Via Alfani: where Piero, Lisa son
 moved in 1546
12 Via Cavour, where Vasari lived in 1556–57
13 Via Por Santa Maria, Del Giocondo's silk
 workshop
14 Via Panzani, in December 1913 the picture of
 the Mona Lisa was found here, two years
 after the theft from the Louvre Museum

Fig. 8. *Key locations in Florence.*

embarking on an ecclesiastical career; Giuliano chose to dedicate himself to foreign trade. He first went to Spain and then to Portugal, finally settling down in Lisbon where, together with two other Florentine merchants, he founded a trading company.[29]

When Francesco married Lisa in 1495, he was a wealthy 30-year-old merchant. He lived in his substantial house in Via della Stufa and, with one marriage behind him, he now celebrated his second marriage. He had inherited a quarter of the two workshops in Por Santa Maria as well as a third of another workshop which was bought later and which bordered the properties of Lorenzo de' Medici's heirs. He owned a villa and two estates on the hill of Montughi above Florence, and he had recently received another estate in Chianti, namely the San Silvestro landholding, donated to him by Antonmaria Gherardini as the dowry of his daughter Lisa. He was, in short, a citizen of some substance, with a thriving business and impressive landholdings.[30]

CHAPTER II

⚬❊⚬

Francesco and Lisa
Family and Finance

Francesco del Giocondo was married twice: first to Camilla Rucellai and then to Lisa Gherardini who was to outlive him. According to tradition, he had three wives: Camilla Rucellai and a certain Tommasa Villani, in addition to Lisa Gherardini.[1] In the archival documents there is no trace of Tommasa Villani or of her marriage to Francesco; in any case, the timing of the events seems to make it impossible for this marriage to have taken place. In 1491, Francesco married Camilla Rucellai and two years later their first child was born. In July 1494, 'Francesco del Giocondo's wife'—who was none other than Camilla—passed away and was buried in the church of Santa Maria Novella.[2] Eight months later, in March 1495, Francesco was united in matrimony with Lisa Gherardini.

His first wife, Camilla, was the daughter of Mariotto Rucellai, one of the many descendants of the powerful dynasty with whom the Del Giocondo had long-term business relationships. Francesco's father was their supplier and, as we have seen, they owed him a large sum of money. The Rucellai were one of the most affluent and influential families in Florence. Its leading figure, the rich merchant, Giovanni di Paolo Rucellai, was among the most important patrons of the fifteenth century. It was he who commissioned Alberti to build the stylish palace in the Via della Vigna and the loggia that faces it. Alberti also reshaped the old church of San Pancrazio, and constructed inside it a beautiful re-creation of the Holy Sepulchre—the *Santo Sepolcro Rucellai*. And Alberti's

Francesco del Giocondo
Marriages and children

First marriage, 1491–4	Birth	Death
Francesco del Giocondo	19.03.1465	??.03.1538
wife: Camilla Rucellai	09.04.1475	24.07.1494
son: Bartolomeo	24.02.1493	11.12.1561
Second marriage, 1495–1538		
Francesco del Giocondo	19.03.1465	??.03.1538
wife: Lisa Gherardini	15.06.1479	14.07.1542
children: Piero	24.05.1496	28.02.1569
Piera	05.05.1497	06.06.1499
Camilla (Sister Beatrice)	09.08.1499	09.01.1518
Marietta (Sister Ludovica)	11.11.1500	08.04.1579
Andrea	12.12.1502	c.1536
Giocondo	20.12.1507	08.01.1508

pedimented façade for Santa Maria Novella carries a massive inscription that leaves no doubt about who paid for it.

Mariotto di Piero Rucellai did not belong to Giovanni's branch of the family, but he was a member of the same clan and he lived in the communal palace in Via della Vigna, on the corner with the 'Via degli Orafi', now the Via de' Federighi. He too was a merchant and he was married to Mistress Pippa, who stoically bore him nine children over twenty years: five sons and five daughters, one of whom was Camilla.[3]

Camilla Rucellai was born on 9 April 1475 as one of Mariotto's youngest daughters.[4] When she was in her teens, her parents started looking for a husband and considered that Francesco del Giocondo might be the right man, given his financial situation. As for the Del Giocondo, they were not nobles and hence had an interest in marrying into one of the most illustrious families in Florence. After the usual preliminary meetings the families agreed on the

size of the bride's dowry and fixed the dates when the ring would be presented to the bride and when the marriage would be consummated. These events took place in 1491. Camilla left the Via della Vigna Palace to live in her husband's house in Via della Stufa, a humbler street. Francesco was 26 years old and Camilla was ten years younger. Unlike today, when there is a tendency for women to marry late, many were to marry at an early age and bear children immediately. Indeed, the following year Camilla was pregnant, and on 24 February 1493 she gave birth to a baby boy whom they named Bartolomeo after his paternal grandfather.

Their marriage seemed to be going well and, after the birth of their first son, Francesco and Camilla expected to have more children; they could not have imagined that their union would end so soon. We do not know whether her death was related to a further pregnancy or an illness, but on 24 July 1494 at the age of just 19, Camilla died, leaving her husband to care for the little Bartolomeo. Her funeral was attended not only by the most prominent families but also by many ordinary citizens, as was the custom of the time. The ceremony was held in the church of Santa Maria Novella, where the Del Giocondo had a family vault, which became Camilla's final resting place.[5]

Francesco recovered from his loss and in the spring of the following year he stood at the altar with his new bride. It is likely that Francesco and Lisa's father had known each other for some time. Both were related to the Rucellai, having married Rucellai women—even if these marriages took place twenty years apart. And it is possible that in 1491 Antonmaria attended both Francesco and Camilla's wedding, as well as Camilla's funeral three years later.

On 5 March 1495 Antonmaria Gherardini left home to complete the legal transfer of Lisa's dowry, passing down Via de' Pepi—where he lived—and turning the corner into Via Ghibellina. He headed towards the house of a trusted notary, Ser Bernardo Gucci. They read through the necessary documents, and Antonmaria added his signature, perhaps somewhat reluctantly.[6] He was giving away his best property in Chianti, the San Silvestro estate, ceding it to his young and ambitious son-in-law (fig. 9; see note 13, chapter I).

Lisa was not yet 16. In the notarial act, written in Latin, she was referred to as 'the wife of the said Francesco', which means that she was already legally married to Francesco del Giocondo. Antonmaria transferred to his son-in-law the properties which constituted his daughter's dowry, but the signing of the marriage contract and the presentation of the ring had taken place earlier.

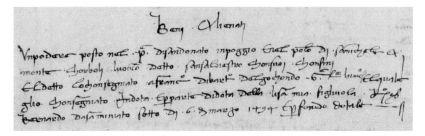

Fig. 9. *Dowry of Lisa, the Podere San Silvestro, in the cadastral declaration of Antonmaria Gherardini, 1495.*

At the time, marriage was not a one-off event, a single act that was concluded on just one day.[7]

The initial contact between the families would have been made either through a professional matchmaker or through personal connections, and the aim was to reach a preliminary agreement. At that stage, the negotiations were conducted by the bride's father and the future husband, who formalized their commitment in a private contract, which was usually drafted by a third party and which was concluded with a handshake (known as *impalmamento*). Then, in the presence of a notary and the bride, they signed the public act, that is the actual contract, which confirmed the obligations undertaken by the two parties, involved the exchange of consent, and culminated in the presentation of the ring to the woman (*datio anuli*).

The presentation was the high point of the ceremony: it symbolized the bride's official entry into the nuptial rite and the union of the couple. In the evening of the '*dì dell'anello* [ring day]', the bride went to her spouse's house, and her spending the night there constituted indisputable proof of their carnal union. Only after the marriage had been consummated could the husband collect the dowry and use it as he saw fit; in the event of his death, however, it was returned to his widow as her means of support. According to a number of studies, the most popular 'ring day' in Florence was Thursday; on Friday the dowry would be handed over, and on Sunday the wedding celebrated and the wife brought to her husband's house, making their union public. The ritual was the same in the countryside, even if in a rural wedding everything was most likely conducted in a more financially constrained manner, not least with a far smaller dowry. Marriage at this time was characterized by the wide age gaps between spouses. Women often married very young, as soon as their menstrual periods started, while men married much later. The most common age for a

Florentine girl's first marriage was 15–16 compared to 26–27 for a man. Following the custom of the time, by the time he was 30 years old Francesco del Giocondo had married twice and on both occasions to girls much younger than himself.

We do not know how Francesco came into contact with Lisa's father, but it was a mutually advantageous union. Lisa belonged to a relatively prosperous family who lived off the income from their estates in Chianti, but whose economic resources could not be compared to Francesco's. The Gherardini had to give away an estate to provide their daughter with a dowry, while Bartolomeo, Francesco's father, set aside 4,000 florins in total for his daughters, ten times the amount of Lisa's dowry.[8] Francesco was 30, fourteen years older than her and it is likely that he was attracted by Lisa's youth and beauty. He was alone; he had recently lost his wife and his mother Piera, and he needed a woman who could look after his home and raise Bartolomeo, who had been left without a mother.[9] And Lisa Gherardini brought with her a good name.

After her wedding, Lisa lived with her husband in Via della Stufa. The building was rather large but of no particular architectural merit. It was on two floors, the rear windows of which overlooked an inner courtyard and a porch, and it extended to the parallel Borgo la Noce (fig. 10).[10] It consisted of the main house, with the front door in Via della Stufa, and a small adjacent house facing onto Borgo la Noce, which housed an oven that baked bread for the entire quarter. It stood at the end of the street, and from their upper windows they would have enjoyed an excellent view of the garden and the courtyard of the Taddei Palace, where Raphael resided in 1505, as we will see later. The Taddei were also patrons of Michelangelo.

If their town house was not particularly stylish, Francesco had inherited another residence which was highly desirable, outside the city on the Montughi hill. Perched on the top of the hill was the body of the villa with a garden in front, which in spring would be awash with flowers and lemon trees in pots. It served as a wonderful platform from which to enjoy a panoramic vista of unrivalled beauty. On one side of the villa stood the farmhouse and below there were tree-lined fields and the road which ran down to Florence. In the middle distance, between the olive branches and the silhouettes of cypress trees, lay the city: a patchwork of red roofs which led the eye to the palaces, the churches, and the taut, arching dome of Florence Cathedral whose majestic form was readily visible from the villa. From their house and the streets of San Lorenzo, it did not take them long to reach this paradise. A pleasure retreat, a family seat

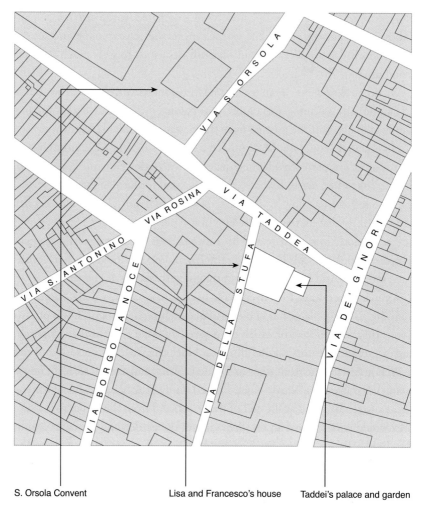

S. Orsola Convent Lisa and Francesco's house Taddei's palace and garden

Fig. 10. *Lisa and Francesco's house in Via della Stufa and the Palazzo Taddei, with the Convent of Sant'Orsola.*

and a symbol of social status, the Montughi villa had been in the family for more than fifty years. Bought by Bartolomeo, it passed to his children after his death and then to Francesco, who perhaps spent more time there and took better care of it than any of his predecessors. He had it luxuriously furnished and in certain periods of the year it would have served as the family home. As a prominent and influential person, he gave his name to the location, which

came to be known as 'Francesco del Giocondo's place'. It was referred to as such in the deed of sale when the villa was sold to the Uguccioni family.[11]

The Del Giocondo family always had maids who helped with domestic chores. Since his childhood Francesco had lived side by side with some 'female slaves who had converted to Christianity', bought by his father, and after Bartolomeo's death it was his responsibility to find new ones. Sometimes he bought more slaves than he needed. Considering that he bought them regularly—and the sheer number of 'converted' girls' with whom he was associated—it seems likely that he took part in the slave trade. In 1487 he brought to the baptistery a certain Caterina, in 1488 a girl with an exotic name, Cumba, and on 1 December 1490 two girls, Dianora and Caterina. In 1499, a few days before Christmas, he baptized a certain Giovanbattista, a 12-year-old boy who came via Portugal, and five months later, three more women. Moreover, at the beginning of May of the following year, when Lisa was pregnant with her fourth child, Francesco was seen in front of the cathedral in the company of three 'Moorish women', that is to say three young women from North Africa, whom he had bought who knows where, and whom he was now leading to be baptized. The women were purified and given new names, Silla, Grazia, and Caterina, but they could not have all remained in his household: three were too many and one or all of them would have been sold on.[12]

Lisa's marriage and her life with her new family gave her security and financial stability. She had married one of the most prominent businessmen in Florence, a wealthy merchant who was also well-connected. She would be expected to keep up appearances. Given her husband's commercial activities, she would inevitably have acquired an impressive wardrobe and plenty of jewellery—as is confirmed by Francesco's will.[13] In any portrait, we would expect her to be dressed in a manner appropriate for the wife of a rich silk merchant. It was a family tradition to give expensive presents to mothers of newly born children: Francesco's cousin Bartolomeo spent a fortune on his wife's clothes and jewels, and every time she bore him a child he gave her a diamond, a pearl necklace, or a gold bracelet.[14] One of the riddles of Leonardo's portrait, as we will see, is that Lisa's costume is not quite as we might expect.

Lisa played her assigned role, above all by producing children. She became pregnant shortly after her wedding, and in May 1496 she gave birth to her first child, named Piero.[15] The baby was dressed up for baptism, taken to the baptistery and at the end of the ceremony everyone was invited to a celebration in the family's palace. As was the custom of the time, wealthy women did not

breastfeed but assigned their newborns to a wet-nurse, which allowed the mothers to regain their fertility quickly. This is what Lisa did. Soon after the birth of her first child, she became pregnant again, and in May 1497, her first daughter, Piera, was born, named in honour of her paternal grandmother who had recently passed away. The little girl was unlucky; she only lived until she was able to take her first steps, and at the age of 2 she contracted an illness that took her life. In the meantime, Lisa conceived for the third time, and when the little Piera died at the beginning of June 1499, she was already seven months pregnant.[16] Piera's funeral took place in the church of Santa Maria Novella, and she was interred in the Del Giocondo family vault. Two months later, at the beginning of August 1499, Lisa gave birth to another girl whom they called Camilla, which was Lisa's second name and also the name of Francesco's first wife.[17]

After her three pregnancies at the end of the fifteenth century, Lisa was pregnant on three more occasions at the beginning of the sixteenth century: in early November 1500 she gave birth to Marietta, in December 1502 to Andrea, and five years later to Giocondo, who only lived for about twenty days.[18] The birth of Marietta was providential because, as we shall see, it was she who was prepared to take care of the widowed Lisa when she retired to the convent of Sant'Orsola. Lisa thus had six children, three sons and three daughters, two of whom died in infancy. At the beginning of the sixteenth century, Bartolomeo, Piero, Andrea, Camilla, and Marietta were all at home. The eldest of them was barely a teenager. She raised Camilla's son Bartolomeo without prejudice. After her husband had died, she named him executor of his estate on several occasions, putting him before her own first son Piero.[19]

Bartolomeo, Piero, and Andrea completed their apprenticeships, learnt their father's trade and thus represented the fourth generation in the family business. Andrea, perhaps the most resourceful of them all, dedicated himself to international trade. He left Florence and moved to Antwerp, where he founded a trading company, a branch of the Florentine enterprise. The other two brothers stayed in Florence and worked with their father, taking his place after his death.

From a tender age, Camilla and Marietta were destined for convent life. The latter took her vows at a difficult time, soon after the untimely death of her older sister. Camilla became a nun in 1511, at the age of 12, with the name of Sister Beatrice. She entered the convent of San Domenico, which was then situated in open land, between the church of San Marco and the city

walls. Lisa's two siblings, Sister Camilla and Sister Alessandra, to whose care she was initially entrusted, also lived in the convent.[20]

Sister Camilla Gherardini, however, was not a paragon of chastity and cannot have been a good role model for the noviciate. She was implicated in a rather unedifying episode in which she was accused of indecent acts by a man with excellent eyesight and a strong concern for morality. The accusation was made via the system of anonymous complaints, called 'drummings [*tamburazioni*]', which were favoured by the authorities, who saw them as a powerful tool of social control. Once written, the denunciations were folded up, posted into special letter-boxes located outside the main public buildings, placed into a container in the form of a drum (hence the odd name), and delivered to the magistrate in charge. One of these *tamburazioni* alleged that on 20 April 1512 four men, armed and carrying a ladder, went to the convent of San Domenico, and having climbed up the wall, reached 'certain small windows, where two nuns were waiting for them [and] having stayed there three or four hours…they touched the breasts of the said nuns and fondled' the other parts of their bodies, not to mention the other indecencies which were committed.

One of the intruders was none other than the brother of the Cardinal of Pavia, accompanied by two friends, while the procurer, the man who had taken care of them and who had let them in, was called—ironically enough—Giusto (or 'Just'). He was the young and energetic administrator of the convent. As for the two nuns who 'were waiting' for them 'with gold gorgets and decked out as brides', they were Camilla Gherardini, Lisa's younger sister, and Sister Costanza Corbinelli. Behind them there were two more nuns, Sister Diamante and Sister Diana, who were watching with rapt attention, their eyes filled with similar desire.[21] Similar events had happened before. Florence was full of involuntary friars and nuns, whose levels of piety and chastity did not always withstand the temptations of the flesh. Perhaps they could claim that such pleasures are also a divine gift. A short trial was held; the nuns were absolved and the four men were found guilty.

Leonardo himself was subject to one the anonymous *tamburazioni*. In 1476, shortly before his twenty-fourth birthday, Leonardo together with three other young men was anonymously accused of sodomitic activity with Jacopo Saltarelli, who was notorious for such things.[22] The charge was not upheld but was to be '*retamburentur* [re-drummed]'. Two months later, the charge was considered again and no further action was taken.

A few years after she had taken her vows, Sister Beatrice fell ill and in January 1518, aged just 18, she died, much to the sorrow of the other nuns and to the shock of her family.[23] Despite her untimely death, Francesco and Lisa decided to commit their last remaining daughter to a convent. From a human point of view their decision might seem surprising, but it made perfect sense financially, as it enabled Francesco to save hundreds of florins. Even for a rich merchant, this was an important consideration.[24]

For some time Lisa had been a frequent visitor at the nearby convent of Sant'Orsola and she supported it through offerings and by purchasing some of its products, as she did at the end of August 1514 when she bought from the nuns a strange concoction, a 'distillation of snail water' (fig. 11).[25] This must be the medicine recorded in the *Universal Pharmacopoeia* in 1738:

One leaves snails in their shells, washes them, and then crushes them in a marble mortar. They are placed in a large glass jar, positioned on a bain-marie, into which the fresh milk of a female donkey is poured. The whole is mixed well with a wooden spatula, and then left for digestion for 12 hours before it is distilled. The resulting distilled water is exposed to the sun for several days in a glass bottle, and then kept in the bottle. This is a hydrator, and is refreshing, useful for skin redness, and can be used to clean up one's face...It can also be used internally for the spasms of spitting blood accompanying tuberculosis, and for the urine ardour of nephritis [inflammation of the kidneys]. The dosage is between one and six ounces.[26]

One hopes that Lisa needed it for external application.

At other times Lisa assumed a different role, acting like a good merchant's wife and trading with Sant'Orsola. For example, in September 1523 she sent the convent 30 kilograms of cheese produced in the family estates: the nuns received the rounds of cheese and made a payment in the name of 'Monna Lisa del Giocondo', as recorded in a neat, modern humanist hand (fig. 12).[27]

The now ruinous Benedictine convent of Sant'Orsola, founded in 1309 and transferred to the Franciscans, was a large, austere quadrangular building, circumscribed by four streets.[28] Inside, it centred around a gracious courtyard with a cloister, which could be seen from the windows of the church. There were shared facilities, such as the infirmary, the office of the apothecary (where the snail water was distilled), 'the weaving room', the kitchen, and the entirely frescoed chapter house. On the first floor a long corridor led to a seemingly never-ending succession of cells, and then there were the novices' and servants' dormitories. Sant'Orsola was one of the most prestigious female convents in Florence; it accepted only well-born girls and was home to about sixty nuns, in

Fig. 11. *Mona Lisa del Giocondo and Sant'Orsola: on 11 August 1514, she donates 3 lire (2nd line); on 29 August 1514, she buys* distillato d'acqua di chiocciole *(distillation of snail water) for 7 lire (4th line).*

Fig. 12. *Mona Lisa del Giocondo and Sant'Orsola: on 8 September 1523, she sells 95 pounds of cheese to the nuns.*

addition to the young women who were 'set aside', waiting to take their vows. It was well supported financially by leading Florentine families, not least the Medici.[29] There were also a large number of other women who carried out the most humble tasks in the convent, such as various artisanal activities and working in the infirmary, which was for the most part reserved for lonely or ailing women of means.

The nuns led productive lives. Many were assigned to the 'weaving room', a rather large hall in which they manufactured rolls of white cloth; others were busy embroidering sacred vestments, and still others made gold thread. The goods they produced were then sold to other religious institutions, which guaranteed a steady income for the convent. One of the nuns supervised these activities and at the end of each month had to report to the Mother Superior.

Placing a daughter in the convent of Sant'Orsola was difficult and also quite expensive. One needed a noble pedigree and, above all, a substantial sum of money, the level of which was set by the Mother Prioress, who would take into account the family's fame and wealth. The family, in turn, could make specific requests, as was the case with Cassandra Ricasoli. The girl's

parents undertook not only to pay the required 200 florins but also 'to construct the cell walls and to provide for her every need'. In return the convent agreed that Cassandra 'would not be forced to observe the rules and would be spared the hardships of religious life'. To put it simply, by making a substantial offer one's daughter could live very comfortably in a convent. For a well-off family, a daughter in a convent meant much money saved. To find a suitable husband, the family needed between 500 and 1,000 florins. Becoming a nun was significantly cheaper. Lisa decided to offer her last remaining daughter to God.

Again we can envisage the scene. Lisa took Marietta by the hand and led her to the convent. It took them only a few minutes to walk down the street that separated them from the front gate; they knocked and the nuns opened and escorted them to the Mother Superior. Having received her share of customary compliments and advice, the girl took leave of her mother and disappeared in the long corridor behind her. As was agreed at the meeting, it was the girl's parents who paid her living expenses, and Lisa stayed true to her word. Thus, in July 1519 Lisa walked down the road to Sant'Orsola once again. The abbess greeted her and hinted, we may imagine, at the many expenses the convent had incurred. Lisa understood the ritual, opened her bag and took out eighteen gold florins, which was a rather large sum (roughly the annual rent for a good house). The nun carefully recorded the payment, its reason, and who made it, stating that she had been 'paid for the whole of last January for the boarding of Marietta, the daughter of Monna Lisa del Giocondo'—written by an old nun in rather big, angular, shaky handwriting, perhaps the product of age and poor eyesight (fig. 13). She chose to designate Lisa by her husband's surname. Marietta took the monastic habit on 20 October 1521 under the name Sister Ludovica, and professed her vows during the Christmas Mass the following year. Unlike her sister, she lived a long life and died in 1579. Her conduct won her the trust and respect of her fellow nuns, so much so that in the second half of the century she became the legal representative of the institution.[30]

Lisa focused on her family's domestic life and Francesco on his business. Every morning, his workshops in the Ponte Vecchio area opened to customers, and, together with his cousins, Francesco oversaw the production of fabrics, negotiated with suppliers and clients, checked the accounts and the turnover of payments, and dealt with the inevitable legal matters which came up from time to time. Traces of his activity can be found in the notarial archive, in the

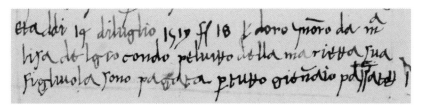

Fig. 13. *Mona Lisa del Giocondo and Sant'Orsola: on 14 July 1519, she pays the nuns 18 gold florins for her daughter Marietta's food.*

proxy arrangements, contracts, and arbitration agreements between him and other entrepreneurs. But apart from his relations with his customers, Francesco also had to think about his relationship with his family, in particular with his brother Giuliano, who traded in Lisbon and who came to owe him a significant amount of money. Francesco came to understand that his brother would never pay it back and suggested that Giuliano repay his debt by giving up his part of their father's inheritance. The two brothers had recourse to a process called 'a large arbitration award' to reconcile their conflicting interests. They chose two impartial arbitrators, one of whom happened to be Antonmaria Gherardini, Lisa's father! The two experts examined their books, calculated their debts and credits, estimated the value of the inherited property prior to its division, and then proceeded to divide it. The agreement was signed on 26 August 1501. Under its terms, Francesco became the sole owner of the house in Via della Stufa, the delightful Montughi villa, and one-quarter of the silk trading company (the other three-quarters belonged to their cousins) for approximately 11,000 florins, as well as 5,600 florins of outstanding credit that his brother owned him. To be more precise, the family palace was appraised at 1,800 florins, the villa and landholding in Montughi at 1,200 florins, the 'furnishings and furniture' in the house in Florence and in the convents of Sant'Orsola and San Domenico at 1,650 florins, and one-quarter of the company and Francesco's credits at more than 6,000 florins.[31]

Of all these amounts, the most striking is the appraisal of the 'furnishings and furniture' in the house in Florence and the convents: this is a considerable sum, only slightly lower than the value of the family palace. This can be explained by the quality and quantity of the furniture, tapestries, paintings, sculpture, metalwork, ceramics, etc. Yet it is less obvious why some of them were in the two convents, where Francesco's daughters would later lead monastic lives, Camilla in the convent of San Domenico, and Marietta in Sant'Orsola.

Francesco del Giocondo's property *after his agreement with his brother Giuliano* *26 August 1501*	Gold florins
House in Florence in Via della Stufa	1,800
Furnishings and furniture in the house in Florence and the convents of S. Orsola and S. Domenico	1,654
Landholding and Villa in Montughi on the hills of Florence	1,200
Furnishings and furniture in Montughi	148
One-sixth of the estate in S. Andrea a Ferrone	140
One-quarter of the silk workshop in Por Santa Maria (the other owners: Antonio di Zanobi, Amadio di Amadio, Giovangualberto del Giocondo's heirs)	200
One-quarter of the silk trading company	3,618
Francesco's credits in the family books	2,442
Value of the movable and immovable property owned by Francesco	11,202
Outstanding credit to Giuliano	5,590

It may be that the family were investing in the nun's comfort in advance of their daughters entering the institution.

Two years later Francesco signed another document which this time was about the distribution of his property: he was almost 40 years old and, being a prudent man, he thought about his children's future and decided to deed everything to them. He talked to a trusted notary, arranged a meeting in the cloister of the convent of San Gallo, and in the presence of a number of friars, gave 'all his movable and immovable property' to his three sons, Bartolomeo, Piero, and Andrea, and made provisions for a dowry of 1,000 florins for his daughter Camilla.[32]

A month a later, on 5 April 1503, he visited the same notary again, but this time he came as a merchant and with very different intentions. He asked the notary to draft a contract for the purchase of a house next to his in Via della Stufa. Francesco was very good at seizing opportunities. When he learnt that the artisan who lived next door was up to his neck in debt, he proposed to pay

his creditors in exchange for his house. The artisan accepted the deal. Francesco kept the house for four years, renting it out while waiting for the right buyer. He falsely claimed it as his main residence, to avoid taxes. In the end he received almost twice the amount he had originally paid for the house.[33]

These financial transactions, conducted in the same year that Vespucci recorded the *Mona Lisa* as underway, serve to place the relative values of property and paintings in perspective. We do not know how much Francesco was prepared to pay for a portrait of his wife, but it is likely to be considerably less than 100 florins, a sum for which an altarpiece could be commissioned. This is not to say that the portrait did not carry other values. The worth of an image of a 'beloved lady' for the commissioner was not to be measured only in financial terms, any more than the significance of a sonnet was limited to whatever income the poet might earn from his writing. However, for a merchant like Francesco, Leonardo's defaulting on the commission is unlikely to have figured high in his daily priorities.

In the years when Francesco was busy managing his property, a major political change took place in Florence: in October 1502, Piero Soderini was elected Standard Bearer of Justice for Life (*Gonfaloniere di Giustizia a vita*). This was the highest office in the government. Until then, no one had been permitted to hold the office for more than two months at a time. It was hoped that the change would give the *Gonfaloniere* more freedom to act and render him more independent from the political factions that had undermined his status and power. The idea made sense at the time, but in the longer term did not decisively reverse the deteriorating situation. Somehow Piero Soderini remained at the helm of the government for ten years. In the fields of foreign and military affairs, he took advantage of the close cooperation of one of the most intelligent men of that period, his friend Niccolò Machiavelli. It was Machiavelli who was responsible for one of the contractual agreements with Leonardo for the mural of the *Battle of Anghiari* in the new Council Hall.[34]

Machiavelli was also a promoter of the unworkable scheme to divert the Arno around the recalcitrant city of Pisa, for which Leonardo served as the foremost advisor. It was Soderini himself who reluctantly acquiesced to Leonardo leaving to serve the French, complaining about the lack of work completed by the painter in the hall, compared to the goodly sums of money he had been paid.[35]

The republican government headed by Soderini ultimately proved to be unable to withstand the power struggles of the European states in the Italian

peninsula. In 1511 Florence lost the support of the French and was effectively doomed. A series of unsustainable pressures came to a head. On one hand, there was the conflict between France and the conjoined forces of the Pope and Spain. On the other, the factions who sought to reinstate the Medici were exploiting the instability with increasing success. Soderini's indecisiveness proved to be the last straw. At the end of August 1512 Spanish troops sacked Prato, massacring its inhabitants, which spread such terror among the citizens of Florence that they surrendered without any resistance. On 1 September, the Medici returned to Florence. Piero Soderini fled to Rome, and Niccolò Machiavelli, despite the false impression that he had been confirmed in his office as one of the secretaries to the government, was deposed, charged with corruption and placed on trial. Francesco del Giocondo was himself involved in the dramatic events of late August 1512. Accused of being an enemy of the republic and a supporter of the Medici, he was arrested together with a number of other citizens and released on bail a few days later.[36] We do not know how actively Francesco was a conspirator, but when the Medici had regained power, he was elected as one of the Priors of the Signoria, a post that he would have never obtained if he had not shown obvious favour to them.[37] He was also one of thirty-five citizens who each subscribed 500 ducats to the new regime.[38]

Giuliano de' Medici, the third son of Lorenzo il Magnifico, ruled Florence for about six months and he would inevitably have been in contact with Francesco, who was a member of the government. In March 1513, Giuliano moved to Rome, to the court of his brother Giovanni, who had become Pope Leo X, leaving Il Magnifico's grandson, also called Lorenzo, in charge of the city. It was Giuliano who was Leonardo's direct patron in Rome from 1513 to 1516.

The young Lorenzo and his brother-in-law, Filippo Strozzi, were involved in a curious incident involving Francesco and his wife at this time. Filippo outlined the story in a humorously ironic letter to Lorenzo, recently discovered by Rab Hatfield.[39] In late September 1515, Francesco visited Lorenzo and told him that a friend of Francesco's first son, Piero, had secretly recounted how Filippo and Lorenzo had attempted to 'tempt' the honour of Lisa. She was much older than the two propositioners, but was apparently still considered attractive enough to make the story credible. Lisa was said to have spurned their advances. It was reported that Lorenzo and Filippo had accordingly become the sworn 'enemies' of Francesco. Worried that Lisa's rejection of them had cost him their friendship and support, Francesco anxiously assured Filippo that he was wholly wedded to the Medicean cause. Filippo, whose tastes, as he admitted, were

generally for young men, replied that he personally had never been interested in Francesco's 'women'. He went on to reassure Francesco that he could still count himself as one of the Medici's 'close servants and friends'. Lorenzo had apparently reassured Lisa that nothing was amiss during a meeting which was said to have taken place in a 'a little hut [*capannuccia*]'. Francesco was duly reassured and 'left content and satisfied', as Filippo noted sarcastically. He anticipated that Lorenzo would 'gain the same pleasure' out of the risible incident that he did himself.

This reads like a story from a typical Florentine *novella*, in which duped husbands are frequently the butts of sexual jokes. The meeting in the 'little hut' sounds improbable—unless we regard '*in una capannuccia*' as a figure of speech for 'in private'. We can imagine that the Medici and Strozzi regarded Francesco as trying to rise above his station. Moreover, Filippo Strozzi may have harboured some resentment towards Francesco over a recent deal.[40] Hatfield notes that Francesco was termed a 'friend' of the Medici, not 'a close friend [*amicissimo*]'. This less than close relationship explains why in the immense corpus of correspondence of the Medici family there are only two letters in which his name is mentioned.[41] By insinuating this scurrilous story via Francesco's son, someone in the Medicean camp was setting up the merchant for an amusing humiliation.

In any event, Francesco took the story seriously and was clearly concerned about his own interests over and above his wife's honour. He appears to have implicitly yielded his wife's virtue to a kind of *droit de seigneur*—the old 'rule' by which the local lord enjoyed rights over a bride before her wedding. Instead of holding Filippo and Lorenzo to account, he in effect asked to be excused for her refusal in order not to lose their support. However we interpret the incident, Francesco does not emerge with much credit. That was the intention of the jest.

Francesco seems to have gained a reputation in some quarters for showing scant respect for rules and those who enforced them. The 'Eight Guards of the Watch [*Otto di Guardia*]', the state officials charged with maintaining law and order, heard him described as 'pugnacious [*garoso*]' when they had to deal with some of his high-handed behaviour. In May 1510, the guards had sequestered a large amount of wheat in the countryside near Florence, but, disregarding the order, Francesco sent his representative to seize it, provoking a hostile reaction from its rightful owner. Francesco was denounced to the authorities, and in the indictment he was berated in an unmerciful manner.[42] Even if the words of the

plaintiff were exaggerated, they nevertheless convey some idea of the kind of reaction Francesco could provoke. He was portrayed by his accusers as 'a man blinded by sin and very pugnacious, for that is how he acts in all his undertakings, so much so that there are very few offices in the city by which he has not been condemned as a usurer'. According to the complainant, Francesco's conduct was slippery even with his own family, which resulted in some relatives ostracizing him 'as a corrupt member'.

On the other hand, Francesco demonstrated the levels of diplomacy and reliability necessary to develop the company both in Italy and abroad. More than once he travelled to France to oversee the dealings of the branch which the Del Giocondos had opened in Lyon at the end of the fifteenth century. A few years before 1510, Francesco had been in dispute with his cousins but this seems only to have served to invigorate him and strengthen his sense of initiative. Without any doubt, he had the assertive qualities of a successful merchant: he sensed changes, had an instinct for opportunity and was boldly opportunistic in his decisions. He had begun in the textile sector, but when he felt that a crisis was approaching, he was quick to branch out and begin selling other items. In addition to the fine fabrics, such as silks, satins, damasks, taffetas, and velvets, he began to trade in cheaper mass-consumption products, beginning with sugar.

For many years Francesco imported cane sugar from Madeira, and between March and April 1509 he sold about 2,300 pounds (about 700 kilos), supplying wholesalers in different Tuscan cities.[43] From his workshop by the Arno he managed to send orders to the distant island in the Atlantic Ocean. Usually his request would be forwarded to the captain of a ship in Pisa. The ship would weigh anchor, call at the ports of Provence, Spain, and Portugal, and then sail southwards towards Madeira. There Francesco's correspondents and sometimes his brother-in-law Giovangualberto Gherardini, who spent many years in the Canary Islands, purchased sugar on his behalf.[44] Returning by the same route, the cargo would be discharged at the port of Pisa. From there, small vessels sailed up the Arno as far as they could, before the bales of sugar were transported on carts to Florence, arriving several months after they had been ordered. Francesco's sustained involvement in the sugar trade brought him more profit than his other enterprises. Always on the lookout for opportunities to make money, he sold hundreds of kilograms of sheepskins from Provence, bales of wool and wax from Spain, coarse cloth from Lyon, leather and hides from Ireland, bags of soap from Genoa, and even '1,200 pounds of butter in 24 pots'. He always ordered large quantities and each shipment was worth

hundreds and sometimes thousands of florins, as was the case with the leather from Ireland, which was delivered to Florence at the end of January 1515.[45]

Trading through foreign contacts, Francesco was very familiar with the currency market and tried directly to profit from it. Just to give an example, in the autumn of 1502 the convent of the Santissima Annunziata—which he supplied with fabrics for sacred furnishings—asked him to cash a bill of exchange. He obliged the friars but made sure that he profited from the exchange.[46] Not only did Francesco act as a money changer, he was also a money lender who charged high interest rates, even when his clients were members of the clergy. Angered by his terms and conditions, the monks twice accused him of usury before the ecclesiastical tribunal of Florence, first in 1512, and then in 1536, when he was old and nearing his end. Francesco was a leopard who did not change his spots.[47]

He was not averse to lending to his close relatives. In 1515, Francesco lent more than 500 florins to Lisa's father, a sum with which one could buy a decent landholding. He subsequently sought repayment of the loan, but Antonmaria made it clear that he was broke. To save the honour of her old father, Ginevra, Lisa's sister, took upon herself to pay more than half of the debt and Francesco wrote off the rest, albeit reluctantly, realizing that he would never recover his money.[48]

More capable than his father-in-law, Francesco managed his properties in Chianti very shrewdly. In 1502, he negotiated with the Hospital of Santa Maria Nuova for the return of his landholdings in Panzano, which had been leased to Antonmaria at the time of Lisa's birth, and he succeeded in persuading them to reimburse all the money he had spent on the improvement of the fields and the houses. As we have noted, Antonmaria supplemented the income from his country estates by serving as an arbitrator in Florence. At the beginning of the sixteenth century he had to support his wife and their six children, sons and daughters, two of whom were still very young. He did not own a house in Florence, and, after Via de' Pepi, he moved to the corner of Via Ghibellina and Via de' Macci, then to Corso dei Tintori, and finally to the Borgo Albizi neighbourhood. Antonmaria must have died in 1526, the year in which his sons Giovangualberto and Francesco accepted his legacy and legally assumed the succession.[49] The former lived in the Canaries and traded in sugar, as we have seen. The latter remained in Florence and died prematurely, leaving behind two new born babies whom Lisa took to live with her in Via della Stufa.[50]

The activities of Francesco's company continued apace until 1515, when they slowed considerably, as is attested by the drastic reduction in the number of

notarial contracts drafted on behalf of the company. As the propelling force behind his trading diminished, Francesco changed strategy and progressively invested in agriculture. He transferred his share of the family workshops to his cousins, Leonardo, Tommaso, and Paolo, and rented a workshop close to Piazza Signoria.[51] He sold the idyllic villa at Montughi, and bought several estates located between Florence and Pisa, another in Chianti, and half of Marcello Strozzi's landholding in the plain near Pisa, at a cost of more than 4,000 florins.[52] Francesco had a life-long business relationship with the Strozzi. Marcello was the older brother of Maddalena, Agnolo Doni's wife, who was immortalized by Raphael in his companion portraits of husband and wife. Maddalena's portrait (fig. 43) was clearly based on the *Mona Lisa*.

Francesco had a finger in many pies, including property dealings. In May 1528, he represented the Conti della Gherardesca in the sale of the pastures of Donoratico in Maremma Pisana.[53] It could be that Francesco felt the wind of change blowing, foreseeing some kind of market crisis, and thus decided to protect his earnings, deeming that investments in land were safer and more lasting. He bought estates and rented others, using his credits. In the 1530s, he still traded, but by that time he had largely made the transition to a rich land-owner.[54] At the beginning of 1531, as life in the city was returning to normal after a year of siege, he invested in state bonds. He instructed his son to purchase them regularly, and Piero complied with this request: every week for five months he would register for them and underwrite them at the offices of the State Treasury. He eventually spent almost 1,600 florins on them, a sum with which he could have bought a palace similar to the one he owned. Two years later, once again on Francesco's orders, Piero signed them over to his mother Lisa who could use them with his consent. For inheritance reasons and in order to pay the creditors, two years after the father's death his sons drained the account deposited with the state.[55]

When Leonardo consented to paint the portrait of Francesco's wife, the merchant was at the peak of his activities as a successful trader, and was determinedly climbing the social ladder—even potentially at the expense of his wife's good name. He was a highly successful operator in times when economic success required skills that were not always of the highest probity. Lisa had come with a good family name. From Francesco she gained a married life full of material possessions. Her portrait, painted by the greatest master in Florence, would have been the icing on a rich cake.

CHAPTER III

∽∾∽

Francesco and Lisa
Patronage and Legacy

Francesco, the artists, and Vasari

Within a few hundred metres of Francesco and Lisa's home lived Botticelli, Leonardo, Raphael, Filippino Lippi, the Della Robbia brothers, Michelangelo, Baccio d'Agnolo, Perugino, and Andrea del Sarto. Francesco probably knew some of them in passing and directly associated with others. He would have been aware in the late 1480s that Botticelli had painted a magnificent altarpiece (now in the Uffizi) for the church of San Barnaba next to his house. Some years later Botticelli was painting a fresco of *Saint Francis* in the nuns' dormitory in the Franciscan convent of Monticelli. The convent of the Poor Clares was located outside the city walls, slightly above the Porta Romana, and was demolished in 1529 during the siege of Florence. At the beginning of 1496, the nuns commissioned the *Saint Francis* from Sandro Botticelli and ordered precious fabrics from Francesco del Giocondo. Sandro executed the painting, while Francesco delivered the fabrics, and they were paid on the same day in mid-June 1496.[1] The merchant would obviously have been aware both of the presence of the great artist and the image of his name-saint.

A few years later, Francesco could hardly have missed the young Raphael, who for a couple of years lived in the palace opposite his house in Via della Stufa. Raphael arrived in Florence from Urbino at the end of 1504, staying

with the Taddei family in their beautiful palace in Via Ginori, which had been designed by Baccio d'Agnolo and quite recently completed.[2] The rear façade, internal courtyard, and the garden faced on to the Via della Stufa, and the rear entrance was then opposite the Del Giocondo's front door (figs. 6 and 10). This proximity, and knowing that Lisa was then having her portrait painted by Leonardo, opens obvious possibilities. We know that Raphael gained close access to Leonardo, using Lisa's unfinished portrait as the basis for a drawing (fig. 43), for the portrait of Maddalena Strozzi, Agnolo Doni's wife (fig. 42), and for the portrait of a *Young Lady with a Unicorn* in the Borghese Gallery in Rome. Maddalena Strozzi was the sister of Marcello, a merchant who for many years had a business relationship with Francesco del Giocondo.

In addition to Botticelli, Leonardo, and Raphael, Francesco probably also knew Michelangelo. He certainly had financial ties with the sculptor's father, Lodovico Buonarroti. We do not know why, but in December 1504 Lodovico came to owe Francesco over 200 florins, which was a large sum. In order to protect his interests, Francesco asked the Officials of the Communal Treasury to block the state-registered bonds in the name of Michelangelo's father so that he could not do anything with them without Francesco's consent. It took Lodovico a year to pay his debt, and only then did Francesco release his bonds.[3] Michelangelo was then living in Florence, and given Francesco's dispute with the father, it is hard to imagine that the son did not play a role, given that he was the only person in a position to rescue the family financially.[4]

Francesco may also have come into contact with the much younger Giorgio Vasari (*Giorgino da Arezzo*), who was to provide the famous account of Lisa's portrait in his *Lives of the Most Excellent Painters, Sculptors, and Architects*, often known as his *Lives of the Artists*.[5] The most obvious sources for Vasari in writing his account were Lisa and her husband. Francesco died in 1538 and Lisa in 1542. Vasari stayed in Florence a number of times between 1524 and 1536 and is likely to have encountered Francesco, as we will see. Lisa herself is also a potential witness when Vasari was accumulating data and stories for his *Lives*. Their son, Piero, was little more than 10 years old when Leonardo left Florence, but he may well have heard tell of Leonardo's failure to deliver the picture. Sister Ludovica (Marietta del Giocondo) did not die in Sant'Orsola until 1579. In the middle of the sixteenth century, the Del Giocondo family was still active and present in the life of the city, and some of its members held prominent public positions: Antonio del Giocondo, together with Duke Cosimo I and two other colleagues, presided over the administration of the Santissima

Annunziata. A few years later, Zanobi del Giocondo was appointed Secretary of the Silk Guild.[6] There was no shortage of members of the family who potentially could have told what they knew of an artist and a painting that were already assuming legendary status.

Vasari was familiar with the works of art commissioned by the Del Giocondo cousins, Leonardo and Giovangualberto, and indeed by Francesco himself. He knew where they lived and which paintings they still owned. The first of these, Leonardo di Amadio del Giocondo, was Francesco's business partner. Twenty years his junior, he learned how to run the workshop and deal with suppliers and customers, to such good effect that he later took control of the company, purchasing Francesco's entire holdings and some of the cousins' shares.[7] Vasari recorded that Leonardo del Giocondo commissioned a '*Nostra Donna*' from Andrea del Sarto, which was then inherited by his son Piero, who lived in the Piazza Vecchia of Santa Maria Novella, not far from Francesco and Lisa's house in Via della Stufa.[8] As a pupil of Andrea del Sarto, Vasari was well informed about his activities.

Vasari also knew that both Giovangualberto and Francesco were patrons of Domenico Puligo, who was very closely associated with Andrea del Sarto. Born in 1492, Domenico received artistic training from Ridolfo Ghirlandaio.[9] Later, he began to collaborate with Andrea, a painter 'devoid of faults [*senza errori*]', as Vasari described his master. Domenico died at a young age in the plague of 1527. At the beginning of his career he was a successful portrait painter and increasingly dedicated himself to larger and more complex works. Amongst these was the altarpiece commissioned by Giovangualberto del Giocondo—'the best one he ever executed'—which Vasari probably saw in the patron's house in the 'Via dell'Amore' (the Via Sant'Antonino). Now in the Walters Art Museum in Baltimore, it shows the Virgin's miraculous appearance to St Bernard and is painted with the suave softness that Domenico had learnt from Andrea (fig. 14).[10]

A comparable altarpiece was ordered several years later by Francesco himself. In 1526 the fathers of the Annunziata granted him permission to construct his family tomb in the Chapel of the Martyrs, prominently located in the great centralized choir. The focal point of the choir was the large high altar, for which Leonardo had once been expected to provide paintings. Francesco commissioned Puligo to depict his name-saint, Saint Francis, in the act of receiving the stigmata.[11] He so liked the resulting picture that he retained it in his house. Sadly, it is no longer traceable. In keeping with its dedication, the chapel was

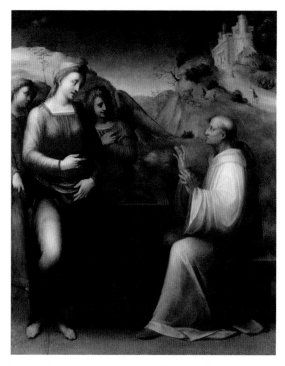

Fig. 14. *Domenico Puligo,* Vision of St Bernard, *1520, Baltimore, Walters Art Museum.*

frescoed by Antonio di Donnino Mazzieri with 'stories of the Martyrs', though in this case we may regret the loss rather less. Vasari in his brief report on Franciabigio's pupils, scathingly reports that 'Antonio performed so badly [in the chapel] that he lost all credit.'[12]

The convent of the Annunziata plays a crucial role in our story in two different periods: first, as the place where Ser Piero, Francesco, and Leonardo were active in the early years of the century, as will become apparent, and then as a locus for contacts between Francesco, Domenico Puligo, Andrea del Sarto, and the young '*Giorgino*' Vasari. At the time of the decoration of the chapel, Vasari was an apprentice in Andrea del Sarto's workshop. Andrea had been working for the monks of the Annunziata for fifteen years; he lived next to the convent and was their trusted artist. He had recently completed a fresco of the Virgin, Child, and St Joseph resting on their flight into Egypt in the lunette above the door leading into Chiostro dei Morti (fig. 15) close to where Francesco was having his tomb built. Andrea del Sarto and Puligo

Fig. 15. *Santissima Annunziata. Corner of the Chiostro dei Morti with Andrea del Sarto's* Madonna del Sacco.

provide another route through which Vasari could have come into contact with Mona Lisa's husband.

The monastery had strong ties with the artistic elite of Florence. It housed the Confraternity of St Luke, to which all professional painters were expected to belong. Leonardo was twice recorded as due to pay his membership fee, once as a 20-year old in 1472, and then in 1503 as he was beginning work on the *Battle of Anghiari*. Vasari later frequented the church and the convent as the founder of the *Accademia delle Arti del Disegno*, and he provided a fresco of *St Luke Painting the Virgin* for the chapel of the Compagnia di San Luca. The friars there would have come to know Vasari well as a person, as an artist, and as a writer.[13] They had read the first edition of the *Lives* and were moved to correct his account of a payment to Iacopo da Pontormo for a fresco in the atrium of the church.[14]

The Annunziata was a focal point for Del Giocondo memories and spiritual hopes. The monks remained in contact with Francesco's family members after his death, not least at the time of the funerals of his two sons, Bartolomeo and Piero, which took place in the 1560s. They were both buried in the sepulchre

which had been built by their father.[15] Francesco had stipulated that a lamp should burn perpetually with oil provided by his heirs. Francesco's children and grandchildren came every year to present the friars with the requisite barrel of oil.[16] After his commercial company went bankrupt, Francesco's grandson Gaspare del Giocondo worked for them as a scribe, serving as a living presence of the family within the monastery.

Later in his career, Vasari with his mother Maddalena and his wife Niccolosa moved into a building in 'Via Larga', now the Via Cavour, on 15 December 1555. Vasari mentioned this event in his *Ricordanze* without specifying the landlord's name but stating that he paid an annual rent of 60 *scudi*, a remarkably high amount.[17] The rent suggests that he occupied the entire building with large work rooms on the ground floor and the living quarters on the second. His residence was situated between Piazza San Marco and the 'Canto di Bernardetto' (now the corner of Via Alfani), opposite and a little further down the road from the palace occupied by Piero del Giocondo, Lisa's firstborn son.[18] For a year and a half Vasari lived in close proximity to Lisa's son, after the publication of the first edition of the *Lives* in 1550 and before the second in 1568. Piero does not seem to have imparted anything that caused him to revise the passage on the *Mona Lisa* in the first edition. There were plenty of other people in Florence who could correct Vasari if he was wrong about Leonardo's portrait. He was always keen to make corrections. For example, in the 1550 edition he had mistaken Leonardo's father for his uncle, but he revised the 1568 text so that Ser Piero was rightly named as the artist's father.[19]

Given that Vasari enjoyed such a complex network of contacts with the family and with those close to them, it is difficult to think that he would not have been held to account for obvious errors in the 1550 edition. When he famously wrote, '*Prese Leonardo a fare per Francesco del Giocondo il ritratto di Monna Lisa sua moglie; e quattro anni penatovi lo lasciò imperfetto*'—'For Francesco del Giocondo, Leonardo undertook to make a portrait of Mona Lisa, his wife; and after struggling with it for four years it was left unfinished'— he did so advisedly.[20]

After Francesco

One year before his death, when he was 72 years old, Francesco, decided to see a notary and dictate his last will. The event which may have focused his mind

on his approaching end was the death of his son Andrea in Antwerp one year earlier.[21] Following Andrea's death, his commercial company closed down, but its dissolution was a slow and cumbersome process. Settling the accounts and shipping the goods to Italy proved to be more burdensome and complicated than it had seemed at first, and his father certainly did not enjoy it. More than one hundred bales of goods were sent to Ancona, but they never arrived in Florence. Having languished in the Adriatic port for a long time, they were eventually sold and the money was used to pay the creditors.[22]

While all of this was going on, Francesco went to the notary on 29 January 1537, and, in the presence of another lawyer and seven witnesses, made a will. Having conventionally invoked 'the mercy of God and of the entire celestial court of Heaven' and expressed a wish that his heirs should live in peace and brotherly love, he asked to be buried in the church of the Annunziata, in the Cappella dei Martiri, where he had furnished the family vault that had been granted to him by the Servite authorities in the monastery (fig. 16). He requested that it be lit by an eternally burning lamp. He also asked for prayers and the offering of Masses for his soul. He left a small legacy to the Opera del Duomo (Office of Works at the Cathedral). He also bequeathed some money and two pairs of sheets and six shirts to his daughter, Sister Ludovica, a nun in the convent of Sant'Orsola.[23]

Fig. 16. *Marker of the vault of the Giocondo family in the Choir of Santissima Annunziata.*

Fig. 17. *Will of Francesco del Giocondo, 29 January 1537:* 'domina lisa…mulier ingenua'.

Then his thoughts turned to Lisa. He returned her dowry, as was required by law, and also gave her all the clothes, fabrics, and jewellery which she had at home and 'on her'. He mentioned their love and Lisa's special qualities, describing her as '*mulier ingenua*' (fig. 17). He used an unusual perhaps unique phrase: wills often refer to *honesta mulier… nobilis mulier… prudens mulier* (virtuous wife, noble wife, wise wife), but very rarely if ever to a *mulier ingenua*. It is an expression that is difficult to translate. It literally means 'a free woman', or more meaningfully a frank, noble, genuine, sincere person. The phrase conjures up a woman of integrity and independence. We cannot tell if Francesco meant what he wrote or if the words were simply prompted by the need to say something nice. They might be seen as inconsistent with the provisions of Francesco's will, given that he left everything to his children and very little to his wife.[24] However, while it is true that he did not guarantee her an annuity, as was often the practice, he nevertheless instructed his daughter to look after her mother, and obliged his sons to attend to her needs in accordance with Sister Ludovica's wishes. Entrusting his wife to his daughter's care, he must have known that Lisa intended to spend her days in the convent and not in her own house. Perhaps Lisa was unwell, in which case the convent of Sant'Orsola would have presented the best solution, as it was well placed to care for ailing noblewomen.

Having made provisions for wife Lisa, Francesco determined the dowries of his granddaughters Cassandra and Camilla, the daughters of Bartolomeo and Piero respectively. He bequeathed some money to their maid (or slave) Caterina, and a barrel of oil annually to the friars of the Annunziata, to be used to keep the lamp in the chapel burning. He ordered his children to make a clear and precise inventory of their possessions; he admonished them to avoid all kinds of conflict and not to bring suits against one another, and finally he appointed as his sole heirs his two sons, Bartolomeo and Piero.[25]

Francesco's premonition was timely, and he died in early March of the fol-
lowing year (1538).[26] His wife and his children had to deal with the complex
and delicate matter of inheritance. Their interests had clashed before, but they
had always managed to resolve their conflicts. This time was no different. They
appointed as 'arbitrator and friendly peacemaker' Filippo Buonsignori who,
having ascertained the value of the estate and appraised all the possessions of
the deceased, divided them between Francesco's sons. Bartolomeo was granted
approximately three-fifths of the landholdings near Pisa and the 'house of the
oven' in Borgo la Noce, which adjoined the family's main house in Via della
Stufa. Piero received the remaining landholdings and the Casa grande in
Florence, including the furniture in the rooms and in the hall on the first floor.
The two brothers divided equally the bonds of the Monte Comune, as well as
the assets and liabilities of the trading companies, including those of the com-
pany in Antwerp.[27] Finally, Bartolomeo was granted four months to move out
of the Casa grande, which had been left to his brother Piero.

When on 17 June 1539 the agreement was signed, Lisa was 60 years old and
her health may have been failing. Lisa lived for a while with her son Piero in the
Casa grande, where she had spent almost fifty years, and then she retired to the
nearby convent of Sant'Orsola.

The precise details of Lisa's death have always been a mystery because it was
not recorded in the city's *Libri dei morti*, nor, for that matter, was it mentioned
in the legal documents of the family. However, the priests of San Lorenzo, who
had known her as a committed parishioner, conscientiously recorded her pass-
ing in a succinct entry: 'Mona Lisa was the wife of Francesco del Giocondo;
she died on 15 July 1542 and was buried in Sant'Orsola [fig. 18]. [Her funeral]
was attended by all members of the Chapter.'[28] But the entry was not exact:
Lisa was buried on 15 July, but she had died the day before on 14 July, as
recorded by the notary in the deed of inheritance four days later, when the
memory of her death was still fresh.[29]

It may be that her funeral was held in the Medicean church of San Lorenzo
rather than the much smaller church of Sant'Orsola, in which it would have
been impossible to fit a large congregation. In any event, the solemn rites were
conducted with the participation of the canons of San Lorenzo, the nuns of
the convent, the sons' families, relatives, and friends. The presence of all mem-
bers of the chapter at the ceremony was not something to be taken for granted.
It was a specific gesture of respect towards the deceased and her family. At the
end of the service, Lisa's body was laid to rest in the church of Sant'Orsola or in

Fig. 18. *Record of Lisa's death and burial, 15 July 1542 (8th item).*

the cloister in front of it rather than in the vault which had been assigned to her husband and family in Santissima Annunziata. This is surprising. It may have been Lisa's choice, signalling some kind of final break with her late husband. On the other hand, it is possible that it was her daughter who determined the matter. Whether the choice was triggered by family problems or was a matter of deep devotion to Sant'Orsola is unclear.

Following the deaths of Francesco and Lisa, their sons Bartolomeo and Piero received a large inheritance, which they handled badly. The company was divided between the heirs and went into slow decline. It is clear that the two brothers were not as cunning and resourceful as their father had been. Piero was forced to sell the main house in Florence and the estate in Chianti in order to balance the family budget. In July 1541, his daughter Camilla married Alfonso de' Pazzi (from the notable family of bankers, patrons, and anti-Medicean conspirators), and Piero did manage to pay her husband a dowry of 1,000 florins.[30] It could be that Piero was already in dire financial straits and that his daughter's marriage was the straw that broke the camel's back. Moreover, he owed his brother around 500 florins which he could not pay back. This sparked a row between them and Bartolomeo resorted to the services of a lawyer to reach an agreement: Piero was given three years—until the end of 1546—to pay off his debt.[31]

Piero resolved to sell the family palace, and find less expensive accommodation. Fortunately, he was able to purchase the house of his second cousin at the favourable price of about half of its commercial value, as a result of complicated inheritance agreements. One April morning he went to see his notary in

the nearby Piazza San Lorenzo and agreed two undertakings: one for the sale of the house in Via della Stufa, and the other for the purchase of a house in Via Larga. On 19 April 1546 he sold the Casa grande to a Florentine merchant, Tommaso Lapi, receiving 1,350 florins. The following morning he was back at the notary's office and he bought the other house, whose price was fixed at 250 florins. A glance at these sums suggests that the financial advantage that propelled Piero to move house, and he emerged with a net profit of more than 1,000 florins.

The price of the Casa grande included both the building and the wooden furnishings, which were appraised at 200 florins, a large amount that would itself have been enough to buy a modest house. This was the kind of high-quality furniture that was found in the most affluent houses of the time. The most valuable furniture was in the three bedchambers and two halls on the first floor, the *piano nobile* of the building. Amongst other items in a less than fully itemized list, we find benches and box-seats (*cassepanche*) along the walls and in the loggia; in the main hall overlooking the Via della Stufa, pine panelling (*spalliera*) fixed onto the wall with benches below and a cornice above running around the glass windows, and two statues above the doors of the adjoining bedchamber; in the bedchamber next to the hall, also over-looking the Via della Stufa, cupboards, decorative panelling, a daybed (*lettuccio*), chests (*cassoni*) and stools (*sederi*), and a bed with a wooden dais (*predella*) at its base; in the bedchamber next to the hall, overlooking the courtyard, panelling, stools, chests, a daybed, and screens; in the bedchamber at the top of the stairs, next to the hall, panelling, cupboards, a daybed, and stools. In the hall behind there were benches and chests, and a cornice running around the glass windows. These interiors would clearly have made a rather grand impression.[32]

Once the contracts had been signed, Piero arranged the move, taking all his belongings and transferring them to his new house in Via Larga on the corner of what are now the Via Cavour and the Via Alfani, then called the 'Canto di Bernardetto', as a weathered stone plaque still reminds us. Ten years later his near neighbour was to be Giorgio Vasari.

Bartolomeo and Piero died in 1561 and 1569 respectively, and both of them were buried in the family vault in Santissima Annunziata.[33] Bartolomeo left his son Gaspare various properties and also the struggling trading company.[34] Inexperienced and somewhat reckless, the young man tried everything to improve its financial performance, going as far as to find another partner, but

all to no avail. At the end of December 1563, he surrendered to the inevitable and filed for bankruptcy.

The insolvency judge opened the proceedings and started the interrogations.[35] Gaspare explained his operations and confirmed the list of his creditors—about twenty in total, among whom were prominent Florentine artisans, weavers, merchants, and bankers. The judge ordered the seizure of Gaspare's property and issued the formal notice, which was made humiliatingly public 'by sound of trumpet in the usual places'. Gaspare may have avoided bankruptcy but the events put an end to his career as a merchant. Ten years later he knocked at the doors of the convent of the Santissima Annunziata, looking for a job. The friars had enjoyed a close relationship with his grandfather, as we have seen, and gave him a warm welcome. Since he knew how to read and write, they employed him as a scribe. The convent was a safe haven; he enjoyed his life there and twenty years later he was joined by his son, who chose to become a friar.[36]

While Gaspare was working as a scribe in the convent, his grandparents' house in Via della Stufa was auctioned by the 'Officials of the Orphans [*Ufficiali dei Pupilli*]', the magistrates who were in charge of protecting the property of young orphans. There is a certain poignancy in knowing that Francesco's former Casa grande was sold to benefit orphaned children. After all, this had been the desperate situation that Leonardo's mother had found herself in Vinci in the previous century.

CHAPTER IV

---⌾⌾⌾---

Coming Together
Ser Piero, the Merchant, and the Friars

Ser Piero in Florence

Leonardo was born into a long-standing family of notaries from Vinci who took their surname from the town.[1] Having joined the Guild of Judges and Notaries at the beginning of the fourteenth century, they obtained Florentine citizenship and were registered in the Quarter of Santo Spirito. The founder of the family was the notary Ser Michele, followed by Ser Guido, Ser Piero, Antonio, and his son Piero who was also a notary and the father of Leonardo. Unlike his ancestors, Antonio (in whose house Leonardo was raised) did not follow the family profession, which would have inevitably taken him to Florence. Instead, he stayed in Vinci and dedicated himself to managing the properties he had inherited from his father.

Antonio presumably encouraged his son Piero to pursue the family profession, setting him to study and directing him into a legal career. The boy would have received a humanist education, learning Latin (indispensable for drafting legal acts) and studying law. He qualified as a notary, which meant that he could use the title 'Ser' before his name. He joined the Guild of Judges and Notaries in Florence and began his legal practice in early 1449, working together with two well-established notaries whose office was located in Via Ghibellina. At the beginning, he spent much of his time in Pisa, serving Florentine merchants who had branches there; he drew up legal

acts in their workshops and sometimes in the Chapel of San Sebastiano in Kinzica or in the Palace of the Consuls of the Sea.[2] He was young and full of energy; he would draw up a contract in Pisa and the following day he would be in his office in front of the Bargello.[3] He put an end to the travelling back and forth in early March 1451, when he decided to concentrate on his practice in Florence.[4] He built a highly successful career, serving a number of the main Florentine families. He handled legal matters for the Medici, most notably Cosimo il Vecchio. He represented shopkeepers and artisans, merchants and bankers, as well as a number of important Florentine convents and monasteries, including Santissima Annunziata, where he had dealings with Lisa's husband.

But Ser Piero maintained close ties with his family and with his home town. In July 1451 there was limited work in Florence, and he drew up only three notarial acts.[5] It is likely that he spent his free days back in Vinci. Leonardo was conceived precisely in that period.

During the course of his long life, punctuated by bereavements, Ser Piero married four times and all of his wives were much younger than he. The first two marriages did not yield the heir he sought. One year after Leonardo's birth, he married Albiera di Giovanni Amadori. Between 1457 and 1462 he lived in Borgo dei Greci, the street which runs from the Palazzo Vecchio to the Piazza Santa Croce.[6] His clientele grew and so did his reputation. In 1461, together with some colleagues, he rented from the monks of the Badia Fiorentina 'an office for legal matters' located in front of the entrance to the Palagio del Podestà, which served as the courthouse (and now houses the great sculpture collection of the Museo Nazionale del Bargello). He was positioned in one of the most advantageous locations in the city for somebody in his profession (fig. 19).[7]

At the end of 1462, the notary changed his residence and moved with his wife to a house near the Palagio di Parte Guelfa, in the old heart of the city, in a maze of lanes winding between the Palazzo Vecchio and the waters of the Arno. Ser Piero lived in his new house for approximately four years, marked by moments of joy and times of sorrow. In June 1463, Antonia was born to Albiera, but in mid-July Leonardo's little half-sister fell ill and died. The next year Albiera followed her daughter. She passed away at the end of her second pregnancy and was buried in the church of San Biagio.[8] Ser Piero did not surrender his ambitions to father more children, and in 1465 he married Francesca di Ser Giuliano Lanfredini, the daughter of a colleague descended from a prominent Florentine family who owned several palaces in Santo Spirito.

Fig. 19. *Entrance to the Palazzo del Podestà on the right, with the location of Ser Piero da Vinci's office on the left.*

Ser Piero enjoyed a long professional relationship with Ser Giuliano, until the older lawyer lost his sight and retired to the countryside. At the time of their wedding, Leonardo's father was a 39-year-old man and Francesca was a 16-year-old girl.[9] At first they lived in the neighbourhood of the Palagio di Parte Guelfa, in the house that Ser Piero had rented several years earlier. At the beginning of 1467, they moved to the Piazza della Signoria, close to the church of San Piero Scheraggio, and then towards the end of the year, they went to live in a street on the other side of the square, now known as Via dei Gondi, in a house which had first belonged to the Guild of Merchants and then to the Gondi family themselves, who bought it to build their family palace there.

In 1474, Ser Piero's second marriage was also tragically curtailed. At the age of 24, his wife Francesca fell ill and passed away, leaving no children.[10] The notary married again in 1475. His third wife was Margherita di Francesco Giulli, a young woman who was almost thirty years younger, the daughter of a silk merchant whose workshop was in Por Santa Maria, near that of the Del Giocondo company.[11] Unlike his previous marriages, his union with Margherita was fruitful. Over the course of a few years his wife gave birth to seven children: Antonio, Maddalena (who died soon after birth), Giuliano, Lorenzo,

Violante, Domenico, and Bartolomeo (who lived only six months and died shortly after his mother's death).[12] After Giuliano's birth, Ser Piero and his wife Margherita moved to a new house. They left their old house in the Via de' Gondi, and at the beginning of 1480 moved permanently to the Via Ghibellina, between what are now Via de' Pepi and Via Buonarroti.[13] This was close to three small buildings bought by Michelangelo in 1508 and which at the beginning of the seventeenth century were to be transformed into the palace known today as Casa Buonarroti.[14]

Ser Piero was a mature man; he finally had a proper family in a home of some quality (fig. 20) and his life had stabilized. However, yet another blow was in store. In June 1485, Margherita gave birth to Bartolomeo and two months later she died, leaving her husband with a large brood of children, many of whom were still very young.[15] He engaged a maidservant to look after

Fig. 20. *The vaulted space and courtyard of Ser Piero da Vinci's house in the Via Ghibellina in 2015.*

the house, and between the end of 1485 and the beginning of 1486, married Lucrezia di Guglielmo Cortigiani, a 26-year-old woman.[16]

Ser Piero was clearly an exceptionally vigorous individual for his age: as he was about to turn 60, he entered his fourth marriage and his wife became pregnant as many as eight times between 1486 and 1498. Lucrezia bore him six boys and two girls: Guglielmo (who died shortly after birth), Margherita (she too died in infancy), Benedetto, Pandolfo, and another Guglielmo, Bartolomeo, another Margherita, and finally Giovanni, who was born when his father was 73.[17]

Ser Piero da Vinci
Marriages and children

Marriages and Children	Birth Date	Death Date
Ser Piero and **Caterina**		
Son: **Leonardo**	15.04.1452	02.05.1519
I Marriage, 1453–64		
Houses: Borgo dei Greci, 1457–62;		
Piazza di Parte Guelfa, 1462–4		
Wife: **Albiera Amadori**		15.06.1464
Children: Antonia	16.06.1463	21.07.1463
II Marriage, 1465–74		
Houses: Piazza di Parte Guelfa, 1465–6;		
Piazza Signoria, 1467; Via de'Gondi, 1467–74		
Wife: **Francesca Lanfredini**	05.12.1449*	21.02.1474
No children		
III Marriage, 1475–85		
Houses: Via de' Gondi, 1475–9;		
Via Ghibellina, 1480–5		

Wife: **Margherita Giulli**	30.12.1457*	26.08.1485
1. Antonio	26.02.1476	
2. Maddalena	04.11.1477	27.11.1477
3. Giuliano	31.12.1478	
4. Lorenzo	24.10.1480	
5. Violante	27.11.1481	
6. Domenico	21.02.1483	
7. Bartolomeo	29.06.1485	19.12.1485

IV Marriage, 1486–1504

House: Via Ghibellina

Wife: **Lucrezia Cortigiani**	05.03.1459*	c.1532
1. Guglielmo	21.10.1486	05.12.1486
2. Margherita	16.12.1487	05.05.1490
3. Benedetto	18.03.1489	
4. Pandolfo	28.07.1490	
5. Guglielmo	06.06.1492	
6. Bartolomeo	30.07.1493	
7. Margherita	03.01.1496	
8. Giovanni	09.01.1499	

* baptism date

When Ser Piero's family sat down at the table, they must have looked more like a village school than a family. Next to the young wife sat eleven children of every age, from the oldest son who was a grown-up man to a baby who still had to be spoon-fed. It is easy to see why upon his return to Florence from Milan in 1500 Leonardo preferred to stay with the friars in SS. Annunziata and not in his father's house. His stepmother Lucrezia—who was much younger than Leonardo—was a stranger to him, and he would not have known most of his

half-siblings, especially the recently born ones. It would not have been a familiar environment, and it certainly would not have been conducive to concentrated work.

Santissima Annunziata

From the very beginning of his career Ser Piero provided legal services to the Servite fathers of the Annunziata, and in February 1497 he acted as 'an arbitrator and friendly peacemaker' between them and Antonio and Francesco del Giocondo, having been asked by both sides to resolve a fractious dispute (fig. 21).[18] The compromise settlement was drafted in the Del Giocondo workshop near Ponte Vecchio, a clear sign that the lawyer knew the owners and had a trusting relationship with them. This was not the only or the first legal act he prepared for the members of the family: between 1484 and 1487, Leonardo's father intervened several times to settle a legal dispute between Zanobi di Domenico del Giocondo, Francesco's cousin and neighbour, and the Chapter of the Annunziata, for whom Zanobi acted as a procurator.[19] The notary had been in contact with the Del Giocondo brothers for many years and it is quite possible that, together with his wife, he visited their workshop to buy precious fabrics and other items. The silk merchant's premises were not far from Ser Piero's house in Via Ghibellina. Ser Piero may well have been responsible for introducing Francesco to his son when the latter returned to Florence in the spring of 1500 after an absence of more than eighteen years. Francesco's and Ser Piero's relationships with the monks of Santissima Annunziata may help to explain how Leonardo arranged to live as a guest at the convent for a year or more.

The monastic complex of Santissima Annunziata in which Leonardo resided was not a secluded place of spiritual isolation. Consisting of the basilica, the extensive monastery and the infirmary, it played a vigorous and public role in the life of the city. It was home to more than seventy friars, some of whom had professed their vows, while some were novices, as well as a large number of laymen who served them. The monks prayed and worked; they did not twiddle their thumbs, idly waiting for the Lord. After they had gathered together for collective prayers, they dispersed to take up their own chores. Some stayed in the church to collect alms, sell candles, and celebrate the numerous services,

which lasted from morning until night, with more than thirty Masses a day. Then there were scholars who spent their days reading, meditating, and teaching the novices, and those who ran the business interests of the monastery and kept the account books where payments in and out were carefully registered. Other friars, with the help of the servants, dealt with more down-to-earth matters that were essential for the life of their community: some were in charge of the vegetable garden, the oven, and the daily shopping; some were responsible for the wash-house and for keeping the premises clean; others for the produce of the monastery's farms; and others still were engaged in the making of wax and the production of candles and sacred objects, the earnings from which had always been an important source of income.

The monastery was itself a village in miniature within the city of Florence, and every day there was a constant coming and going of shopkeepers, artisans, and peasants who met each other on its extensive premises. They received orders, carried out various daily tasks, and delivered products, breathing rude life into the monastic premises. Sometimes we gain a glimpse of the personalities involved, not least through their nicknames. Every month, and more often during the winter season, a burly woodsman from Casentino travelled to Florence and unloaded plentiful stacks of wood into the cellar of the convent: his name was Marco, but everybody called him '*il Piomba* [Mr Lead]', because of his weighty build. The convent's messenger, Andrea, was nicknamed '*Grillo* [Cricket]' because of his slender stature, his nimbleness and his sharp tongue. Francesco, one of the peasant-workers at the monastery, was a known jokester, earning him the wonderful nickname '*Lanciabugie* [Spinner of yarns, or literally Hurler of lies]'. He invented tall tales and 'hurled' them at people he met. Not least, there was '*il Fanfana* [the Prattler]', a terrible chatterbox, as his surname indicates, who was a '*votapozzi* [well-digger]' by profession, a notoriously thankless and malodorous job. He was happy to strike up diverting conversations with passers-by.[20] Such eccentric characters were the subjects of Leonardo's quickly drawn studies of men with memorable faces—jotted down on the pages of the little notebooks he always carried with him. This was the bustling environment in which he held a public exhibition of his cartoon for the *Virgin, Child, St Anne and a Lamb*.

The Servite church of the Annunziata was one of the most popular in Florence. It appealed to the religious sensibilities of the Florentines, who had traditionally enjoyed great devotion to the Annunciation. Piero de' Medici paid for a splendid tabernacle in the church to house a miraculous painting of

the Annunciation that was said to have been completed by an angel. Until 1749, the 'Florentine New Year's Day' was on 25 March, coinciding with the Feast of the Most Holy Annunciation.[21] This occasioned great celebrations in the city. Noisy citizens set up rendezvous with friends in the impressive square in front of the basilica. Bounded on one side by the elegant colonnade of the Ospedale degli Innocenti (by Filippo Brunelleschi), it was an urban stage-set, bustling with scenes of city-dwellers and peasants. The church was a prime destination for the faithful, who in exchange for promised spiritual favours, presented the friars with all sorts of good things: sums of money, votive offerings, and items of value. The monastery possessed a collection of treasures kept in a wooden chest reinforced with metal bands. It was known as the 'chest of three keys [*scrigno delle tre chiavi*]' because of the number of locks it had and the number of monks who had to be present to open it, each of them in charge of a different key.[22]

At the beginning of the sixteenth century, Friar Mariano, who is mentioned by Vasari as the sacristan, standing at the counter where candles are sold, collected the offerings of the faithful and took in the revenue of the church. Every month he emptied the cash box, putting the coins in the *scrigno delle tre chiavi* in the presence of the bursar and the Prior. However he must have taken illicit advantage of his role, for, upon his death, his fellow friars found a large number of silver objects hidden under his bed.[23]

Ser Piero had been the friars' notary for more than thirty years: he had attended their meetings and formalized their decisions. He was well acquainted with the most important figures, those who had a real 'voice in the Chapter'. He had a close relationship with those who were in charge at the time that his son Leonardo stayed at the convent: the Prior, Fra Michele Cambi, and his two associates, Fra Stefano da Milano and Fra Zaccaria da Firenze, who took turns to act as the procurator and the administrator.[24] He had himself drawn up the acts of the Chapter that stipulated how they rotated their positions. On the basis of one of these acts, Friar Stefano was appointed the procurator, and in this capacity in 1497 he signed the agreement to resolve the dispute between the Del Giocondo brothers and the monastery, which Ser Piero drafted in their workshop (fig. 21).[25] Three years later, when Leonardo was staying in the guest rooms of the convent, Friar Stefano became the administrator.

Like Ser Piero, Francesco del Giocondo was an old acquaintance of the monks and enjoyed a professional relationship with them as merchant banker, offering them fabrics and money, and, more generally, as a businessman.[26] In 1497, he was involved in a disconcerting episode which casts light on both

Fig. 21. *Notarial act drawn up by Ser Piero da Vinci in the workshop of Francesco del Giocondo, 17 February 1497.*

his opportunism and the nature of his ties with the monastery. Francesco harboured ambitions to manage a landholding that belonged to the monks. When it was time to renew the lease, the friars found a new tenant farmer and agreed on the rent to be paid. Francesco, however, beat them to the punch and it was he who signed the agreement on his own behalf, lowering the rent to boot. The monks were outraged. They summoned him and demanded an explanation. They could not understand how he dared to 'lease out a landholding which was not his [*allogare un podere che non era il suo*]'. Without showing the slightest sign of discomfort, as if it were a perfectly normal matter, Francesco reassured them and promised to provide all the 'papers [*carte*]' that would justify his actions.[27] The quarrel was resolved, and Francesco managed to regain their trust, mending his relationship with them, especially with Fra Zaccaria and Master Valerio, who occupied key positions in the monastic hierarchy.

Fra Zaccaria was an old monk; appreciated for his honesty, he had served as the administrator several times, and he had recently been entrusted with a special project. He was to arrange for the provision of paintings and the architectural framework for the high altar, agreeing contracts with the artists involved. It was hoped that Leonardo would execute the paintings while resident in the monastery. This assignment was given to the senior monk by the Chapter, and the legal document was drawn up by a notary, who was paid by Father Valerio. Fra Zaccaria did everything he could to convince Leonardo to accept this

commission and begin the work.[28] To judge from the two main paintings eventually supplied by Filippino Lippi and Perugino, it was to be a double-sided altarpiece with depictions of the *Deposition from the Cross* on the front and the *Assumption of the Virgin* at the rear, with subsidiary panels of saints. In mid-September 1500, Fra Zaccaria signed a contract with Baccio d'Agnolo, who was to design and make the elaborate architectural frame that was to incorporate the painted panels. Baccio was famed for decorative woodwork, not least that in the new Council Hall. The good friar waited in frustration for another year in the hope that Leonardo would embark on the paintings, after which he diverted the commission to Filippino Lippi.[29] It seems that Leonardo enjoyed a good relationship with Filippino. Indeed, they were coupled together in a Latin verse by Ugolino Verino, in which Filippino is equated with Apelles and Leonardo with Protogenes (Apelles and Protogenes being two renowned fourth-century BC Greek painters, none of whose work has survived).[30] Filippino died in 1504, and the panels were eventually completed by Pietro Perugino in 1507. By this time Fra Zaccaria had passed away.

While Fra Zaccaria was engaged with the dilatory Leonardo, he approached Francesco del Giocondo for help in connection with the ownership of certain disputed properties. In early June 1503 as the representative of the convent, Fra Zaccaria visited Francesco in his house in order to further the proceedings. Before filing a lawsuit, the fathers decided to seek a compromise, choosing the merchant as the arbitrator for the resolution of the conflict. Clearly, they placed their trust in him and in his mediation skills. Francesco accepted, examined the documents and invited both parties to his house, receiving them in the hall on the first floor. On one side, the monks headed by Friar Zaccaria, on the other side, their adversaries; in the middle Francesco and two notaries acting as witnesses. Francesco started with a brief introduction, considered the statements from both sides, read out the conclusions, and, to the great satisfaction of Fra Zaccaria and his brethren, ruled that the properties be given to the monks.[31]

Fra Zaccaria was frequently in the company of another monk, Father Valerio, 'professor of holy theology', who taught at the school for novices and acted as a spokesman of the order. The monk Valerio knew that he could count on his friend Francesco del Giocondo when making large payments, so much so that he eventually named him his 'guarantor [*mallevadore*]', that is to say the underwriter of his financial obligations.[32] This was not an occasional partnership. It lasted a lifetime, and on his death Father Valerio owed Francesco a

significant sum. This time, however, the merchant decided to be generous: he wrote off most of the debt and accepted the friars' proposal to pay the rest with the possessions' of their deceased brother.

One January morning, Francesco, his wife Lisa, and their daughter Marietta went to the convent and walked up the stairs to what had been Father Valerio's cell.[33] Unhurriedly they went through the things he had left, selecting those of greatest value: some everyday objects, small works of art, sacred images and paintings. His wife Lisa had been there before: she had tended to the friar during his illness and she had lent him some dishes, including 'four tin bowls, two little plates and two little bowls [*quattro scodelle di stagno, due piattelli e due scodellini*]', which the monks gave back to her, thanking her for her kindness. At the end of the morning, while Francesco and Lisa were sorting out things to be taken, their daughter Marietta, wandering around the room, was greatly impressed by a sacred image, 'a small panel of gilded walnut…in which is our lady and six saints [*un quadretto di noce dorato…entro una nostra donna con sei santi*]'. The monks saw this, and perhaps knowing that she was to become a nun, they took down the painting and gave it to her.[34]

The apogee of his thirty-year relationship with the Servites came four years later when the monks offered Francesco one of the most prestigious chapels in the church—one behind the main altar in the splendid circular choir—for the location of his family tomb. Contrary to their normal practice, they asked him for nothing in return.

Francesco cannot but have been alert to the presence of Leonardo, the son of Ser Piero, during the painter's residence between the spring of 1500 and the autumn of 1501. The monastery of Santissima Annunziata was the natural focal point for the relationship between the Servites, Francesco del Giocondo, Ser Piero da Vinci, and Leonardo. This relationship provides a key element in the context for the portrait of Francesco's wife.

Ser Piero's heritage

Ser Piero died on 9 July 1504, aged 78, and was buried in the cloister of the Badia Fiorentina, the monastery in front of the Bargello at the beginning of Via Ghibellina, where his office was located. Leonardo recorded his father's death in a typically matter-of-fact memorandum: 'on the 9th day of July 1504 on Wednesday at the 7th hour Piero da Vinci dies, notary at the Palace of the

Podestà, my father, at the 7th hour. He was eighty years old. He left ten sons and two daughters.'[35] Does Leonardo's insistent repetition of the seventh hour suggest that he was present?

A few days later, Piero's wife saw a notary in order to establish the total value of the estate and finalize the inheritance, taking necessary action to protect her own interests and those of her under-age children from the adult children of the previous wife.[36] The heirs were Ser Piero's nine sons from his last two marriages; as it happened, Lucrezia gave up her share and Leonardo was excluded from the inheritance because of his illegitimate birth. The notary appointed to carry out this task went to the office of the Catasto (Land Registry), and examined the properties registered in Ser Piero's name. There was the house in Florence, the houses in Vinci, and the landholdings in the surrounding countryside. He made a list of them, appraised them one by one, and distributed them between the numerous sons of the deceased, who had divergent interests. It was not easy to find a solution that would satisfy everybody, and agreement was reached only two years later.[37] Most of the landholdings were given to the children of the third wife, Antonio, Giuliano, Lorenzo, and Domenico; the house in Florence, those in the extramural precinct of Vinci, and the remaining landholdings went to Lucrezia's children, Benedetto, Pandolfo, Guglielmo, Bartolomeo, and Giovanni.

Once the fixed property had been dealt with, Lucrezia asked for an inventory of the household possessions, of which there were a great many, including some valuable objects. She arranged the date for the on-site visit, and one July morning, the notary came to the Via Ghibellina. Lucrezia admitted him into the building, which her husband had divided into two living units, one for each of the two families he had fathered. Ser Piero had lived there for more than twenty years, and these well-worn rooms were full of items. The inventory took some time and was carried out over two days, one session in July and another in mid-August.[38] It is more detailed than the inventory of the Del Giocondo house, and provides intriguing insights into the life of the family, ranging from the division and interior design of the rooms to a child's doll. It is clear that Ser Piero's tastes were sophisticated and that his house was furnished and decorated in the latest manner. The interior of his house bears comparison with the grandest families in Florence—albeit on a different scale and of lesser financial value.[39]

It was probably Lucrezia who conducted the notary (and a clerk?) through the rooms, showing him the furniture and its contents, which were described carefully. At one point, they descended to the cellar, where Ser Piero had stored

thirteen barrels of Vinci wine, which he sold in the city. On the ground floor, they visited the kitchen which, judging by its furnishings, must have been rather spacious. One wall was occupied by the fireplace and the remaining walls by other typical kitchen furniture: 'a chest for making bread, a flour chest…a sideboard…a wooden table…a bench…a kitchen table for bowls', along with the tableware for the two family units.

They now went up to the bedrooms on the first floor, where they found four daybeds with rugs, six bedsteads with chests, twenty-five pillows and every-thing that one needed to sleep in the summer and in the winter. Ser Piero's bed was positioned in the middle of the room and was described as 'a walnut [bed] with inlaid walnut box-seats…with a large bag [in which the curtains could be gathered up]…a wool mattress…a pair of sheets on it…a quilt with little but-tons…a square frame [hanging from the ceiling] with fringed side curtains'. Beside it, against the wall, stood a kind of sofa, 'an inlaid walnut daybed [*lettuccio*]…with a small mattress and a rug on it…and a woman's head on the cornice'. The bed (*lettiera*) sat on a base of inlaid walnut box-seats, forming a wider platform.

Daybeds (*lettucci*) were refined and substantial pieces of furniture, import-ant items of domestic display, often decorated with inlaid woodwork or paint-ings. They served as grand couches for elegant reclining, furnished with a small mattress and a coverlet or a rug. The rear panels often carried figurative scenes and were typically capped by decorative cornices. The pictorial decorations could be very splendid; Botticelli's *Primavera* was painted for Lorenzino de' Medici on the vertical rear panel of a grand *lettuccio*. Ser Piero owned *lettucci* that had both painted and inlaid decorations. The *lettiera* and the *lettuccio* usu-ally complemented each other in terms of the quality of wood, craftsmanship, decoration, and the choice of fabrics. Privileged guests were admitted to the inner chambers housing these grand items.[40]

Against another wall of the bedroom stood 'a cupboard…with two small painted angels in relief', and several chests, one of which was positioned at the foot of the bed. The day and night beds, with the chests, cupboards, and panel-ling formed a luxurious and imposing ensemble, which only a limited number of families could afford. From one of the chests, they took out her husband's clothes, some black and others more showy. Judging by the brief descriptions, Ser Piero liked to dress in a colour known as *paonazzo*, a sumptuous and refined red-violet, which was very popular amongst aristocratic families. When the weather was cold, he would put on a close-fitting gown, tight at the neck

and reaching to his feet, 'a red-violet gown lined with red taffeta', or he would sling over his shoulders a more practical 'old-style red-violet cloak' which hung loosely. At other times, when the weather was better, he would wear 'a red-violet tunic with sleeves', which came down to his knees. Ser Piero was very fond of this colour and his wife must have liked it too, for in the winter, when the cold wind blew, she would cover herself with a 'red-violet women's gown lined with lambswool', a long wool-lined garment of the same colour, or with a more elegant 'dried-rose-colour woman's gown', or a 'white *perpignano* dress' (made from a type of wool produced in Perpignan in southern France), which was open at the front.[41] Such garments would have given the spouses an aristocratic air, attracting attention when walking down the streets of Florence. The family's liking for showy clothes was shared by Leonardo.

An idea of Ser Piero's taste for interesting objects is conveyed by 'a pair of ostrich eggs' in a cupboard recorded in the inventory. These large eggs were sought-after items of exotica, often set in fine silver or gold mounts. The 'navigation map...and a world map' confirm that his vision extended beyond Tuscany, perhaps stimulated by the travels of Columbus and Amerigo Vespucci. Maps and globes were important objects of domestic display in Florentine palaces. He also owned a 'magnet in a small box' and a good number of expensive rock crystal glasses and vessels, and others made from gold. Throughout, we get the sense that he prized objects made from precious and exotic materials.

There are some nice insights into family matters. 'A torn brocade sleeve...four bibs...a small chest made of bone...and a wooden child for little girls' were some of little Margherita's things kept in a small chest. There are various pieces of clothing identified as for young persons, and '9 nightdresses for old women'.

At various points, the inventory listed works of art, mostly devotional items on a small or medium scale, without specifying their authorship and precise location. Paintings seem to be described specifically as 'panels [*quadri*]'; the other items are probably three-dimensional. The items include: a 'Madonna in half relief all gilded, with a canopy'; a 'crucifix engraved in the German style' (possibly by Dürer); a 'Saint Francis on a panel'; a 'head with a holy face [*volto santo*]' (perhaps a head of Christ based on the *Volto Santo* in the cathedral at Lucca); a 'gesso Virgin Mary and a Sebastian, white'; a 'head of Christ'; a 'Madonna made in gold'; another 'Madonna'; a 'Saint Francis with two panels' (perhaps a sculpted image flanked by two painted wings); 'two children and two heads' (probably the very popular sculpted heads of infants, often of

Christ or St John, that were often placed in nurseries to inspire pious thoughts in children); and 'a Saint Sebastian'. There seem to be three portraits: 'two heads of women on panels', and a 'head [*testa*], that is to say the portrait of Francesco'. Were the women two of Ser Piero's wives—or maybe unidentified saints? The definite portrait was of his brother Francesco. We learn that Ser Piero also owned a 'red book of Francesco, brother of Ser Piero'.

The obvious question arises: were any of these works of art by Ser Piero's son? The compiler of the inventory, like most so employed, did not share our concerns with attributions but focused on basic description for the purposes of valuation. It is very tempting to think that Leonardo was the author of Francesco's portrait, since he was close to his uncle. We also know that Leonardo was involved in sculptural images of holy infants and Madonnas. However, it is unwise to assume that any were by Leonardo in the absence of further evidence.

Ser Piero had inherited the house in Via Ghibellina after a complicated legal process, which had lasted thirty years, and had taken possession of it at the beginning of March 1480.[42] The house had belonged to a rich banker, and was designed to reflect its owner's wealth in its structure and dimensions. It was a two-floored building in a row of attached houses: the porch, the courtyard, and several rooms on the ground floor; a hall and the bedrooms on the first floor. At the back there was a long and narrow garden which extended up to the opposite street, wedged into the block of houses between the current Via Ghibellina, Via Buonarroti, Via dell'Agnolo, and Via de' Pepi (fig. 22). During the course of his last marriage, Ser Piero had divided it into two sections: he, his wife Lucrezia, and her children lived in one of them; Margherita's four children, who were already grown up, in the other. One part overlooked the Via Ghibellina; the other extended at the rear of the house and could be accessed from the parallel 'Via del Canto alla Briga', today the Via dell'Agnolo, in the stretch between the Via Buonarroti and the Via de' Pepi. Following the division of property, Ser Piero's heirs chose to live in the latter part, which was perhaps more modest, renting out the other one.[43] This arrangement, however, was short-lived: they eventually sold it when they needed money. Or it may be more accurate to say that they undersold it: in 1529 it was bought by an artisan for 230 florins, and the following year, during the siege, it was resold for 260 florins to Michelangelo Pesci, the owner of a well-known 'apothecaries shop' in the Piazza del Grano, behind the Palazzo Vecchio.[44]

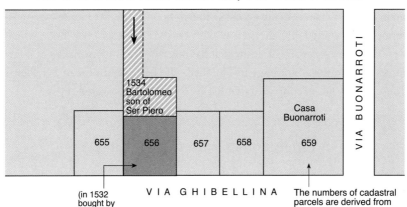

Fig. 22. *Division into two units of Ser Piero's house in the Via Ghibellina.*

Giorgio Vasari knew that Ser Piero's children and grandchildren lived in the 'Canto alla Briga'. Bartolomeo di Ser Piero had a son, Pierfrancesco, who from a young age showed an artistic talent, which encouraged his father to think that he could emulate his uncle Leonardo. The boy trained in the workshops of Bandinelli and Tribolo, and became a very able sculptor, known as Pierino da Vinci. Giorgio Vasari included him in the second edition of his *Lives*, characterizing him as a gifted and promising artist who passed away when he was just 23 or 24 years old. Vasari described some of his works and in particular a sculpture of *Bacchus* that Pierino was making in the garden of his own house, which, according to him, was not in Via Ghibellina but in the 'Canto alla Briga' where its front door was located.[45]

The extent of Ser Piero's former dwelling is confirmed by the 1561 census of houses. The surveys were generally accurate and those carried out in Via Ghibellina confirm that the ownership of the house which had once belonged to Ser Piero had been transferred to the Pesci family, specifying its location, value, and boundaries, which were more or less identical to those recorded thirty years earlier. Coming from the city centre, the building was situated on the left side of Via Ghibellina. A little further on stood Michelangelo Buonarroti's houses.[46]

The house now on this site looks very different from Ser Piero's. Its width has remained the same but it has grown considerably higher. It was enlarged so

that it consisted of the ground floor and three floors above it, with some rooms in the roof which eventually became a fourth floor.[47] And the façade was transformed, becoming high and narrow, with two windows for every floor, which were closed by grey pairs of shutters. It has taken on the impersonal air of many nineteenth-century buildings in Florence. The best indication of Ser Piero's house is the vaulted courtyard that has recently been uncovered (fig. 20).

Family houses in the *borgo* of Vinci

The small town of Vinci lies around 20 miles to the west of Florence. In Leonardo's days it consisted of two clusters of building, those within the castle walls and those in the *borgo* (the extramural precinct). The *borgo* extended along the road which descended from the fortress towards the plain, then known as 'Via di Borgo' or 'Fondaccio', today the Via Roma (figs. 23 and 24). In the fifteenth century Vinci was dominated by the imposing medieval residence of the Conti Guidi, which had been transferred to the Florentine administration and transformed into the government palace. Situated in a strategic position for defence and controlling the surrounding territory, Vinci had been constructed on the rocky peak of a prominent hill not far from Empoli. At the summit stood the fortified palace with its tower, in front of which was the church of Santa Croce. Around it stretched an irregular chessboard of smaller buildings divided by lanes with sharp rises and sudden descents, fringed by a crown of high, narrow houses. These ran along the winding external walls, overhanging the precipitous flanks of the hill. The more recent settlement or *borgo* had grown on the gentler western slope; it consisted of a series of buildings which overlooked the market place and framed the square around the town hall. The new development provided a centre for social life, consisting of a small extramural precinct below the bulwarks of the church and running along the road which descended westwards towards the plain.

In those days Vinci was a small community of less than one hundred families, some living in the extramural precinct of the castle and some within the precincts of the castle walls. In 1384, the number of families was estimated to be around seventy; in 1412, twenty more were registered, and slightly more than ninety in 1427, with a population of approximately 350 inhabitants.[48] These figures are not exact, but they give us some idea of the town's size. At the

The parish of the church of Santa Croce in Vinci
Families, houses, residents
(1384–1830)

Year	Families	Houses	Residents
1384	62		362
1412	84		342
1427	93		359
1750			573
1775	97	82	570
1780	95	82	561
1790	102	87	643
1800	104	85	592
1810	122	91	713
1820	131	102	723
1830	150	150	866

beginning of the nineteenth century, the town grew considerably, with the number of families, houses and residents increasing by almost 50 per cent.[49]

In Leonardo's time, most of the male population of Vinci were day labourers, who worked the fields of others, or small-scale farmers. There were also shopkeepers and artisans: from the miller to the butcher and the grocer; from the barber to the tailor and the weaver; from the cobbler to the farrier, and the two blacksmiths who 'honed iron tools' for the peasants in the town square.[50] Many lived in precarious conditions and the figures from the 1427 Land Registry, which are more complete and accurate than in other years, speak for themselves.[51] Almost 70 per cent of households had total assets of less than 50 florins, which meant that they lived in straightened circumstances. If we consider the entire commune, that is the town and the bordering parishes, out of approximately 200 families, only 4 per cent could consider themselves well-off, owning a house in Vinci and landholdings in the countryside. One-quarter were small proprietors with a roof over their heads in the town and scattered

plots of land. The 'rural labourers' owned nothing or next to nothing—like Papino di Pacino whose only possessions were a field and a bagpipe, which helped him earn a living. As years went by, his strength began to wane and so did his income, and the poor man asked to pay less tax. 'I am forty-five years old, I have little breath left, and the bagpipe is of little use to me', pleaded Papino to the Land Registry officials.[52] As is evident from the tax returns, many were in debt and lived on the verge of destitution. Those who had little available income had to sell plots of land, which were regularly purchased by Florentine landowners, who added them to their estates.[53] In general, only fragmented plots belonged to peasants, while small or medium-sized farms (*poderi*), consisting of larger and more coherent land units, belonged to Florentine citizens or to the few well-off inhabitants of Vinci, one of whom was Antonio di Ser Piero.

The history of the family properties of the Da Vinci family in the two zones, within the castle walls and in the *borgo*, was more complex than their Florentine possessions. For the most part the houses were simple constructions, usually with one or two floors. Even the house of Leonardo's grandfather Antonio consisted only of a ground floor, a first floor and a dovecote. At the beginning of the fifteenth century, Antonio had lived in a modest rented house in the countryside. In Vinci he owned only two 'areas suitable for building a house', that is, two plots of building land, one of which was by the market square and the other one within the castle walls. In the hills he had several plots of land planted with wheat, with rows of vines, and olive trees; a landholding known as 'la Costareccia', and, slightly above the level of Vinci, but still in the parish of Santa Croce, he had a house with some fields which was known as 'la Colombaia'.[54] Antonio had married late in life to a much younger woman. In 1427, he stated that he was 56 years old and that he was married to Mona Lucia, twenty years his junior, who was a notary's daughter. In ten years they produced four children: in 1426 Piero (the future father of Leonardo); two years later Giuliano (who died early); in 1432 a girl, Violante; and in 1436 Francesco who, as we shall see, was very close to his nephew Leonardo, naming him his heir.[55]

When the children arrived, Antonio's existing house in the country would have been too small, and he decided to move to Vinci. He started to search for a new residence, without haste, knowing that he could count on his friends in Vinci and, if need be, in Florence too. Before the birth of his last son he found what he was looking for: a house '*nel borgo del castello*' with land around it, which had the advantage of being located in the town centre.

The house in question had belonged to Giovanni Pasquetti, one of the richest men in Vinci. When he died in 1422, Pasquetti left a substantial inheritance, including his house in the *borgo* of Vinci. Since he had no children, he bequeathed his estate to the friars of the Carmelite monastery in Florence and to the Hospital of Santa Maria Nuova, granting a life tenancy to his wife Paola, who died at the age of 80 or so—probably in 1432. The right of occupancy was transferred to the institutional beneficiaries of Giovanni's will, who were free to dispose of it as they saw fit. In the event, neither the Carmelites nor the hospital was interested in retaining the property. They decided to sell it, entrusting a man from Vinci, Domenico di Bertone, with the task of collecting and preparing the necessary documents.[56] Domenico was no ordinary citizen; he was a kind of 'business consultant' for the town, one of the few inhabitants who was fully literate and numerate. It was he who drafted the peasants' tax returns, and he was Antonio's friend. It must have been Domenico who told Antonio about the house and put him in contact with the administrators of the hospital when he learnt that they wanted to sell it.

Antonio travelled to Florence, negotiated the price and bought it with thirty gold florins under a deferred payment arrangement.[57] Having signed the contract, Antonio left the house in the countryside and moved to the town. It was the last house in the extramural area of Vinci, located to the left of the road which descended from the castle (fig. 23). In 1433, he was already living there; he must have cleared it out and adapted it to the needs of his family. He was in his early sixties, and lived with his 40-year-old wife Lucia, his 7-year-old son Piero, and a 1-year-old baby, Violante; three years later, Francesco, his last son, was born.

In 1458, Antonio gave a detailed account of the property. Starting with the street on the northern side, it bordered the houses of a certain Piero di Domenico Cambini and a Papino di Nanni Banti; at the back, the vegetable garden and the local road; on the southern side, the lands of the Church of Santa Croce.[58] Antonio was more than 80 years old, and he was to die a few years later. In 1469 it was his sons who submitted the new tax declaration: they wrote it jointly, confirming the location of the house and the neighbours' names, one of whom was missing, but there was an explanation.[59] In 1460, Piero di Domenico Cambini, their family friend and neighbour, decided to sell his house; Ser Piero was one of the first to find out and was quick to express an interest. Not only would he have his own house in the town but it would be next door to the house in which he had grown up; it cost less than one-tenth of the price of a house in Florence, and for a professional like him it was easy to

Anno 1585 Anno 1821

− − − − − − − Da Vinci Houses. ⋯⋯⋯⋯⋯⋯⋯ farm of the Church at Vinci.

Fig. 23. *The houses of Antonio and Ser Piero in the* borgo *of Vinci (from maps of 1585 and 1821).*

find 27 florins and to pay for it in cash.[60] Much transformed, there are houses on the same site today (fig. 24)

Following this purchase, Ser Piero took possession of the building which stood next to his father's house, becoming one of his neighbours. The abutting properties were not to change for a long time. For about four centuries, the two houses were bordered by two parallel streets, and on one side, by the house of Papino di Nanni and his heirs (the Corsi) and, on the other by a landholding of the church of Vinci.[61]

Around 1465, when Ser Piero was in his second marriage, his brother Francesco married Alessandra Amadori, the sister of the notary's first wife. Francesco lived in Florence for several years, seemingly in Ser Piero's house, and then returned to Vinci. Following their marriages, the two brothers decided to close the succession and to divide the estate between them: Ser Piero already owned a house in the town, and thus chose the properties in the countryside; as for Francesco, he took the house in the extramural precinct of Vinci and the remaining lands. The two houses were sometimes vacant and

Year	The houses of Antonio, Ser Piero and Francesco in the *borgo* of Vinci
1432	Antonio di Ser Piero bought, for 30 florins, 'a small house where I live, located in the *borgo* of Vinci with a small vegetable garden'.
	Francesco di Antonio inherited the house from his father around 1465, and he described it: 'a house for my residence, partly dilapidated, in the *borgo* of Vinci with an adjacent vegetable garden'. In 1495 he stated it was 'a dilapidated house in which I live in the *borgo* of Vinci with a small vegetable garden'.
1460	Ser Piero di Antonio bought, for 27 florins, 'a half-dilapidated house, for my residence, with a small vegetable garden in the *borgo* of Vinci', adjacent that of his father. In 1495 he declared it was: 'a house which is now falling apart, except for the roof, which is used as a stable and a woodshed, with a small vegetable garden'.
1492	Ser Piero di Antonio bought, for 29 florins, 'a house with one floor and a roof and a small vegetable garden, for my residence, in the *borgo* of Vinci', adjoining the other.
1481–1494	Francesco di Antonio bought 'a house in the castle of Vinci, with floors, roofs, bedrooms and a cellar, for my residence, located by the walls, in the place known as 'la Torre [the Tower]'.
1548–1652	Scarpelli family bought in 1548 for 100 *scudi*, from Marietta Buonaccorsi, Guglielmo di Ser Piero's wife, 'due case contigue [two adjacent houses]' in the *borgo* of Vinci, which were the old houses of Antonio and Ser Piero.
1652–1809	Baldassini family bought, from the Scarpelli family, the ancient Da Vinci houses in the *borgo*, and they owned them until 1809.
from 1810	Salvi family, last owners of the ancient houses of Antonio and Ser Piero in the *borgo* of Vinci.

became neglected; it could be that they had structural defects and over time they fell into disrepair, or so the owners claimed in their tax returns. In 1480 the houses were already decaying and fifteen years later they were in such a poor state that they were used as a stable and a woodshed.[62] Instead of having them repaired, the brothers both decided to purchase new houses: Ser Piero bought a house next door to Francesco's, and Francesco bought one by the castle walls, in the place called '*la Torre*'. Thus, at the end of the fifteenth century, a short time before their deaths, Leonardo's father and uncle owned four

Fig. 24. *The Da Vinci houses in the* borgo, *today Via Roma 17–19.*

houses in Vinci, or rather four small buildings, one of which was in the castle and the remaining three in the *borgo*. Two were in a state of decay.

Ser Piero died in 1504, and his properties passed to his wife and children. Francesco died soon thereafter, granting a life tenancy to Leonardo, which angered his stepbrothers. As Francesco's legitimate nephews, they claimed the entire estate and initiated a lawsuit which lasted for many years and ended only with Leonardo's death. The house in the castle was given to Ser Piero's wife Lucrezia; the houses in the *borgo* to his sons Benedetto and Guglielmo. The former house was regularly mentioned in tax returns; the other two were concealed from the authorities, re-emerging only in the second half of the seventeenth century. Looking at the property's position on the nineteenth-century map, we can identify it on the late sixteenth-century map. The house which Antonio purchased at the beginning of the fifteenth century, and which passed to his children and grandchildren, was located at the end of the built-up area, next to the lands of the Church. [63] Was it here (fig. 24), in the last house in the *borgo*, that Caterina gave birth to Leonardo? The boy certainly spent his childhood in Antonio's house, raised by his grandparents and his next-door uncle until Ser Piero brought him to Florence.

⌐⌐⌐ ✦⊂⊃✦ ⌐⌐⌐

A Child from Vinci

Caterina's child

When Ser Piero fathered his first son, he was 25 years old. One day or one evening in July 1451, in the warm air of summer, he found himself alone with a local girl called Caterina, and they conceived a baby whose many talents neither could have imagined. At the end of July, Ser Piero returned to Florence, and one month or so later, Caterina would have found out that she was pregnant. She either directly informed the notary or told the family. They knew that the girl was alone and that their son would never marry her. Ser Piero was committed to his life in Florence and he would not be of much immediate help. Antonio noted that 'a grandson was born to Ser Piero my son on the 15 April on Saturday at the hour of three in the night' (fig. 25).[1] Nine days after the birth, Ser Piero was already in Florence in his office in Via Ghibellina, seated in front of his clients.[2]

The grandparents gave a ready welcome to their first grandchild, as is clear from the public arrangements for his baptism. They stepped in and acted in the stead of their son, who had effectively abrogated his responsibility. The girl went through her pregnancy and most probably gave birth in Antonio's house in the *borgo* of the town, where grandmother Lucia could count on a network of friends whose presence would have been valuable had they needed help.[3] At the time, such events were not considered scandalous, as we have seen, and were rather common in Florentine families, especially wealthy ones. A maid's child (even that of a slave) could live side by side with the wife's legitimate

Fig. 25. *Leonardo's birth, recorded by his grandfather Antonio.*

children. Such births were routinely reported to the civil authorities. However, illegitimate children were subject to certain restrictions as adults, being excluded from inheritance and prohibited from joining certain guilds, including that of judges and notaries. These exclusions were of obvious relevance to Leonardo's future.

Leonardo was born on 15 April 1452, and his grandparents did nothing to conceal the event. On the contrary, they made sure it was publicly known and celebrated. When the labour was over, the grandfather and his son walked up to the church, told the priest, and scheduled the boy's baptism for the next day, which was Sunday, when the church would be busy with worshippers. The ceremony was celebrated in the presence of ten witnesses, five men and five women, who were more numerous than those who had been invited to Piero's baptism twenty-six years earlier. They were all prominent figures in the local community, and they represented some of the more prosperous families in the town. The men were Papino di Nanni Banti, Meo di Tonino, Piero di Malvolto, Nanni di Venzo, and Arrigo di Giovanni. Next to the godfathers in the church were the five godmothers, three of whom were widows aged between 50 and 60: Lisa, Niccolosa, and Antonia. The remaining godmothers were luckier, for their husbands were still alive: one was called Pippa, the other one was Maria.[4] Apart from Arrigo di Giovanni, the German steward of the large Ridolfi estate, all the witnesses lived either in the town square or in the extramural precinct of Vinci, very close to Antonio.[5] It goes without saying that they had not been chosen randomly. They were invited because of the friendship and support they could offer. They would have been expected to sustain their involvement as the young Leonardo grew up.

The identity of Leonardo's mother has been shrouded in mystery. Numerous hypotheses have been proposed, including speculations that she was a slave from North Africa or the Middle East. There is no evidence of slaves in provincial Vinci. As it happens, the likely answer—like the identity of Leonardo's sitter—is straightforward.

In 1451, in a farmhouse located between Vinci and Poggio Zeppi, under a mile from Vinci (fig. 26), lived the 15-year-old Caterina di Meo Lippi, with her infant brother (or stepbrother) who was called Papo. They had lost their parents and their grandmother had recently brought them to live with her in her house in the hamlet of Mattoni, which had been in her husband's family for a long time.[6] Demonstrating that this Caterina is by far the best candidate to be Leonardo's mother involves detailed histories of obscure and struggling families—and a series of recurrent Christian names.

The brothers Lippo and Giusto di Nanni Lippi resided in Mattoni at the beginning of the fifteenth century. Lippo married Giovanna and fathered Bartolomeo, known as Meo, who was to be Caterina's father. Giusto married Antonia and they had four children. The two families lived together, and in addition to their house in Mattoni, they owned plots of land and half of a house which stood alongside the walls of the castle of Vinci.[7] Twenty

Nanni Lippi's descendants*

		Nanni Lippi	husband	1354			
		Simona	wife	1360			
		Lippo	son	1376			
		Giusto	son	1387			
Lippo di Nanni	husband	1376		Giusto di Nanni	husband	1387	
Giovanna	wife	1387		Antonia	wife	1390	
Meo	son	1406		Orso	son	1422	
				Pasquino	son	1425	
Meo di Lippo	father	1406		Orso di Giusto	husband	1422	
Caterina**	daughter	1436		Sandra	wife	1427	
Papo	son	1449		Giovanni	son	1449	
				Antonio	son	1450	

* Birth dates are taken from tax returns and are often imprecise.

** Caterina, likely Leonardo's mother.

years later, Lippo passed away, leaving Giovanna as a widow, and, as was her right, she asked for her dowry to be returned to her. She also entered into a dispute with her son, Meo, over the division of the property. She decided to take the matter to court, and eventually she was granted the farmhouse with some land around it and two plots of land nearby. Her son received the remainder, which was meagre: one-quarter of the 'dismal [*trista*]' house in the castle of Vinci and three plots of land, one of which he co-owned with his uncle Giusto in Campo Zeppi.[8]

Following the dispute with his mother and the unequal division of property, Meo led a wretched life and died early. He left the house in Mattoni and retreated to the 'dismal' property within the castle of Vinci. In the meantime, he fell into debt to Arrigo di Giovanni, the German steward of the Ridolfi estate whom we have met as a witness at Leonardo's baptism. When Meo submitted his tax declaration in 1427, the Land Registry officials reduced his tax liability to the minimum amount—signalling that he owned no taxable property. At the time Meo was in his early twenties, and we have little information about him. Around 1436 he fathered Caterina and in 1449 a son, both by unknown mothers. Meo passed away soon afterwards, at the age of about 40, and his two children were taken in by their grandmother. Unfortunately, they did not stay long with her, because she was to die shortly before 1451.

This left the two unfortunate children—Caterina, who was recorded as 15 years old in 1451, and Papo, who was only two—with no assets and no obvious support. Luckily, their father's uncle, Giusto, lived next door. Giusto was more than 60 years of age, and in his family declaration he also mentioned the family of his son Orso, then 30 years old, who was married to Sandra and had two children of the same age as Papo. The family was not rich, but not impoverished either; they owned several plots of land, equivalent to one medium-sized farm. It was located between the valley of the Vincio and the village of Poggio Zeppi, and supported a large quantity of cattle. They had a decrepit house located alongside the castle walls and another one which was 'half ruined' in Mattoni, where they lived (fig. 26).[9] They were the only relatives of Caterina and Papo, and it must have been Sandra and Orso who took care of them, not least of Papo who was orphaned when still an infant. In any event, Sandra and Orso are names worth keeping in mind as our story develops. The location of the house in Mattoni is today the site of houses of an altogether more substantial nature (fig. 27).

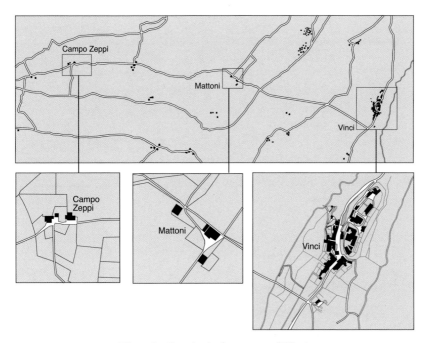

Fig. 26. *Caterina's places around Vinci.*

Fig. 27. *The present houses in Mattoni, where Caterina Lippi lived in 1451.*

Fig. 28. *Tax declaration, presented in the name of Monna Giovanna, late and widow of Lippo di Nanni Lippi, listing Caterina aged 15 and Papo aged 2.*

In the tax declaration of 1451 (fig. 28) Caterina was already of marriageable age—although very young by our standards. Given her circumstances, with no immediate family and no dowry, she would not have readily found a husband. She might all too easily have ended up in the arms of an opportunistic man— particularly someone from a higher class who took an interest in her. She was not well placed to resist the advances of the young notary from a leading local family. Caterina di Meo Lippi was poor and vulnerable, a teenage girl who had few expectations. She has the right profile to be the mother of an illegitimate child. And indeed, we will see that there is an intricate web of evidence that supports the identification of Caterina di Meo as Leonardo's mother.

The 'Caterina' of the popular tradition, as she has generally been imagined until now, is of a similar age to Ser Piero. In that case the notary would have had a son with a woman who was around 25 at the time of the baby's birth, almost ten years older than was the average for women at the birth of their first child. If she were in her mid-twenties, it would have been difficult for Ser Piero and his family to find her a husband at the end of the pregnancy. On the other hand, Caterina di Meo Lippi, as an orphaned teenager, was a ready target for Piero's sexual attentions, and it would not be so difficult to marry her off afterwards with the support of Ser Piero's family.

The first public record of Caterina's son is in his grandfather's tax return, which was drafted in 1457 and submitted the following year. At the end of it, Antonio listed the members of his family in order to obtain an allowance of 200 florins for each of them, a sum which was exempt from taxation. He recorded his wife and children first and then added Leonardo, Ser Piero's illegitimate son who, as his grandfather specified, was 'born of him and of Caterina, at present the wife of Accattabriga'.[10] Antonio failed to obtain any allowance for Leonardo's mother. The tone of his record was more colloquial than formal; he spoke of 'Caterina' as if it were obvious locally to whom he was referring, without needing to say more. Caterina Lippi and her little brother would have been pitied in the small community. They were nobody's children. Their circumstances would not have been unique. However, theirs was an extreme case which was bound to attract notice. Considering that she had a child with the notary and then married 'Accattabriga', her life would have been the ready subject of talk.

Local families

Very soon after Leonardo's birth, Caterina found a husband. She would not have made a decent marriage so quickly without somebody helping her. Ser Piero had every reason to bring closure to his youthful adventure, since he was about to marry Albiera Amadori in Florence. It was best that he took care of the situation in Vinci, and the sooner the better. Caterina needed a modest dowry to encourage a potential husband to accept her, given her past. Caterina had no possessions of her own; what little property her father had owned went to her brother Papo. At the time, the dowry of a peasant girl from Vinci was about 8–20 florins, a modest if not derisory sum for the notary.[11] We do not know how the negotiations between the two families proceeded. What we do know is that they concluded promptly, and that at the beginning of 1453 Caterina became the wife of Antonio di Piero Buti, known as 'Accattabriga' (a nickname that indicates a combatative temperament). The following year their first daughter was born, whom they called Piera in honour of her paternal grandmother.[12]

The Buti family came from Poggio Zeppi, a hilly rise dominating the Vincio valley, located in front of the old church of San Pantaleo. In 1427 there were eighteen family members living together in the ancestral house in the hamlet of Campo Zeppi. They owned a landholding with a significant amount of livestock, which provided additional earnings to supplement the revenue from arable farming. They also owned a house within the castle of Vinci, situated next to that of Nanni Lippi, Caterina's grandfather.[13] The Buti family was large yet moderately prosperous, with a relatively high taxable income. Later the family split; its patrimony was dispersed through inheritance, and the newly formed families received meagre inheritances. And when they needed money, they had no choice but to sell their land, for they had no other financial resources. This is what happened to Antonio.

In 1451, Antonio's father owned a house in Campo Zeppi and two plots of land, which were insufficient to support his family and to provide work for his sons. Iacopo, the eldest son, decided to move out and go his separate way; Antonio and Benedetto remained dependent on him, while Andrea left to become a soldier and for nine years there was no news of him, as his disconsolate father complained.[14] In an attempt to improve the family's economic situation, Antonio experimented with a different occupation and spent some time working in a nearby kiln. He eventually went back to farming.

Caterina and Antonio had five children: a son and four daughters, Piera, Maria, Lisabetta, and Sandra.[15] The first three daughters were named after members of the Buti family, but not the fourth one; the youngest daughter was given a name which had no precedent in the family history on the father's side and is more likely to have come from the mother's family. The first three names were common in Vinci, but Sandra's name was rather rare; leafing through the family status declarations of that period, it becomes clear that she had very few namesakes. In 1459, there were twenty-nine Caterinas in the entire Commune and only three Sandras.[16] And in the countryside between Vinci and Campo Zeppi, where the Buti lived, the only woman with this name was the wife of Orso, Caterina Lippi's second cousin. The naming of Antonio's fourth daughter as Sandra is consistent with the identity of Antonio's wife as Caterina Lippi. It is easy to understand that she named her last daughter after a close member of her own family. Indeed, it had been Sandra who took in Caterina and her younger brother Papo. The derelict house next door was the one owned by Papo.[17] When Caterina named her child Sandra, she was saying thank you.

Following his father's death, Antonio Buti inherited part of the house in Campo Zeppi and several plots of land. It was not much, and in order to make ends meet Antonio had to work as a day labourer in exchange for agricultural products and modest rewards. His income was insufficient to allow him to save for special occasions or large expenditures. Thus, when he had to pay for his daughters' dowries, he had to sell some of his plots of land to replenish his meagre financial resources. This is what he did when Piera married in 1475 and when Maria married three years later.[18]

There are two notable aspects of Maria's marriage and the subsequent sale of a plot of land. The first of these confirms the connection between the families of Antonio Buti and Orso Lippi. The marriage contract was signed in Maria's parents' house in Campo Zeppi, before a notary and two witnesses, one of whom was none other than Sandra and Orso's son, Antonio. This Antonio was 28 years old; he was still unmarried and lived with his two brothers, four sisters, and their mother Sandra, by then a widow, blind and in ill health.[19] Since Orso Lippi's son had been invited to be a witness in the bride's house, there must have been a relationship between the two families. The obvious connecting link was Antonio Buti's wife. Caterina was the bride's mother and she was a relative of the witness. Accattabriga's wife was the only Caterina who was related to Sandra and Orso Lippi.

The second unexpected factor is the relationship between Antonio Buti and Ser Piero's brother, Francesco. In 1480, two years after Maria's marriage, her father Antonio had to sell another plot of land, as he again needed money. The contract was signed in the presence of a notary in the square of Vinci. The buyer was the German steward of the Ridolfi, and one of the witnesses was Francesco, Leonardo's uncle.[20] Thus, to conclude a sale agreement, Caterina's husband turned to Ser Piero's brother. Almost thirty years had passed since the marriage negotiations, but the two families had apparently remained in amicable contact.

There is another link. At the beginning of September 1487, shortly before his death, Accattabrigha found a husband for his third daughter, Lisabetta, marrying her to a peasant from Montespertoli to whom he promised a dowry of 35 lire.[21] Like the dowries he had given to his other daughters, it was a modest sum, but he did not have it in cash and offered his future son-in-law a plot of land near his house, located on the slopes of Poggio Zeppi. As usual, a legal deed had to be drafted, establishing the composition of the dowry and the terms of transfer. This time he chose not to use the services of a local notary, as he had done before, but went to Ser Piero. Antonio travelled to Florence, first to Ser Piero's office in Via Ghibellina and then to the Gabella dei Contratti, the office in charge of registering notarized contracts, where he signed the legal document prepared by the notary. We do not know if Ser Piero charged him for his time, or if he acted generously towards the husband of the woman who had borne his first child. Either way, Ser Piero acted as a notary on behalf of Caterina's husband. He was rather a grand lawyer for such a modest local transaction.

Caterina resided in Campo Zeppi, and every time she had to go to Vinci, she would have passed the houses in Mattoni, that of Sandra and Orso Lippi, and the miserable house next door which was owned by her brother. Papo inherited his grandmother Giovanna's house and a plot of land around it, which were regularly mentioned in his tax declarations. In 1459, a tax return submitted on behalf of the boy who was then 10 years old aroused suspicion from the Land Registry officials. They thought that the declared value of the properties was less than their real value and made an on-site inspection. They confirmed that the house was indeed falling apart and that the land was hard-soiled and uncultivated. They recorded that Papo was 'orphaned and abandoned [*pupillo ed bandonato*]' as a neglected minor. Seeing his extreme poverty, the inspectors changed their mind and reduced his taxable income and tax liability.

If twenty years earlier Papo's house had been described as falling apart, by 1480 it had mostly collapsed and, having lost its roof, was no longer habitable. In the meantime, Papo had run away; he had left the town and his whereabouts were unknown. The only people with whom he had maintained contact were Sandra and Orso Lippi, but the former was 'blind and in ill health [*accecata e inferma*]' and the latter was dead. According to the Land Registry officials who were looking for him, news could only be obtained through Sandra's children. The unfortunate Papo's story ended just a few years later. He died in his early thirties, and by 1487 his house had become a total ruin. It no longer held any value and it was written over to Orso Lippi's heirs.[22]

Thus, before Papo's death, for information about him one had to go to Sandra's sons, Giovanni and Antonio. They were the same age as he, and they had all grown up together. According to the tax officials, Papo lived in a state of semi-abandonment, and it seems that the only people who cared for him were his relatives and neighbours: at first Sandra and Orso, and then their sons Giovanni and Antonio. When the latter was a witness at the wedding of Caterina's daughter, it is likely that he had been invited as a representative of the family and in particular of the parents in recognition of their support in the sad life of Caterina's young brother.

Putting all these facts together, we conclude that there was a relationship between the Buti and Lippi families: Antonio Buti and Caterina gave an unexpected and unusual name to their daughter, Sandra, the name of Orso Lippi's's wife, and they chose to invite Sandra's son to be a witness at the wedding of their second-born daughter Maria. And Ser Piero acted as notary for Antonio Buti. Caterina di Meo Lippi is the obvious social glue in this network, as Antonio Buti's wife and as Papo Lippi's sister.

If, as is highly likely, Caterina Lippi can be identified as Antonio Buti's wife—as the '*donna dell'Accattabriga*'—she was of course Leonardo's mother. This is the simplest and the most convincing answer to the question of her identity. There is no need to look for mysterious women who might more readily satisfy the myth-makers.

Caterina may well have spent the post-natal period in the grandparents' house, breastfeeding her son, while entrusting Papo to her only remaining relatives, her second cousins Orso and Sandra Lippi. This situation lasted no longer than one year, when she married Antonio Buti and moved to Campo Zeppi. Leonardo remained with his grandparents and was raised by them. His grandmother Lucia, who was much younger than her husband, and Francesco,

Ser Piero's brother, who was then a young man, were on hand to act as surrogate parents. Leonardo would have spent his childhood in the extramural precinct of Vinci, in the midst of its houses and families, some of the most prominent of whom had taken part in his christening ceremony, and acted as his godparents.

The alternative is that Leonardo was born in Mattoni, either in Papo's house or that of Sandra and Orso Lippi next door. Papo's house can be ruled out because of its uninhabitable state. If he had been born in Sandra and Orso's house, they surely would have been amongst the godparents.

If it is unlikely that Leonardo was born in Mattoni, we can be certain that he was not born in the so-called *Casa Natale* (birthplace) in Anchiano, a hamlet that is a 2-mile climb from Vinci. In 1452, the houses in Anchiano were occupied by two widows and a peasant family. One of these widows, Lorenza, was 55 years old and she had two children, Maria, aged 13, and Andrea, aged 10. Following the death of her husband, Lorenza had inherited the house in which she lived and a 'dismal little house which is uninhabitable'—a small, run-down and uninhabitable house with a vegetable garden and a farmyard in front of it, situated along the road which ascends from Vinci. In the house next door lived Fiore, the widow of Andrea Bartolini, who was 70 years old. She was the mother of Piero di Malvolto, one of Leonardo's five godfathers. She was old and she lived on her own in a house which no longer belonged to her, as three years earlier she had sold it to the priest of the church of Vinci together with an olive grove.[23] Behind Lorenza's and Fiore's lands stretched the landholding of the Marchesi, a peasant family who had been settled in that countryside for several generations and who would remain there for many years.

At the time of Leonardo's birth, his grandfather and his father did not own any property in Anchiano. In 1480 Ser Piero still did not have any property in that area. Two years later he obtained from the Marchesi a plot of land in the locality called *La Fornace* in exchange for a debt. He then purchased two small farms, one from the monks of the Annuziata in Florence, and the second in 1494 from the daughter of Lorenza. Thus, it was only towards the end of the fifteenth century that the houses and landholdings in Anchiano were acquired by Ser Piero, when Leonardo was already a grown man. The rickety peasants' houses in Anchiano cannot be where he was born.[24]

This will be disconcerting for the authorities in Vinci, who have over the years invested a good deal in transformative restorations of the crumbling fabric of the modest house at Anchiano. Unrecognizable for what it was, it now

houses exhibits and multimedia displays, and is served by a spacious car park. Much of the modern Leonardo is legendary, and the *Casa Natale* joins those legends that have assumed a level of truth that is independent of the facts.

When Leonardo was nearing his sixth birthday, he was again listed in Antonio's tax return. On 28 February 1458 he was still living with his grandfather, while his mother is recorded as married to 'Acchattabriga di Piero del Vaccha' (Antonio di Piero Buti). Antonio also claimed the 200 florin allowance for 'Francesco my son, who resides in the villa and does nothing, 22 years old'.[25] Francesco was not pursuing a profession but was presumably involved with the family's local property holdings. The aged Antonio died at some point before 18 September 1462, and Ser Piero assumed responsibility for recording Francesco and Leonardo as 'mouths' in the tax return he submitted in Florence when Francesco was 32 and Leonardo 17.[26] Alessandra, the 26-year-old wife of Francesco, is also listed, together with Antonio's widow Lucia, who was 74 years old. Ser Piero's wife Francesca is recorded as 20 years old. By this time Leonardo may have moved to Florence, but we cannot be sure.

Leonardo's uncle was an important presence in Leonardo's upbringing. Francesco had no children of his own. There are a series of fleeting references to Francesco in Leonardo's early manuscripts.[27] The best evidence of their relationship comes on 12 August 1504 when Francesco nominated Leonardo as the life tenant to 'several of his farmsteads located in the Commune of Vinci'.[28] After Francesco's death, at some time before 1505, Ser Piero's sons disputed the will on the grounds of Leonardo's illegitimacy. Greatly distressed, Leonardo appealed to Cardinal Ippolito d'Este in a formal letter written by Agostino Vespucci, asking that the cardinal support him in obtaining his rightful inheritance.[29] The dispute was to rumble on until Leonardo's death.

If the records of Leonardo's life in Vinci are meagre, those of his early years in Florence are missing altogether. He is first recorded in Florence in July 1472 at the age of 20, when he was required to pay his professional dues to the painters' Confraternity of St Luke.[30] We have no documentary evidence about how the illegitimate son of a notary, brought up in his family's home in provincial Vinci, became a painter in Florence. Unable to follow the family profession, on account of his illegitimacy, he probably received a good basic education in literacy and numeracy, perhaps in what was called an 'abacus school'. His early style of handwriting is (albeit in reverse) broadly comparable to that of his father—as a standard fifteenth-century hand with abbreviations—and is very different to the newer, fashionable 'italic' hand favoured by the humanists.

Michelangelo, by contrast, adopted a pleasingly legible version of the humanist script. At some point Leonardo entered the busy Florentine workshop of the leading artist Andrea Verrocchio, famed chiefly as a sculptor but also as the producer of works in a wide range of media, including painting. Leonardo is not recorded in the workshop until April 1476, when the ruling about the accusation of sodomy noted that he was 'with Andrea del Verrocchio'. We can best assume that he entered as an apprentice when he was in his early or mid-teens. So, by his early twenties he was, like his father, a resident of Florence with a profession to pursue.

Caterina's interment

There is a tantalizing post-script to the story of Caterina—or at least of one Caterina. In the third of the Forster Codices in the Victoria and Albert Museum, amongst a series of memoranda, Leonardo notes that 'Caterina came on the day of 16 July 1493'.[31] There would be no obvious reason to connect this Caterina with Caterina Lippi, were it not for the record of the death of a 'Caterina de Florentia' in the Milanese *Libro dei Morti* on 26 June 1494.[32] She was recorded as 60 years old. Caterina Lippi would have been about 58. The difference of two years is well within the margins for error in recording people's ages at this time.

A further memorandum in the second of the Forster Codices lists items that are connected with the 'interment of Caterina'.[33]

Expenses for Caterina's interment (in *soldi*)	
3 pounds of candles	S 27
For the catafalque	S 8
For the cloth over the catafalque	S 12
The conveying and placing of the cross	S 4
For the conveying of the corpse	S 8
For four priests and clerics	S 20
Bell, book, sponge	S 2

For the gravediggers	S 16
To the elder	S 8
For the licence to the officials	S 1
[total]	S 106
To the doctor	S 5
Sugar and candles	S 12

The total cost of these items came to 123 *soldi*.

Caterina is a common enough name. Was she Leonardo's mother? On one hand, we may note that Leonardo's memorandum is impersonal, as all of them tended to be, and he did not mention that Caterina is his mother. Would he have called her Caterina? On the other, he paid directly for her funeral and burial. On balance, we are inclined to think that Caterina Lippi travelled as a widow to join her remarkable son in Milan. Perhaps she was already ailing and wanted to seize some precious time with him before her death. If so, they were to be reunited for rather less than a year.

CHAPTER VI

⊶⊷

Renaissance Records

Leonardo in 1503

As we will see, Leonardo is documented as working on a portrait of Lisa del Giocondo in October 1503. At this time he was already 51 years old. We tend to think of him as belonging to the same generation as Michelangelo and Raphael. However, Michelangelo was only 28 at this time, and Raphael a mere 20-year-old. Leonardo had returned in April 1500 to the city in which he had trained, having worked in Milan for eighteen years or so. He came via Mantua and Venice. His reputation was high, not only as an artist but also as someone who knew about architecture and engineering, but the Florentines had few works of art to judge what he could accomplish. From his first period in Florence, he had completed small paintings of the Madonna and Child and the youthful *Annunciation*. The startlingly direct portrait of *Ginevra de' Benci* was known in the circles of the ousted Medici, but probably not widely seen. The work that suggested his magisterial potential, the large altarpiece of the *Adoration of the Magi*, was left unfinished as a tumultuous underpainting. Of the few paintings completed in Milan, the innovatory portraits were not available to Florentine spectators. They are unlikely to have known of the *Virgin of the Rocks*, which was still the subject of legal wrangles in Milan. The fame of the mural of the *Last Supper* had spread to Florence, but again the original was not available for viewing in the city. Knowledge of his doomed project for the huge equestrian memorial to Francesco Sforza had preceded him. He needed to re-establish himself—a need that he may have felt more keenly given his father's prominent position as a pillar of the legal community.

Leonardo did not arrive in a state of penury. On 14 December 1499 he had transferred the considerable sum of 600 florins to a bank account in Santa Maria Nuova in Florence, with guarantees from the Capponi, aristocrats and bankers, and from the Gaddi, a family of painters who had moved into bank-ing.[1] To put this sum in perspective, 20 florins would have rented a very decent house for a year. Thereafter we can trace a small number of substantial transactions between 1500 and May 1507, including six withdrawals of 50 florins. It is likely that these withdrawals were to meet his overall living and workshop costs, not least the renting of a suitable property after he left his lodgings in Santissima Annunziata.

While he was accommodated in the monastery, Leonardo first flexed his artistic muscles in public with a cartoon for the *Virgin, Child, St Anne and a Lamb*, which Vasari tells us was exhibited to the public—an exceptional move. The composition was described in 1501 by the head of the Carmelites in Florence, who was reporting to Isabella d'Este in Mantua. He was duly impressed by the interlocked complexity of poses of the figures, which was very innovatory, and also remarked on the implicit narrative, centred on Christ's embracing of the passion as he seizes a lamb, a sacrificial animal. He also described a small painting of the *Madonna of the Yarnwinder*, which was equally novel is in its story-telling quality, with the cruciform yarnwinder pre-figuring Christ's death on the cross.

In 1502 Leonardo entered the service of the notorious Cesare Borgia, acting as a military engineer and map-maker in various Italian locations. He was back in Florence in February the following year, and was engaged by the Signoria to work on the unsuccessful canal to by-pass Pisa. By October he was planning his great battle mural for the Sala del Consiglio, the massive new Council Hall of the republic. For someone who had done little in Florentine eyes to justify his reputation and secure his enduring fame as a painter, the *Battle of Anghiari* presented an opportunity to do something exceptional on a very large scale. In the event, it was a portrait of a bourgeois woman begun at the same time that was to grant him immortality.

The portrait on which he was engaged in 1503 does not have a continuously documented history. But this is true of all Leonardo's paintings other than the *Last Supper*, which has remained in place in the refectory in Milan, in spite of the reported desire of Francis I to remove it to France. Given the apparently insatiable need to insert 'mysteries' into the story of the *Mona Lisa*, and the endless desire of commentators to come up with new theories about the sitter

and the painting, gaps in the provenance have been seized on as spaces for unsubstantiated speculation. Were the *Mona Lisa* not such a legendary picture, the landmarks would be seen as secure enough for us to say with reasonable confidence that it is a portrait of Lisa, and that it remained with Leonardo until his death in 1519. Thereafter it seems to have come into the possesion of his pupil Salaì and was one of the paintings involved in a legal dispute between Salaì's wife and sisters in Milan in 1530. With several other Leonardo paintings already in the Louvre, it was acquired at an unknown date by Francis I, who died in 1547. In 1550, Vasari noted that it was at Fontainebleau, Francis's great Renaissance palace south of Paris. Subsequently, whatever its adventures during turbulent periods of constitutional upheaval, war, and theft, it has a continuous history as one of France's most revered cultural treasures.

In looking at the various documents and visual records we will encounter, we should bear in mind their varied functions at the time they were made. Legal documents have their own kinds of functions, as do all other kinds of record, and were designed to serve specific and limited purposes at the time. They were not designed to serve our present needs, and we should be careful not to force them to do so. It is all too tempting to draw unsubstantiated conclusions from what they do *not* say. In the literature about the *Mona Lisa* there is also a pronounced habit of selecting those parts of a document that suit a given case, ignoring the less welcome parts of the same record. What is needed is a consistent and careful evaluation of the sources. The level of reliability of those compiling the documents needs to be in the forefront of our analyses.

We are concentrating in this chapter on early documentation, citing some witnesses who provide special insights into how the painting was regarded in the early years of its existence. The following chapter looks selectively at significant public landmarks in its subsequent rise to fame, rather than giving a comprehensive account of its later history and critical reception.[2]

We begin with two records that date from Leonardo's own lifetime, the first in 1503 and the second in 1517.

The new 'Appelles'

Unusually for a Renaissance portrait, we have an eyewitness account before the painting was finished. The record occurs unexpectely in an edition of Cicero's *Letters to his Friends* (*Epistulae ad familiares*) printed in Bologna in 1477 and

now in the University Library in Heidelberg. It was owned by Agostino di Matteo Vespucci, and was richly marked up and anotated over a series of decades by Agostino and others, as the librarian and author Armin Schlechter has recently shown.[3] On page 111r in the printed edition, Cicero mentions the great Greek painter Apelles—misprinted as 'Appelles' in the Bolognese edition and duly corrected. Cicero tells us that, 'Apelles completed with the most polished art the head and bust of Venus but left the other part of her body incohate.'[4] Whether 'incohate' means unfinished in the literal sense, or less fully defined is unclear. Cicero's reference prompts Agostino's to mark off five lines in the printed text and to annotate as follows in the margin (fig. 29):

> Apelles the painter. That is what Leonardo
> da Vinci does in all his
> pictures, as in the head of Lisa del Giocondo,
> and Anne, the mother of Mary.
> We will see what he will do in the hall
> of the great council, about which he has made an agreement
> with the standard-bearer. 1503. October.[5]

It sounds like Agostino was well-informed about Leonardo's activities. He had every reason to be. He was one of the humanist clerks employed by the Florentine republican government as an assistant to Niccolò Machivelli, who was one of the adminstrators responsible for Leonardo's contractual agreement to paint the *Battle of Anghiari* in the Council Hall.[6] Machiavelli was also heavily involved with Leonardo on the disastrous project to divert the Arno around the recalcitrant port of Pisa. Agostino provided both Machiavelli and

Fig. 29. *Agostino Vespucci, annotation in Cicero's* Epistulae ad familiarae, *Bologna, 1477, Heidelberg, Universitätsbibliothek.*

Leonardo with clerical assistance.[7] Most pertinently, he was responsible for the translation of Leonardo Dati's Latin account of the battle that is found in the compilation known as the *Codice atlantico*.[8] He also seems to have acted as scribe for Leonardo's letter to Cardinal Ippolito d'Este in 1507 when the painter was attempting to secure the legacy of his uncle, in the face of opposition from Ser Piero's sons.[9]

The basic information in the annotation is unambiguous. Leonardo had begun to paint a portrait of Lisa del Giocondo by October 1503. Agostino's testimony also indicates that Leonardo's difficulty in finishing paintings was well known to him—and presumably to others. What is less certain is whether the reference is specifically only to the 'head' of Lisa. The Italian term *testa* (*caput* in Latin) was often synonymous with 'portrait', as is clear in the inventory of Ser Piero's possessions.[10] It is safest to think that Agostino is simply saying that the portrait as a whole is unfinished. He is not to be taken as saying that it is the head of St Anne that is specifically finished or unfinished. Our best contemporary record of Leonardo's work on his composition of the *Virgin, Child, St Anne and a Lamb* is a letter from the Carmelite Fra Pietro da Novellara to Isabella d'Este in 1501.[11]

That the portrait Vespucci describes as underway in 1503 is the same as the picture in the Louvre is more or less confirmed by clear and early echoes of it in Florentine portraiture, above all in the work of Raphael, as we will see (figs. 42 and 43).

A tourist attraction in 1517

Leonardo was the brightest star recruited by Francis I as he fulfilled his ambitions to annexe the Renaissance culture of Italy. He was housed grandly in the Manor House of Clos Lucé, in the lea of the royal castle of Amboise. He was expected to do things, not least the planning of a huge royal palace at Romorantin on the Loire, but he was also important for just being there—as an artistic and intellectual ornament of the court. He was awarded the princely sum of 2,000 *écus d'or* for two years '*pension*'.[12] This is far more than even a higher court functionary would have received. The sculptor and goldsmith Benvenuto Cellini, a later Italian recruit for Francis, recounted in his *Discourse on Architecture* that:

King Francis, being enamoured to the very highest degree of Leonardo's supreme qualities took such pleasure in hearing him discourse that he would only on a few days in the year deprive himself of Leonardo...I cannot omit repeating the words I heard the King say about him, in the presence of the Cardinal of Ferrara and the Cardinal of Lorraine and the King of Navarre. He said that he did not believe that a man had ever been born in the world who knew as much as Leonardo, not only of sculpture, painting and architecture, but also that he was a very great philosopher.[13]

It was in his capacity of resident *magus* that Leonardo was shown off to the visiting Cardinal (Luigi) of Aragon, illegitimate son of the ruling house of Naples and one of the richest and most powerful princes of the Church in Rome. The ambitious cardinal was undertaking a demanding whistle-top tour of major European centres during the course of 1517 and early 1518, accompanied by an entourage of thirty-five persons (which had risen to forty-five by the end of the journey). In all they covered more than 3,000 'Italian miles', including Nuremberg in the east, the Netherlands in the north, Nantes in the west, and Marseilles in the south.

We would know nothing of the cardinal's excursion down the hill from the castle in Amboise to visit Leonardo were it not for the garrulous travel diary of one of his party, Antonio de' Beatis.[14] From modest beginnings, and in spite of his lack of a humanist education, Antonio had risen to become Canon of Molfetta in Puglia. He did not spell out his precise role, and he was not the senior prelate in the entourage. He probably acted as a secretary, undertaking various administrative and clerical tasks. His lively and perceptive travel diary, full of shrewd observations, was undertaken as he says 'at the sacred desire' of the cardinal himself. It is likely that he found some private time at the end of each day to recall and record what they had seen and whom they had encountered. Antonio's account was not conceived as a book to be printed but was intended for his superiors and friends in manuscript form. It did not appear in print until the first edition of 1905, based on three surviving manuscripts.

Antonio's diary has been cited uncountable times in accounts of the *Mona Lisa*. His record of Leonardo's 'show and tell' has been given widely diverse and often contradictory interpretations. To reach any judgement about what Antonio was saying, we need to pay more attention to the circumstances of his writings than is usual. Not least, we should remember that Antonio was a functionary, not a leading player, and would have remained in the background when the cardinal was engaging with rulers and other prestigious persons.

On 10 October the cardinal's train of horsemen, mules, and carts left Tours (noted for the manufacture of 'sword blades of great perfection') and journeyed to Amboise, which had a 'castle on a knoll...which has comfortable apartments and a delightful prospect':

Our master went with the rest of us [the ten 'gentlemen' and the leading clerics in the party?] to one of the precincts to see Messer Leonardo da Vinci, and old man of more than seventy [actually 67], the most outstanding painter of our age. He showed to His Excellency three pictures, one of a certain Florentine woman portrayed from life at the behest of the late Magnificent Giuliano de' Medici, another of St John the Baptist as a young man, and one of the Madonna and Child set in the lap of St Anne, all most perfect, though as he suffers from paralysis in the right hand [Leonardo was left-handed] nothing good can be further expected. He has successfully trained a Milanese pupil [Francesco Melzi?] who works well enough. And although Messer Leonardo cannot colour with his former softness, yet he can still make drawings and teach.[15]

Leonardo, apparently affected by a stroke, also showed the cardinal books of anatomy, based on the dissection of 'more than thirty corpses' (almost certainly not all human). He also made them aware of 'innumerable volumes' on water, engineering, and 'other subjects'.

The next day the cardinal's party travelled to Blois. Visiting the palace, they delighted in a magnificent library of books 'all on parchment, handwritten in beautiful lettering and bound in silk in various colours, with elaborate locks and clasps of silver gilt'. These treasures included many volumes once owned by Ludovico Sforza, Leonardo's former patron in Milan, who had been overthrown by King Louis XII in 1499. Antonio also recorded with admiration 'an oil painting from life of a certain lady of Lombardy: a beautiful woman indeed, but less so, in my opinion, than S.ra Gualanda'. A marginal note gives Gualanda's Christian name as Isabella.[16] Antonio did not say that the portrait of the Lombard lady was by Leonardo, and there is no reason to think that it was. A 'portrait of a lady of the court of Milan' was already in the French royal collection by 1500.[17]

Before returning to their visit to Leonardo on 10 October, it is worth eliminating Signora Gualanda as a serious candidate to be the *Mona Lisa*. Antonio does not say or infer that the painting of either or both of the beauties were by Leonardo, and, in any event, his comparison is not concerned with the quality of two paintings but with estimating which was the more beautiful woman. King Francis was conspicuously interested in international beauties. Isabella was born in 1491 in Naples to a Pisan courtier and clearly provided a good

point of *paragone* for the Neapolitan cardinal. She was too young to be the subject of a portrait begun in 1503, and she was not from Florence. We will return to Isabella later.

The young St John and St Anne seen by the cardinal and his deferential entourage are unproblematic. They can be identified with items on the Salaì lists, as we will see, and with the paintings now in the Louvre. On the other hand, the 'certain Florentine woman portrayed from life at the behest [*ad instanza*] of the late Magnificent Giuliano de' Medici', has given historians an inordinate amount of bother. If the portrait is identical with the 'portrayed lady' in the Salaì lists, it might conceivably be *La Belle Ferronnière* (probably Lucrezia Crivelli). It seems far more likely that Leonardo chose to parade the *Mona Lisa* to show what he really could do. However, this runs into an obvious difficulty. If the *Mona Lisa* is indeed a portrait of Lisa del Giocondo underway by 1503, it is most unlikely to have been commissioned by Giuliano, son of Lorenzo il Magnifico, who had been exiled from republican Florence and was then largely resident in Urbino.

The first likely points of direct contact after 1500 between Giuliano de' Medici and Francesco del Giocondo, and between Giuliano and Leonardo, would have been after the restoration of the Medici in Florence in 1512 and the accession of Giovanni de' Medici, Giuliano's brother, as Pope Leo X in 1513. We know that the opportunistic Francesco was an active supporter of the Medici on their reinstatement in Florence. He was one of fifty-five who contributed funds to support the government that replaced the republican regime.[18] Francesco also had commercial dealings with the Medici in Florence and Rome. In August 1514, Francesco with two other financiers was granted a three-year concession from Leo X to manage a customs house in Rome, a share that he sold after a few months to Filippo Strozzi for 1,100 *fiorini d'oro*.[19] Giuliano, who was not averse to sexual shenanigans on his own behalf, may have enjoyed the sneering story about Francesco and his wife in Filippo Strozzi's letter to Lorenzo, his nephew.[20] The links between Giuliano and Leonardo were so close between 1513 and Giuliano's death in 1516 as to need no emphasis. Giuliano was Leonardo's direct patron and host in the Belvedere of the Vatican.

We might suppose that Antonio was simply wrong in associating Giuliano with the *Mona Lisa*, perhaps recalling something else Leonardo had said during their visit earlier in the day. However, Giuliano had been an important figure in Rome and would have been well known to the cardinal. His secretary

Antonio was habitually alert to the networks of the powerful and keen to be accurate about such things. However, there is a plausible way to reconcile the apparent contradictions, as follows. Leonardo arrived to join the Medicean mafia in Leo's Rome with a clutch of pictures in various states of completion. We know he carried a few key works with him during the later stages of his life. Amongst these was his unfinished portrait of Francesco's wife, of whom Giuliano was likely to have been aware. Giuliano recognized that the painting was altogether exceptional as an image of a beloved lady—portrayed with the greatest refinement in accordance with the tropes of Florentine love poetry in which Giuliano was literally well versed—and wanted it finished as a 'picture'.[21] For Leonardo, who knew like Antonio that powerful people appreciated references to prominent acquaintances, saying that the image was being finished for Giuliano before his patron's sudden death, would have been of more interest to the cardinal than its origins as a commissioned portrait of the inconspicuous Lisa, Francesco's wife. Lisa only ranked as 'a certain Florentine lady' in this elevated context.[22] As we will see, this hypothesis, speculative as it seems, gains strong support from our later analyses of the painting's content and its technical examination.

The 'little demon'

The next major player in our story is Giovanni Giacomo Caprotti da Oreno (also known as Gian Giacomo Tegnosi), who entered Leonardo's workshop in 1490. His start was not auspicious. Leonardo recorded that:

Giacomo came to stay with me on the day of the Magdalene in 1490 aged 10 years. The second day I had two shirts cut out for him, a pair of hose, and a jerkin, and when I set aside the money to pay for these things he robbed me of the money from the purse, and I could never make him confess, though I was quite certain of the truth.[23]

In the margin, Leonardo launches a percussive volley of abuse: '*ladro, bugiardo, ostinato, ghiotto* [thief, liar, obstinate, glutton]'. Gian Giacomo was accorded the nickname Salaì, from a demon in Luigi Pulci's epic poem *Il Morgante*, where the name is given as 'Salai', without what has become the standard accent on the 'i'.[24] Leonardo continued to record the young rascal's misdemeanours and thefts, but somehow Salaì survived, and became an integral part of

Leonardo's household until his death. There were obviously aspects of his personality that offset his less desirable traits. Vasari indicates that he was an attractive youth with curly hair. This has led to a cluster of profile drawings of what Kenneth Clark called 'epicene youths' being identified as Salaì. However, this is a type that runs through Leonardo's earlier drawings. The truth is that we do not have a reliable portrait of him, unless his appearance conformed to Leonardo's existing type—a case of nature imitating art.

Salaì proclaimed his own artistic talent, but never became an independent practitioner. His one signed picture, dated 1511, is an image of *Christ* (not a *Salvator Mundi*). It shows that he could ape some of Leonardo's stylistic tropes and could achieve a delicacy of touch, but also that that he exhibited an insecure grasp of structure, overall and in detail.[25] The *Christ* indicates that most of the other paintings ascribed to him must be by other pupils or followers. The impression is that he remained an operator with an eye for the main chance, useful to Leonardo as a general assistant and functionary, who could shrewdly handle external approaches to the master. In Leonardo's elaborate will, drawn up in Amboise on 23 April 1519, under the name of Salai, he is referred to generically as a 'servant', and given half of Leonardo's 'garden' in Milan, on which he had already built a house. Leonardo's artistic and written heritage was left to Francesco Melzi, 'nobleman of Milan', who was the only member of the entourage who was engaged with the range of his master's intellectual activities. Following Leonardo's death, less than a month after the will, Salaì returned to Milan to live in his own house, and was married in 1523 to Bianca Coldiroli, who brought him a very decent dowry of 1,700 lire.

Salaì would at best be a footnote in the story of the *Mona Lisa* were it not for a list of his possessions drawn up after his sudden accidental death in 1524. He died intestate, and on 21 April the following year, his possessions were valued for division between his two married sisters, while his wife was to retain her dowry and possessions.[26] Salaì's estate was worth more than his career would lead us to expect. He owned some quite valuable things, including two diamonds and a chalcedony (ancient gem), and was owed money by some prominent citizens. Most surprisingly, the itemized possessions include eleven (or twelve) paintings. The artist's name is not given. The notaries were concerned with values not authorship. However, the subject-matter and high valuations, up to 200 *scudi*, indicate that they were by Leonardo. To put things in perspective, an altarpiece could be commissioned from a reputable painter for some 100 *scudi*. The most expensive picture is worth as much as Salaì's house.

The list survives in two copies. In what seems to be the first, the value of one of the items, a 'woman portrayed', is omitted, while the second copy is untidily marked up in such a way as to suggest that it is the same as 'the painting… called *la Ioconda*' (fig. 30).[27] The person who corrected the list has tried to cope with the valuations becoming out of step with the titles. The result is something of a muddle, and it is not altogether clear if the *Ioconda* is valued at 100 or 80 *scudi*—though the former seems more likely given the first list.

The translation of the list below is annotated with the likely identification of the paintings as far as is possible.

Painting called a Leda, no. 1 scudi 200, lire 1,010
The major painting last recorded in the French Royal Collection in 1694.

Painting of St Anne, no. 1 scudi 100, lire 505
Probably the painting of the *Madonna, Child and St Anne* in the Louvre.

Painting of a woman portrayed, no. 1
Given no value on the line above.

Painting [called *La Honda*—crossed out] *Co no. 1*
Called la Ioconda [in the margin] scudi 100 (?), lire 505
The *Mona Lisa*.

Painting with a St John large scudi 80, lire 404
The *St John the Baptist* in the Louvre.

Painting with a St Jerome large, no. 1 scudi 40, lire 202
Not known but related to the unfinished painting in the Vatican?

Painting with a half nude, no. 1 scudi 25, lire 126 soldi 5
The so-called 'Nude Mona Lisa', perhaps the version in the Hermitage?

Painting with a St Jerome half nude, no. 1 scudi 25, lire 126 soldi 5
Not known.

Painting with a St John little young, no. 1 scudi 25, lire 126 soldi 5
The *Bacchus* in the Louvre that was once a *St John the Baptist*?

One Christ in the form of God the Father scudi 25, lire 126 soldi 5
The *Salvator Mundi* in a private collection.

Madonna with a Child in her arms scudi 22, lire 101
One of the two prime versions of the *Madonna of the Yarnwinder*.

One Christ at the column not finished scudi 5, lire 25
Not known.

The scale of values reflects the size of the pictures and their status. The smaller devotional pictures, perhaps involving studio participation, are the least valuable.

Fig. 30. *Paintings in the list of the late Salaì's possessions in 1525.*

It is strange that two paintings of St Jerome are neither traceable in themselves or via copies.

Not the least interesting aspect of the list is the indication that the *Mona Lisa* was already known by the nickname, *La Gioconda*. How Salaì came into possession of the pictures is not known. Perhaps he reached an agreement with Melzi. Or perhaps he had used his well-documented wiles.

The next we hear of the late Salaì's estate is in 1530. Again we are in for a surprise. One of Salaì's two sisters, Lorenziola, had used the paintings as a security for a loan, for which specific purpose the paintings were accorded the modest value of 26 *scudi*, perhaps corresponding to the size of the loan rather than an independent valuation.[28] We learn of this because Salaì's inheritance had seemingly become a matter for running dispute between his wife and sisters, involving Bianca's dowry. As we have seen, the recovery of dowries was often a fraught business. For the moment, the paintings were deposited in the sacristy of San Satiro, pending a settlement. The list now runs:

one contains the depiction of the figure of St Anne with the figure of the blessed Virgin Mary and figure of God [the Son] with a lamb;
another contains the figure of Joconde;
two contain the image of St Jerome in both;
two contain the image of St John in both of them;
another contains the figure of one *galice* [?];
another contains the image of God the Father;
and another has the figure of one nude.

Compared to the 1525 list, the paintings of *Leda*, the *Madonna*, and the *Christ at the Column* do not feature. Or maybe the *Leda* does. The odd reference to 'one *galice*' makes no obvious sense in either Latin or Italian. Might the notary have transformed the swan illiterately into a *gallus* (rooster)? Improbable as this idea may seem, the *galice* does not correspond to anything else in the earlier list. It is also worth noting that the '*dona aretrata*' does not feature in the later list, helping to confirm that it is the same as the *Ioconda* in the 1525 document and that the *Mona Lisa* was indeed in Salaì's estate.

However, there is a fly in this ointment. This takes the form of another document discovered relatively recently—a document that follows the rule that each new piece of evidence raises more questions than it answers. It again involves Salaì. A note by the treasurer for the French region of Languedoil (which took primacy amongst the king's treasuries) in his estimate of

forthcoming expenditure for the state of Milan in 1518 states that 'Mister Salaì son of Pietro Opreno' was to be paid for 'several paintings on panel which he has delivered [*bailées*] to the King' for the considerable sum of 2,604 *livres tournois*, 3 *sols*, and 4 *deniers*.[29] Given the declining exchange rate for the *livre* against the *ècu*, it is difficult to arrive at an exact equivalent according to the gold standard, but the total is certainly in excess of the value of the 400 plus *scudi* in 1525 list.

How can we make sense of the treasurer's forecast expenditure in relation to the earlier lists of Salaì's possessions? Art historian Bernard Jestaz, who published the document, assumes that Salaì was selling Leonardo's paintings to Francis I in 1518, and that the 1525 list comprises Salaì's own copies. This runs into two difficulties. The first is that the 1525 valuations are consistent with the paintings being by Leonardo. The second is that it is unclear why any payments for Leonardo's paintings would not have been made directly to the master, who was on the royal payroll. We might speculate that Salaì sold Francis copies and kept the originals, or that he never handed them over and escaped to Milan with them. But both these scenarios are unthinkable, even for a sharp operator like Salaì.

There are two ways out of this dilemma. One is to assume that the estimated expenditure did not occur and that the paintings were not actually sold to Francis. It may be that Leonardo's deteriorating health, which led to the drawing up of his will in 1518, put the sale on hold, even though the 1518 estimate suggests that the paintings had already been delivered (*bailées*). An alternative is that the 'several paintings' were not by Leonardo, whose name is not mentioned as their author. Were they by other Italian artists whose works Francis coveted?[30] Was the shrewd Salaì in the import business, acting as agent for Italian artists with whom he was acquainted in Milan, Florence, and Rome? The first of these alternatives is preferable, but all the possible interpretations of the treasurer's note are less than conclusive.

If the Leonardos were still in Milan in 1530, we need to assume that Francis took steps to purchase those he wanted. Perhaps Salaì's sisters cashed in their assets once they had them securely in their hands. However, in all this Salaì business there are too many 'perhapses' for us to be comfortable.

Which Leonardos did Francis acquire, whether in 1518 or after 1530? Four of them are now in the Louvre, the *St Anne*, the *Mona Lisa*, and a large and small *St John the Baptist*. The lost *Leda* may have been one of Francis's Leonardos, though it is not recorded in the royal collection before 1625 and

is not traceable after 1692. The *Madonna, Child, St Anne and a Lamb* was in the possession of Francis by 1527.[31] It is later recorded in Cardinal Richelieu's Parisian palace in 1651, and is not documented again in the royal collection until 1683. Paintings certainly left the collection as gifts and sales, and it may have been presented to Richelieu, who was evidently an enthusiast for Leonardo.

The idea that Francis had to purchase the *Mona Lisa* after 1530 is given some limited credence by the statement of Père Pierre Dan in his *Le Trésor des merveilles del la maison royal de Fontainbleau* in 1625 that Francis paid 4,000 gold crowns (12,000 francs) for 'the portrait of a virtuous Italian woman, & not of a courtesan (as some believe) called Mona Lissa commonly known as La Joconde, the wife of a Ferrarese gentleman named Frencesco del Giocondo, an intimate friend of Leonardo who permitted the painter to depict his wife'.[32] The stated purchase price is barely credible, even for what Dan considered to be the 'first in rank as a marvel of painting'.

In any event, the painting was definitely in Fontainebleau by 1550.

Artist-authors: Vasari and Lomazzo

Our next two witnesses were both painters by training—and both became more than painters. The hugely ambitious and hard-working Vasari rose to become a major architect and large-scale decorator at the Medicean court of Granduke Cosimo I in Florence.[33] His immortality has been secured by his writings, above all his *Lives of the Most Excellent Italian Architects, Painters and Sculptors from Cimabue until our Times*, first published in 1550 and revised in 1568. Nothing like his massive compilation had been attempted before. It involved assiduous research, extensive travel, innumerable contacts, close collaboration with other authors and observers, and goodly measures of imagination and literary verve.

The tenor of a life by Vasari is rather different from that of a modern biographer. On a framework of those facts that were available to him, he interwove entertaining and instructional tales in the manner of Renaissance writers of short *novelle*. Each life is true to what he regards as the spirit of the artists and the essence of their careers in the broader context of the progress of art. The lives are embroidered with vivid set-piece accounts of notable works by each artist—the kind of word-painting that was known as *ekphrasis*. Written from

memory, or at best from notes and visual records, the *ekphrases* aspire to capture the reader's visual imagination rather than offering sober description.

Vasari's *Life of Leonardo da Vinci* has often been criticized for its inaccuracies. But reading it in the light of modern knowledge, the life in the 1550 edition does a good, if limited, job. The chronology is sometimes wobbly, and there is much that Vasari did not know at this stage, but the broad framework for his sequential accounts of the major works—the *Last Supper* in Milan, a cartoon for the *Virgin, Child and St Anne* exhibited in Florence, the *Mona Lisa*, and the unfinished mural of the *Battle of Anghiari*—stands up quite well. The substantially expanded *Life* in the second edition benefits from a large amount of new material, much of it probably supplied by those who read Vasari's first account, including Francesco Melzi and Florentine acquaintances. Vasari's account of the *Mona Lisa* is unchanged, and it is therefore the 1550 account that concerns us here. It is as vivid as anything that he wrote:

Leonardo undertook to make for Francesco del Giocondo, the portrait of Mona Lisa, his wife; and after struggling with it for four years, he left it unfinished; this work is now in the possession of the King Francis of France at Fontainebleau. In this head, anyone who wishes to see how closely art could imitate nature, may comprehend it with ease; for in it were counterfeited all those tiny things that only with subtlety can be painted, seeing that the eyes had that lustre and watery shine which are always seen in life, and around them were all the vivid rosy tints of the skin, as well as the eye lashes, which cannot be done without the greatest subtlety. The eyebrows, through his having shown the manner in which the hairs arise from the flesh, where more thick and where more sparse, and curved following the pores of the skin, could not be more natural. The nose, with its beautiful nostrils, rosy and tender, seemed to be alive. The mouth, with its cleft and its ends united by the red of the lips to the flesh-tints of the face, truly seemed to be not pigments but flesh. In the pit of the throat, if one gazed upon it intently, one could see the beating of the pulses; in truth it may be said that it was painted in such a manner as to induce trembling and fear in every valiant craftsman, whoever he is. He also made use of this strategy: since Mona Lisa was very beautiful, he always retained, while painting her portrait, persons to play or sing and jesters, who continuously made her cheerful, in order to take away that melancholy that painters often tend to give to the portraits that they make. And in this work of Leonardo's there was a smile so pleasing, that it was a thing more divine than human to witness; and it was held to be something marvellous, since it was not other than alive.[34]

It is highly unlikely that Vasari had seen the portrait, and it is easy to point to things he invented for the sake of his vivid *ekphrasis*. However, he did realize that it was a very special painting and, as we have seen, he had ready contact

over a wide period of time with those who could tell him about it. Vasari's account corresponds to what the family and other Florentine witnesses would have known: that Leonardo 'struggled' with the picture for four years, and that it was unfinished when he left Florence.

If Vasari's contacts conveyed the gist of the portrait's extraordinary effect, he was well able to concoct literary flourishes to evoke how it seemed to be uncannily alive. Not least Vasari was alert to the exceptional magic of the smile and its 'divine' aura. The painting was probably unfinished when Leonardo took it from Florence and when members of the family last had a chance to see it. Leonardo had indeed been struggling with it for four years at that point. Its unfinished status was the reason why it had not been delivered to Francesco del Giocondo.

Our other sixteenth-century witness, Giovanni Paolo Lomazzo, presents a Milanese perspective rather than Vasari's Florentine one. Lomazzo was a productive painter of narratives and altarpieces, with particular interests in proportion, perspective, and foreshortening. As an ambitious theorist he attempted to forge an all-embracing philosophical basis for the art of painting. He was instrumental in founding a self-parodying academy, the Accademia della Val di Blenio, dedicated to a made-up language that was supposed to be have been used by porters in the Blenio Valley in Switzerland.[35] By 1571 Lomazzo had lost his sight and concentrated on his writings. *Mona Lisa* first features in his manuscript, *Gli Sogni e Ragionamenti* (*Dreams and Reasonings*) in 1563, in which his short account of Leonardo is directly dependent on Vasari.[36] The qualities of the portrait are subsequently emphasized in his two major books, his *Trattato dell Pittura* (*Treatise on Painting*) in 1584 and his *Idea del Tempio della Pittura* (*Idea of the Temple of Painting*) in 1590.

In his *Treatise*, discussing excellent portraits of women, he writes:

Amongst these [portraits of women], we see those by the hand of Leonardo, adorned in the guise of *primavera*, like the portrait of the Gioconda, and of Mona Lisa, in which he marvellously expressed, amongst other features, the mouth in the act of smiling, and [we see] the faces of their [the painters'] beloved women embellished in the most graceful manner, like those of Raphael...[37]

Lomazzo's syntax is often hard to follow, but we can begin to disentangle what he means if we take into account what he knew. He knew Vasari's *Lives*, and he also enjoyed direct contact with Francesco Melzi, who was involved in the 'Academy'. Melzi was compiling a manuscript of a treatise on painting from

Leonardo's scattered notes. Lomazzo had not seen the *Mona Lisa*, and had limited access to Leonardo's original paintings. His citing of *primavera* (spring) almost certainly refers to one of the north-Italian versions of the so-called 'Nude *Mona Lisa*' presented as a *Flora* or *Spring*, courtesy of copious quantities of blossoms.[38] This strange variant will concern us later. Lomazzo made an apparent distinction between the Gioconda and the Mona Lisa (the first time this name is used). He may have heard Melzi using both names, assuming that they referred to distinct pictures, or perhaps he meant that it was the smiling, nude and 'jocund' Gioconda who was presented in 'the guise of *primavera*'. However, another possibility presents itself. If, as sometimes happened, the '&' in the printed book was a misprint for '*o*' (or), the text should have read 'like the portrait of the Gioconda or Mona Lisa'—as alternative names for the same portrait.[39] This possibility is enhanced by the fact that Lomazzo refers to 'the portrait' not 'the portraits' in the plural. In any event, Lomazzo was not an eyewitness, and was reporting according to his memory of what he had read or been told.

In his other treatise, he remarkably visualizes a round temple of painting supported by seven human 'pillars' of art, of whom Leonardo, Michelangelo, and Raphael are the most notable. Within the structure he interweaves elaborate metaphysical theories of the planets, elements, and temperaments in order to lay down the eternal foundations of painting and explain the individual artistic personalities of the seven 'pillars'.[40] He again mentions the *Mona Lisa* here, recommending that we should:

gaze at finished works by Leonardo da Vinci (although there are few of them), like the nude Leda and the portrait of Mona Lisa the Neapolitan, which are in Fontainebleau [*fontana de Beleo*] in France.[41]

Lisa certainly was not from Naples. Again, our confidence in Lomazzo's reporting cannot be very high, although he had learnt, probably from Melzi, where the two star pictures were then located.

One of the most striking features of the accounts by both Vasari and Lomazzo is that they grant a portrait of an inconspicuous person the status of a stupendous work of art—even though neither of them had seen it first-hand. The extraordinary qualities of this unique masterpiece were clearly, already at this point in time, beginning to spread by word and in print.

CHAPTER VII

The Rise to Fame

When our charting of significant landmarks in *Mona Lisa's* rise to fame moves into the seventeenth century, we encounter two witnesses of particularly high calibre, who testify to the remarkable status that *La Gioconda* was achieving in Italy, France, and Britain. This status is also reflected in the steady proliferation of copies and variants.[1] By the 1620s, there were no less than three painted copies at Fontainebleau, including one by Amboise Dubois, the court artist from Flanders, and another commissioned from Charles Simon.[2] The production of high-quality copies was an esteemed business, and good copies were ranked much more highly than now.

'La Bella Jucunda': Cassiano, Buckingham, and Richardson

The first of our witnesses is Cassiano dal Pozzo in Rome, who was a figure of great authority in the worlds of art and learning. He was a notable patron in his own right, not least of Nicholas Poussin. The universality of his interests are well represented by his prodigious 'Paper Museum' of drawings and prints, which contains systematically annotated images of antiquities, architecture, and natural wonders.[3] His dedication to Leonardo's painted, drawn, and written legacy was second to none. He possessed a painting of St John that he believed to be by the master himself, and a 'head of a woman', a work copied from 'Leonardo Ravinci'.[4] His long-term importance for Leonardo is that he strove to establish the best possible text of Leonardo's *Treatise on Painting*,

Fig. 31. *Charles Errard,* Engraving of the Mona Lisa *from the* Traité de la Peinture, de Léonard de Vinci, Paris, *1651.*

which led towards the 1651 first editions in the original Italian and in French translation, with illustrations by Poussin and Charles Errard.[5] It was in the French version that the first engraved reproduction of *Mona Lisa* appeared, though it hardly lived up to the painting's reputation and was in reverse (fig. 31).

In 1625 Cassiano was in Fontainebleau, serving Cardinal Barberini on his travels in a way that resembled the earlier activities of Antonio de' Beatis in the train of the Cardinal of Aragon. Cassiano's eye was captivated by the *Mona Lisa*:

At the Chateau of Fontainbleau is a portrait at life size on wood in a carved walnut frame of a half-length figure and it is a portrait of a certain Gioconda. This is the most complete work by Leonardo da Vinci to be seen, since it lacks nothing but speech. The appearance is that of a lady between twenty-four and twenty-six, whose face does not wholly resemble those of the statues of Greek women, but is somewhat broader and with such softness in the cheeks and around the lips and eyes that such a degree of delicacy seems impossible. The head is adorned with a simple hairstyle, but nevertheless very fine. The costume exhibited a black or dark brown colour, but it has been so badly served by varnish that it can no longer be clearly discerned. The hands are beautiful and, overall, despite the bad treatment this painting has suffered, the face and hands manifest such beauty that they enchant all who see them. We noted that the lady for all her beauty is rather lacking eyelashes, which the painter has not made evident, as if she did not have them. The Duke of Buckingham, sent from England to accompany back the wife of the new English King, expressed his desire to acquire the portrait, but the King of France was strongly dissuaded by several people who put it to his Majesty that he would thus deprive the kingdom of the

finest painting in his possession. Amongst those to whom the disappointed Duke complained about this refusal was Rubens of Antwerp, painter to the Archduchess [Isabella of Austria].[6]

Although there are conventions at work in Cassiano's account—the idea that a portrait only lacks speech was a humanist commonplace, drawn from the Roman author Pliny—there is no doubt that he looked hard at the painting, and was sensitive to the elusive magic of Leonardo's technique in flesh tones. He looked closely enough to discover that there were no eyelashes apparent— which might suggest that the eyebrows were still visible at this point. The early darkening of the draperies is also acknowledged, though perhaps overstated. Intriguingly Cassiano gets the age of the sitter right for the date of 1503, when the portrait was started. Did he have a good source of information, or was this just a good estimate?

Cassiano was certainly well informed about the Duke of Buckingham, one of the most avaricious and successful of all English collectors.[7] In 1625, Buckingham did indeed attempt on his own account to purchase the *Mona Lisa* while in France acting for the proxy marriage of Charles I with Henrietta Maria, daughter of Henry IV and Maria de' Medici. Having failed to dislodge the painting from the royal collection, as Cassiano attests, he obtained a copy, which is listed in his inventory in 1635 as 'Labella Jucunda—A Little Picture a Copy'. In all the other entries the artist's name is given, whether originals or copies. Clearly the name 'La Jucunda' was already enough on its own.[8]

Buckingham's copy may well be the version later owned by the painter, connoisseur, collector, and author Jonathan Richardson the Elder. In his *An Account of Some of the Statues, Bas-Reliefs, Drawings and Pictures in Italy*, published with his son, Jonathan Richardson the Younger, in 1722, the copy is praised by the younger Richardson for its fidelity:

L. da Vinci. The *Jocunda* spoken of at large by *Vasari* in the Life of this Master. I consider'd it with the utmost Attention, Landskip, and every Part, and find it the same as my Father's in every respect; the same Particularity in the Colouring of the Hands, as distinguish'd from that of the Face: so that at that distance I could remember no difference, nor can I tell which I should chuse.[9]

He has astutely picked up the difference in the handling of the flesh in the face and hands. He is also the first to mention the landscape, which earlier authors regarded as entirely secondary. The Richardsons' copy is almost certainly the

high-quality French version later owned by Sir Joshua Reynolds, who touted it as the original.[10]

The catalogue of the posthumous sale of Reynolds's old master paintings in 1795, reported that the founding president of the Royal Academy of Arts in London had contacted the secretary of the French Academie Royale, the portraitist Paul Barbier, to enquire about the painting in the French royal collection. Surprisingly, Barbier replied that it was 'not esteemed or considered as the original'.[11] Reynolds's belief in his own cherished 'original' was suitably reinforced.

This was not the last of the copies that aspiring owners have proclaimed to be the real *Mona Lisa*. The financial pay-off if one of the pretenders were to prove its status would be truly enormous. The most notorious of the claimants is the so-called Isleworth *Mona Lisa*, once owned by the painter Hugh Blacker, and later the subject of a promotional monograph in 1966 by the dealer, Henry Pulitzer, who owned both the picture and the publishing house.[12] Having rightly faded from contention, the unfinished painting has recently resurfaced and been accorded the elevated status of Leonardo's 'earlier version', courtesy of a massive, gold-edged book published by the Mona Lisa Foundation in Geneva.[13]

Barbier's testimony is an extreme expression of the rather diminished reputation of the *Mona Lisa* in eighteenth-century France. In the previous century, it had been transferred to Versailles from Fontainebleau, and had been placed by Louis XIV in the Premier Salon in the Petite Galerie du Roi at Versailles, that is to say in an honoured position in the king's private suite of rooms. However, a century later it had been relegated to the premises of the Directeur des Bâtiments—the official in charge of all building works.[14]

By the time of the Reynolds sale in 1795, the Louvre painting was in the hands of the newly established French republic. The great painter and politician, Jacques-Louis David, had resoundingly declared the foundation of a national museum in the Palais du Louvre to 'nourish a taste for the arts, train art lovers and serve artists'.[15] The actual transfer of the collections from Versailles to the Louvre was completed in 1797, when we are told in the catalogue that the painting of 'Mme Lise called the Joconde' is 'celebrated for its beauty'. The royal holdings were amplified by items confiscated from the Church and private owners. As Napoleon's campaigns successively overthrew European regimes, the Louvre became the home of an astonishingly wide range of pillaged treasures, including the *Apollo Belvedere* and *Laocoon*, which

Leonardo would have known in the papal collections at Rome, and the four famous ancient bronze horses that he would have encountered in Venice in 1500.

Mona Lisa subsequently caught the eye of Napoleon who kept her in his bedroom in the Tuileries in 1800. She seemed to be a worthy pictorial consort for Europe's greatest leader. When Napoleon was elected emperor in 1804 the portrait was returned to the Louvre where it is still semi-visible today.

Two reproductions and two musings

The *Mona Lisa* was much copied, as we have noted. Such is the melting elusiveness of Lisa's features and even of the outer contours of her head that every copyist has struggled to capture the unique 'air' of her expression. It is not just a question of replicating what can be seen on the surface of the painting, but of recreating the optical complexities of Leonardo's pictorial layers. If painters faced difficulties, engravers encountered even graver problems.[16] Translating Leonardo into the linear conventions of woodcuts, engravings, and etchings, or even into the softer media of stipple engraving and lithography, resulted in uneasy homages in which there was always 'something wrong about the mouth', as the common expression goes.[17] The nineteenth century saw one remarkable engraver, Luigi Calamatta, tackling the problems in an unusually intense and effective manner. The long time-scale over which he generated his engraving spans the birth of direct reproduction via photography. In keeping with the selection of landmarks in this chapter, Calamatta will represent the high point of the printmakers' graphic commentaries on the picture, while the photographer who will stand more generally for the advent of photography is Gustav le Gray.

Luigi Calamatta trained as a painter and engraver in his native Italy, before moving to Paris in 1822, where he entered the inner circle of Ingres, the cerebral master of history paintings and highly polished portraits. Calamatta was the subject of a notably affectionate drawing by his friend.[18] He gained acclaim for virtuoso engravings in which he evokes the quality of complex paintings, not least those by Ingres himself, whose drawings he also engraved with great skill. It was Ingres who facilitated Calamatta's making of a very precise drawing of the *Mona Lisa* during the winter of 1825–6 in a specially reserved room in the Louvre.[19] The drawing was exhibited in the engraver's studio and became well

known in its own right. It was much admired by George Sand and Chopin, amongst other visitors. It was not to be realized as a published engraving until 1855. The inscription accurately declares that the image was 'drawn and engraved by L Calamatta'. The current whereabouts of his actual drawing is unknown, but it must have been very sophisticated.

Creating a highly finished intermediate drawing to translate the colouristic and atmospheric subtleties of Leonardo's painting techniques into the linear-cum-tonal medium of a print was not so much a convenience as a necessity. As we will see, Leonardo had pioneered a technique of tonal painting in which each hue, ranging from high-keyed yellow to dark blue, was immersed in a unified system of light and shade. Each hue was pitched carefully according to the tonal scale between white and black, descending into unified darkness in the shadows and progressively emerging with modulated brightness in the lit areas. The trick for an artist attempting to replicate the *Mona Lisa* in a monochrome medium was to sustain the translucent shadows while evoking those parts of the image, such as the sleeves, stole, and landscape, that were inherently lighter in tone without disrupting the whole. The effort that Calamatta put into translating his monochrome drawing into the engraving was prodigious.

Calamatta performs miracles of minute evocation with his copperplate engraving tools (fig. 32). Delicate networks and parallel arrays of straight, curved, and rippling lines, cut to different depths and intersecting in varied ways, sometimes interspersed with little dots, construct precisely pitched effects of light and dark tones, firmness and softness, transparency and opacity. The sitter's veils are conveyed by open cross-hatching, while the landscape is a blur of fugitive marks. The internal contours of Lisa's face dissolve under a miraculously refined mesh of lines and dots. Not only was the act of engraving accomplished to a supreme level, but the engraved surface of the plate needed to be inked and printed with the highest levels of subtlety.

So long did Calamatta take to realize his print that photography was waiting in the wings to take over the job of faithful reproduction. The first great photograph of the *Mona Lisa* adopted the same method as Calamatta, that is to say the replication of an intermediate drawing. Early photography was simply not up to sustaining Leonardo's level of definition in the shadows, particularly given the darkened and cracked state of the masterpiece. The drawing was commissioned from the accomplished if conservative sculptor, Aimé Millet. In his teaching as professor at the École des Art Decoratifs he was a keen advocate of the benefits of copying drawings as a way of instructing pupils how to

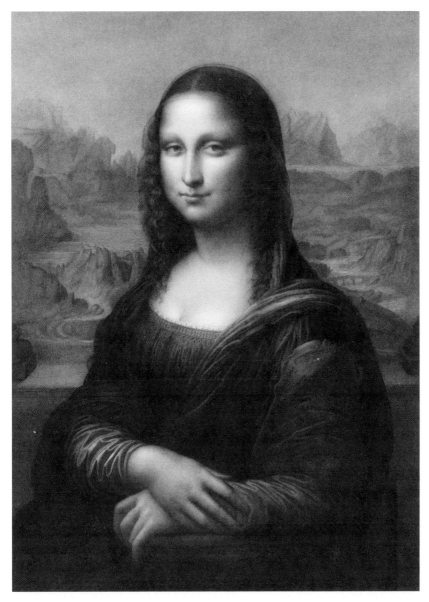

Fig. 32. *Luigi Calamatta,* Mona Lisa, *engraving, 1825–55, Philadelphia Museum of Art.*

represent three-dimensional form in light and shade.[20] To judge from the photograph, his drawing of the *Mona Lisa*, now lost, provided testimony to his own skill in rendering tonal subtleties. His drawing was inscribed on the parapet to the left, '*Leonard de Vinci Pinxit. Aimé Millet Del[ineavit] 1848* [Leonardo da Vinci painted it. Aimé Millet drew it in 1848]'. The photographer

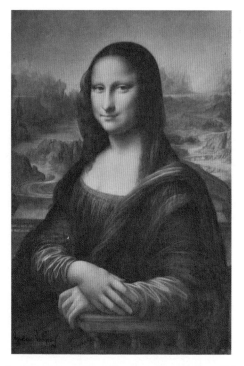

Fig. 33. *Gustave Le Gray,* Mona Lisa, *albumen silver photograph based on a drawing by Aimé Millet, 1848, Malibu, J. Paul Getty Museum.*

Gutstav Le Gray conspicuously scratched his own signature into the bottom left corner (fig. 33).

Le Gray was not just any photographer. He gained a huge international reputation as a cunning master of light and shade, particularly in a magnificent series of moody seascapes that benefited from his pioneering use of separate negatives for sea and sky.[21] He was well placed to appreciate how Leonardo sustained the tonal intricacies of the figure against the potential glare of the landscape. Le Gray made a large negative on glass coated with a collodion emulsion (first developed for surgical dressings), which was then sensitized to light with silver nitrate. He used the new albumen silver technique for making the final positive print, using direct sunlight and toning the printing paper with a solution of gold chloride in hydrochloric acid. The resulting image is strikingly rich in tone and implied colour, and meltingly soft in the transitions between light and shade, without the black-and-white edginess that even Calamatta had not entirely circumvented. Le Gray's

photographic methods were ideally suited to capturing what came to be called Leonardo's *fumato*—the smokily veiled effect of his shadows. The Millet–Le Gray *Mona Lisa* has almost entirely avoided the peril of 'something wrong about the mouth'.

Direct photography did not achieve comparable results until the issuing of a fine photogravure by the firm of Goupil et Cie around 1880. Adolphe Goupil, leader of the company, became a major dealer in Paris and developed a massive business in moderately priced reproductions of art works in various media. Photogravure also involves an intermediate process. The photographic image is chemically etched with precision and tonal subtlety on to a copper plate, enabling it to be printed on paper and in books in considerable quantities. Leonardo's painting was now at last finally available in a reliable black-and-white analogue on a widespread basis.[22] The *Mona Lisa* was becoming public visual property. We will witness the key role played by good photographs following the painting's theft in 1911.

The qualities for which Calamatta and Millet-Le Gray were striving—the paradox of a precisely rendered indefiniteness—are very much those celebrated in the great outburst of critical writing that welled up in the middle years of the nineteenth century. The literary effusions have been well discussed.[23] A list of those commentators who feature in books on the *Mona Lisa* includes towering literary figures, alongside those whose reputations have since faded (given here democratically in alphabetical order): Charles Baudelaire, Charles Blanc, Charles Clément, Charles Coran, Edmond and Jules de Goncourt, Théophile Gautier, Arsène Houssaye, Joseph Lavallée, Pierre Marcy, Walter Pater, Jules Michelet, Gustave Planche, Edgar Quinet, George Sand, Bayle St John, Hippolyte Taine, Thomas Wainewright, and Jules Verne. Unsurprisingly, French writers predominate. The collective tenor of the verbal accounts is to paint a picture of Leonardo's sitter as a woman of deeply unsettling mystery, underscored by a veiled threat to the equilibrium of the male observer's mind. There was something in common with the idealized and inaccessible beloved lady who haunted Renaissance poetry, which was coming much into fashion in the nineteenth century. But the desired female was now endowed with a touch of Faustian power, not resting content with wounding her aspiring lover with Cupid's sharp arrows, but devouring the life blood of her helpless devotees like a female Dracula.

Again, two notable landmarks will stand for the wider phenomenon of the romantic mystification of Leonardo's masterpiece. Neither is a surprising choice, but they both warrant repeating.

The first is P. J. Théophile Gautier, literary giant and one of the greatest of all art critics. His account was first published in *L'Artiste* in 1857, the journal of which he was editor. It then featured in his *Les Dieux et les demi-dieux de la pienture* in 1864, illustrated with specially made prints by Calamatta. Leonardo opens Gautier's anthology as the first of his painter-gods, followed by Fra Angelico. The poet then cannibalized his essay for his *Guide de l'amateur au musée du Louvre* in 1882. Gautier was clearly pleased with his evocative words on Leonardo, and they have been rightly admired:

Leonardo has retained the finesse of the Gothic while animating it with a spirit that is entirely modern. As we have already declared, just as Virgil is the author for Dante, Leonardo is our painter. The faces of Vinci seem to come from the upper spheres and to be reflected in a glass or rather in a mirror of tarnished steel, where their reflection remains eternally fixed by a secret akin to that of the daguerreotype. We have seen these faces before, but not on this earth, in some previous existence perhaps, which they recall vaguely to us.

How to explain in another way the strange, unique, almost magical charm that the portrait of Mona Lisa exercises on the natures of even the least enthusiastic! Is it her beauty? Many faces by Raphael and other painters are more correct. She is no longer so young and her age must be that loved by Balzac, thirty years; through the caressing fineness of the modelling we divine already a certain fatigue, and life's finger has left its imprint on the peach of her cheek. Her costume, through the carbonizing of the pigments, has become almost that of a widow: a crepe veil falls with her hair beside her face, but the expression, wise, deep, velvety, full of promise, attracts you irresistibly and intoxicates you, while the sinuous, serpentine mouth, turned up at the corners, under violet-tinged shadows, mocks you with such sweetness and grace and superiority, that you feel wholly timid like a schoolboy before a duchess. Further, this head with its violet shadows, perceived as through a black gauze, captivates us over hours of reverie as we lean on the museum rail, haunting us like a symphonic motif. Beneath the form *expressed*, one feels a thought vague, infinite, *inexpressible*, like a musical idea; we are moved, troubled; images *already seen* pass before one's eyes, voices whose tones seem familiar whisper languorous secrets in our ears; repressed desires, despairing hopes well up painfully in the shadow shot with sunbeams, and you discover that your melancholy arises from the fact that la Jocconde, three hundred years ago, greeted your avowal of love with the same mocking smile which she retains even today on her lips.[24]

Gautier's English paragon is Walter Pater in his short biography of Leonardo, first published in the *Fortnightly Review* in 1869, and four years later in his notable set of essays, *Studies in the History of the Renaissance*. It was translated into French in 1894. The famous passage reads:

The presence that thus rose so strangely besides the waters, is expressive of what in the ways of a thousand years men had come to desire. Hers is the head upon which all 'the

ends of the world are come,' and the eyelids are a little weary. It is a beauty wrought out from within upon the flesh, the deposit, little cell by cell, of strange thoughts and fantastic reveries and exquisite passions. Set it for a moment besides one of those white Greek goddesses or beautiful women of antiquity, and how would they be troubled by this beauty, into which the soul with all its maladies has passed. All the thoughts and experience of the world have etched and moulded there, in that which they have of power to refine and make expressive the outward form, the animalism of Greece, the lust of Rome, the reverie of the Middle Ages with its spiritual ambition and imaginative loves, the return of the pagan world, the sins of the Borgias. She is older than the rocks among which she sits; like the vampire, she has been dead many times, and learned the secret of the grave; and has been a diver in deep seas, and keeps their fallen day about her; and trafficked for strange webs with eastern merchants; and, as Leda, was the mother of Helen of Troy, and as Saint Anne, the mother of Mary; and all this has been to her but as the sound of lyres and flutes, and lives only in the delicacy with which it has moulded the changing lineaments, and tinged the eyelids and the hands. The fancy of a perpetual life, sweeping together ten thousand experiences, is an old one: and modern thought has conceived the idea of humanity as wrought upon by, and summing up in itself, all modes of thought and life. Certainly Lady Lisa might stand as the embodiment of the old fancy, the symbol of the modern idea.[25]

Pater's remarkable account provides testimony that poetic reverie can inhabit historical territory to the high mutual benefit of both. In reproduction and in print, Mona Lisa was becoming a leading citizen of the world.

Repatriated, briefly

Whose heritage is the *Mona Lisa*? Is it best recognized as a work by an artist from Vinci? Or is it Florentine, given that it was begun in Florence? Or maybe Roman, in that it may have been finished there for Giuliano de' Medici? Perhaps Milan has a claim in that Leonardo spent more years working there than anywhere else, and the city is now a major centre for Leonardo studies. Or does Francis I have the best claim, as Leonardo's patron and as the first documented owner of the painting after Salaì? But is republican France the true heir of the French monarchy? Or does such a 'universal' painting belong to the world, to use a cliché—as the British Museum claims in defence of its ownership of the marble sculptures from the ancient Greek Parthenon. If great art transcends parochial and national identities does it matter where it has eventually settled? There are no absolutely right answers to such questions, not least when faced with the incredible tangle of provenances of the major works in the world's museum and galleries. One practical consideration is that it should be

housed in a highly accessible and much-visited venue, even if that venue is now faced with the almost impossible job of making it decently visible to the elbowing throng of visitors—mostly now capturing digital records of the moment rather than using their eyes to experience the painting.

Vincenzo Peruggia, émigré Italian handyman and painter of sorts, thought he knew the answer. The *Mona Lisa* had been stolen by Napoleon and needed to be returned, along with other Italian masterpieces in the Louvre, to its home country. He had been employed in Paris by a company commissioned to clean and glaze important paintings that were felt to be vulnerable to attack, not least from French anarchists. The extraordinary episode of the theft of the *Mona Lisa* in the early hours of Monday 21 August 1911, and the no less remarkable story of its recovery, have been much recounted.[26] In keeping with the concentration on landmark sources in this chapter, we will concentrate on the largely unpublished testimony of the three major actors in the drama, Peruggia himself, the Florentine art dealer Alfredo Geri, and the Director of the Uffizi, Giovanni Poggi.

Peruggia's account is the official statement he made in the old prison in Florence after his arrest in 1913. It is here given almost in full.

Vincenzo Peruggia, perpetrator of the theft of the *Mona Lisa* Interrogation in the Carcere delle Murate [old prison] in Florence 15 December 1913

My name is Vincenzo Peruggia...born 8 October 1881 in Dumenza (Como)...I know how to read and write, having attended elementary school until the third grade, unmarried, I was a soldier for a few days, being discharged due to weakness of the chest, or more accurately, due to a general propensity for weaknesses...

I have been working in the Louvre on two occasions, the first in 1909, the second in 1910, and remained there three or four months each time. I helped clean the canvases and put them under glass.

During my work I learned that a large quantity of the paintings that were located in the Louvre had been stolen from Italy. One day, during a break, I went into a small library...I took a book that was in a cupboard located in the laboratory and in that book (I cannot remember the author) I read, and I also saw the photographs, that many paintings were stolen from Italy by Napoleon I.

From that point, a desire was born in me, and I felt indignant, given my pride in Italy, and it came into my mind to be able to give one of those paintings back to Italy.

...And having finished my work [in the Louvre], I decided to put my project into operation.

On a morning of August...about 7.30, dressed as a worker with a white linen smock, I went to the Louvre, and I entered, through a back door where workers were entering, a door that opens towards the Seine. I followed in and found myself...in the square hall

[the Salon Carré] and my choice fell, with no premeditation, on the *Gioconda* by Leonardo da Vinci.

I knew that in that room there were to be found the *Gioconda*, several paintings by Raphael, that is to say *La Belle Jardinière*, the *Holy Family of Francis I*, and the *Archangel Michael*, another painting by a certain Castiglione, and Bernardino Luini (a *Madonna*).

The picture of the *Gioconda* was fixed on the wall on two hooks and I did nothing more than raise the picture and detach it. Then I hid in a small stairwell adjoining the Room of the Seven Meters [known from the height of its ceiling]—in a corner of it—and with a screwdriver (which I had brought expressly with me) undid the screws that secured the picture and took it out, leaving the frame in the stairwell, and finally I descended into the courtyard where I was hiding the picture under my smock.

The custodian, who was busy at the exit door with others, did not notice me…I do not know the name of the custodian. I returned immediately to my house (Via de l'Hospital Saint Louis no. 5) and I left the picture in my room without hiding it. After that I returned to my work in a new house located in the street…I do not remember the name of the owner nor do I remember the company for which I worked. No one could get into my room because I only had one key which I always had with me and I did all the servicing myself. Subsequently, I myself built a trunk with the double bottom and hid the picture of the *Gioconda* in it. I continued to work and did not think of returning it immediately in Italy and handing it over, because I was afraid of being arrested as a thief and that Italy would not take the picture. In essence, I wanted time to pass and erase the memory of the disappearance of the picture. When a controversy between the two countries arose in the press about the Aegean islands occupied by Italy, I then thought it was the opportune moment to realize my dream and consign the picture to Italy.

I add that I read in the Corriere della Sera the address of a certain Signor Geri, antiquarian dealer in Florence. I wrote to him whether he was inclined to act because the Uffizi Gallery could acquire the painting of the *Gioconda*, and he said that my proposal could be accepted if I were to bring the painting to Florence. I responded by writing that I would come to Florence, and he replied that, if I hastened my arrival, I was free to choose another city if I preferred it to Florence. I replied that I would go first to Milan, where I actually went, but I did not choose to stay there…and I telegraphed to Geri that I was leaving for Florence and I remained in Milan only about two hours, and I arrived in Florence on Wednesday morning at 11.00 (actually 10.00), current time.

The trunk with the double bottom containing the *Gioconda* travelled with me as baggage. At the border, the trunk was opened, but no one was aware that it contained the picture. The trunk contained my effects, linen goods, an outfit and tools of my trade, such as brushes, ruler, a small palette, and some iron tools.

Entering Florence, I saw the Hotel Tripoli and took lodgings there, and afterwards I myself went to pick up the trunk from where I left it at the station. I hastened to find Signor Geri. I found him and told him that the picture was with me, and he gave me an appointment for the next day because he had to talk to the person who was to acquire the painting.

I had asked only for a reward for my efforts in returning the *Gioconda* to Italy, but I did not specify any amount. Geri advised me to ask five hundred thousand lire [then about £5,000] because the amount from the person who was to purchase the painting would be greatly reduced [over its market value], and thus I could secure my reward and he would receive a percentage. The day after my visit to Geri of which I spoke just now, I went back looking for him and found him together with Prof. Poggi.

They wanted to see the picture and I took them with me to the hotel Tripoli, and since there was sufficient light, Prof. Poggi wanted to bring the painting to the Uffizi Gallery, which I did straight away, and all three of us went to the Uffizi Gallery.

There, Prof. Poggi, also consulting photographs, was persuaded that the picture was authentic, and then I left the painting there, and agreed that Poggi would write to his boss, the Comm. Ricci in Rome, who would then come and would settle the reward to give me. All that happened on Thursday afternoon (December 12), when it was almost night.

The next day I waited until noon, when I decided to seek Geri again. I did not find him at home and his son said to me, on behalf of his father, who had returned but could not be seen, that I should stay at the hotel from 3.00 to 5.00, when I would be telephoned. 5.00 o'clock arrived and having seen no one, I was preparing to leave when I was arrested.

And it is useless for you to force me to tell the truth, because I told you the whole truth and nothing but the truth. I acted according to a force stronger than me, and I have no accomplices. I repeat that I took the picture with the set idea that haunted me for a long time, to return it to Italy…

I have nothing to add.

Asked if he wants bail, he answers: where do you want me to go?[27]

Peruggia was of course hoping to show himself in the best light, motivated by patriotism rather than financial greed. In effect he was killing two birds with one stone, repatriating Leonardo's masterpiece, which he wrongly believed to have been Napoleonic plunder, and easing the poverty of himself and his family. He exaggerated the ease with which he exited the Louvre. He found the door at the bottom of the staircase firmly locked. He seems in desperation to have unscrewed the door knob, to no avail. Fortuitously a workman with keys arrived and opened the door. Peruggia looked like a legitimate employee.

All the accounts of Peruggia during the affair comment on his apparent lack of anxiety and even of engagement. He felt he was doing the right thing, and would be well recognized for his efforts, however much the immediate course of events seemed to be going against him. His real emotional involvement was with *Gioconda* herself. Not even in her relatively insalubrious birthplace could Lisa have countenanced the circumstances under which she was surviving in Peruggia's squalid Parisian apartment, emerging regularly from

her claustrophobic trunk to be feasted on by her captor's loving eyes—as he himself recounted.

Peruggia contacted Geri in response to the dealer's advertisement for items to display and sell at top prices in a prestigious exhibition of old masters that he was planning in 1913 for his Florentine gallery. Geri was a major international dealer and collector, resident in a fine villa in Settignano outside Florence.[28] That Peruggia should make contact via this commercial route confirms the financial dimension to his escapade. He was no innocent abroad. He had convictions for attempted robbery and possession of a weapon.[29]

Geri's court testimony confirms much of Peruggia's account. After initial scepticism about the implausible letters he was receiving from a certain 'Leonard' in Paris, he encouraged their sender to come to Florence with the painting, and he contacted his friend, Giovanni Poggi, the relatively new director of the Uffizi, who was to play a vital role in the protection of Italy's artistic treasures during the Second World War.

Geri tells how:

that Wednesday in the afternoon a young man, thin with a small black moustache, modestly dressed, appeared at my office and said that he was the possessor of the *Gioconda* and invited me to accompany him to his hotel to see the picture. He answered all my questions with much assurance and told me he wanted 500,000 lire for his picture. I said that I was prepared to pay this sum and invited him to return the next day at 3.00 p.m. At 3.00 the next day Poggi was at my house. At ten minutes past 3.00 the man had not arrived. Had the business fallen through? We became impatient. Finally at 3.15 Leonard arrived. I introduced Leonard to Poggi. They shook hands enthusiastically, Leonard saying how glad he was to be able to shake the hand of the man to whom was entrusted the artistic patrimony of Florence.

The three of us left together. Poggi and I were nervous and also anxious. Leonard, by contrast, seemed indifferent. We arrived in the little room that he occupied on the third floor of the Hotel Tripoli-Italia. He locked the door and drew out from under his bed a trunk made of white wood that was full of wretched objects; broken shoes, a mangled hat, a pair of pliers, plastering tools, a smock, some paint brushes, and even a mandolin. He threw them on to the floor in the middle of the room.

Then from under a false bottom in the trunk he took out an object wrapped in red silk. We placed it on the bed and to our astonished eyes the divine *Gioconda* appeared, intact and marvellously preserved. We took it to the window to compare it with a photograph we had brought with us. Poggi examined it and there was no doubt that it was the original. The Louvre's catalogue number and stamp on the back of it matched the photograph.[30]

Giovanni Poggi's testimony is less picturesque and not consistent in every detail with Geri's.

Testimony of Dr Giovanni Poggi, December 19, 1913 in Florence.

At 3.00 on 11th [December] I was already in the premises of Geri in Borgo Ognissanti. Peruggia arrived after a delay of about an hour. Geri alerted me to his arrival because at that time I was in another room. The three of us left, on our own, with nobody else, to go to the hotel where Peruggia was resident. Along the way there was no talk at all of the *Mona Lisa*. I talked with Geri, Peruggia walking a little ahead of us. I should add that Geri had not actually introduced me to Peruggia and did not say anything about me, and hence I do not know if Peruggia knew who I was.

Having arrived at the Hotel Tripoli and the room occupied by Peruggia, and after he had shut the windows for fear of being seen, he opened a white chest and extracted a picture wrapped in a cloth of red felt.

As I looked at that painting, I realized straight away that I had found myself in the presence of Leonardo's masterpiece, but I did nothing to convey this to Peruggia, and then said that I would have to examine it more fully, which I could do more readily in the Uffizi Gallery.

Peruggia was amenable, not saying anything to try to persuade me that it was the authentic 'Gioconda', and he promised that he would transport the picture to the Gallery.

In fact all three of us left the Hotel immediately, and took a *fiacre* [a horse-drawn carriage] and Peruggia carried the picture, which was then delivered without any difficulty to the Gallery.

I indicated to him that I needed a little time to write to Rome and receive an answer, so, having expressed the wish to leave at once, he had to stay at least until the following Friday 12th ...

And then I asked him how he came into possession of the painting. He immediately replied that he had stolen it from the Louvre and that he had unsuccessfully attempted the theft on four other occasions, when he was not successful because of the surveillance.

He explained that he had actually been working at the Louvre putting the pictures back in their frames and putting in the glazing, and thus he had a very workable pretext. One morning after he had stopped working there, he went wearing his worker's smock to the Louvre, where he arrived in the Salon Carré where the *Mona Lisa* was located, and undisturbed he was able to take the picture and detach it from the wall, subsequently removing the frame, which he left in another place in the Louvre, from where he was able to leave via a service door, hiding the painting under this smock, because if he took it off he could roll it around the picture ...

I never gave any hint to Peruggia of any reward that he might want for handing over the painting and I was careful not to make him any such offer.

I later learned from Geri that Peruggia had first asked for a reward of two million lire and then the sum was reduced to five hundred thousand, from which he would give a dividend of 25% to Geri himself, as already indicated in one of his letters ... [31]

There is a sense that Poggi, as a public employee, was distancing himself from a potentially shady deal.

At the resulting trial in June 1914, Vincenzo Peruggia was given the lenient sentence of one year and fifteen days in prison, reduced to seven months on appeal. He was clearly not regarded as a common thief who simply stole for money, and in the publicity that ensued he was gaining something of the status of a folk hero. He exuded a kind of innocent naivety which attracted sympathy.

The one substantial beneficiary of his theft was the Hotel Tripoli, which rapidly re-christened itself as the Hotel Gioconda, where room number 20 now boasts a brass plaque commemorating the brief stay of *Mona Lisa* as a guest on the third floor.

The theft had been massive news in France and abroad. Newspapers and journals enjoyed a series of feast days, ridiculing the authorities, brandishing accusations, and dragging up false stories. The panicked police sought desperately for concrete leads and possible suspects. Their eyes fell on the avant-garde poet Guillame Apollinaire, who had earlier been involved with Picasso in receiving Iberian statuettes stolen from the Louvre by the writer's one-time assistant. The alarmed poet was arrested on suspicion of the theft, languishing in jail for six days, and Picasso was amongst those brought in for questioning. Apollinaire was scathing about the lack of security in the Louvre, writing in *L'Intransigeant* that 'not even the smallest paintings are locked to the wall, as they are in most museums abroad…The situation is careless, negligent and indifferent. The Louvre is less well protected than any Spanish Museum.'[32] There was no available evidence against him or anyone else, and the trail went cold—until Peruggia's emergence from his scruffy refuge.

After the painting's recovery, there was understandable nervousness on the French side that Peruggia's attempt to repatriate Leonardo's masterpiece on a permanent basis might prove to be effective. These fears were rapidly allayed by the Italian authorities, and the Louvre agreed that the painting would first be displayed triumphantly in Florence, followed by brief sojourns in Rome and Milan. On 14 December 1913, the first day of its showing in Florence, it attracted a huge throng of visitors. The queues rivalled those who earlier had lined up in Paris to view the blank space once occupied by *La Joconde*. On 4 January 1914, the *Mona Lisa* embarked on its return journey to the Louvre, assuming its normal place in the Salon Carré.

The stories of the theft and recovery follow a relatively simple narrative, involving a rather simple thief and simple *modus operandi*. However, as always

with Leonardo, simplicity does not suffice. Mystery and conspiracy are pre-ferred to the reality. The most persistent tale woven around the theft is that involving an aristocratic Argentinian criminal, Eduardo, Marqués de Valiferno. On 25 June 1932 the *Saturday Evening Post* published an article by a respected journalist, Karl Decker, headlined 'Why and How the Mona Lisa Was Stolen'.[33] Decker reported that Valiferno, whom he claimed to have interviewed in Morocco, had commissioned the theft by Peruggia in order to sell forgeries that Valiferno had already commissioned. He had apparently lined up no less than six collectors for his 'stolen' *Mona Lisa*. There is nothing to substantiate any element in the story, even the Argentinian's existence, but Valiferno's plan continues to exhibit some kind of conspiratorial reality in the more shadowy literature on the painting.

A subsequent mythical theft has also gained credence. The *Mona Lisa* was part of Nazi loot in the Second World War, supposedly stored deep under-ground in the Alt Aussee salt mines in Austria, in company with Jan van Eyck's *Ghent Altarpiece* and other pillaged masterpieces.[34] The reality is rather different. In an extraordinary operation before the Nazi invasion, thousands of French artistic treasures, including Leonardo's masterpiece, were dispatched into suc-cessful exile in provincial strongholds. The official records attest that the *Mona Lisa* was transported in its specially constructed crate to successive hiding places: the Château de Chambord, Louvigny, the Abbey of Loc-Dieu, the Musée Ingres at Montauban, and finally in the Château de Montal, successfully evading Nazi capture each time. The presence of a '*Mona Lisa*' in the inventory of works recovered from the salt mines is explained by the Louvre as referring to a good copy of unknown provenance, which they still hold pending a claim of ownership. Thus, Napoleon's companion had managed to evade Hitler's grasp.

The theft by Peruggia played a notable role in cementing wider public atten-tion on Leonardo's little picture. However, the fame of the *Mona Lisa* did not effectively begin in 1911, as sometimes inferred. We have seen over the course of these two chapters how it asserted its presence from a very early date, radically transcending its apparent limits as the portrait of a woman of little interest beyond the immediate circumstances of her life in Florence. Over the years the portrait has also for many people become a 'she' rather than an 'it'. *Mona Lisa* had become *the* Leonardo and was well on its way to becoming *the* painting of all paintings, even before its theft. It is now famed not least for becoming enduringly famous.

CHAPTER VIII

⬥⬥⬥

Portrait to Poetry

The Dolce stil nuovo

Although portraiture was not the highest-ranked genre in Renaissance painting or in the later academies—that honour fell to narrative subjects—it was the very model of mimetic art and was indeed seen as providing its origins. Leon Battista Alberti in his seminal little book *On Painting* provides two rather conceptualized alternatives. The first involves Narcissus, the supremely beautiful youth who rejected the nymphs and 'fell in love with the fantastick shade' of his own reflection in a gleaming pool of water, 'And o'er the fair resemblance hung unmov'd', to quote from the beautiful translation by Dryden of Ovid's *Metamorphoses*.[1] Narcissus expired in the face of his unrequitable love, as so many later poets promised to do:

> By his own flames consum'd the lover lyes,
> And gives himself the wound by which he dies.

Alberti asks rhetorically, 'What is painting but the act of embracing by means of art the surface of the pool?'[2]

He then notes the opinion of the Roman orator Quintilian that the earliest painters began by drawing outlines around shadows cast by the sun. The full story is told by Pliny in his *Natural History*: 'The daughter of the potter Butades of Sicyon was in love with a young man; and she, when he was going abroad, drew in outline on the wall the shadow of his face thrown by a lamp.'[3] No matter that the potter was said to have filled in the outlines with clay

to invent relief sculpture. The story gained wide later currency as telling of the origin of painting. Both the origin myths involve representations of a beloved person.

More generally Alberti exults in the 'divine power' of painting to 'make the absent present (as they say of friendship), but it also represents the dead to the living many centuries later, so that they are recognized by spectators with pleasure and deep admiration for the artist'.[4] This ability to grant enduring life to portrayals of real people means that 'masters see their works admired and feels themselves to be almost like the Creator'. The immortality of the portrait and its strong ties with love were crucial for the power of painting and sculpture as seen in ancient Rome. These associations were inherited by the Renaissance. The portrait became the most widespread secular genre during the years spanned by Leonardo's life.

Images of women carried a special emotional charge, even if they comprise a minority amongst Renaissance portraits. A rough survey of portraits of men and women by Antonio Pollaiuolo, Domenico Ghirlandaio, Sandro Botticelli, and Raphael indicates that there are more portraits of men than women, according to a ratio in the region of 3:2. This is not a severe imbalance given the asymmetries of power between men and women in the Renaissance. In the northern Italian courts it is likely that the ratio is more equal. With Leonardo, who is atypical in this as much else, the four surviving portraits of women—*Ginevra de' Benci*, *Cecilia Gallerani*, *Lucrezia Crivelli* (the so-called 'La belle Ferronière'), and *Mona Lisa*—are accompanied by only one man, the *Musician* in the Ambrosiana. With his 'suave' style Leonardo seems to have been recognized as the right painter for portraits of women. The relatively large number of portraits of women in the Renaissance may be explained by a number of factors: the commissioning of pendant paintings of husbands and wives; portraits of women painted or sculpted in advance of marriage as likenesses of geographically distant brides; portraits at the time of marriage or in connection with pregnancy and childbirth; and the taste for images of *belle donne* within the family.

The last of these mirrors the huge predominance in shorter poetic forms of fervent love poems directed towards beloved ladies, who typically feature as ideal distillations of nominally real individuals.[5] They become idealized to the point at which the poet's rich parade of pleading, glances, sighs, tears, self-pitying lamentations, and metaphorical deaths can never hope to be redeemed. Indeed the subjects of the poems increasingly became esteemed ladies with

whom the poet never expected to enjoy an intimate relationship. A conspicu-
ous branch of the poetry of love became a public game of courtly preening.

The most notable poetic form was the sonnet, canonically of fourteen lines
with a number of set rhyme-schemes. Typically the first part is the octave of
eight lines with an *abbaaba* scheme, followed by a six-line sestet with more
varied patterns of rhymes. The octet typically lays out the substance of the mat-
ter, while the sestet reviews and resolves the problem, rarely to the advantage of
the tormented lover. The other frequent form was the somewhat more flexible
canzone or song, whether or not actually set to music. It typically consisted of
a set of stanzas that obey the rhyme scheme of the first verse. While there is no
doubt that love mattered then and matters now, the content and forms of
the verses came to serve as fields in which the poets could indulge in virtuosic
exercises in self-conscious sensibility and poetic ingenuity. The conventional
formalities of these and other poetic genres became ideal containers for elegant
variations and flashes of daring.

The Italian modes of love poetry in the thirteenth and fouteenth centuries
were developed from mediaeval European traditions mainly by Guido Cavalcanti
and Dante Alighieri. What they were founding was categorized by Dante
himself as the *dolce stil nuovo* (sweet new style). Its hold persisted well into the
sixteenth century, and provided a characteristic flavour of the versifying that
Leonardo encountered in the Florence of Lorenzo de' Medici (who was a notable
poet on his own account) and the court of Ludovico Sforza in Milan.

The two main booklists compiled by Leonardo contain a goodly number of
literary and poetic works, even if they do not comprise a representative library
of the best texts available.[6] Amongst works of poetry, he listed volumes by
Petrarch, by the brothers Luigi and Luca Pulci, Burchiello and Gasparo
Visconti, together with collections of stories (*novelle*). The range extends from
poetry of love in the tradition of the *dolce stil nuovo* (most notably Petrarch),
through rumbustious epics (Luigi Pulci's *Il Morgante*—the source of Salaì's
name) to cutting vernacular satires on the high pretentions of humanist poetry
by Burchiello, whose iconoclastic celebration of the rough language and
unmannerly behaviour of the lower strata of Florentine society was not the
normal fare for poets or their readers.[7]

It is right to issue a caution about how we use Leonardo's book lists. They
record books that he had placed or was placing in storage. They do not feature
some texts that he knew intimately and presumably possessed, such as Alberti's
On Painting and Dante's *Divina commedia*. Perhaps he kept these with him.

He was noted as an expert on Dante, as was Michelangelo. This is reflected in a story later told by Bernardo Vecchietti about an encounter not far from the Del Giocondo shop:

Leonardo was passing Santa Trinità by the benches at the Palazzo Spini where several worthy men were assembled and where they were debating a passage in Dante. They called Leonardo, asking him to come and tell them about this passage. And at that moment it happened that Michelangelo was passing and, one of the crowd calling to him, Leonardo responded 'Michelangelo will be able to tell you.' To which Michelangelo, thinking this had been said to trap him, replied: 'No, *you* explain—you who have undertaken the design of a horse to be cast in bronze but were unable to cast it and were forced to give up in shame.' So saying, he turned his back on them and left. Leonardo remained there, blushing. And then, wishing to sting Leonardo, Michelangelo called out, 'And to think that you were believed by those Milanese capons'.[8]

Vecchietti was noted as a patron of sculpture. Dante viewed through Leonardo's eyes will feature prominently in this chapter.

We begin our exploration of the *Mona Lisa's* poetic resonances by looking at Leonardo's *paragone*, his highly staged comparison of the various arts, not least for what it tells us about what he thought poetry could do. When Francesco Melzi compiled the *Book on Painting* from Leonardo's diverse manuscripts, he devoted the first part to the *paragone*, as a fitting introduction to his master's ideas—presumably reflecting the importance it held for Leonardo himself.[9] We next encounter some running tropes in love poetry from Dante to Leonardo's own day that provide a way of looking at Leonardo's portraits of women. We will next look in a complementary way at the poems specifically written on Leonardo's portraits by contemporary poets. Finally, we will see how the *Mona Lisa* sits within the tradition of the poetic image of the beloved lady—and then moves beyond it.

The *Paragone*

Leonardo tells a story about a painter and poet jostling for the attention of King Matthias Corvinus of Hungary, a major patron of things Italianate:

A poet brought him a work made to commemorate the day on which the King was gifted to the world, when a painter presented him with a portrait of his beloved lady. Immediately the King closed the book of the poet and turned to the picture, fixing his gaze on it with great admiration. Whereupon the poet very indignantly said, 'Read, O King! Read and you will discover something of greater consequence than a dumb

painting.' The King, on hearing the accusation that he was giving credence to a dumb object said, 'Be silent, O poet. You do not know what you are saying. This picture serves a greater sense than yours, which is for the blind. Give me something I can see and touch, and not only hear, and do not criticize my decision to tuck your work under my arm, while I take the painting in both hands to place it before my eyes, because my hands acted spontaneously in serving the nobler sense.'[10]

We need not think that this is direct reportage. The placing of words in the mouth of a prestigious speaker was a literary device, but the courtly setting for a rhetorical contest between proponents of the various arts, including music, is entirely realistic. We know that Leonardo took part in at least one such debate in Ludovico's court. He had learnt how to play the game. The self-professed 'man without letters' was learnedly alluding to an ancient topos credited to Simonedes of Ceos, which Leonardo interprets bluntly to mean that 'painting is mute poetry and poetry is blind painting'.

Leonardo's *paragone* roundly denigrates poetry on a series of fronts, most of which depend on his characterization of poetry as vainly attempting to be as visual as panting. However, reading between the lines, we gain a sense of where he thought that poetry offered a challenge worth rebutting. He is clear that both arts strive to present the beauty of proportional harmonies to their organs of sense. In portraying the delights of beloved ladies, the painter and the poet equally aim to 'inflame men with love, which is the central aim in all animal species'.[11] He now tells a story that, once again, is as much rhetorical as literal:

The painter…can place in front of the lover the true likeness of that which is beloved, often making him kiss it and speak to it. This would never happen with the same beauties set before him by the writer. So much greater is the power of a painting over a man's mind that he may be enchanted and enraptured by a painting that does not represent any living woman. It previously happened to me that I made a picture representing a holy subject, which was bought by someone who loved it and who wished to remove the attributes of its divinity in order that he might kiss it without guilt. But finally his conscience overcame his sighs and lust, and he was forced to banish it from his house. Now, poet, attempt to describe a beauty, without basing your depiction on an actual person, and arouse men to such desires with it.[12]

Turning to literary scenes of terror and delight, Leonardo quotes a poetic antagonist as claiming that 'I will describe hell or paradise or other delights and terrors.' Dante was obviously on his mind. Leonardo goes on to say that:

if you, poet, were to portray a bloody battle you would write about the dark and murky air amid the smoke of fearful and deadly engines of war, mixed with all the filthy dusts that fouls the air, and about the fearful flight of wretches terrified by awful death.[13]

Epic fights in chivalric poetry were picturesquely narrated but did not embrace the kind of fiery modern violence that Leonardo described.

Although he emphasized that the painter will always surpass the poet in visual things, we can sense that the challenge set by poetry was real. When it comes to imagining 'monstrous things, which might terrify or which would be buffoonish and laughable or truly pitiable', he was clearly alert to the types of literature that specialize in these vivid subjects, including Luigi Pulci's mock-chivalric tale of the giant Morgante and Burchiello's collection of sonnets that rudely subvert conventional preciosity. Both were in Leonardo's library. The same spirit of emulation applies to his evocation of 'shady valleys irrigated by the play of winding rivers' and related pastoral delights, which were notable features of poetry at the court of Lorenzo il Magnifico and in Venice during Leonardo's lifetime.

Not least he meets head-on the poet's supreme claim to 'make a story that signifies great things'. His visual counter-example is the *Calumny* by Apelles, who was credited by Lucian with inventing a pictorial drama in which an innocent man is assaulted by slander, ignorance, suspicion, envy, fraud, conspiracy, and repentance, before the arrival of naked truth. Alberti cited the *Calumny* as a supreme example of a painted narrative. The most famous Renaissance reconstruction of Apelles's lost masterpiece was by Botticelli (Florence Uffizi).[14]

Even Leonardo had to acknowledge that 'blind painting' is good at telling stories that signify 'great things' and can directly present spoken words, but he argued with some desperation that any momentous content is borrowed by the poet from other professions, such as oratory and philosophy.[15]

The extent to which Leonardo the painter could directly rival the poetic genres that he criticized is necessarily limited. There are not many paintings in total and they were of commissioned subjects. His narrative paintings, above all the great 'history' (*istoria*) of the *Last Supper*, demonstrably signified 'great things' in the most eloquent and dramatic manner. The poet's account of a battle would have been directly answered by his mural of the *Battle of Anghiari* in the Council Hall in Florence, sadly incomplete and lost. Others of his visual answers feature less publicly in his drawings. There are views of both charming and grand scenes in nature. There are terrifying images of cataclysms, most notably the ravaging vortices of the late *Deluge Drawings*. There are fevered imaginings of monsters, incongruously assembled from components of diverse animals. There are scribbled heads of grotesque characters in great numbers that are both 'laughable and pitiable'. Leonardo delighted in

the god-like powers that allowed him to summon up his teeming cast of beauties and monstrosities.

The one genre in Leonardo's painted *oeuvre* that existed in sustained dialogue with poetry was his portrayal of beloved ladies. The dialogue was two way. On one hand he was striving to emulate and ultimately surpass poetry on its own ground. His aspiration was to create images of such compelling presence and emotional attraction that they would spontaneously lead the male patron to tuck the poet's flowery verses under his arm. On the other, his portraits were themselves the subject of poetic effusions, as we will see later in this chapter. Our intention at this point is to assemble an anthology of the kind of poetic voices that would have resonated in Leonardo's ears as he strove to move the viewer as no earlier portraitist had done.

Dante and Petrarch: loving eyes and sweet smiles

A full study of Leonardo and poetry would be highly rewarding—and very demanding. Our intention here is more limited. It is to look at poetic motifs that give us insights into how *Mona Lisa* would have looked in the eyes of spectators who were well versed in Renaissance love poetry, as was Leonardo himself. Our main focuses will be threefold. The first is on the eyes as 'windows' through which the image of the beloved lady is drawn into the mind and into the soul of the beholder, and from which love is transmitted to the tormented poet, frequently in the guise of Cupid's wounding arrows. The second focus will be on the lips, above all smiling lips, which speak the words that the painter can only imply. The third theme will involve poems that specifically address painted portraits within the context of love. Poems on pictures became a distinct genre during the course of the fifteenth century.[16]

The anthology of excerpts is presented in a broadly chronological order. We begin, unsurprisingly with Dante. Although chronologically the most remote from Leonardo's day, Dante is the poet to whom Leonardo reacted most profoundly, not least because Dante was the profoundest. Leonardo found in Dante the marriage of *fantasia* and *intelletto* that was the bedrock of his own art. Dante's poetry integrates central themes in mediaeval natural philosophy—medicine, psychology, dynamics, optics, and astronomy—into his imaginative vision in a way that was fully apparent to the alert reader without seeming contrived. For someone like Leonardo who preferred not to

grapple with Latin texts unless he had to, Dante's poetry and prose provided a treasury of wisdom about the behaviour of nature.

The tone was indelibly set by Dante's love for Beatrice, customarily identified as Beatrice di Folco Portinari, whom the poet tells us he once met when they were children and later as young adults in a passing encounter when they briefly spoke. In 1290 at the age of 24, Beatrice was dead. Her image served as the fulcrum for Dante's poetic emotions in the most elevated and spiritual manner. It is significant that on the first anniversary of her death he should be found working on a graphic image of an angel:

On that day which completed one year since this lady had become a citizen of the eternal life, I was sitting in a place where, thinking of her, I was drawing an angel on some panels.[17]

Beatrice, an angel on earth and in heaven, was first extolled in Dante's *Vita Nuova*, composed sometime between 1292 and 1294, in which thirty-one poems are accompanied by knowing commentaries that set them and indeed Dante's poetic development in the context of his 'new life'. His brief glimpses of Beatrice and the highly charged meeting of their eyes became an insistent motif, a burning memory:

From out her eyes, wherever they may move
come spirits that are all aflame with Love;
they pierce the eyes of any one that looks
and pass straight through till each one finds the heart;
upon her face you see depicted Love [Cupid],
there where none dares to hold his gaze too long.[18]

In his commentary on Canzone I in *Convivio* II, Dante draws upon mediaeval optical theory to explain how the perpendicular visual ray that runs from the object to the optic nerve is the one that certifies the perception of the object:

Here it should be known that although many things can enter the eye at the same time, nevertheless that which enters along a straight line into the center of the pupil is the only one that is truly seen and which stamps itself upon the imagination. This is because the nerve along which the visual spirit runs is pointed in this direction; and therefore one eye cannot really look into another eye without being seen by it; for just as the one which looks receives the form in the pupil along a straight line, so along that same line its own form proceeds into the one it looks at; and many times along the extension of this line is discharged the bow of him against whom all arms are light.[19]

Derived from mediaeval optical theory in the Islamic tradition, the notion of this dominant axis for vision was adopted in *On Painting* by Alberti, who called it the centric or 'prince' of rays, and by Leonardo, for whom it was crucial in prioritizing the plethora of rays from diverse angles that impinged on the front and inner surfaces of the eye. Dante was supremely alert to mediaeval natural philosophy in such a way that it became naturalized within his poetic vision.[20] It is easy to see why Leonardo appreciated the great poet above all others.

The divine Beatrice's smile is not a great deal less important than her eyes in Dante's imagery:

> The image of her when she starts to smile
> breaks out of words, the mind cannot contain it,
> a miracle too rich and strange to hold.[21]

Dante then comments on:

two actions of her mouth: the first is her sweet manner of speaking, the second is her miraculous smile. I do not mention how this last act of her mouth works in the hearts of people because the memory is not capable of retaining the image of such a smile nor of its effects.[22]

In the *canzone* in which Beatrice's eyes and lips work most intimately in concert, he again adopts an optical tone:

> In her countenance appear such things
> As manifest a part of the joy of Paradise.
> I mean *in her eyes and in her sweet smile*,
> For here Love draws them, as to himself.
> They overwhelm our intellect,
> As a ray of sunlight does weak vision;
> And since I cannot fix my sight upon them,
> I am content to say but little of them.[23]

The overwhelming of our sight by extreme effects was a stock motif in mediaeval optical science.

In the commentary that follows, Dante's exposition and the *Mona Lisa* seem to come together over an interval of over 200 years. It is worth quoting at length:

Since someone might ask where this wonderful delight appears in her, I distinguish in her person two parts in which the expression of human pleasure and displeasure are most

evident. And so we must know that in whatever part the soul most performs its work, it is this that it is most determined to adorn and at which it works most subtly... And since in the face the soul operates principally in two places (because in those two places all three natures have jurisdiction, each in its own way)—that is, in the eyes and in the mouth—it adorns these most of all and directs its full attention to creating beauty there, as far as possible. It is in these two places that I maintain these delights appear, saying *in her eyes and in her sweet smile*. These two places may be called, by way of a charming metaphor, the balconies of the lady who dwells in the edifice of the body, which is to say the soul, because here, though in a veiled manner, she often reveals herself... Consequently given that there are six emotions proper to the human soul, of which the Philosopher makes mention in his book on *Rhetoric* (namely, grace, zeal, pity, envy, love, and shame), by none of these can the soul become impassioned without its semblance appearing at the window of the eyes, unless by exercise of great force it is kept closed within.[24]

This is not to suggest that the *Mona Lisa* somehow *illustrates* Dante's text. Rather, the imagery deployed by Dante here and elsewhere played a prominent role in the formation of the vocabulary of visual metaphors and analogies that Leonardo emulated and indeed strove to surpass in his image of the soul of the beloved lady.

In the *Divina commedia* Beatrice's beatific smile signals her all-embracing spiritual awareness. In the *Paradiso*, Dante's guide tells him that his earth-bound sense of sight needs to be transformed so that it is strong enough 'to sustain my smile'.[25] Beatrice had been preceded as a female guide by Matilda, who conducts him tenderly from the hazards of *Purgatorio*. Dante spies her near 'the bank of the stream' in a beautiful sylvan setting:

As a woman dancing turns herself
With her feet close to the ground and to each other,
And hardly advances one toe out of line,
She turned in my direction, looking over
The red and yellow flowers, exactly as
A virgin will modestly lower her eyes;
...
As soon as she was where the grass was bathed
Already by the waves of the lovely stream,
She graciously raised her eyes to meet mine.
I do not think that so much light shone
Under the brow of Venus, when she was pierced
By her son, who did not often strike carelessly.
She smiled straight at me from the other bank...[26]

A drawing by Leonardo at Windsor Castle precisely captures the spirit of Dante's vision of feminine grace in the idyllic grove beside the river (fig. 34). In

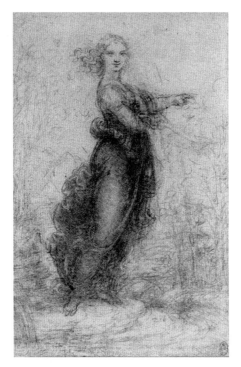

Fig. 34. *Leonardo da Vinci,* Pointing Lady in a Landscape *(Matilda?), Windsor, Royal Library, 12581.*

this case we may think that the image is more directly illustrative of Dante's vision. In any event, Leonardo is as much a Dantesque painter as Michelangelo, albeit in a rather different way, given that the sculptor's *fantasia* was fuelled by divine ideas rather than the immediate delights of nature.

The impact of Petrarch on Leonardo is harder to define, even though the painter made at least three allusions to the poet. One refers to Petrarch's popular *Triumphs*: 'Our triumphs pass, our pageantry?', which is not a direct quote but compactly summarizes two lines from the *Triumph of Time*.[27] Another quotes a Petrarch sonnet in the same set of aphorisms on a sheet in Windsor, which also contains poetic fragments written by someone else. It coruscates slothfulness, a vice that Leonardo despised:

> Greed and sleep and slothful beds
> have banished every virtue from the world,
> so that, having almost lost its way,
> our nature has been conquered by its habits.[28]

One of Leonardo's own fables told of a slothful razor, much taken with its own glistening beauty, which decided to leave the barber's arduous employ, only to find that it rusted irreversibly without use. As the title says, 'the rusty blade is compared to the human mind'.[29]

The third mocks the poet's obsession with his beloved Laura, in a manner that chimes nicely with Burchiello's irreverence: 'if Petrarch loved the laurel so much it was because it is good with sausages and thrushes; I cannot value their trifles'.[30]

In Petrarch, Leonardo would have found no shortage of ingeniously crafted variations on the eyes and smiles of the beloved lady. To cite just two:

> these are those lovely eyes that are alive
> forever in my heart with flaming sparks,
> and speaking of them never tires me.[31]
> That charming paling of the face which covered
> her smile of sweetness with the mist of love
> so nobly was presented to my heart
> that he went up to meet it on my face.[32]

The major importance of Petrarch in our present context resides in the two poems that he composed on the lost portrait of Laura by the great Sienese master Simone Martini. The portrait was *in carte*, that is to say on a page (of vellum), like the bucolic and stylish frontispiece Simone produced in 1340 for Petrarch's manuscript of Virgil.[33] He also talks of Simone taking his 'stylus'— his drawing instrument—in hand. The portrait may have been for a volume of Petrarch's poems.

Sonnet 77 envisages a portrait conceived in paradise, beyond the reach of earthly vision and mortal hand:

> No matter how hard Polyclitus [the Greek artist] looked,
> and all the others famous for that art,
> not in a thousand years would they see even
> part of the beauty that has won my heart.
> For certain my friend Simon was in Heaven,
> the place from which this gracious lady comes;
> he saw her there and copied her on a page [*in carte*]
> as proof down here of such a lovely face.
> The work is one that only up in Heaven

could be imagined, not down here with us
where body serves as veil for souls to wear...[34]

Sonnet 78 plays on the poet's remorse that even Simone's 'high concept' can-
not endow the image with speech and mind. Petrarch contrasts this with
Pygmalion's cold marble Galatea who, in Ovid's tale, was transformed by Venus
into warm nuptial flesh:

> When Simon first received that high idea
> which for my sake he took his stylus in hand,
> had he then given to his gracious work
> a voice and intellect as well as form,
> he would have freed my breast of many sighs
> that make what others cherish vile to me,
> for she appears so humble in her image
> and her expression promises me peace.
> And then when I begin to speak to her,
> most kindly she appears to hear me speak—
> if only she could answer what I say!
> Pygmalion, how happy you should be
> with your creation, since a thousand times
> you have received what I yearn for just once![35]

Not of the least significance of Petrarch's elegant poems was that they were
written at all. They provided the highest sanction for later poets to try the same
with portrayals, whether based on people they knew or purely imaginary.
Leonardo was, as we will see, a notable beneficiary of the tradition.

Courtly love: Lorenzo il Magnifico

The poetry of the courts in which Leonardo moved was saturated in the
flowing tropes of Petrarchan love. But the visual arts also played their part.
Leonardo's master Verrocchio and his colleague Botticelli were deeply involved
in visual expressions of courtly love in the Florence of Lorenzo de' Medici,
particularly in mythological and emblematic designs for the famed joust in
honour of Giuliano de' Medici in 1475, immortalized by the poetic *fantasia* of
Angelo Poliziano. The beloved lady whose favours Giuliano sought was

Simonetta Vespucci, from whose eyes issued an arrow directly into the heart of her champion, as we might expect.[36] A drawing for a tournament banner of *Venus and Cupid* by Verrocchio involved some of Leonardo's characteristic handiwork in the drawing of the vegetation (fig. 35).[37]

Lorenzo himself not only composed a good deal of fine poetry in the Petrarchan tradition, but also produced knowing and lengthy commentaries in the manner of Dante—with copious quantities of beloved eyes that bewitch fatally, reciprocated by the weeping eyes of the inflamed poet. He also has a marked taste for fine white hands of the kind that Lisa places before us. One sonnet tells of the river of tears he shed 'at the foot of a small picture in which there was a lady', testifying to the power of the painted image.[38]

There are very many eye-catching laments that could be selected, but one will suffice:

> Eyes, you are indeed within my heart,
> and you see the torment it endures
> and its total faith: how can it be then
> that my lady takes no notice of my pain?
>
> Go back to her, and let Love [Cupid] come with you,
> he too a witness of so much suffering;
> and tell her that my heart's only remaining hope
> is in your prayers, and if this be in vain, it will die.
>
> Please carry to her my wretched laments.
> But, alas, how mad is my desire,
> if my heart cannot live without her beautiful eyes!
>
> O eyes, the solace for my torments,
> oh! come back to my wretched heart!
> Let Love go on his own, and let him speak for me.[39]

The commentary, which at almost 600 words rather overwhelms the hundred or so of the sonnet, begins:

The image of her beauty had reached my heart through my eyes, and her eyes had made such a deep impression within it that they were always present to it; and Love, which, as we have said, always resided with them, had also come in the company of those eyes; and the heart was surrounded by so many flames because of this that it could no longer bear the agony born of its burning desire...[40]

Fig. 35. *Andrea Verrocchio with Leonardo da Vinci,* Venus and Cupid, *pen and ink and wash, Florence, Uffizi.*

A particularly nice, if difficult, sonnet exploits musical and pictorial allusions, with an obvious hint of Petrarch on Simone Martini's heavenly portrait of Laura:

> If with sweet harmony two instruments
> are played in the same key,
> touching one string, the other string, in tune with it,
> produces the same accents.
>
> So it seems that in my heart is reawakened
> the impressed image, deaf to our sighs,
> if it reminds me, due to its resemblance to it,
> of the face, which the human mind cannot conceive.
>
> Love, in how many ways you lure back the heart!
> For fleeing the features of her beautiful face,
> feeding my heart on a vain painting,
>
> be it that our eyes don't see anything else
> or that the painter was in Heaven,
> I truly saw her. Now try to flee from Love![41]

The most directly relevant of the Medicean poets is Giuliano de' Medici, the third son of Lorenzo il Magnifico. We have already suggested that it was

Giuliano who encouraged Leonardo to finish *Mona Lisa* in Rome. More than seventy poems by Giuliano are known.[42] One will give the flavour of the Petrachan endeavours of a poet who seems to have used his social position in the papal court to further his real sexual adventures. Again, eyes are the repeated key:

> Madonna from your radiant eyes [*luci*] there comes often,
> or rather, always, an aid to my sighs,
> that which renders them sweet and so inflates my desires
> that I am content to serve you, I confess.
> I long and yet fear to be close to you,
> for I do not know if I am happily living or expiring
> if it happens that I set my gaze on your eyes,
> so much grace and sweetness has Love placed there.
> Thus from my many hopes and sufferings
> for you all my well-being is born and depends,
> every time I gain succour from your eyes;
> And anyone who understands my sweet death for you,
> as I reject and spurn every other goodness,
> forcibly reignites an eternal love for you.[43]

Coming from Leonardo's major patron in Rome, this brings the poetic tradition almost as close to the painter as the poems written in the Sforza court, to which we now turn.

CHAPTER IX

⸺⸙⸺

Painter and Poets

Poets look at Leonardo

On moving to the grand and more formal court of Ludovico Sforza in Milan, Leonardo encountered a cadre of poets operating in the Petrarchan manner and jostling for favour, both with each other and those who were employed to produce sculpture, painting, music, and other kinds of writing. The practitioners of the rival arts could also come together in common cause. There is good evidence that there was some kind of cultural 'academy' in Milan. It occurs in the manuscript of Henrico Boscano's *Isola Beata*, which recounts an imaginary shipwreck on a 'blessed' island. In a letter in the manuscript of his story he nostalgically recalls an 'academy' that met in his Milanese palace. He gives us the names of eleven literary men, including Gasparo Visconti and Bernardo Bellincioni, before listing Leonardo, Bramante, and Caradosso (famed as a medallist) together with eight musicians—'and many other philosophers and musicians whose names I do not remember'.[1] Leonardo's elaborate knot designs (fig. 50) that announce an 'Academia Leonardi Vinci' may signal his intention to promote his own courtly 'academy'.

At least two of the leading Milanese poets enjoyed the considerable advantage that they were 'gentlemen' and were not on the court payroll as *stipendiati* or entirely reliant on patronage. Gasparo (or Gaspare) Visconti came from a branch of the ruling family superseded by the Sforza, while Niccolò da Correggio was a courtier who moved with social ease across the north Italian cites ruled by Ludovico's relatives.

Visconti, official court poet, is now the less well regarded of the two. We have seen that he featured in Leonardo's library, either in printed or manuscript form. He is known to have been a patron of Leonardo's colleague Donato Bramante, commissioning grand frescoes of 'Armed Men' for his Milanese Palace.[2] Bramante, the painter-architect, was a sonneteer in his own right. Leonardo is all-too clearly identifiable as the 'bad painter' who features in Visconti's rather ponderous attempt to be witty:

> Formerly there was a painter
> Who could draw nothing but a cypress tree,
> According to what Horace tells us
> Where he teaches us to understand poetry.
> There is one nowadays who has so fixed
> in his conception the image of himself
> that when he wishes to paint someone else
> he often paints not the subject but himself.
> And not only his face, which is beautifully fair
> according to himself, but in his supreme art
> he forms with his brush the manners and customs of men.
> It is true that he neglects important matters,
> That is to say his brain goes wandering
> Each time the moon wanes:
> Hence, when it comes to making a good poem
> And to make paintings which work well as a whole,
> he lacks the fetters, restraints and chains.[3]

This laboured mockery, which sounds amiable in tone, features in a deluxe volume of poems dedicated jointly to Beatrice d'Este, the duke's wife, and Bianca Maria Sforza, his niece. The manuscript version inscribed to Beatrice is in the Biblioteca Trivulziana, Milan, written on purple-stained vellum and bound spectacularly in copper. A copy apparently intended for Bianca Maria is now in the Österreichische Nationalbibliothek, Vienna, and was bound in black velvet with gold decorations. The first manuscript dates from 1494–5 and the second from after Beatrice's death in 1497.[4]

The slur that Leonardo 'often paints not the subject but himself' testifies to the poet's knowledge of Leonardo's thinking. Picking on the traditional tag that 'every painter paints himself', Leonardo argued that self-imitation was an artistic vice to be avoided at all costs.[5] It is highly likely that Visconti and Leonardo had crossed rhetorical swords in the actual *paragone* debate in the

court. The writer participated on his own account in the well-established genre of poems about pictures, composing one 'in the name of a gentleman to whom his beloved had sent him a little picture from far away'. It was difficult to tell whether the painting was 'celestial or just human'. He also produced a sonnet on a 'painted panel' in which Cupid is nominated as a heavenly painter. Visconti also wrote three poems on works of sculpture.[6]

Niccolò da Correggio composed five elegant and ingenious poems on works of art.[7] One, devoted to a portrait of a lady who had died, alludes to the *paragone*. Niccolò asserts that informative words endure better than paintings—directly contradicting Leonardo. The allusion at the end is to Daedalus, who aimed too high by flying close to the sun with wings glued together with wax:

> If you show men what you looked like when you were alive,
> dead like you, they will not see anything;
> but your invisible parts will remain
> after this age has been robbed of these days.
>
> I praise the painter, but I praise more the one who writes
> for posterity what his coevals know,
> your origin, your condition and that in your twenty-first year
> death quenched all the good that blossomed in you.
>
> But just as your form surpasses the brush,
> your virtues surpass the pen,
> and both the latter and the former will remain imperfect.
>
> Yet when the fencer lunges as if to attack,
> even if he does not strike, his movement is beautiful,
> for the sun burns the wings of those who fly too high.[8]

Another specifically features 'my Leonardo' in the most distinguished ancient company. Like other writers, Niccolò puns on 'Vinci' and 'conquers' (*vince*).

> If Zeuxis, Lysippus, Pyrgoteles or Apelles
> had to paint this lady on 'paper' [*in carte*],
> having to gaze at each of her features
> and at the grace with which they are then infused,
>
> like when one looks at the sun or counts the stars,
> his eyes and his art would fail him,
> because nature does not grant to the eye
> the powers in what nature herself excels.

So, my dear LEONARDO, if you want
to be true to your name, and conquer [*vince*] and surpass everyone,
cover her face and begin with her hair,

because if you happen to see all her beauties at once
you will be the portrait, not her, since
they are not for the mortal eye, do trust me.[9]

The failure of our earthbound sight to see the ultimate beauty recalls Dante
and Petrarch. There is also more than a hint in the penultimate line that 'every
painter paints himself'. That the portrait is *in carte* (which conveniently rhymes
with *arte*) indicates that it was on a page not a panel, and was almost certainly
on vellum, like the *Portrait of Bianca Sforza* (fig. 41).

The poet who appears to have worked most closely with Leonardo was his
fellow Tuscan, Bernardo Bellincioni, who openly esteemed the painter as sur-
passing all the ancients and all the moderns. They were direct collaborators on
a magnificent poetic, musical and visual spectacle, the *Paradiso*, to celebrate
the wedding in 1489 of Gian Galeazzo Sforza, the nominal Duke of Milan,
to Isabella of Aragon. Contemporaries marvelled at the vault of the heavens
conceived as a mighty 'half egg', gilded internally and sparkling with a multi-
tude of starry lights.[10] The planetary deities revolved on Leonardo's wondrous
machinery, accompanied by suave music. At a key moment, 'Apollo' descended
from the heavens to present the bride with a 'little book' of the verses in fine
calligraphy. 'Apollo' first conveys the spiritual gifts of the three Graces and the
seven Virtues into the bride's care, and then places the precious *libretto* into her
young hands.

It is Leonardo's collaborator who provides the best testimony as to how his
friend's portraits looked in the sophisticated eyes of those well versed in courtly
conceits. Bellincioni dedicated a sonnet to the portrait of *Cecilia Gallerani*
(the 'Lady with the Ermine' in Cracow, fig. 36). Cecilia, born in 1473, was
Ludovico's mistress in her teenage years, before the arrival of Beatrice d'Este,
his dynastic bride from Ferrara in 1491.

Nature, what provokes you, who makes you envious?
It is Vinci, who has painted one of your stars!
Cecilia, today so very beautiful, is the one
Beside whose beautiful eyes the sun appears as a dark shadow.
The honour is yours, even if in his picture
She seems to listen and not to tell.

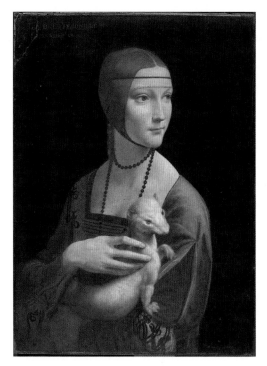

Fig. 36. *Leonardo da Vinci,* Portrait of Cecilia Gallerani, *Cracow, Czartoryski Museum.*

Think only, the more alive and beautiful she is,
The greater will be your glory every future era.
Give thanks therefore to Ludovico, or rather
To the supreme talent [*ingegno*] and hand [*manus*] of Leonardo,
Which allows you to partake in posterity.
Everyone who sees her thus, even later
Seeing her alive, will say, that 'this is enough for us
To understand what is nature and what is art'.[11]

Bellincioni's poem knowingly adopts standard tropes: starry eyes that outshine the sun; a compelling likeness that only lacks voice; art that trumps nature; and the coupling of *ingegno* (talent) and *manus* (hand), which was a recurrent theme in humanist writing about art. That they were stock motifs is part of the game. We are given to appreciate how they have been used here with a particular refreshing ingenuity. Bellincioni cleverly sets nature and poet in combative dialogue about the supreme portrait, introducing the 'creators' of the image,

Ludovico and Leonardo, at the start of the sextet. He concludes with a rousing declaration that Leonardo has demonstrated to posterity the true relationship between art and nature.

The poet has astutely picked up the implied dialogue in the painting, with the lovely Cecilia turning to look with a trace of a sweet smile at an otherwise unseen arrival to her left. The subject of her glance can only be Ludovico Sforza. Leonardo is positing a triangulation of looking between Cecilia, Ludovico, and himself (or the spectator). No portrait had attempted such an implicit narrative before.

It is no surprise that the ermine is not mentioned. Accounts of portraits in the Renaissance did not discuss symbols, emblems, or backgrounds—as we saw with the landscape in the *Mona Lisa*. This is because the sitter and the artist were the protagonists in the particular genre of poems about art, often in company with the lover of the person represented.

This is not to say that Cecilia's alert ermine is unimportant. The ermine, according to the animal lore that Leonardo enthusiastically embraced, was a symbol of moderation (only eating once a day) and of purity, since it would allow its capture by hunters rather than soil its pristine coat by traversing a muddy field. Leonardo depicted the ermine's imminent capture in a little emblematic design, drawn within a round framing line.[12] There is also a link with Ludovico. In one of Bellincioni's poems, the duke is described as 'pure ermine' in his virtues, and Ludovico was a member of the distinguished order of the ermine.[13] The ermine is more than a symbol or emblem. Its svelte and refined self-possession perfectly echoes the poise of the sitter. It is not only Cecilia who is alive in this portrait—without of course either the sitter or her pet having an audible voice. It is often said that Cecilia's animal is too big to be an ermine. If we use this line of argument, then we must also remember that most of the infant Christs in Renaissance paintings of the Madonna are too large to be of the human species. The French pioneer of multi-spectral scanning and image analysis Pascal Cotte has found evidence that the ermine was once a good deal smaller in the underpainting and was enlarged for pictorial reasons.[14]

It is likely that Cecilia's portrait was presented to her by Ludovico when their relationship was curtailed by the arrival of Beatrice d'Este as his wife. Cecilia was certainly in possession of her image in 1498 when Isabella d'Este requested to borrow it to compare with portraits by Giovanni Bellini.[15] After Beatrice's early death in 1497, another of Ludovico's mistresses became visibly

apparent, Lucrezia Crivelli. She was also portrayed by Leonardo, as is testified in three Latin epigrams, attributed to Antonio Tebaldeo. Ludovico Sforza, 'Il Moro', features as *Maurus*:

> How well learned art here responds to nature!
> Vinci could, as so often, have depicted the soul.
> But he refrained so that the painting might be a good similitude,
> Because the loving *Maurus* alone possesses her soul.
>
> She whom we see is called Lucretia, and to her the Gods
> Gave everything with generous hand.
> How rare her beauty; Leonardo painted her, *Maurus* loved her:
> The one, first among painters, the other, among princes.
>
> Surely the painter has offended Nature and the Gods above
> With his image. It galls her [i.e. Nature] that the human hand is capable of so much
> And that the beauty which shall quickly perish has been given enduring life.
> He did it at the behest of *Maurus*: for which *Maurus* protects him:
> Both gods and men fear to anger *Maurus*.[16]

The poet works neat variations on familiar themes. The third is clearly dependent on Bellincioni. Although there is no direct evidence indicating that the portrait in the Louvre called '*La Belle Ferronnière*' (fig. 37) is Lucrezia, the identification is a working probability. It is from the right period and plays the kind of visual games that were permissible with a mistress but not appropriate for one of the Sforzas, who were portrayed in decorous profile. 'Lucrezia' is not actually staring at us (or the artist), but is looking submissively and/or lovingly at someone marginally to our right—presumably the duke, who is insistently credited by the poet.

After the French invasion of Milan in 1499 and the fall of Ludovico, Leonardo's workshop dispersed. His most accomplished and individualistic accomplice, Giovanni Antonio Boltraffio, went to Bologna, where he was taken up by the merchant-adventurer and poet, Girolamo Casio. The latter appears with his father as donor in an accomplished altarpiece of the *Virgin and Child with St John the Baptist and St Sebastian* painted by Boltraffio in 1500 for the Casio Chapel in S. Maria Misericordia, Bologna (now in the Louvre).[17] Boltraffio also created inventive portraits of the poet, who responded with poetic praise.[18] Casio composed tetrastichs (stanzas of four lines) dedicated to Leonardo and his 'disciple', Boltraffio. Leonardo is victorious over death and nature, while the late Boltraffio (d.1516) is eulogized for making every man more beautiful than nature.[19] More substantial is Casio's sophisticated

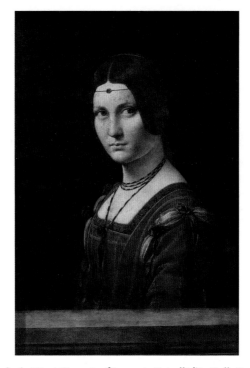

Fig. 37. *Leonardo da Vinci,* Portrait of Lucrezia Crivelli ('La Belle Ferronière'), *Paris, Louvre.*

and difficult poem on Leonardo's composition of the *Virgin, Child, St Anne and a Lamb*:

On the St Anne Leonardo Vinci is painting, who holds in her arms Mary the Virgin, who does not want her Son to mount the lamb.

> *Ecce Agnus Dei* [behold the lamb of God], said John,
> Who entered and departed the womb of Mary
> Only to guide with his holy life
> Our feet to the celestial sacrifice.
> Of the immaculate Lamb he would seize and cries
> To make himself a sacrifice for the world.
> His mother restrains him for she does not wish
> To see her son's destruction and her own.
> St Anne, as one who knew
> That Jesus was clad in our human veil
> To cancel the sin of Adam and Eve,

Instructs her daughter with pious zeal,
Drawing her back from light thought,
That his immolation is ordained by Heaven.[20]

Casio's is a rare poem on a devotional image rather than a portrait, and he is fully alert to the innovatory narrative that Leonardo has infused into the conventional subject. Fra Pietro Novellara had also been struck by the story-telling quality in Leonardo's St Anne compositions when he reported to Isabella d'Este about the cartoon or painting that Leonardo was producing in 1501. Since Casio is talking about a painting, it is likely that his poem refers to Leonardo's work in Milan after 1507.

The last of our poets who directly addresses Leonardo, Enea Hiripino (or Irpino) from Parma, was not a member of the Milanese court, and spent much of his career in Naples. He may have met Leonardo in Rome after 1513, and it is just possible that he saw the *Mona Lisa*. He credits Leonardo with one or more portrayals of beloved women in a manuscript of poems, seemingly dedicated to Costanza d'Avalos, Duchess of Francavilla, or perhaps in the cases of some poems to an unspecified 'Isabella'.[21]

Here we include one sonnet and one madrigal to give a flavour of the poems about the portrait(s):

Is this that human and true form
that is venerated amongst mortal men in our times?
Is this that broad forehead that resembles
the source of a bright, glowing light?

This is the living Lady, an example and a model
for those who want to paint heavenly features;
this is her beautiful mouth, where Love
forms such sweet and gracious words.

These are her eyes glittering with lofty zeal;
this is her beautiful neck and her bosom, where Heaven
depicted its own immeasurable beauty.

That excellent and famous painter, who painted
so much beauty beneath the modest veil
surpassed the limitations of art and vanquished [*vinse*] himself.

In vain does my famous and noble Vincio paint,
endeavouring today to depict the lady on 'paper' [*in charte*],

because art alone is not enough
to depict her divine eternal beauties.
Human talent [*ingegno*] cannot reach so high
with its sight, nor does it perceive well enough
such supreme beauties
to be able to depict them clearly at least in part.
In order to paint her beneath the beautiful black veil
we need the one who first created her in Heaven.[22]

It seems clear that Irpino is also envisaging a portrait on vellum (*in charte*) like Petrarch's Laura, the portrait eulogized by Niccolò da Correggio, and Leonardo's own portrait of Bianca Sforza. Again the poet neatly exploits the trope of the limitations of art and mortal sight to capture the lady's divine beauty. In the first, Leonardo triumphs; in the second, the limitations prevail. Both poems describe a veil—'modest' and 'black'—which sounds real rather than metaphorical, and which suggests that the portrait was of a widow.

There are a number of candidates for Irpino's elusive 'Isabella'. One is Isabel de Requesens, the wife of Ramón de Cardona, viceroy of Naples from 1509 to 1522, who was to be depicted by Raphael and Giulio Romano in 1518 specifically as a supreme image of a beautiful woman.[23] We should also consider the possibility of Gian Galeazzo Sforza's wife, Isabella of Aragon. Perhaps the best candidate is Isabella Gualanda, the Neapolitan daughter of a Pisan courtier born around 1491 and widowed in 1514.[24] As a celebrated beauty, she provided Antonio de' Beatis with a reference point when the Cardinal of Aragon was comparing admired women, as we have seen.[25] Leonardo could only have portrayed her if she had moved to Rome in her early twenties as a widow, which would explain the black veil. Whoever was the subject, the likelihood is that Irpino was imaginatively *inventing* a portrait or portraits by Leonardo of a Neapolitan beauty within what was by then a well-established genre of poems on portraits.

Painted poetry

Given the extraordinary poetic prevalence of beloved ladies with devastating eyes and sweet smiles for two centuries after Dante, we might expect to find that Renaissance portraits of women reflect the dominant tropes. This is true to only a limited degree. What was permissible in the idealized genre of love poetry, which existed in a conceptual arena of its own, was not acceptable in the concrete portrayal of actual women in the material media of painting and

sculpture. Until the later fifteenth century, we find little or no eye contact in portrait paintings, no reaction by the sitter to an observer, no smile. For a woman to indulge openly in extensive and sustained eye contact when meeting a man other than close family could be seen as tantamount to some kind of invitation. The decorous young lady would be expected to keep her eyes lowered rather than commune via glances with a potentially importunate man. This decorum is respected in most fifteenth-century painted portraiture of women in Italy.[26] Even with portrait busts, direct eye contact is generally rendered elusive, and the beautiful marble portraits by the Dalmatian-born sculptor Francesco Laurana feature downcast eyes that resist our enquiring gaze.[27]

The norm when Leonardo was learning his trade was the profile portrait. Domenico Veneziano, the Pollaiuolo brothers, and Domenico Ghirlandaio created profiles of the highest pictorial refinement.[28] The virtuoso *Portrait of a Young Woman* in the Museo Poldi Pezzoli in Milan, generally attributed to Piero Pollaiuolo rather than Antonio, is an exquisite example of the genre in which the brothers specialized (fig. 38).[29]

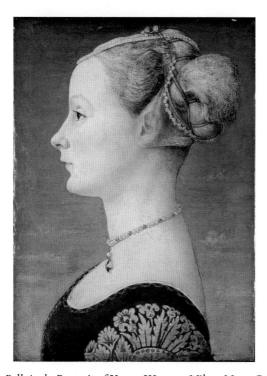

Fig. 38. *Piero Pollaiuolo,* Portrait of Young Woman, *Milan, Museo Poldi Pezzoli.*

The avoidance of any direct communication with the viewer is consistent with the remoteness of the ladies worshipped by poets—ever out of reach. However, the issue of decorum is the determining factor in the predominance of the profile in women's portraits. The format and gaze of male portraits tended to loosen up before those of women. Antonello da Messina is a pioneer in this respect. His male sitters look directly at the spectator, sometimes reacting with imperious smiles. Antonello's portraiture was known in Sforza Milan.[30]

An exception amongst women's portraits is Botticelli's image of a young woman in the Victoria and Albert Museum, London (fig. 39).[31] The context is domestic and intimate. She is glimpsed on a balcony through what is unlikely to be an exterior window, wearing a translucent *camisa* or summer over-gown. She may well be pregnant. This is anything but a public portrait, and must have been conceived for an intimate domestic setting.

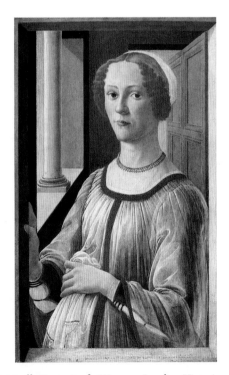

Fig. 39. *Sandro Botticelli,* Portrait of a Woman, *London, Victoria and Albert Museum.*

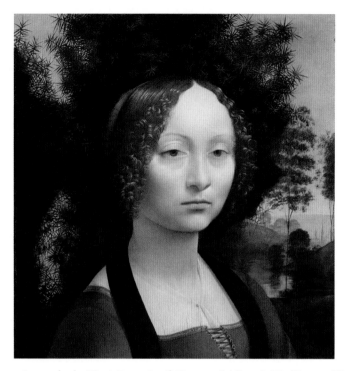

Fig. 40. *Leonardo da Vinci,* Portrait of Ginevra de' Benci, *Washington, National Gallery of Art.*

It is likely that Leonardo's portrait of Ginevra de' Benci, painted around 1478, follows Botticelli's precedent. It certainly surpasses it in its strange naturalism (fig. 40). It was commissioned as a celebration of the courtly love directed towards her by Bernardo Bembo, the Venetian 'ambassador' in Florence and father of the poet Pietro.[32] It seems likely that Bembo was responsible for the making of the portrait, just as he was for the commissioning of a suite of Petrarchan poems in her honour, including elaborate verses by Cristoforo Landino, the Medicean man of letters and commentator on Dante. Laden with classical erudition and ancient name-dropping, Landino's poems pointedly emphasize Ginevra's chastity in order that Bembo's honourable intentions should not be misread. Excerpts from one of his poems will give a flavour of the highly wrought flattery it featured:

Come now, Erato [the muse], let us speak of Bembo's love, but only love of which heavenly Venus herself would approve. Here there is nothing unclean or foul with base lust; a chaste love always demands chaste faith....

Marvel with astonished eyes at ancient statues, whether they are images of men or gods, or if some picture shines with the glory of Parrhasius or any colour is derived from the art of Apelles. But once you saw images of the Venus of Cnidus revealed by the skilled hand of Praxiteles, and so far you have not seen any Italian, French or other lady who is like them. But as soon as Bencia recently appeared before your eyes with a band around her golden hair, then how all other forms of beauty, being common in comparison, fled from your heart!…

If you look at Ginevra's neck, you will rightly be able to scorn white snow. In the spring red flowers glow like fire, but they are nothing compared to the beautiful lips of your lady. Why should we mention her snow-white brow, her teeth like ivory, and her dark eyes set in rosy cheeks?…[33]

The poems do not mention the portrait and presumably precede it. We feel that the painter is openly rivalling the poet. The assertive directness of Ginevra, her 'snow-white brow' and 'golden hair' set off by the spiky juniper (*ginepro*) that was emblematic of her name, is highly original, as is the watery landscape of veiled distances. The eye contact in the portrait would have been challenging even in the private setting in which it would have been placed. It was as intimate in its own way as any codex that contained the poems. The public ogling of such portraits in our art galleries is far removed from their original contexts of viewing.

When Leonardo moved to Milan and entered the court of Ludovico il Moro in the early 1480s, he encountered a situation in which the standard mode of court portraiture was highly controlled. The authorized portraits of rulers of North Italian courts were in profile. Leonardo does not seem to have been involved with official paintings of Ludovico, his wife Beatrice d'Este, or his niece Bianca Maria, who married the Emperor Maximilian, and other members of the family. The only time he entered this realm of official portraiture in Milan was in his portrayal of Bianca, Ludovico's illegitimate but legitimized daughter, for a deluxe version of the *Sforziada* produced specifically for her marriage to Galeazzo Sanseverino in 1496 (fig. 41).[34] The portrait, in inks and chalk on vellum, and excised from the copy of the book now in the National Library in Warsaw, contains clear echoes of the kind of portraits that Leonardo knew in Florence. It shows that even in the intimate setting of a book printed on vellum, the profile format was still deemed appropriate for Ludovico's close family. When in 1500 Leonardo was asked to portray Isabella d'Este in Mantua, Ludovico's sister-in-law, the profile mode still prevailed for sitters of high status.[35]

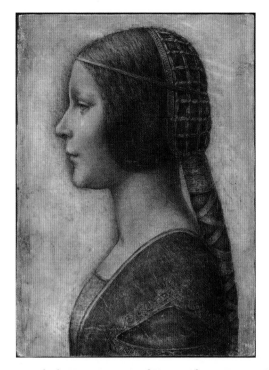

Fig. 41. *Leonardo da Vinci,* Portrait of Bianca Sforza, *Private Collection.*

Mona Lisa was also a private work, destined for one of Francesco's proper-ties. It is nice to think that it was for his out-of-town villa at Montughi, high above Florence, where the views from balconies were and are splendid. This is not of course to say that Lisa's mountainous vista corresponds to Montughi's actual view across the Arno valley.

Lisa's direct if elusive eye contact takes the work beyond the portraits of Ludovico's mistresses, and its smile beyond the *Ginevra de' Benci*. It is a truly daring conception, even if the smile is read as an emblematic pun on her mar-ried status as the 'jocund lady'—*la gioconda*. Had the portrait ever been deliv-ered, we may imagine that visitors who were intimate enough with the couple to see the work in one of the more private spaces in their house or villa would have understood that the smile was for Francesco and not specifically for them. Even so, they might justifiably have been disconcerted by its intensity of com-munication—albeit an enigmatic intensity. It is significant that Maddalena Doni in Raphael's portrait in the Uffizi (fig. 42), which openly emulates the

format of Leonardo's portrait, does not allow herself even a hint of a smile, or any other definite expression for that matter.

We have seen that the portraits of Cecilia and Lucrezia were set in a reciprocal dialogue with poetry, working visual variations on verbal formulas, and in turn being subject to verbal inventions by the poets. *Mona Lisa* takes the dialogue into unforeseen realms. It does so by establishing a new kind of intense and suggestive relationship with the viewer that allows unprecedented scope for our imagination. In the poems we read of eyes that ravish the sight of the lover yet remain beyond earthly reach. Looking at Beatrice, Dante discerns that 'Love' is 'pictured in her face, there where no man may fixedly gaze'. The key moment for so many of the poet/lovers is when the beloved turns the gaze of 'her holy eyes' on him. The ladies' smiles signal spiritual insights beyond the poets' pedestrian scope. Beatrice needs to fortify Dante's sight so that he can bear her smile. The smile is elusive and indefinite as 'in a loving mist'. The lady exists in a realm that is 'more heavenly than earthly'. There are many such phrases that resonate with the *Mona Lisa*. This is not a simple matter of Leonardo aping poetic devices, but of his deep awareness of modes of looking and thinking in Renaissance love poetry that allows him some-how to devise visual strategies that achieve analogous effects. Supreme amongst these strategies is an indefiniteness that at once withdraws the lady's elusive feel-ings from us and invites us at the same time to project feelings into her heart.

Where Leonardo could justifiably claim in the manner of his *paragone* to exploit something that went beyond the poet's words is in the material fact of the lady's corporeal existence before our eyes. The poetic ladies existed in a realm of divine emotional idealization, as creatures of our conceptual imagin-ation. Leonardo's lady is not less poetic but has a concrete presence. However much we feel that Leonardo's picture is idealized, and however much he exploits blurred indefiniteness, she sits in front of us as someone we cannot but relate to as an individual, however strange an individual we may feel her to be. She is at once a real person and a poetic enigma.

But how real is she? When we look at the scientific examination in the final chapter, it will become evident that Leonardo's painting underwent a sustained development with many underlying changes. For the moment we may note that the composition appears to have begun as a commissioned portrait of a bourgeois Florentine woman, in line of descent from his *Ginevra de' Benci*. As we will see, the costume in the under-drawing appears to be standard for the period in Florence, and is closely paralleled in Raphael's portrait of *Maddalena Doni* (fig. 42). It is evident that Raphael knew the painting before it was fin-ished, or at least the cartoon. We have seen that Raphael lived for a time

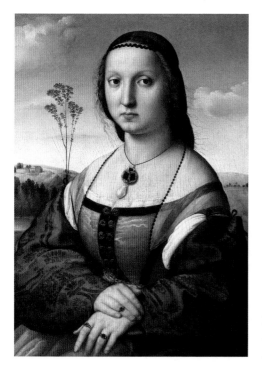

Fig. 42. *Raphael,* Portrait of Maddalena Doni, *Florence, Palazzo Pitti, c.1506.*

immediately opposite Lisa's house. Raphael's portrait of a *Lady with a Unicorn* in the Borghese Gallery in Rome provides further evidence that the disposition of the figure was established before 1507, when Raphael left Florence. There is also a rather uncertain drawing in which Raphael works his own sketchy variation on Leonardo's composition (fig. 43). These three homages by Raphael undermine any attempt to argue that the picture of Lisa begun by 1503 is not the one we now know.

If Lisa's costume began as something credible and recognizable for Florence at this time, it seems to have developed a life of its own that took it away from the norm.[36] It became an improvization on veils, layers, folds, spirals, opacity, translucency, textures, and restrained colour in which recognizable elements are combined in a way that probably never adorned a real woman. As Renaissance costume expert Elisabetta Gnignera stresses, the way she is dressed has undergone a radical process of abstraction.

The basis of Lisa's original and developed costume is a standard dress, *camora* (*gamurra* in Tuscan) with detachable sleeves in a silken fabric of tawny gold (what Leonardo called *lionato*). The sleeves are attached by ribbons (*nastri*), leaving room for a pretty white puff of the fine undergarment to extrude, as

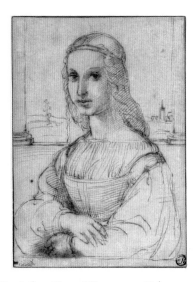

Fig. 43. *Raphael,* Study for a Young Woman on a Balcony, *c.1504, Paris, Louvre.*

can be seen in the Raphael. The scalloped edge of this undergarment once ran along the top of the neckline of the dress but has been the victim of a cleaner's zeal. Overlying the cloth of the dress is the very fine, darkish, silk-muslin layer of a *camisa*, gathered into little rivulets at the neckline by a running knot design in gold thread. Her husband was a silk merchant, and such refined silk-muslin would have been in the top range of her husband's merchandise. So far, reasonably orthodox.

However, there are a number of features that remove the costume from what we might have expected Lisa to wear. The protruding white puff (*finistrella*) that emerges above the detachable sleeves is all but concealed by an overlapping veil. This does not occur in other Florentine portraits. It seems (although it is not certain) that it is the upper part of this veil that twists across her shoulder and breast. Or maybe the twisted cloth is a separate stole, under which the veil of the sitter's head passes to cover the *finistrella*. The veil that hangs beside her cheeks and her tumbling hair are looser and less formal than in other Florentine and court portraits of the period. There seems to be a double sleeve, a darker one that is tucked up at elbow level, below which is the silky sleeve over her forearm. Or maybe the darker fabric that passes down to her elbows is the veil that falls from her head. It is also noticeable that the lower sleeve, which must be the one tied by the ribbons, is much less voluminous than is customary. The fact that there are so many ambiguities in the structure of the

costume is significant. Leonardo had shown himself to be very alert to the construction of dress and accoutrements. He is here endowing the sitter with a costume that draws away from the real in the direction of a *fantasia*. The optical play on veils clearly appealed to Leonardo, giving him the opportunity to display his virtuosity with translucent glazes of pigment, but it also resonates with the poetic veils of the sonneteers, above all with Dante's vision in the *Vita Nuova*. A veil teases our sight with something that is not quite fully apparent, and can serve as an allusion to modesty—delicately withdrawing things from intrusive vision. Even those things in the picture that are not under actual veils are visually and poetically veiled to varying degrees.[37]

The development of the 'portrait' from a representation of a specific person into an image that miraculously hovers between the optically real and an abstracted poetic vision is consistent with the hypothesis that Leonardo was encouraged by Giuliano de' Medici in Rome to complete his unfinished portrait. In any event, Leonardo transformed the portrait into a 'picture' that 'signifies great things'. What it signifies as the image of a woman in a landscape is the subject of the next chapter.

There is a somewhat bizarre footnote to the process of generalization through which the commissioned portrait became a 'universal picture'. It involves an extraordinary invention generally called the '*Nude Mona Lisa*', which is known in a cartoon in Chantilly and in various painted versions, the best of which is in the Hermitage in St Petersburg (fig. 44).[38] It does not belong to the mainstream of the story we have been following, but it does shed light on one of the directions in which the portrait was travelling. And there is clear evidence that Leonardo himself was involved with the invention.

The first thing to say is that this is not literally a nude version of the *Mona Lisa*. There are obvious similarities in the overall staging of the woman and the landscape, which no one who is aware of the two compositions would miss. However, her head is turned towards us such that the centre line of her nose lies precisely on the central vertical axis of the picture. The assertive centrality is emphasized by her eyes, which stare straight at us with no sidelong glance. The facial type is a stock Leonardo, without Lisa's long nose and high forehead. Lisa in the Louvre is somewhat smaller than her nude counterpart.[39] We are looking at a new invention on the same formal base and not simply a replication of the layout of the Louvre painting.

The first documentary reference to this painting appears in the inventory of the late Salaì in 1525, where it is listed as a '*meza nuda*'.[40] Identifiable subjects

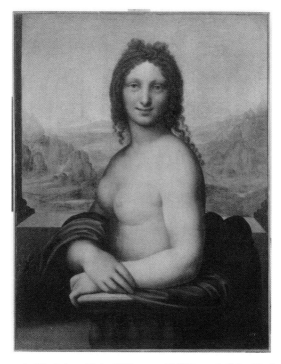

Fig. 44. *Leonardo Workshop,* Naked Woman, Half Length ('the Nude Mona Lisa'), *St Petersburg, Hermitage.*

with naked or semi-naked figures, such as the *Leda* and *St Jerome*, were listed with their specific titles. The 'half-length female nude' is precisely what the picture represents. It has no other subject. Valued at 25 *scudi*, the *'meza nuda'* is quite cheap compared to the *Mona Lisa* at 100, and is likely to be a studio work.

What prevents us from writing off the seated nude as a *risqué* variant of the *Mona Lisa* devised by a pupil or follower—only peripherally connected to Leonardo—is the cartoon in the Musée Condé in Chantilly (fig. 45).[41] Executed in black chalk with some signs of blended white heightening, its quality is very high. Although drawn for the most part by a skilled right-hander, there are some decisive interventions with left-handed hatching in the background, just to the rear of her left elbow, in her upper and forearm, at the right of her left breast and in her right cheek.

The pricking to transfer the figure to the panel has been carried out with great care and in key places it revises the design. The most conspicuous revision

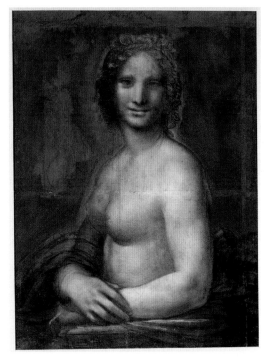

Fig. 45. *Cartoon for the 'Nude Mona Lisa', Chantilly, Musée Condé.*

is in the complex knotting of the plaited braids above the centre of her fore-head. In the cartoon the draftsman has not fully understood the structure of the knot. The pricking has been undertaken in such a way as to clarify the dou-ble intertwining of the braids. The woman's fingers have been deliberately modified during the process of pricking. To the left of her face, some curls have been created by pricking without any evident drawing. Moreover, the position of her right pupil and iris has been centralized in the outlines as pricked. It seems that the main responsibility for the production of the cartoon was dele-gated to a reliable assistant, but that Leonardo intervened to make corrections, ensuring that the outlines transferred to the panel were as he required, before one of his associates painted it.

We can therefore assign the invention of the seated nude woman to Leonardo himself. It was very daring—as daring in its own way as Manet's *Olympia*. The subject's unabashed exposure, her wispy draperies falling from her torso, is overtly challenging. Her fully frontal stare and smile are openly communicative in a way that surpasses even the *Mona Lisa*. She is not identifiable as a known

classical goddess or nymph. She is simply a *Bella Donna*, of the kind which Venetian artists were shortly to create in some numbers. Some of the later versions of Leonardo's invention solve the iconographical dilemma by converting the figure into a *Flora*, courtesy of a rich array of flowers.[42]

When did Leonardo come up with the composition? There is a clear indication that the idea was in the air before Leonardo left Rome in 1516, since Raphael's '*La Fornarina*' in the Borghese adopts and adapts the concept in a very knowing manner.[43] The main impact of the image was in France after 1513, and it may have been there that the cartoon was made into a painting. It stimulated a cluster of French images of naked women in baths within domestic settings, a fine example of which is also in the Château at Chantilly, attributed to François Clouet.[44] Traditionally, the naked or semi-naked woman in this family of French paintings has been identified as Diane de Poitiers, the mistress of Henri II.

The '*Nude Mona Lisa*' is certainly not a 'universal picture'. It occupies a special niche as a provocative image of a sexualized woman. She is a *femme fatale* in a way that draws upon and transgresses the smiling and beguiling ladies of the Petrarchan poets. Leonardo's invention here is a logical extension of just one facet of the portrait that he transformed from the particular into the universal.

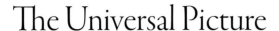

The Universal Picture

In his most assertive mode, Leonardo headed one of the notes intended for his treatise on painting, 'How a painter is not worthy of praise unless he is universal'. The note continues:

Of some it may be said that they deceive themselves when they call that painter a good master who can only do a head or a figure well…Since we know that painting embraces and contains within itself all things that are produced by nature or whatever results from man's passing actions—and ultimately anything that can be taken in by the eyes—he seems to me to be a pitiful master who can only do one thing well…He is not universal who does not love equally all the elements in painting.[1]

Later in the note he divulges that he has 'our Botticelli' in mind, who 'makes very sorry landscapes'.

Such universal painting proves a model for the all the sciences and arts, since it is the supreme means by which we may express our understanding of nature's operations. Another heading reads, 'He who despises painting loves neither philosophy or nature':

If you scorn painting which is the sole imitator of all the manifest works of nature, you will be scorning a subtle invention, which with philosophical and subtle speculation considers all manner of forms: sea, land, trees, animals, grasses, flowers, all of which are enveloped in light and shade. Truly this is science, the legitimate daughter of nature, because all visible things have been brought forth by nature and it is among these that painting is born. Therefore we may justly speak of it as the granddaughter of nature and as the kin of god.[2]

It is this universality that relegates the sculptor to the second rank in disclosing the 'marvellous works of nature and man':

The art of painting embraces and contains in itself all visible things. It is the poverty of sculpture that it cannot do this; namely, show the colours of everything and their diminution with distance. Painting shows transparent objects...The painter shows to you different distances and the variations of colour arising from the air interposed between the objects and eye; also the mists, through which images penetrate with difficulty; also the rains, behind which can be discerned the cloudy mountains and valleys...[3]

The smallish panel of the *Mona Lisa*, which Leonardo kept with him until his death, served as a supreme vehicle into which he poured his powers as a painter. It became his personal expression of what the 'science of painting' could accomplish, just as it laid down his most subtle challenge to the poet's *fantasia*. All the varieties of science involved in Leonardo's programme are powerfully visual, and it is appropriate to begin with the science that investigates how the eye itself actually works.

The window of the soul

The eye, which is said to be the window of the soul, is the primary means by which the *sensus communis* of the brain may most fully and magnificently contemplate the infinite works of nature.[4]

The *sensus communis* (or *senso comune*), from which we derive our term 'common sense', is the faculty of the brain that receives and correlates all the incoming sensory impressions. It does so according to the mediaeval doctrine of brain functions. The faculties of the brain—the receptor of impressions, the *sensus communis*, various kinds of imagination (including *fantasia*), intellect, voluntary and involuntary motion, and memory—were located in the three interior ventricles, acting as servants to the soul which resided at the centre of the cerebral system. Of the five senses, that of sight was by far the most important, direct, and certain.

Painting is the prime expression of the understanding of the natural world that we gain though our eyes:

Painting embraces all the ten functions of the eye; that is to say, darkness, light, body and colour, shape and location, distance and closeness, motion and rest. My little work will

comprise an interweaving of these functions, reminding the painter of the rules and methods by which he may imitate with his art all these things—the works by which nature adorns the world.[5]

Our acts of seeing are performed in strict accordance with the geometrical rules of optics—the mediaeval science of *perspectiva*—which decrees that everything thing is seen in due order and proportion:

Perspective is divided into three parts, of which the first is concerned solely with the outlines of the bodies; the second is diminution of colours at varying distances; the third concerns the loss of definition of bodies at varying distances.[6]

Leonardo made a number of attempts to define the various 'parts' of perspective, which resulted from three main features of the visual array: (1) the progressive and graded enfeeblement of the 'species' (the mediaeval term for optical images), which diminished in strength as they passed through space; (2) the increasingly narrow angles subtended within the eye by seen objects as they became more remote; and (3) the progressive and graded effect of the interposed air that progressively obscured the object in keeping with the colour of the air. He talked of 'aerial perspective', which resulted from the veiling qualities of air, and of the 'perspective of colour', which involved the progressive weakening of the 'species' over distance. These two perspectives were not clearly differentiated, in either seeing or presentation.

Linear perspective was not the chief optical concern of Leonardo in the *Mona Lisa*. Indeed the vanishing point of the rather casually added column bases lies above the horizon. He seems to have laid them in to 'look right' in the overall composition. He had become increasingly concerned with anomalies with the standard perspective construction. He was particularly concerned with what happened with wide viewing angles. If, for example, we look at a long wall that runs to the left and right across our line of sight, the lateral ends should look smaller than the middle since they are further from the eye. Such problems led him to distinguish between 'natural perspective', which is how the eye actually sees in practice, and 'accidental [or artificial] perspective', which is the geometrical method of linear perspective used by the painter. He continued to think that the painter's system worked effectively enough to construct illusionistic space, but preferred to use other mechanisms for the creation of recession in his later works. Scale obviously plays a key role in the *Mona Lisa*, with the figure dwarfing the mountains, but this effect does not rely upon other than the most general principle of perspectival diminution.

Although linear perspective had lost its centrality, he remained strongly committed to the rational optics of light as it strikes solid bodies. He argued that the intensity of light on a form was directly proportional to its angle of impact. The most powerful effect—a 'percussion' or blow like that of a thrown ball—would occur when a physical ray of light struck a surface perpendicularly. A 45° impact would result in a blow that was half as powerful, and the intensity of the seen light would be half that caused by the perpendicular impact—and so on, according to a proportional law. This law applied to flat planes inclined at varied angles to the source of light, but it also operated in a complex way with irregular shapes, such the human head.[7] Obviously Leonardo did not make specific calculations for each portion of Lisa's face, torso, and hands, but the blended grading of light and shade reflects his knowledge of the behaviour of light in an implicit manner. Light and shade on a curved convex or concave surface would be proportionally graded in a wholly smooth and continuous manner according to the changing angles of impact.

Additionally, every optical effect in a landscape was to be graded in accordance with its own proportional rule, diminishing in strength by half across half the distance of its total range. In the case of aerial perspective, increments of blue from the air would be progressively added. Thus the painter should make 'that which is five times more distant...five times more blue'.[8] There would also be a vertical grading, since the lower reaches of air would be more humid, closer to the moist earth, and progressively more translucent in the upper zones.

Typically, he also set out to explain why the air appeared blue. In the Codex Leicester, a manuscript that concentrates largely on water in nature, he undertook a characteristic experiment with smoke to show 'how the air has darkness behind it and therefore it appears blue':

Let smoke be made out of a small quantity of dry wood, and let the solar rays strike this smoke; and behind this smoke place a piece of black velvet, which is not exposed to the sun, and you will see that all the smoke between the eye and the darkness of the velvet shows itself to be of a very fine blue colour; and if in place of the velvet you put a white cloth the smoke will be [ashen or grey?].

Excessive smoke impedes and little amounts do not produce the perfection of this blue: therefore a middling disposition of smoke produces a fine blue.

How the water blown in the form of atoms into a dark place into which the orb of the sun passes makes the sunbeam blue, and particularly if it is distilled water; fine smoke makes blue; and this is said to show that the blue of the air is caused by the darkness which is above it.[9]

The reference to the *atomi* visible in light beams reflects some knowledge of the atomic theories of the ancient philosopher Epicurus, probably via the Roman poet Lucretius. He would also have known from the fourteenth canto of Dante's *Paradiso* of the radiant cross that became visible in the air because of dancing particles that caught the rays of light. At the start of the same canto Dante refers to the way that agitated water in a round vessel ripples 'from centre to rim and rim to centre', a phenomenon Leonardo illustrated in the Codex Leicester.[10]

Alongside the veiling effects of moist air, which rendered clear sight elusive, there were a series of variabilities in the eye itself, above all those that resulted from the actions of the pupil. These complicated the visual process in subtle ways and led him increasingly to realize that absolute certainty of seeing was impossible. Some involved light and shade. For example he observed that 'if we are inside a room with an adequate window it will seem bright, but if we stand outside looking in, it will look dark inside'.[11] He also noted that dark objects tended to look more distant than light ones. Black surfaces look blacker when they abut white surfaces or backgrounds, particularly at their borders. 'Lustre' (shine) disrupts surface colour and appears to move position on a reflective object as the eye moves. What he called 'contrasting colours' (more or less equivalent to what we call 'complementaries') enhance each other when juxtaposed, like yellow beside blue and red next to green. The different colours work best at different light levels: 'Black possesses beauty in shadow, and white in light, and blue and green and tawny in middle shadow, and yellow and red in light, and gold in reflected light, and [red] lake in shadow'.[12] His tawny is the *lionato* that he once listed as one of his eight 'simple colours'.[13] It is the colour of Lisa's shiny sleeve, which is in the light but only moderately illuminated, given the implicit shade of the balcony within which she sits.

Leonardo was the inventor of what came to be called 'tonal painting', that is to say an optical system founded on the scale of light and shade between white and black. All colours were subject to the tonal foundations of painting. Each colour would show itself individually in its true tone in direct light. Thus light-toned yellow would be brighter than blue if subjected to the same level of illumination. Red and green might be very close on the tonal scale, but would stand out from each other because of their contrasting hues. As the colours dive into the shade, they progressively lose their inherent hue and tone: 'Do not make it the practice that in your final shadows you are able to discern the colours which border on another, because nature does not let this happen.'[14]

This effect is precisely observed in the *Mona Lisa*, endowing the form of the sitter with a unified sense of mass. The foundations for tonal unity were laid down at a very early stage in the making of a picture. In his under-drawings on primed panels Leonardo laid down blocks of shadow that would persist in determining the tone of the paint laid over them, even when a fine priming of white was painted thinly over the under-drawing.

The main colouristic opposition deployed in the *Mona Lisa* is that of the cool blues of the background and the warmth of her flesh tones, but the contrast is quite restrained. Even allowing for the darkening of the varnishes and the shadows, and the loss of colour in the greens, we can see that he has generally avoided hues that are stridently contrasting in hue and tone. Leonardo's colouristic moderation and tonal unity is the reason why black-and-white or monochrome reproductions like Calamatta's engraving and Le Gray's photograph work so well.

What the painter has not done is to follow the optical implications of viewing Lisa from inside a shady space against a sunlit background, the glare of which would suppress much of what we can now see of her person.[15] He is, after all, principally painting a portrait of a lady, with the landscape as *background*, not slavishly obeying optical rules in every respect.

Leonardo's optical moderation is fully in keeping with the ideas of the eleventh-century Islamic philosopher, Ibn-al' Haytham (Alhazen), who argued that we see best within a 'range of moderateness', in which nothing is too bright, too dark, too large, or too fast.[16] When Leonardo undertook his most sustained exploration of the working of the eye in MS D around 1508 he had gained a working knowledge of Alhazen's remarkable book of optics (*De Aspectibus* or *Perspectiva* in Latin), in which the mathematics and vagaries of seeing are intensively explored, geometrically and experimentally. Leonardo increasingly realized that the simple model of the eye he had adopted around 1490, in which a pyramid or cone of light rays was received in the eye as a neat linear array, was unworkable. From Alhazen and from the English Franciscans, Roger Bacon and John Peckham, he adopted and adapted a complex system of internal refractions that resulted in the reception of an upright image at the rear of the eye in the region of the optic nerve. First, the incoming cluster of rays passed through the aperture of the pupil, where it was inverted in the manner of a camera obscura (fig. 46). The inverted array was then righted by successive refractions at the front and back of the spherical 'crystalline humour' so that the *virtu visiva* (visual power) could pick up the rectified image and pass it

Fig. 46. Optics of the eye, with a proposed experiment, *Paris, Institut de France, MS D 3v.*

via the optic nerve to the receptor of impressions and the 'common sense' at the centre of the brain. Leonardo worked a number of diagrammatic variations on this scheme, and remarkably planned to make an experimental glass model, full of water, to see if the set-up delivered what the theory said it should.

The consequence of the complex device of the eye was that rays from a wide range of angles would pass through the pupil and enter the refractory system, eventually impinging on the receptive area at the rear of the eye. Leonardo adduced various pieces of empirical evidence to show that this was the case. For example, he noted that 'the thing in front of the eye which is smaller than the pupil will not interrupt in the eye any other distant object and although it is dense it has the effect of a transparent thing'.[17] Since there was no sense that the crystalline humour acted like a lens to focus images—that notion was not formulated clearly until the early seventeenth century—the problem was how to obtain a clear image of anything from the profusion of rays that seeped through to the *virtu visiva*. The answer was that those rays passing most directly though the device, above all the perpendicular ray along the central axis, would register most strongly, followed by those that are refracted to only small degrees. We have seen Dante citing this idea. The rays impinging at wide angles would have the least effect. An edge would best be registered by the axial ray, but it would be surrounded by a blurred diaspora of progressively weaker images. As he wrote, 'the eye does not know the edge of any body'.[18] We might wonder whether Leonardo's ageing sight played some role in this. In any event, the internal optics of the eye were serving to undermine the geometrical clarity of light rays in the external world. This new uncertainty is manifested insistently by the non-linear contours of everything in the *Mona Lisa*.

Lisa is veiled by the optics of uncertainty. Everything is elusive. Enhancing the ambiguous optical effects, Leonardo has transformed the standard Florentine fashion of the time with veiled overlays. One of the loveliest passages is where the veil at the top of her forehead passes over the sky. The needle-fine dark border tracks the course of the diaphanous material. Against her skin transparency prevails, as the light is reflected strongly. When the veil floats over the sky, its inherent smoky darkness becomes apparent. On the right, where it falls over her hair and dark drapery, its transparency is barely evident and it picks up unassertive highlights of its own. But where it passes over the white puff of the extruded undergarment, its thin transparency again becomes manifest. The rivulets of silk-muslin at the neckline of her dress play comparable games with the impinging light and the background cloth over which they

flow. In thicker areas of hair where the skin is not visible, the colour is predominantly dark, whereas the strands become lighter and more open in tone as they cascade lightly over her skin. All such effects are thought through with a meticulousness that is awesome.

The 'windows of our soul' were designed to admit such optical marvels. The windows, as we have seen, were also wide open to fervent love and poetic anguish. The *intelletto* of Dante's scientific knowledge and the *fantasia* of his poetic vision here find perfect expression in paint in a way that no poet could have anticipated.

Body of the woman

Leonardo has painted a portrait with a landscape background. He had already done so in his *Gineva de' Benci*, probably inspired by Netherlandish precedents. But to call the landscape a 'background' is to miss what Leonardo was doing. He saw a profound commonality of natural form and function in the human body and what he called the 'body of the earth'. The human body was a 'lesser world', mirroring in all its aspects the functioning of the greater world and all its constituent elements. Leonardo was here consciously adopting the ancient notion of the microcosm and macrocosm, on which he composed two extended statements. The first dates from around 1490 and is in MS A.[19] The second, in the Codex Leicester, dates from around 1508. The first is more frequently quoted; it is the latter that was composed when the portrait was still being painted:

Nothing can be generated in a place where there is neither sensitive, vegetative nor rational life. Feathers are generated on birds and change every year; hair is generated on animals and changes every year, except some parts, like the hair of the whiskers of lions and cats and similar; grasses are generated on the meadows and leaves upon the trees and are renewed in great part every year. So that we might say that the earth has a vegetative soul and that its flesh is the soil, its bones are the arrangements of the connections of the rocks of which the mountains are composed, its cartilage is the tufa [a porous limestone], its blood is the veins of waters; the lake of the blood, which is throughout the heart is the oceanic sea; its breathing and the increase and decrease of the blood through the pulses in the earth is thus: it is the flow and ebb of the sea; and the heat of the soul of the world is the fire which is infused throughout the earth; the seat of the vegetative soul are the fires, which breathe in various parts of earth through baths and mines of sulphur, and in Vulcano and Mount Aetna in Sicily and in many other places.[20]

This later reformulation was overtly concerned with life in its cyclic renewals.

Leonardo now stressed the violent internal fires, which he came to see as active agents in huge transformations in the body of the earth, which could no longer be regarded as 'perpetually stable'. This change in his thinking is deeply embodied in the landscape behind Lisa, which he places in dialogue with the 'lesser world' of her body. The key events in arriving at this dialogue are his most crucial dissection and his involvement with the schemes of canalization in the Arno valley. Since anatomy is the older of his concerns, let us begin with the dissection.

In the Florentine Hospital of S. Maria Nuova, then one of the finest in the world, Leonardo witnessed the death of a man who claimed to be 100 years old.[21] This was probably in the winter of 1507–8, and Leonardo gained permission to make a dissection. That he banked his money and stored his books there suggests that he had a special relationship with the hospital. In his own words:

This old man, a few hours before his death, told me that he had lived one hundred years and that he was conscious of no bodily failure other than feebleness. And thus sitting on a bed in the hospital of S. Maria Nuova, without any movement or sign of distress, he passed from this life. And I made an anatomy to see the cause of a death so sweet.[22]

Leonardo concentrated his efforts on the irrigation systems of the centenarian's body, which he decided had effectively dried up though deprivation of the moist humours of the body, above all the blood. He noted that:

the old dread the cold more than the young, and those who are very old have skin the colour of wood or dried chestnut, because the skin is almost completely deprived of sustenance. And the network of vessels behaves in man as in oranges, in which the peel becomes tougher and the pulp diminishes the older they become.[23]

Delving deeper it became apparent that:

the liver loses the humour of the blood...and becomes desiccated like congealed bran both in colour and substance, so that when it is subjected to even the slightest friction its substance falls away in tiny flakes like sawdust and leaves behind the veins and arteries.

The shortage of blood that resulted in this deathly desiccation was a consequence of the failure of the vessels to deliver their life-giving spirits to the organs, including the heart itself. The vessels had become progressively 'parched, shrunk and withered'. Their walls had become thickened and they no longer pursued straight courses, twisting themselves 'in the manner of a snake'.

Leonardo adduced the cause of death in this instance as 'weakness through failure of blood and of the artery which feeds the heart and lower members'.[24]

This astute diagnosis was backed up by theory in a hugely innovative way. Leonardo realized, not least through his intense studies of water through pipes, channels, and rivers, that the most efficient flow in branching systems was facilitated by straight branches in which the total cross-sectional area at each stage in the system of branching is constant. Comparing the bronchii in the lungs to the branches of a tree, Leonardo declared that 'the total amount of air that enters the trachea and bronchii is equal to that in the number of stages generated from its branches, like...a plant in which the total estimated size of its branches when added together equal the size of the trunk'.[25] He was well aware that a meandering river flowed turbulently, eroding its banks on the out-side of the bends and depositing silt and other materials on the inside. The tortuous irrigation system of the old man had effectively silted up.

Leonardo gained a great deal from the dissection of the centenarian, which served as the centre-point of a series of investigations into the way that the cardio-vascular, respiratory, nervous, and urino-genital systems operated to animate the 'lesser world' in its cycles of birth, life, and death. The culminating 'demonstration' of this phase of his anatomies was a large and astonishing drawing of various systems in a female body (fig. 47). We might imagine that he had also made a similar 'demonstration' of a male body, or intended to do so.

The drawing, on a double-sized sheet at Windsor, is a heroic effort to repre-sent more than a single drawing could ever do, even utilizing the many graphic techniques at Leonardo's disposal. It is pricked for transfer, and he reminded himself to make a similar 'demonstration' from the side and back. The woman is in the prime of life. We see the organic plumbing that conveys vital forces through the woman's body and into the future body of the child that she can conceive in her womb. The trachea and bronchi bifurcate in such a way as to facilitate non-turbulent flow. The blood vessels, progressively diminishing in diameter, pursue courses that are either straight or gently curved. The round womb with its traditionally cellular chamber and lateral horns, is an ideal vesi-cle for the conception and growth of a new life. The great anatomical synthesis in this drawing combines quotients of traditional knowledge, with Leonardo's studious design of forms to fit functions, as well as data from dissections.

The notes that fringe the mighty outline deal not only with a number of anatomical structures and functions, including the action of the rectum in expelling faeces with gaseous noise, but also with issues of life and death.

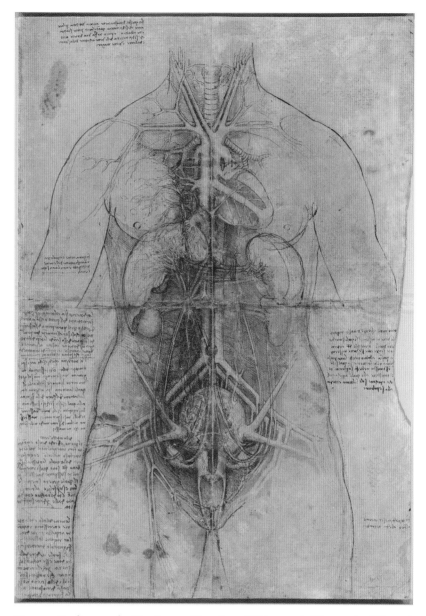

Fig. 47. Cardio-vascular, Respiratory, Hepatic, and Urino-genital Systems in a Woman's Body, *Windsor, Royal Library, 12281r.*

He reminds himself that 'your series will commence with a child in the womb, stating which part of it is formed first, and then successively putting in its parts according to the phases of pregnancy until birth and how it is nourished, learning in part from eggs laid by hens'.[26] He also weighs into the vexed debate about the respective roles of men and women in the formation of the embryo, and their responsibility for the baby's soul, and is specifically critical of the Bolognese anatomist Mundinus (Mondino de' Luzi), whose *Anatomy of the Human Body* (1316) had become the standard text-book. 'Mundinus states that the spermatic vessels or testicles [ovaries] do not excrete real semen but only a certain saliva-like humour that nature has ordained for the delectation of coition in women, in which case if it were so it would not be necessary that the origin of the spermatic vessels derive in the same way in the female as in the male.' Since Leonardo adjudges that the ovaries and testes are essentially equivalent in their form and function, they must share equally in forming the embryo from a combination of their 'semen'. Elsewhere he states that the bodies of the mother and child are governed by 'one and the same soul' during pregnancy.[27]

In a damaged passage of writing on the double sheet under the woman's left arm, Leonardo goes on to write that:

man dies and is always reborn in part by the mesenteric veins [serving the intestines], which are the root of vital nourishment. He dies by the arteries and is always generated by these mesenteric veins; one takes away and the other gives. One takes up life and the other gives out death, which is deposited and which is mixed in the venous superfluity and the intestines. This process is the ultimate one that only occurs underground, that is to say in graves.[28]

This is a difficult note. The mesenteric arties and veins feed and drain the intestines. Leonardo seems to be saying that the arteries are taking life from the intestines, while the veins deposit dead waste. The end of this process occurs when people are buried. However we interpret this enigmatic formulation, it serves to remind us that anatomy for Leonardo involved far more than a detailed description of the body's morphology or even of its functioning. It was a philosophical pursuit that illuminated the great issues of generation, birth, life, death, and the soul, set in the context of the earth as a living organism.

The monumental anatomy of the woman in the Windsor drawing stands alongside the *Mona Lisa* as an exploration of the woman's microcosmic presence in nature. One involves the internal perspective; the other the outer.

Body of the earth

When Leonardo turned his attention to systems that vivified the earth, he was well placed to recognize their bodily dimensions. In Milan he had begun to engage with rivers and canals, and with the awesomely complex behaviour of water. He had also formulated a broader vision of the earth as a kind of organism, as described in MS A. The decisive events in his studies of the earth came in 1503, the same year that Vespucci recorded the unfinished *Mona Lisa, Battle of Anghiari*, and *St Anne*. In that year, Leonardo and a Florentine official presented a plan for the diversion of the Arno around the city of Pisa in order to deprive it of the river that was vital to its livelihood. This desperate strategy was being considered because Pisa had seceded from Florentine rule during the French invasion of Tuscany in 1494. Florence had no direct access to the sea, and the port of Pisa was therefore of huge strategic and economic interest. The secretary to the Florentine government, Niccolò Machiavelli, was a keen supporter of the diversion project and work was put in hand, involving 1,000 labourers. By October 1504 it was clear that the Arno would not cooperate, and the project was abandoned as a fiasco.

Alongside this military debacle, Leonardo was more peaceably thinking about the long-standing idea of by-passing the non-navigable reaches of the Arno west of Florence. He envisaged a great canal that arched to the north and west, avoiding the mountainous terrain through which the rocky Arno coursed. The canal was to serve Prato and Pistoia, along the route of the present *autostrada* towards the sea, then turning south-west into an area of lake before rejoining the Arno at a point west of Pisa, where the river was navigable. The maps in which he explored these possibilities are more than mere charts of the surface of the land (fig. 48). They exude an extraordinary sense of the living body of the earth, traversed by its *vene d'acqua* (veins of water). The canal was a great vision, but it was not beyond reality. He had seen canals of comparable scale near Milan. He was alert to the logistics of the task and to the income that might be generated from tolls and from licences to draw water from the canal to irrigate agricultural land.[29]

His hands-on engagement with the Arno valley disclosed to Leonardo's alert and critical eye a copious amount of evidence that the landscape had undergone vast transformations over huge tracts of time. He looked at where rivers had cut through the hills and mountains, disclosing successive strata of rocks, gravels, sand, and shells. It became clear from layers of ancient shells at

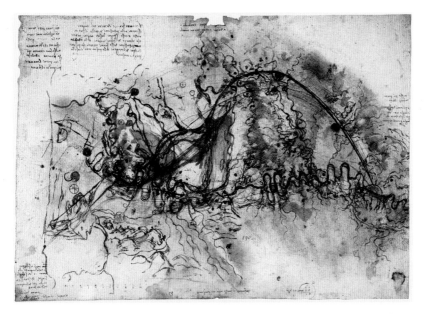

Fig. 48. Map of the Arno from Florence in the East to the Sea in the West, with the projected Canal to the North, *Windsor, Royal Library, 912279.*

diverse levels that the waters had not only risen to great heights but that they had remained there over long periods during which the marine creatures had lived and thrived in colonies. He insistently argued that the biblical deluge could not alone have been responsible for the material deposited in the strata.

He went on to declare that what we now see as fertile valleys were formerly submerged by vast lakes and seas. The tops of high mountains were once islands in a watery vastness. Segments of the earth's mighty crust had risen and sunk, totally transforming the relative centres of gravity of the sphere of water and the irregular mass of the earth that it incompletely covered. The 'veins of water' within the body of the earth played their role in these huge transformations, animatedly spouting water from high springs that eroded mountains and generated rivers.

Leonardo's magnificent vision of change embraced the whole of the known world. Valleys with major rivers had become seas. Large seas had become valleys drained by rivers. He predicted that the Straits of Gibraltar would become wider to such an extent that they would no longer hold back the waters of the Mediterranean and that 'only the lowest part of the Mediterranean will remain as the bed and course of the Nile, the greatest river which pours into that sea.'[30]

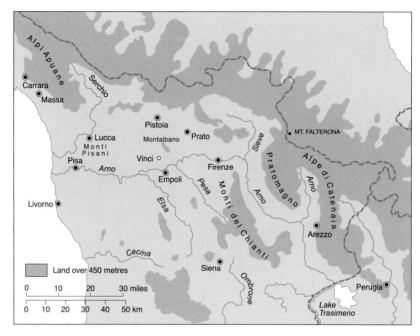

Fig. 49. *The Arno valley.*

More locally in Tuscany he observed that:

In ancient times Gonfolina was joined to Montalbano to form a very high bank. This
dammed up the Arno in such a way that, before entering the sea, which at that time
extended up to the rock, the river formed two lakes. The first was where the city of
Florence now flourishes along with Prato and Pistoia [fig. 49]. Montalbano extended
the other part of the bank as far as where Serravalle [Pistoiese] is now located. A second
lake was also formed, which emptied its waters into the first lake. It was shut in about
where Girone is now located, and occupied all the upper Arno valley for a distance of
forty miles.

The Masso della Gonfolina to the west of Florence is a huge monolithic rock,
past which the Arno now surges on its journey to the sea.

The lower of Leonardo's prehistoric lakes had occupied the ground that runs
in a north-western arc from Florence through Prato, Pistoia, and Serravalle, and
corresponds to the route for his projected canal. The second lake ran from
S. Jacopo al Girone just to the east of Florence in a south-easterly direction to
Arezzo, extending for 40 miles. The Pratomagno range of mountains now
marks the watershed between the upper and lower Arno valleys. This upper lake
was once joined to Lake Trasimeno, west of Perugia and to the south of Arezzo.

Using this sub-stratum of geological understanding, we can look at the landscape behind Lisa with Leonardo's attuned eyes. On the right a high lake is dammed up with mountains behind and a rock barrier in front. As we will see, the Prado copy (fig. 56) indicates that the upper lake reaches across to the left of the sitter, a feature that is now barely discernible in the original. Below this on the left a second lake spreads its waters behind and to the left of the sitter. At least one of the mountains behind this lake shows signs of undercutting that promises collapse in the not too distant future. A tongue of the lake on the left reaches across to the mid-ground on the right. It is from this tongue of water that a river originates, running under a three- or four-arched bridge of a common kind. By contrast, on the left below the lake is a meandering road that appears to be a dried-up river bed. It is a landscape that embodies past and future transformations. There appear to be two likely alternatives for the dry bed. It may have resulted from ancient processes when that portion of land was once emerging from the waters. Alternatively, it may have dried up as the river on the right opened up. The latter seems more likely.

This is not to suggest that the landscape is a specific reconstruction of the pre-historic Arno valley. Leonardo has created a landscape on the basis of what he understood of geological processes. His aim in the landscape, as in his portrayal of the woman, is to *remake* nature on nature's own terms. It is this remaking that effectively excludes the ingenious and often fanciful efforts to recognize the landscape as a portrait of the specific geographical location.[31] Leonardo's aim was universality not particularity.

In microcosmic terms we can see the *vene d'acqua* though which pulses the 'lake of the blood'. The flesh of the soil is quite sparse in this particular landscape, though we might imagine that fertile soil would be more evident as the land approaches the building that contains the balcony. The bones of the earth are richly manifest. One odd feature is the translucent curve on the right behind Lisa. It may be a rounded hill painted in brown pigments that have faded over time. Or perhaps it is not fully finished.

The juxtaposition of the woman's body with that of the earth raises the question about the time-scales involved. We saw that the great anatomical demonstration of the woman's irrigation systems was accompanied by notes about the cycles of life and death. The two bodies may be undergoing comparable processes and transformations, but the life cycle of one is short and transitory while the other stretches backwards and forwards over vast tracts of time. Leonardo expressed his frustration with the relentless march of time

on a human scale, not least in his meditation on the fate of the beautiful Helen of Troy:

Time consumer of all things. Envious age. You destroy all things and devour all things with the hard teeth of old age, little by little with lingering death. Helen, when looking in a mirror, seeing the shrivelled wrinkles of her face made by old age, wept and contemplated that she had twice been ravished.[32]

Helen's first abduction had been by Paris.

Leonardo's image of a women at a specific point in her life has been under-scored by the implied ravages of time, inscribed very evidently in the land-scape, and present, by implication, in her own perishable flesh and blood.

The physics of hair and cloth

Leonardo's magical landscape of fluid and structural transformations finds its echoes in the sitter and her costume. Lisa's hair obeys a watery principle of flow:

Observe the motion of the surface of water, which resembles the behaviour of hair, which has two motions, of which one depends on the weight of the strands, the other on its line of revolving. This water makes revolving eddies, one part of which depends on the principal current, and the other depends on the incident and reflected motions.[33]

In Lisa's hair the strands are less densely curled than in many of Leonardo's drawings, but the two determining forces remain the same. Her hair is less formally disciplined than in other Florentine portraits, but in the course of a diatribe against rigidly set hair-styles, he instructs the artist 'not to depict elaborate hairstyles or head gear where for the simple-minded one single hair out of place presages to the wearer high disgrace'.[34] He prefers a more natural look in which hair or some elements of it should be free to 'play in the wind around youthful faces'. Even when he did depict an elaborate coiffure in his studies for the head of *Leda* he allowed some vivacious strands to misbehave.[35]

The very fine cloth of Lisa's costume adopts analogous patterns of flow—spiral in the case of the stole over her left shoulder, and cascading in little rivulets below her neckline. These are analogous to the coursing fluids that vivify the woman's body. Leonardo could not but have projected his knowledge of the inner into the description of the outer. We can do the same if we

understand how he thought and saw. The great anatomy of the woman at Windsor lies beneath Lisa's skin.

Other aspects of the drapery speak of other kinds of physical processes. Each type of cloth obeyed its own rules: 'If you wish to make woollen cloth, use folds appropriate to that, and should it be silk or fine cloth or rude cloth or linen or voile, differentiate the folds for each type'.[36] And, 'some draperies will have soft folds and their sides will not be angular but curved—and this occurs with silks and satins and other thin cloths, like linen and voile and suchlike. Also make some draperies with a few large folds as with coarse cloth, like that seen in felt.'[37] Leonardo is keen here to invent what we might call the physics of draperies:

That part of a fold that is located farthest away from its gathered edges will most completely revert to its natural state. By nature everything has a desire to remain as it is. Drapery being of equal density and thickness both on its reverse and on its right side strives to lie flat, wherefore when it is forced to forsake this flatness by reason of some fold or pleat, observe the nature of the force on that part of it which is most bunched up, and you will find that part which is farthest away from these restraints reverts most to its natural state, that is lying spread out and flat.[38]

Leonardo scrupulously showed how the thin draperies flow in various kinds of sinuous curves, while the thicker cloths fold in a stiffer manner. The sitter's lower sleeves have a thickish, satin-like quality, and accordingly compress into pronounced ridges and valleys, as if subjected to a geological process of folding. This sensitivity to varied qualities of cloths is appropriate for the portrait of the wife of a silk merchant. For good measure, Leonardo explains that such folds will look different on an arm that is foreshortened compared to one that runs parallel to the picture plane. Where a limb 'is foreshortened ensure that a greater number of folds are seen than when it is not foreshortened, and its limbs should be surrounded with repeated folds revolving around these limbs'.[39] Thus the folds on Lisa's right arm are optically compressed into a tighter array than those on her left.

Alongside the fluid geometry of the flowing and compressed folds, Leonardo also introduced an overtly geometrical device that plays one of his favourite mathematical games (what he called *ludi geometrici*), namely the topology of knots, a set of which were designed as emblems of his 'academy' (fig. 50).

Lisa's knots are relatively simple, but ingenious nonetheless. Perhaps there is an echo of Islamic motifs he would have seen in Venice in 1500.

The upper border of her dress is composed from a band of interlocked octagons. Leonardo rounds the angles of the octagons somewhat, because they

Fig. 50. *Knot design for the ACADEMIA LEONARDI VIN[CI], woodcut, Washington, National Gallery.*

would have been made of golden thread not drawn lines. Eight-sided figures provide the underlying pattern for the motif of running knots suspended from the band and lying freely over the delicate creases of the fine cloth in the upper layer of the dress. The diagram illustrated here (fig. 51) presents what seems to have been the underlying template for the design—with built-in variants. A single thread runs through each of the cruciform motifs and the paired intervening loops, passing over and under in strict succession. The geometry is not precise, as Leonardo has deliberately characterized the knots in terms of *needlework* and the irregularity of a worn garment rather than a precise linear construction. Accordingly, he painted the threads free-hand. The sides of the octagon-like figures implicit in the hanging design are not regular—some sides are discernibly longer than others and do not precisely align. Some of the hanging cruciform motifs are more regular than others. The threads only roughly follow the angles that underlie the construction: 45°, 90°, and 135°. We may doubt whether real threads would bend so angularly at the vertices,

Fig. 51. *The pattern of the hanging knots below the neckline of the dress (drawn by Matt Landrus).*

unless they were quite stiff and wiry. Again, we suspect Leonardo is presenting a dialogue between an actual and conceptual costume in such a way that the painted motif is not that of an actual dress but only *appears* to be.

Demonstrating what painting could do

Aligning Leonardo's studies—mathematics, optics, anatomy, geology, statics, dynamics, and the broader philosophy of nature and life—with the visual qualities of the *Mona Lisa*, as we have been doing, it is difficult to know where to stop. This is a symptom of Leonardo's patterns of thought. Everything was related, if not superficially then fundamentally to the underlying rationale of the basic laws that governed the functions and forms of nature. There were clearly limits to what Leonardo could demonstrate in a portrait, even one that evolved into a universal picture. There could be none of the overt motions of a battle, and none of the range of portentous emotions in a biblical narrative. Yet all is implicit motion, apart from the chair and balcony that frame her living presence. And no one has ever doubted that the portrait works emotionally on our imagination, even if we are unsure of quite what that emotion is. Well might the aged Leonardo have proudly shown his image of a 'certain Florentine lady' to the king's distinguished visitors to show what he could do and what painting could do. He knew that no one had ever done anything like it before. We now know that no one has ever done anything quite like it since.

CHAPTER XI

---⊗∞⊗---

Close Observation
Science Intervenes

*M*ona Lisa, as the world's most famous painting, has featured prominently in the increasing battery of scientific examinations that have become available in the last one hundred years. The first effective technique for looking under the surface of paintings was X-radiography. There are recorded X-ray examinations of Leonardo's masterpiece in 1927, 1929, 1933, and 2004.[1] The results, as we will see, were ambiguous and limited, as is typical with X-rays of Leonardo's paintings, and tend to be over-read. Three more recent techniques, infrared examination, X-ray emission, and multispectral scanning, have yielded remarkable bodies of evidence about what lies below the visible surface of the *Mona Lisa*. Indeed the data has become so prodigiously complex that there is a real problem in knowing what we are looking at.

Inspection and restoration

Before looking at the often puzzling images, it is worth establishing some of the 'archaeological' basics of the panel and its layers of paint. It is painted on a single poplar panel (as was common in Florence). Its height varies from 79.1 to 79.4 cm (a little over 31 inches), and its width from 53.3 to 53.4 cm (around 21 inches). Many who are acquainted with the sitter's monumental presence in reproductions are surprised at how small it looks—not least in its grand

air-conditioned and bullet-proof prison in the Louvre. In fact, it is quite large for a domestic portrait in the Renaissance. Like many portraits, Lisa's head is close to life-size. The depth or thickness of the panel or varies from 12.4 to 13.8 mm. (averaging about ½ inch), which is unusually thin. It has almost certainly been thinned down, and the edges have been shaved a little. The paint surface and priming do not reach to the very edges of the panel but stop at a small ridge about 6 mm inside the borders. This indicates that the original panel was prepared with an attached moulding that would have been gilded. It also tells us that the panel has not been significantly cut down. We do not know when the original moulding was stripped off. In 1906 the panel was placed in its present frame, which dates from the Renaissance. During a campaign to protect the Louvre's masterpieces with glass, the *Mona Lisa* took its turn to be glazed in 1910. Paradoxically, it was this move to protect the painting that presented Vincenzo Peruggia, who had been employed by the Parisian firm of glaziers, with the opportunity to steal the picture in 1911.

For a panel of its age it is in fair condition. It has warped slightly and unevenly, fighting against its attached frame and later with the relatively rigid bars once attached horizontally to the rear of the panel. The bracing created varied tensions in the panel and in the paint layers. The most obvious symptom of the ageing of the poplar panel is a vertical crack running left of centre from the upper margin and into the sitter's hairline, which has been restored. Looking at the back of the panel (fig. 52) we can see some old repairs. At one stage two butterfly joints were inset to bridge the crack and prevent it from opening further. The upper of the joints was at some time replaced by strong canvas, and canvas strips were pasted down the line of the crack. The crack is presently stable.

The other noticeable result of the flexions in the panel is the network of cracks that have become such a familiar feature of the famous picture. The crack patterns vary considerably across the surface. There are the expected vertical cracks along the grain in the wood, not least in the thicker paint on her forehead. There are fine horizontal cracks, particularly in the shaded areas of the figure, which have in places interacted with the horizontal cracks to produce a kind of grid. There are also oblique cracks, particularly in the sky in the upper-right sector and in some areas of her chest, together with some 'crazy-paving' cracks in the upper-left sector. The remarkable variety of patterns is the result of the interaction between the irregular warping, the varied physical characteristics of the paint layers in different areas of the picture, and tensions

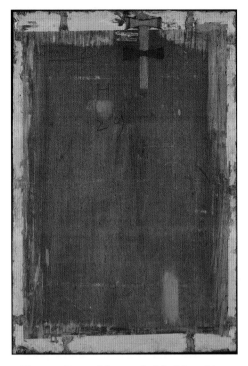

Fig. 52. *Rear of the panel of the* Mona Lisa.

that arose during Leonardo's painting process as the result of varied drying times in different paint layers. The contrast between the fine network in Lisa's hands and the deeper furrows in the flesh of her face and chest reflect the thinner and more homogenous nature of paint application in her hands. It is likely that much of the cracking occurred during the early years of the painting's history. Retouchings and layers of varnish later set up their own tensions and have amplified the varied behaviour of the cracking. The overall result is a kind of micro-jazz of varied craquelure patterns that has become integral to the image we know. It may be that the perceptual game of seeing both the surface cracks and Lisa's elusive three-dimensional features has become part of the pleasure of viewing. In any event, the cracks would present a considerable problem to any potential restorer.

We can also see an irregular scar in the dark drapery over Lisa's left elbow. This is the legacy of an attack in 1956 by Ugo Ungaza Villegas from Bolivia in 1956, who threw a missile with sufficient force to damage it through its

protective glazing. The painting was subsequently protected by bullet-proof glass. The retouching of damage has become more apparent over the years. Strangely, the other most conspicuous area of paint loss occurs in the area of Lisa's right elbow, as we will see, but there is no record of how this occurred.

At least one other assault has foundered on the protective casing that was made in 1974, the year it toured to Tokyo and Moscow. Such a famed image, like Rembrandt's *Night Watch* in Amsterdam, potentially serves as a prominent vent for deranged frustrations. It is perhaps surprising that such attacks do not happen more often to major works of art, or, dare one say, as an act of spectacular terrorism.

Inevitably over the centuries, well-meaning efforts have been made to improve the appearance of the ageing picture. The most frequent intervention has been to coat it with more varnish, which produces a relatively short-lived benefit of enhancing the translucency of the existing varnishes. The long-term effects of successive varnishing have been to emphasize the craquelure and to endow the whole image with a yellow-brown tonality—resulting in Walter Pater's 'submarine goddess'.

Early restorations of paintings were rarely recorded but they would have occurred. The first substantial intervention of which we are aware is that by Jean-Marie Hooghstoel in 1809, when the Louvre was known as the Musée Napoleon. Hooghstoel was paid for ninety days work at 14 francs, using varnish, colours, and 'wine spirit' (ethyl alcohol, which can act as a strong solvent). It would be good to have an account of what he did for his money. It was later reported that the painting had suffered from heavy over-cleaning, but this seems to be exaggerated—at least by the harsh standards of many early restorations. At the time of its reframing in 1906, the surface was subject to some further restoration by Eugène Denizard, including watercolour retouching of the cracks, which has subsequently discoloured. Following the theft, a commission recommended limited repairs in 1914, again by Denizard and not involving solvents.

A series of investigations and reports followed, utilizing the latest technologies of examination. None of the reports then or now have been bold enough to recommend the radical restoration of this hottest of hot potatoes in the world of art. Matters came to a head in 1952, on the occasion of the major exhibition to mark 500 years since Leonardo's birth. Germain Bazin, the powerful curator of paintings in the Louvre, was keen to see what could be rescued from those 'dregs of...beauty' that remained in the Leonardos.

An international commission was set up to recommend what should be done 'to improve the appearance of the work, compromised as it has been by varnishing and overpainting'. The eventual recommendations were judicious and cautious. Any temptation to remove the discoloured varnish was overcome by doubts about the state of the pigments below, which have deteriorated in different ways and are to some extent harmonized by the discoloured layers on top of them. The commission did however recommend some reduction in the blotchy inequalities in the varnishing of the sky.

Scientific analysis and the 2004–5 campaign

Decisions to restore or not to restore have been increasingly informed by scientific examinations. The first pioneering X-rays and ultraviolet tests were undertaken in 1927, and six years later a high-quality X-ray was taken. This and more recent X-radiographs (fig. 53) pick up a good deal of the

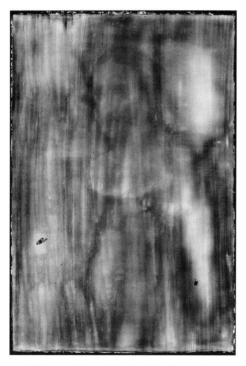

Fig. 53. Mona Lisa, *by X-radiography.*

graining of the panel but convey only a limited amount of information about the paint layers. Aspects of Leonardo's technique in the *Mona Lisa* remain elusive. It seems that he applied white lead (which depletes or blocks the X-rays) in thin layers containing a high proportion of oil binder and low proportions of pigment. The white lead priming of the *Mona Lisa* does not help the clarity of the X-rays. A later image created with X-ray emission (fig. 54) presents a more comprehensive map of areas of flesh painted with white lead.[2] The areas of damage near both her elbows are readily apparent on both X-ray images.

Changes have been confidently read into the ghostly traces in the standard X-rays, such as an alternative position of the sitter's eyes and a narrower face, but these are the result of ingenious 'seeing in' rather than definite features of lower layers of the painting. We could very fancifully say that she was originally standing, perhaps naked and pregnant. We will say more about the problems of reading such images in due course. An odd feature of the two best X-ray

Fig. 54. Mona Lisa, *by X-ray emissography.*

images is a series of straight scratches or incisions at various angles, apparently in the surface of the panel and mainly on the right side of Lisa's head.[3] These have nothing to do with the composition and are difficult to explain. Perhaps the board that was to carry the portrait of Lisa was casually used as a base for cutting paper of some other material.

The most sustained campaign of examination was undertaken in 2004–5 by the Centre de Recherche et Restauration des Musées de France, housed in the Palais du Louvre, which serves all the French national and provincial museums. It resulted in the large-format book by Jean-Pierre Mohen, Michel Menu, and Bruno Mottin, *Mona Lisa: Inside the Painting*, from which much of the evidence in this section of the chapter is drawn. Here we will be concentrating on those pieces of evidence that have most significance for our actual viewing of the painting.

High-resolution reproductions of the surface as a whole and in detail supplement what can be seen with a magnifying glass when the panel is released from its prison for its annual inspection. Filtering out the obtrusive noise of the craquelure, we can see detailed blue retouches in the sky, often as a scattering of light blue dabs, along with broader areas of retouching, especially at the upper margin and along the vertical crack. Similar well-intentioned 'repairs' can be detected, including a pale patch near the inner corner of Lisa's right eye, which has been misguidedly interpreted as a skin defect resulting from high blood cholesterol! The retouching is very apparent in the infrared reflectogram (fig. 55). We can see evidence of abrasions that have damaged some of the most delicately painted details, such as the thin, dark edge of the veil that runs across Lisa's forehead. There is a comparable broken line above her hair to the left, which may result from a combination of damage and a change of mind on Leonardo's part. It is likely that her eyebrows, of which the slightest trace remains above the inner part of her right eye, were so delicately painted that they did not survive the application of solvent or abrasive cleaning. The same applies to her eyelashes. The lower zone of the painting that includes the sitter's lap and the balusters of the chair has suffered from quite severe deterioration.

On a happier note, looking at the high-resolution images we can discern which of the refined details were amongst Leonardo's final touches, most charmingly in the interlace of gold thread over the gathered silk-muslin that flows from the neckline of her dress. We can also trace the motions of his fine brush, moist with a light yellow-tawny-orange pigment, as it describes the

zigzag peaks of the silken folds over her arms. The same applies to the gently lit prominences in the folds of her veils, and to the elusive lighting that brushes across the distant mountains and nearer water courses. The barely visible motions of Leonardo's brush in these areas of the picture testify to his deft skill.

As we move in closer, the apparent contours of Lisa's face dissolve into indefiniteness. There are no defined linear edges, even at the right edge of her face where it abuts her dark hair. Those parts of the face to which we turn most intently to read her expression are the most elusive as we scan her features. What seems to be there when we are not looking very directly at a particular feature proves not to be clearly defined.[4] There are optical and psychological dimensions to this ambiguity. As we have seen (fig. 46), Leonardo insisted in a small notebook called MS E in the Institut de France, devoted largely to the complex internal optics of the eye and written around 1507, that our discernment of edges was never absolutely certain.[5] He was also much concerned with the way the eye reacts subtly to different lighting conditions, and with the veiling effects of moisture-laden air. He increasingly came to regard seeing as a slippery process.

The psychological dimension concerns what he called '*il concetto dell'anima*', the inner intentions of the mind. When appropriate, he could define those motions without ambiguity, as in the shouting warriors in his studies for the *Battle of Anghiari*, but he also learnt how to tease the viewer with enigmatic inaccessibility, a feature that was related to a standard trope in Renaissance love poetry, as we have noted.

Aspects of the chemistry and execution of the painting have also been clarified, though Leonardo's precise methods remain unusually resistant even to modern analyses. Although his technique varied experimentally from one painting to another, and underwent a good deal of change over the course of his career, we can use information gleaned from other scientific examinations in conjunction with studies of the *Mona Lisa* to reconstruct how Leonardo worked on the poplar panel.[6]

On the immediate surface of the panel were the standard priming layers. It is possible that the *Mona Lisa* was painted on one of the wooden panels that Leonardo primed directly with white lead rather than with preliminary layers of gesso. The design was transferred to the white priming as a series of charcoal dots (*spolveri*) from the pricked cartoon. The dots provided the basis for the linear under-drawing, to which were added blocks of shading in dark wash. The shaded under-drawing provided tonal foundations that were to control

the tonal properties of the final painting. The under-drawing was lightly coated with a translucently thin *imprimatura* of white lead, a practice that was characteristic of his technique. The overlying flesh tones were composed from dispersed white lead, tinted with small portions of vermillion (and perhaps red lake) with some yellow. This pink layer was shaded with burnt umber and black, and perhaps the lit areas were emphasized with a whiter veil of thinly dispersed pigment. Very small traces of pale blue are also apparent in the skin tones. The underlayer of the sky was composed of azurite, while expensive lapis lazuli (ultramarine) has been used to create a final effect of greater radiance. Lisa's draperies involve subtly orchestrated golden yellows (probably lead-tin yellow and ochre) and copper greens. Over time pigments deteriorate in different ways. Browns tend to become more transparent, red lake fades and copper greens tend towards brown. Leonardo used a limited number of standard pigments, and there is no secret alchemy in their composition. The magic is in their application.

A later analysis undertaken with X-ray fluorescence spectroscopy by the Centre de Recherche et de Restauration has confirmed the remarkable refinement of Leonardo's technique.[7] The team at the Centre have shown that the flesh tones are created by extraordinarily fine layers of thinly dispersed pigment in an oil binder, which remain difficult to detect even with modern technology.[8] His technique for the Milanese portraits was a good deal simpler, without such a veiled application of layered glazes.

The veils of shadow in the *Mona Lisa* are created by successive overlays of burnt umber. So subtly blended are the transitions across the different tones in the skin that there is no obvious sign of brushstrokes—magic indeed!

The largest scientific yields in the Centre's 2004–5 examinations, as is the case with many Renaissance paintings, came with infrared reflectography. The picture was illuminated with an infrared lamp, and the rays selectively penetrated the more translucent of the pigment layers, particularly those containing little or no carbon or copper. The radiation was reflected off the priming and recorded in a special camera. With luck, some of the rays may be absorbed by the carbon-rich media of early under-drawings or underpaintings on the white lead priming. These register in the resulting image as dark lines or strokes.

The overall effect of the *Mona Lisa* reflectogram (fig. 55) is to convey a clear sense of the feathery vitality of Leonardo's execution. The shape of Lisa's body becomes apparent, much slimmer than the more bulky effect conveyed by the darkened draperies in the painting. We can better appreciate the containing curve of the arms and back of her chair. The IR image has a fresh beauty of its

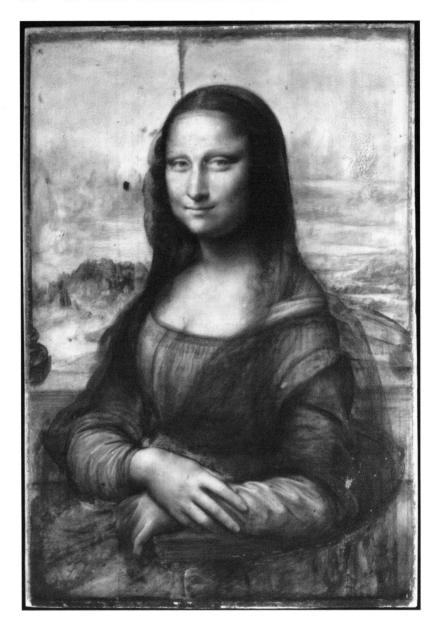

Fig. 55. Mona Lisa, *by infrared reflectography.*

own. It is illustrated here in a version made in 2008, which further clarified the under-drawing.

Details of Leonardo's preparatory procedures also become evident, including some distinct changes of mind. The more significant of these are outlined here.

Beginning in the upper part of the painting, we can see an arching line slightly above the present upper contour of Lisa's hair. This is either an alteration (*pentimento*) or a barely perceptible indication that the veil she wears stands slightly proud of her hair. At the top of the hair itself there is a lighter crescent, also just visible in the picture itself, which probably denotes the presence of a tightly-fitting cap, caul, or net on the back of her head. Tracking the veil though the deteriorated dark area to the right of her face, we pick up a definite curving line that passes behind her hanging tresses and below the twisted veil on her shoulder (see fig. 59). This corresponds to the line of the veil in Raphael's portrait of *Maddalena Doni* (fig. 42), which is strongly dependent on Leonardo's composition. In fact this line is just visible in the painting itself, once we know where to look.

Looking in the area of the sitter's left shoulder, its rear outline is apparent. It is evident that the twisted stole was painted over the landscape, low wall and a portion of the decorated neckline of her dress. It sweeps across her chest and dress, apparently to be gathered at her waist. The running knot border of her dress passes under the upper margin of the stole for a short distance. The stole seems to fall on the right to cover her left arm to the level of her elbow and to fall just inside the back of the chair. It was probably added quite late. Above her waist, we can see a series of curved horizontals that may indicate a binding of some sort or perhaps the kind of creasing we see in *Maddalena Doni*.

Below the stole in the upper part of her left arm, just below her shoulder, there is a lighter crumpled crescent of drapery, visible in the actual painting. This, as we have noted, is the fashionable extrusion of an underlayer through an aperture between the dress and the detachable sleeve. The IR image contains hints at the right end of the aperture of the ribbons that tie the slashed elements of the dress together.

The contours of the stole to the left (her right) have been subject to some freely painted manoeuvres, again passing over the landscape and wall. At her right elbow, the stole sits over a protrusion, almost certainly the termination of the far arm of the chair. The chair's rear arm is not clearly apparent in the painting.

Returning to her hair, we can observe that the main body of it is darker and more opaque, particularly on her left, which suggests that it was bound in a net as is common in Florentine portraits of this period, stopping at shoulder level or passing down her back. Alternatively, the thicker area of hair may have been given a more dense under-painting. The tresses hanging over her flesh are laid in with rhythmic delicacy and correspond to Leonardo's recommendation that the artist should avoid overly regimented hair-styles. More heavily pigmented paint is apparent in some of the prominent cascades.

Just above the neckline of the bodice of her dress, a long darkish smudge occupies the zone that was to be occupied by the scalloped border of her chemise. The midline of her dress was first marked with a curved line to the left of her cleavage in the painting—a feature that is still detectable in the finished painting. From her waist a damaged and darkened area of drapery passes downwards beneath her arms and into her lap. It appears to have been laid in quite sketchily, and precise details of the configuration of folds are difficult to determine.

Not the least interesting portion of the reflectogram is the zone that includes Lisa's hands. Her right hand emerges in very shapely form, and the upper contour of her index finger has been marginally adjusted. Between her index and middle finger, drawn lines of the folds are clear. The fingers of her left hand have been substantially changed. Her index finger was originally lower and less bent, as also seems to have been the case with her middle finger. Her third finger was originally drawn as bending back to touch the end of the arm of the chair. Her little finger may have been straighter. Perhaps she was at one point intended to gather some of the drapery of her lap in her index and middle fingers.

The lower part of the reflectogram below the curved arm of the chair indicates quite extensive damage and is difficult to read. The baluster at the left end that supports the chair's arm is clearly laid in, while others seem to be more erratically sketched. Those to the right, where the curved balustrade is most foreshortened, bear witness to considerable experimentation. To the right of the first baluster are some star-shaped marks, which we will encounter again. The problem with deciphering what is happening in this area, as with the draperies in her lap, is that it is difficult to disentangle what is significant from the visual 'noise', much of which is occasioned by deterioration and damage in the darkly shaded zones towards the bottom of the picture.

The architecture behind the sitter is laid in quite casually. The low wall and its panelling is lightly indicated. The base of the column on the left is drawn

quite casually on top of the ledge of the wall, and that on the right (probably added after that on the left) is little more than a ghost in the under-drawing. It seems that the pigments used in the column bases have become translucent over the years. This casualness extends to the perspective. The vanishing points of the column bases are high above the horizon. The bases with their slim slivers of columns appear to have been added as pictorial adjuncts that serve to frame and set up the view into the distance, probably quite late in the process of painting.

The visible thinness of the painting of the mountains is confirmed by the reflectogram. The open translucency of the upright rocks and mountain peaks conjures up the progressive veiling and blueness in the distant landscape, an effect Leonardo repeatedly emphasized in his writings. The pale prominences of most distant mountains leave only faint traces in the IR image. The soft and elusive subtlety of Leonardo's drawn studies of mountain ranges is here fully carried over into their painted counterpart.

The 'Prado Mona Lisa'

In the story of the scientific examinations, a Spanish protagonist arrived unex-pectedly on the scene in 2012. This was a copy of the *Mona Lisa* in the Museo del Prado in Madrid (fig. 56), which showed the sitter against a dark background rather than a luminous landscape. It seemed unremarkable. This changed when the painting was restored and subjected to scientific examination.[9] Most dra-matically, the dark background was removed to reveal a delicately painted land-scape close in spirit to the Louvre painting (fig. 57). The sitter, her costume and chair were rendered with skilled but niggling precision that seems to clarify fea-tures that are unclear in the cracked and darkened original. It appears that the twisted stole over Lisa's left shoulder is indeed separate from the large veil that falls over her shoulders and down to her elbows and the arms of the chair. Above the neckline of her dress is the prettily scalloped fringe of her bodice, of which slight traces remain in the scientific examinations of the original. A fringe of the same fine garment appears at her right wrist, though there is no sign of this in the Louvre painting or the scientific examinations of it. The edge of the veil over her forehead is here hemmed by a light row of stitches, in contrast to the dark border of the original. It seems in these two latter cases that the copyist added some refined details of his own.

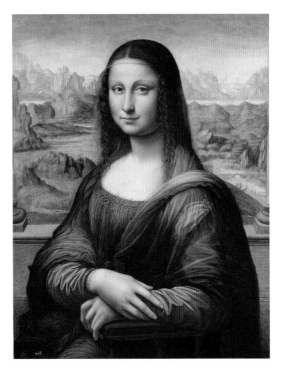

Fig. 56. *Unknown artist,* Copy of the Mona Lisa, *Madrid, Museo del Prado.*

The careful painter of the copy has indicated the sitter's eyebrows with extremely delicate lines of brown pigment, while tiny, upcurving marks with a very fine brush describe eyelashes towards the outer edges of her upper lids on left and right. Her lips are infused with the subtle rosy hue described by Vasari. We may reasonably think that these were features of the original when the copyist was at work. However, one aspect of the sitter's countenance remains inaccessible to this copyist as to all others; that is to say the melting ambiguity of contour and expression that removes the sitter's expression from the definably specific. The Prado lady conveys a sense of charming anxiety rather than the spiritual knowingness of Leonardo's Lisa.

More was to come from the programme of conservation and scientific examination of the Prado picture. Infrared reflectography disclosed clear signs of a free-hand under-drawing that sketchily laid in the main elements of the figure and costume, including Lisa's eyebrows, eyelashes, nose and lips. Some of the surprisingly freely drawn lines suggested that the copyist was not using Leonardo's cartoon. However, the virtually identical dimensions of the main

Fig. 57. *Infrared reflectogram of the Prado* Mona Lisa.

elements in the two paintings indicate that a direct or very controlled method of transfer was used.

Other aspects of the under-drawing and underpainting detected by infrared reflectography, suggested that the relationship to the Louvre painting might not be entirely straightforward. This led to claims that the Prado version was made in Leonardo's studio at a time when the master's painting was evolving. These claims were based on observations that the Prado version and its preparatory layers exhibited features more in common with the underlayers of the original than with the finished picture. However, looking at the evidence afresh it is safer to say that the Prado copyist must have known the *Mona Lisa* in its finished or near-finished state.

Aspects of the Louvre painting that arrived late—perhaps in some cases some years after the painting was first underway in 1503—are evident in the Prado picture. For instance, the columns and their bases are fully apparent in the Prado under-drawing. The veil that falls over Lisa's right shoulder and upper arm is in its final position. And the veil to her left is shown in the Prado

underpainting as bunched up on the back of the chair, just as it was to be in the Louvre picture. More generally, the fold patterns of her dress follow the final disposition of the Louvre painting rather than its underlayers. The knot motif at the border of Lisa's dress in the Prado under-drawing is a late feature in the execution of the Louvre portrait. And finally, the position of her fingers are closer to the Louvre painting than to the *pentimenti* of its under-drawing, though the copyist has lengthened her right index finger.

On the other hand, there are features in the reflectograms of the copy that suggest that aspects of the Louvre painting were *not* resolved before the copy was commenced. This applies particularly to the background. Only the immediate range of small mountains on the left is laid in. There are no distant mountains and lakes, no bridge on the right, and little sign of the brown curve behind her left shoulder. We may also note the far end of the armrest of the chair is just visible. If these indications are reliable, we may suppose that the copyist had access to the unfinished original quite late in its evolution, perhaps after Leonardo left Florence in 1507 or even when he was in Rome after 1513. It may be that the full landscape was added quite late in the Prado copy, perhaps even by a different artist. The relatively open and free handling of the mountainscape is different in feel from the precise and pedantic handling of the figure and costume. Perhaps two painters were involved. The rock forms resemble those in Leonardo drawings datable to after 1508, which supports the idea that the Prado copy was completed in Milan or Rome.[10] It is painted on walnut, which is unusual in Florence but common in Milan.

We know that painters in Leonardo's workshop used its resources to make copies and versions of his paintings, and that two versions of one composition, the *Madonna of the Yarnwinder*, evolved beside each other.[11] The developing composition of the *Madonna* generated further variants by followers that reflect the unfinished state of the picture. Although the evidence is less decisive in the case of the Prado *Mona Lisa*, it seems likely that it was also produced by one or more artists who were or had been in the inner circle of pupils and collaborators. As such it can legitimately assist our visual examination of the Louvre picture. One feature is especially germane to our reading of the landscape. The upper lake on the right is continued behind the nearer range of mountains on the left, which affects and clarifies the sense of space in the distance before the final range of mountains.

We do not know who was responsible for the copy. Attempts to attribute it to known pupils, such as Francesco Melzi and Salaì, are unconvincing. Salaì's

one signed and dated painting has nothing in common with the copy, and we have no reliable core of paintings certainly attributable to Melzi.

The LAM method

It seemed that the 2005–6 examination of the original *Mona Lisa* would remain definitive for some time. This has proved not to be the case. On 19 October 2004, Pascal Cotte of Lumière Technology in Paris, the hugely inventive pioneer of very high resolution scanning, had already garnered a massive quantity of data in the Louvre's laboratories using his multispectral camera. To understand what he found, we need to outline the technicalities of his method.

Cotte's camera gathers data within thirteen distinct spectral bands, across the visible spectrum and extending into the infrared and ultraviolet at either end. An astonishing 3.2 billion bits of data were harvested in the Louvre. The reflected light in its discrete spectral bands not only comes from the surface of the picture, enabling the assembly of an overall image of extremely high resolution, but it also contains elusive data from deeper layers, depending on the different properties of the longer and shorter wavelengths of light. The greater the wavelength, the greater the penetration. We have already seen that waves in the infrared band are more penetrative than those in the visible spectrum. Ultraviolet light picks up surface features, particularly retouchings. Different pigments and binders are penetrable to varying degrees. The results are complicated to unravel.

Over a prolonged period of calculation and experimentation, lasting about ten years, Cotte devised a series of procedures and algorithms drawn from signal analysis for the extraction of slight and often fugitive optical effects previously concealed by the dominant characteristics of the scanned images. Applying his analytical algorithms to very small sections of the multispectral images, optical features emerged from different depths in the paint layers. Some clarified what had already been seen in the infrared band, while many others were entirely new. Cotte has called his resulting technique 'Layer Amplification Method' (LAM). This method is expanding what it is possible to extract from within a painting. The technique produces a huge number of images, just six of which are illustrated here. Some of the very many images produced by the technique correspond quite closely to the earlier images from the technical examinations, but others differ substantially (fig. 58).

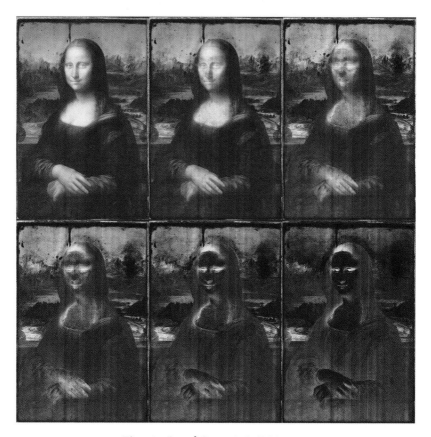

Fig. 58. *Pascal Cotte, six LAM images.*

The difficulties in interpreting what has emerged are of two kinds. First, we do not know precisely what is happening as the various wavelengths penetrate the paint layers to differing degrees and interact in diverse ways with the varied optical properties of the materials within the layers of the picture. We have no comprehensive understanding of the relationship between the light that is reflected back to the camera and the physical characteristics of the original pigments, binders, areas of deterioration and damage, restoration, dirt, cracking, and varnishes. The second difficulty is that each LAM image does not necessarily equate neatly to a particular layer at a precisely definable depth but incorporates data from other levels. This latter difficulty applies to IR analysis and X-rays, but the simpler processes behind the better-known techniques can more readily be equated with specific features in the paint and design layers, and in the support of the picture.

In the face of these problems, we have to be very careful with what we think we are seeing—as is the case also with IR and X-ray imagery. Every act of looking, whether in science or art, involves selective attention and embeds implicit assumptions and expectations. All technical examinations of a painting generate very selective and incomplete data about one or more aspects of the work's production. Well-informed and experienced scrutiny is needed to tease out significant features.

There is a danger that we over-interpret elements resulting from the enhancing of very fugitive features of the LAM images, seeing them as historically significant features in the evolution of the design of the work. The techniques devised to process the data can be used inadvertently or more intentionally to enhance slight and insignificant marks of varied origins and to represent them as part of the artist's original procedures. We should also bear in mind that the possibility that the algorithms might produce anomalous results with such complex layered structures.

There is an analogy here with image analysis applied to low-grade close-circuit television pictures to extract data that will allow the identification of a bank robber. In this case, we can select and emphasize those visual traces that specifically serve purposes of identification, such as the relative measurements of key features of the face. In the case of the painting, we have no such clear and limited criteria for filtering the data, and we need to devise more than one visual goal towards which we selectively work.

True, these cautionary remarks are as applicable to medical scanning methods (X-rays, CT scans, fMRI, etc.) and to images in a wide range of scientific and technical investigations, including a range of signal processing techniques. The IR and X-ray images at which we have already looked are far from easy to 'read' even for experienced professionals. For example, a surgeon typically will prefer to work with the X-rays produced by radiologists and radiographers with whose techniques she or he is familiar. The lay person might not be able to see much at all in the X-radiographs.

Let us begin by looking at some of the less challenging analyses in the LAM images as presented in Cotte's notable recent book, *Lumière on the Mona Lisa: Hidden Portraits*.[12]

An important aspect of Cotte's LAM images concerns the possible presence of *spolveri*. The *spolvero* dots made by black powder pounced through the holes in a cartoon often do not survive (even when not deliberately brushed way after drawing a line linking the dots). They may, for instance, be

Fig. 59. *Pascal Cotte, LAM image of lower line of the veil.*

masked by the drawn line and the pigment layers overlying them. In a number of the LAM images we can discern dots that might or might not be *spolveri*. The one illustrated here does indeed confirm the use of a cartoon. There are clear signs of *spolveri* that indicate a lower position for the edge of the veil on Lisa's forehead (fig. 59), much as in the veil on St Anne's head in a drawing at Windsor.[13] Comparable clues appear elsewhere, most notably in the line that marks a shift in position of the very top contour of her head, along the neckline of her dress, and in the boundary that separates her left and right hands.[14]

Amongst other useful features of the LAM examination, we can see that the original edge of her veil over her left shoulder and the curved band that borders her dress are greatly clarified (fig. 60). We know from Cotte's analysis of the *Cecilia Gallerani* that Leonardo mapped the borders of a sitter's dress in just this way.[15]

There are many features of the LAM images that do make comparably good sense as belonging to the preparatory stages of the painting. The manoeuvres in the position of her left hand and fingers are very evident, although the damage in this area renders problematic any reading of the lower ends of the longer fingers. The sleeve of her right arm was originally outlined in a lower and fuller position. The contours of the sleeve and veil in the upper part of her right arm were subject to adjustment in the under-painting.

The confusion of marks and potential manoeuvring in the area below the arm of the chair as Leonardo attempted to position the balusters is very evident, though alternative shapes and positions for the row of balusters are not demarcated in a readily definable manner, as we saw in the earlier reflectogram (fig. 55 and 57). More evident is the termination of the end of the far arm of the

Fig. 60. *Pascal Cotte, LAM image of the drawn edge of the veil and the border of the dress.*

chair under the drapery, already noticed with IR. A series of marks in the LAM images slightly above it and to the right span the area of paint loss near Lisa's right elbow, clearly visible with X-ray emission (fig. 57), and so cannot be part of the original paint layers, which no longer remain.[16] Such an appearance of marks not originating in the paint layers indicates that we need to be very careful in drawing conclusions from features in scientific examination that arise from unknown causes and processes.

There are many features of the LAM images that make good sense as belonging to the preparatory stages of the painting. The inner contour of the index finger of Lisa's right hand was originally lower, and other small manoeuvres may have taken place in the position of her hand and fingers. The *pentimenti* that we noted in her left hand are revealed even more clearly although the damage in this area renders problematic any reading of the lower ends of the longer fingers. The sleeve of her right arm was originally outlined in a lower and fuller position. The contours of the sleeve and veil in the upper part of her right arm were subject to adjustment in the under-painting.

Fig. 61. Mona Lisa, *detail of hair and sky to the upper-right of the head.*

Some aspects of the LAM images are more problematic in terms of what we can clearly see and how we interpret the visual evidence. One conundrum involves a feature that we can see in the actual painting, once we know where to look. Behind and to the right of the sitter's hair, at the level of the top of her hairline, are some just-visible light streaks (fig. 61). It is difficult to see these as representing something specific, and there are other comparable streaks else-where in the sky. In one of the LAM images, the marks have resolved them-selves into a more definite outline, shaped a bit like the head of a seeding poppy (fig. 62). Cotte sees this as the under-drawing of the head and shaft of a hair-pin, and illustrates two examples of actual pins from the Renaissance. Once this is pointed out, we can 'see' it. The marks are real, but is the pin? The light streaks seem likely to me to be features on the surface of the painting, akin to other similar if less pronounced marks in the sky that have accumulated over the years.

On this basis Cotte has ingeniously used LAM imagery to identify some eleven other marks around Lisa's head as hair-pins, or perhaps as pearls (fig. 63). Some of the 'pin heads' appear as solid dark spots. In other LAM images they show as light spots or circles, or a combination of both. In different images the same feature can appear as solid or hollow. Some are rather irregular in shape, and very difficult to see. Are these marks, in their variety, erratic distribution, and elusiveness, distinct from those that signify small damages to or irregulari-ties in the paint and varnish layers? Some certainly correspond to spots of

Fig. 62. *Pascal Cotte, LAM image of the detail of hair and sky to the upper-right of the head.*

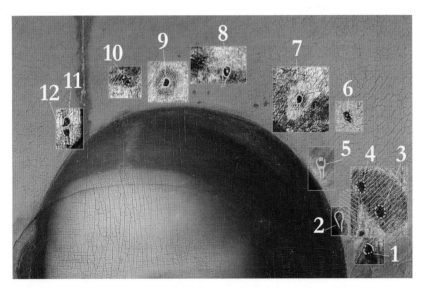

Fig. 63. *Pascal Cotte, location of the marks of 'pins' or 'pearls' above the head.*

damage, visible in the emissograph and reflectogram (figs. 54 and 55). From the historian's point of view, it is not feasible to see a coiffure or headdress in any Renaissance painting as being erratically peppered with so many pins—either on the grounds of headdress structure or pictorial good manners.

Another very puzzling feature in some of the LAM images is the scattering of dark marks to the right of the first baluster of the chair.[17] These were visible with less clarity in the IR image (fig. 55). The clearest of the marks is composed of an inverted V crossed by a vertical bar. Cotte interprets the marks as pentagrams, and suggests that Leonardo may have been thinking of sprinkling the whole of her costume with stars. However, star patterns in Renaissance costumes were not pentagonal, and they are much too small to comprise a credible pattern. They remain very difficult to interpret at this stage in our understanding of what the method is delivering.

Equally challenging are the crosses that can be seen to the immediate left of the pupils of both eyes (fig. 64). They seem to mark the centre point of the eyes, and would be the position of the pupils were Lisa to be looking straight forward rather than turning her enigmatic gaze on us. Were these crosses placed there by Leonardo so that he could offset her pupils effectively? The crosses appear more definite than the 'pentagrams', but we cannot be wholly confident that the record aspects of the design of the composition rather than later interventions.

The LAM images and the X-Ray emissograph reveal substantial areas of disturbance in the paint layers that can be read either as changes during the process of painting or as the result of the efforts of successive restorers.[18] The important halo of sky immediately surrounding Lisa's head is perhaps the most important of these disturbed areas. It has clearly been the major focus of one or more campaigns of cosmetic restoration aimed at reinstating the blueness that sets off her flesh tones and creates a spatial contrast between the modelling of her head and the atmospheric distance. The LAM technique reveals very clearly the disruptions in this area (fig. 62, and the third, fourth, and fifth of the six LAMs, fig. 58). A fine series of diagonal hatchings are evident in this halo of disruption. In this area Cotte discerns the under-drawing of an elaborate

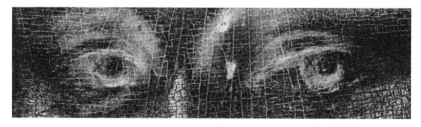

Fig. 64. *Pascal Cotte, LAM images of the 'crosses' in the eyes.*

headdress, extending high above the sitter's hair.[19] He also sees lines of *spolveri* and other drawn lines in chaotic profusion above her head in terms of a folded headdress, to which the twelve pins or pearls belong. However, the lines are devoid of the kind of structural logic that always characterized Leonardo's sketches of drapery. Whatever we are looking at, the lines do not make functional sense as Leonardo's under-drawing or underpainting of a headdress. At this stage of our understanding of the LAM technique, these lines and the tiny diagonal hatchings can best be attributed to a restorer's effort to improve the surface of the sky adjacent to Lisa's head. An ultraviolet fluorescence photograph produced during the 2004–5 examination strongly suggests that this is the case.[20]

The most challenging aspect of the reading of the LAM, IR, and X-ray images is how to interpret emergent shapes or patches that suggest different facial features for the sitter, and even a much slimmer face, as in three of the images we have already illustrated (fig. 58). Although it is not always clear what is being picked up and why, it is likely that such effects as a less rounded contour for the right side of her cheek and chin or a higher original position for her eyes (particularly as discerned in the X-rays) are the result of the differential recording of paint layers of greater thickness, pigment density and type, as well as differing degrees of cracking and layers of restoration. In particular, a number of the LAM images of Lisa's head exaggerate the contrast between the lit areas, which are rich in white lead, and the shaded portions at the side of her face, in which brown was prominently used to shade the flesh. The result is that the outer contours of her face are suppressed and appear to move inside the present outlines. The resulting effect cannot be read credibly as an indication of what Leonardo intended to paint on either technical or aesthetic grounds. A number of the stranger images (such as the third, fourth, and fifth in the illustrated set) cannot be safely seen as corresponding to anything that Leonardo actually produced during his execution of the painting.

Above all, it is unsafe to extrapolate from the scientific examinations, as both Cotte and Hatfield do, that there were two or three substantially different paintings—even representing different subjects—under the surface of the visible picture.[21] Instead, what we are witnessing, albeit in an incomplete and tangled manner, is a very fluid process of creation on the basis of an initial cartoon in which different ideas and motifs are laid in at various stages into various parts of the developing picture, often fleetingly. This improvisation, typical of Leonardo, permeates every phase of detailed work on the under-drawing,

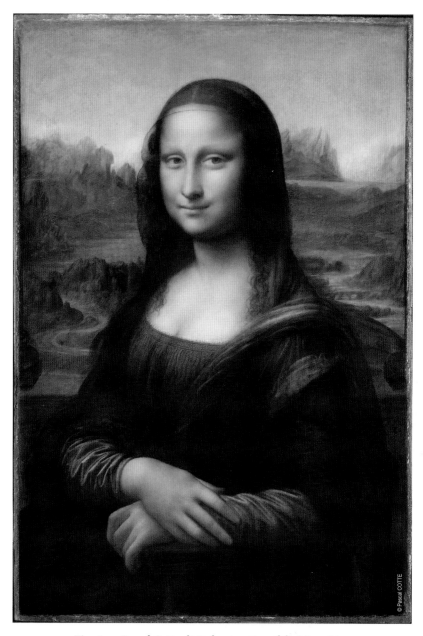

Fig. 65. *Pascal Cotte, digital restoration of the* Mona Lisa.

underpainting, and pigment application, in an inspirational and experimental manner. In spite of all this, it cannot be stressed enough that the overall disposition of the figure in the original cartoon appears to have persisted.

There is no such thing as a clearly definable layer that corresponds to the first version of a finished or even quasi-finished painting under the present one, to be succeeded by a comparably resolved composition, and so on. We should not at this stage read more into the techniques of scientific examination than they can safely give us. This is not to deny that there were distinct phases of execution over the decade or more that Leonardo worked on the painting, or that the nature of the image evolved in detail and even in overall function. Indeed, we are arguing that what began ostensibly as a functional portrait of a bourgeois woman was transformed into a kind of philosophical panting that embodied much of Leonardo's understanding of the visible works of the microcosm and macrocosm.

Will the large body of data from the scientific examinations be used to inform a restoration at some point in the future? It seems unlikely that any director of the Louvre will take it on. Given the legion of problems, not least the elaborate craquelure, this is wise. The future may lie with digital restoration, such as that skilfully performed by Pascal Cotte (fig. 65).

Are more 'secrets' yet to emerge? We are not thinking of the kind of hidden images—esoteric numbers, mystic geometry, alligators, Persian script, mysterious faces, and so on—that a goodly number of hopeful observers have discovered in digital versions of the painting. Close inspection of the picture itself and very high resolution scans shows that such 'hidden' images are projected into the picture by the observer rather than drawn out of it. We are thinking of more concrete things. There is of course always the possibility of new documentation, like the important dated note by Agostino Vespucci in the printed book of Cicero's letters, which was only discovered in 2005. We believe that the documents in this book enrich our ways of looking at the people involved and at the picture that emerged from their interaction. Scientific examination continues to develop into new areas, as Pascal Cotte's researches indicate. What would be transformative is a technique that reliably isolates a succession of very fine layers within the paint surface, filtering out noise from other layers. The future is full of possibilities.

A Compact Conclusion

In this book, we have concentrated on real people doing real things in real places at real times. One of our subjects, Leonardo, was doing extraordinary things, but the context that gave rise to the portrait was no less embedded in the daily business of life in Renaissance Florence than when Francesco del Giocondo imported leather from Ireland. Indeed, the commissioning of a portrait from a local artist was *less* notable in the context of the time than Francesco's trading with the one of the 'Grand Turk's' functionaries.

History has set us up to view everything in the lives of the participants in this story through the generation of a great cultural icon, setting up the need for an account of its origins that is as extraordinary as the painting. Modern priorities could hardly be more different from all the main actors in our story, with the exception of Leonardo himself, who was interested in fame. For Francesco, as a shrewd commercial operator, the fact that Giovanni Rucellai owed him 300 florins was likely to be of more concern than the failure of the son of a lawyer whom he knew to deliver a portrait of his wife. Lisa's six pregnancies and the fate of the five living children for whom she was responsible far outweighed the anticipated results of the application of paint onto a poplar panel. She may have spent some time sitting for Leonardo, but probably not more than was needed to make a drawing or drawings, or laying in the basis of the design. Our image of a sitter spending many long days in front of the artist does not correspond to how things worked in the Renaissance. Given Leonardo's reputation, neither Francesco nor Lisa would have been surprised that they never received a finished portrait. It is unlikely that Francesco had made a down payment on it.

Leonardo's father was a considerable figure, a pillar of the Florentine legal community. Having fathered his illegitimate first son with the lowly Caterina, Ser Piero was happy to prioritize his career, secure in the knowledge that the boy would be nurtured in the family home in rural Vinci and that a modest dowry for Caterina would ensure that she could be married off to a man from her own stratum of society. We have frustratingly little evidence of the relationship of father and son when Leonardo settled in Florence, moving from a rural setting into a city of great social, cultural, economic, and political vibrancy. Anything that can be regarded as a heartfelt expression of personal sentiment is notably absent from Leonardo's thousands of pages of notes. He recorded his father's death with the objectivity of an official inscribing the register of deaths. If the Caterina who joined him in Milan in 1493 is his mother, we would not know it from Leonardo's language.

We do know that Leonardo was publicly identified as his father's son. In all official documents Leonardo was designated as 'Leonardo di Ser Piero da Vinci'. Indeed, the presence of Ser Piero may have been a factor in both his big early commissions. That the painter's father was a respected lawyer may have encouraged the Florentine Signoria to entrust the young Leonardo with an altarpiece for the government palace. And Ser Piero was procurator for San Donato a Scopeto, the monastery outside Florence for which Leonardo was to begin his *Adoration of the Magi*—with a rather strange contract. It cannot have been comfortable for Ser Piero that Leonardo defaulted on both commissions.

At the time when he began the portrait of Lisa in October 1503, it can hardly have been Leonardo's highest priority. He may have taken it on at the urging of his father. The other two works mentioned by Vespucci were of more obvious significance. No contemporary commission was greater than that for the huge battle painting in the council chamber, and the arrival of Michelangelo as a rival can only have served to sharpen his desire to show what he could do. His *Virgin, Child, St Anne and a Lamb*, which is also recorded as underway, was a knowing demonstration of how a conventional subject could be rethought as a kind of narrative that 'signifies great things'. A mere portrait of a bourgeois woman destined for a private residence can hardly have taken precedence over his other commissions, to say nothing of his prominent work as an engineer of canals and his scientific endeavours. But, somehow the portrait became a picture into which Leonardo poured all his ambitions for the 'art of science' and the 'science of art'.

The central current of the documentation leaves doubt about the identity of the picture in the Louvre only for those who avidly wish there to be doubt. It has unfortunately proved repeatedly possible for writers on the *Mona Lisa* to divert the current of debate into the kind of unworkable side channel that Leonardo favoured when he aspired to change the course of the Arno. Such scholarly diversions of the main flow of the documentation are contrived to meet predetermined goals, such as the *idée fixe* that Leonardo painted two separate versions on his own account, or that the sitter must be someone more interesting than Lisa del Giocondo. Take away the predetermined goal and the tenuous evidence for it collapses.

Of course we have our own desired goal, namely what we may call the default position. This states that what has been obvious for centuries remains obvious. We should only depart from this position when it decisively collapses in the face of the evidence. We are advocating a form of Ockham's razor, the principle enunciated by the fourteenth-century English philosopher, which states that the hypothesis with fewest assumptions and is most consistent with the evidence is to be preferred. This is the law of parsimony, the *lex parsimoniae*, which is a very rare bird in the flocks of modern theories about the *Mona Lisa*. The alternative theories all involve giving selective credence to witnesses of uncertain reliability and denying one aspect or another of the more straightforward mainstream of evidence. Our theory is considerably more straightforward. There is one *Mona Lisa*. It was painted by Leonardo. And it is in the Louvre.

Tracking the major accounts of the painting over the centuries, we tend if anything to be less surprised than we should be that the portrait of a Florentine wife should have received such a rapturous reception. Any attempt to explain this phenomenon in definitive terms seems to founder on the fact that each spectator makes their own *Mona Lisa*—or rather, it is perhaps better to say that the protean quality of the image is the reason why its fame crosses so many cultural and temporal boundaries. Any work of art sets up a field for interpretation, and Leonardo exploits this in a way that is uniquely his own. He emulates the visual suggestiveness and emotional seduction of Renaissance poetry, while granting his sitter a material tangibility which, with his magic touch, remains paradoxically intangible. If we add this seductive engagement to the stories that engulfed the painting from the nineteenth century onwards, most prominently the drama of its actual theft, we gain some sense of why it has exercised its spell.

We can also add the unique way in which the picture embeds Leonardo's science of art. His deep penetration of the underlying structures and dynamics of nature was not devoted to a one-to-one imitation of nature but to the *remaking* of it, the artist acting as a second nature in the world. The *Mona Lisa* is a manifesto not only of *what* we see on and below the surfaces of nature, above all in the human body and the body of the earth, but also of *how* we see. Optics is not simply a matter of the geometry of light that happens 'out there'. It needs to be understood in terms of the complex variables of our perception of light, shade, colour, and motion. This scale of ambition and achievement is not rivalled elsewhere in art at any time—though Seurat was to ask some comparable questions four centuries later.

The underlying direction of the book has been from the gritty detail of the real circumstances which gave rise to the painting towards its universalizing by Leonardo and by subsequent generations as the picture of all pictures. The scientific examinations, complex and difficult as they are, play an important part in confirming this direction from the particular to the general.

Above all our hope is that we have laid secure foundations on which each viewer can build their own personal relationship with this most remarkable of paintings.

Appendix

Inventario della casa di Ser Piero in Via Ghibellina a Firenze
(Luglio-Agosto 1504)[1]

ASF, Notarile antecosimiano 5111, ff. 107r–111v.

[f. 107r]

A ddì 1... di luglio 1504

Inventario di tutte le masseritie rimarranno nella heredità di ser Piero da Vinci e in prima
in camera di ser Piero in sulla sala.

1	legname di noce con cassapanche di noce intarsiate
1	sacchone
1	materassa piena di lana
1	coltrice con dua primacci
25	ghuanciali tra grandi et picchioli
2	saccha di piuma peso libre ***
1	paio di lenzuola in su decto lecto
1	choltre a bottoncini biancha in su decto lecto
1	chortinaggio quadro con chortine attorno frangiate
1	lettuccio di noce intarsiato
1	materassino in su decto lectuccio
1	tappeto in su decto lectuccio
1	testa di femmina di rilievo in sul chornicione di decto lectuccio
1	testa, cioè el ritracto di Francesco
2	agniolini di rilievo dipincto in sullo armadio
1	armadio dentrovi le infrascripte cosse a llato al decto lectuccio

15	paniere tra grande et picchole et nuove et vecchie
1	sacchetto di quoio dentrovi più borse
3	sportelline
1	fodera da fare 1 primaccio
2	bacini e 1 miciroba d'ottone
1	bacino e 1 miciroba per la Margherita[a]
	Più vreti[b] in decto armadio, cioè
12	taze di cristallo tra grande et piccole
4	choppe et tre bicchieri choperchiati di più coloro
7	paia di saliere tra chol piè e con le palle
3	tazzatte messe d'oro
8	bicchiere messi d'oro che ve n'è uno a fighure
13	guastade di cristallo
20	bicchieri di cristallo
12	quadri di stagno nuovi
1	schatola rossa entrovi 16 nappe e più chordigli di refe

1 schatola dipinto dentrovi 2 charnaiuoli

3 scharselle 1 temperatoio et 1 paio di forbicine

1 forzerino per la Margherita^c

1 forzerino dipinto messo d'oro dentrovi le infrascripte chose, cioè:

2 filze d'ambre nere

3 berrette di seta

2 borsotti

1 angnusdeo con 9 perle

2 rinvolti di rice o vero frange

1 agoraiuolo et 1 brieve anticho

[f. 107v]

1 paio di forbice

1 crocifisso alla tedescha d'intaglio

4 tondi di stagno da guastade

4 bossoli di legno da spetie

1 rinvolto di banbagia

1 croce d'allume

1 schato[la] dentrovi più seta braccia 2 di reticella bianca di refe

5 schatole, cioè 7

4 lucerne nuove

1 paio d'uova di struzzolo

1 fiaschetto con due manichi di vreto

1 dirizatoio d'avuorio antico

3 berghamene bianche ne' lettuccio

1 usciale d'arazzo

3 piattelli grandi di stagno

14 berrette tra rosse et nere all'anticha

31 libre col saccho d'accia tra di lino et di stoppa

29 libre d'accia di stoppa col saccho

1 paio di forzeretti entrovi le infrascritte cose

30 tovagliolini bianchi

4 tovaglie bianche

3 guardonappe

6 mantili

2 teli da pane

5 tovagliuole

3 tovagliette chaptive

5 chanovacc*i*uzi per le choltella

4 bandinelle buone

6 bandinelle captive

31 chanovaccio 14 sottili e'l resto grossi

11 lenzuola triste

Nelle chasse

7 sciughatoi da chapellinaio

3 sciughatoi da lettuccio

…^d sciugatoi dal viso

24 federe da guanciali

6 chamiciotti da fanciulli di guarnello

6 chamiciotti da fanciulle di guarnello

2 pezze di guarnello da fanciulli

1 cuffia richamata

più chamiciacce

più pezze triste di panno lino

[f. 108r]

2 benducci nuovi

3 sciughatoi grossi

4 striscie di panno per la Margherita^e 1 manicha di brocchato sdrucita

9 chamiciaccie da donna vecchie

4 sacchetti

1 sciughatoio sottile con verghe nere

per la Margherita^f 3 rete di verghola

1 pezzo di taffeta rosso usato per la Margherita^g 4 bavaglini per la Margherita^h 1 forzerino d'osso usato

2 pezze di guarnello a Ser Giuliano et Benedectoⁱ 4 cintole fornite d'ariento

1 chassa da piè del lecto di drieto dentrovi più panni sudici, cintoli, paneruzzole et altri ritagli

8 paneruzzole di più sorte

1 descho biancho con quatro piè

1 celone in su decto descho a uso di tappeto raso

1 celone di refe di più colori

7 chucchiai d'ottone

2 chassoni a uso di forzieri

1 farzetto di raso nero tristo di ser Piero

1 chapuccio rosato di ser Piero

1 chatelano allazzato di Pandolfo

1 chatelano allazato di Benedecto

2 chatelani allazati uno di Guglielmo e uno di Bartolomeo

1 luccho paghonazzo foderato di taffetà rosso di ser Piero

1 mantellino di domaschino bigio foderato di pancie

1 chotta di raso paghonazzo con le maniche

1 chotta di domaschino nero con le maniche di decto Domenico

1 cotta di taffettà changiante sanza maniche

1 mantello paghonazzo alla uzana di ser Piero

1 ghammurra rosata con maniche di raso rosso

1 cioppa cinta di panno nero di perso da donna

1 cioppa di mistio

1 cioppa di rose secche

1 saia a uccellini azzurra et biancha

1 ghammurra di perpignano biancho sanza maniche

1 cioppa di panno rose secche foderata di pancie

1 altra cioppa di rose secche foderata di pancie

1 cioppa di *ci*anbellotto nero foderata di martore

1 cioppa di panno tane foderata di dossi

1 cioppa da donna paghonassa foderata d'agnelli

1 mantellino paghonazo foderato d'agnelli

[f. 108v]

1 mantellino tane foderato di soriantone biancho

1 robucc*ia* di rascia nera trista

2 chatelani neri

1 imbusto da donne di parto rosso più schampoli di panno di più colori

2 chappelli 1 choperto di nero e 1 di paglia

2 schodelle di terra da Faenza

1 bambino di legno da fanciulle

1 specchio

2 orciuoli di cristallo

1 coda da tenere pettini

4 infreschatoi di cristallo

2 guastade di cristallo

2 schodelle 3 tazze di terra

60 candele benedecte

1 sciughatoio grande nuovo

1 choltre nuova bianca a bottoncini

1 paio di guanciali con nappe rosse et grandi

3 paia di guanciali grandi e un paio di piccholli infederati con le nappe

1 paio di maniche di zetani rosso et bianco

1 tovaglia di renza

2 choltrucce da lettuccio una a bottoncini

1 paio di lenzuola da parto

1 tela di guardonappe con tirella da lato

1 altra tela di guardonappe col segno da ogni testa

6 tovagliuole capitate tra nuove et
 vecchie
55 fazzoletti nuovi in tre fili
4 sciughatoi in un filo
11 sciughatoi sottili con verghe nere
 in un filo
4 sciughatoi in un filo mezani
 con verghe nere
16 sciughatoi in un filo grossi
37 tovagliolini in un filo
1 sciugatoio sottile nuovo
4 fazzoletti da chapo sottili
1 Nostra Donna di mezzo rilievo tutta
 d'oro con uno padiglioncino

[f. 109r]

1 cha[m]panella nello schannello
1 borza entrovi tre grossi vecchi et soldi
 38 di quattrini pisani
1 charta da navichare
2 martelli
2 paia di guanti
3 scharselle d'ottone da occhiali
2 bacinetti da banchieri
1 lucerniere
1 paio di sproni

[f. 110r, in a different hand]

 A dì 18 d'agosto 1504
Uno chassone di braccia 3 e mezzo
Uno chassone di braccia 3 e mezzo
Una archa di braccia 3 da farina
Una archa usa di braccia 2 e mezzo
 da farina
Uno paio di chasse antiche a 4 serrami
Una madia da fare pane nuova
Uno cassone da farina
Una stia et descho
Uno descho da scodelle
Una credenza in cucina
Uno paio d'alari grandi peso libbre 104
Uno paio d'alari piccoli peso libbre 42

1 San Francesco in un quadro
1 testa di un volto santo in uno quadro
1 Vergene Maria di gesso e 1 San
 Bastiano bianchi
133 pezzi di terra di più sorte cioè
 piattelli, schodelle, mezzette et
 metadelle
22 libri leghati in asse di più volumi
1 libro giallo titolato libro verde
 di ser Piero
1 libro titolato libro di villa coverta
 biancha coregge bianche
1 chalamita in una schatolina
3 stagnoni da utriacha

1 tascha entrovi 3 chiave
1 scharsella usata
1 apamondo [mappamondo, world
 globe]
1 pennarella
1 sacchettino di tavole
1 libro rosso[j] di Francesco fratello di ser
 Piero
 più scripture et atti di piati
 di più persone

Uno paio d'alari da chucina peso libbre 28
Una chatena da fuoco
Uno paio di stadere grosse
Uno paio di chassoni piani
Una lectiera colle chasse, sachone et
 materassa di lana
Una choltrice di penna di pollo
Due primacci di penna sangiovanni
Una coltre cattiva
Uno coltrone di braccia 5 pieno
 di banbagia
Una lettiera colle chasse piccola,
 sachone et materassa
Due sacha di penna di pollo

Uno coltrone cattivo
Una choltrice di braccia 4 uno primaccio
 penna sangiovanni
Uno primaccio di penna di pollo
Una predella da chachare [to defecate]
Una seggiola

[f. 110v]

Una testa di Cristo [e]
Due quadri da lato
Un paio di forzieri a sepultura dipinti
Una Nostra Donna messa a oro
Uno Sancto Francesco con due quadri
Due banbini et due teste et uno
 Sancto Bastiano
Una lettiera colle chasse sachoni
Due materasse di lana da letto
Una coltrice da letto piuma [e]
Due primacci uno primaccio peso
 libbre 130
Uno lettuccio di braccia 4
Uno tappeto di braccia 4 da lettuccio
Uno materassino da lettuccio
Uno tappeto di braccia 5 raso
Uno descho d'albero
Uno armario in camera
Uno sopracielo colle cortine
Due forzeretti ferrati
Una sargia rossa

[f. 111r]

Uno lettuccio dipinto
Uno chassone a sepultura di noce
Una lettiera, chasse, sachone,
 materassa di lana
Uno primaccio di penna
Una coltrice di penna d'ocha [e]
Un primaccio peso libbre 108
Tre teste in sull'uscio
Uno coltrone pieno di banbagia
Una pancha
Uno descho

Uno tondo
Una Nostra Donna
Una tavola di braccia 5 con trespoli
Una tavola di braccia 7 con trespoli
Due panchaccie
Due teste in quadri di donne

Una coltre da letto
Una lettiera, chasse, sachoni,
 materassa di lana
Uno lettuccio in detta camera
Uno materassino di pelo
Uno panno da letto vermiglo
Uno sciugatoio da lettuccio
Una coltre da letto a agho
Uno sopracielo piano con una palla
Una coltre tessuta usa
Uno usciale da camera a fighure
Uno tappeto di braccia 5
Una coltrice [e]
Uno primaccio peso libbre 76
Uno primaccio
Una tavola con trespoli di braccia 4
Una pancha
Un descho
Uno paio di forzieri dipinti nell'altra
 casa [the house with entrance in
 Via dell'Agnolo]

Uno sacho da grano coll'asse
Una archa
Una tavola
Tre sacha da grano
Uno armario
Una pancha da scrivere
Uno staio di legno
Due schale di legno a piuoli
Tre botti di tenuta
Due chaldaie
Uno treppiè

Uno ramaiuolo

Uno barachano di braccia 7 da arazo

Uno cappuccio di panno rosato

Una chotta di taffetà changiante

Una cioppa di cianbellotto nera foderata

Una cioppa di panno pagonazo foderata
di zibellini

Uno farsetto di raso nero

Una gammurra di panno alazato

[f. 111v]

Uno cioppone di panno bigio fiandrescho
foderato di dossi

Uno cioppone di panno pagonazo
foderato di vai

Uno mantellino di domaschino bigio
foderato di dossi

Uno mantellino bigio doppio di biancho

Uno mantellino fodera biancha

Uno chapuccio di panno nero da huomo

Uno cioppone di panno bigio fiandrescho
foderato

Uno mantello [e]

Uno chapuccio di panno monachino

Una cioppa di panno nero da donna

Una cioppa di panno mischia

Una cioppa di panno pagonazo

Una gammurra di perpignano biancho

Una robetta di saia nera da donna

Una ghammurra di saia a ucellini azurra et
biancha

Una cioppa di panno pagonazo da donna
foderata

Tre chappucci di panno di più colori
se la penna non à errato

Una gabbanella di saia nera

Una gabbanella, cioè di saia nera

Uno cioppone bigio foderato

Una gabbanella pagonaza

Uno chapperone di panno nero

Una gabbanella di panno nero doppia
di rovescio

Tre farsetti di più ragioni

Tre sechie di rame

Cinque botti grandi di barili 50

Cinque botti di tenuta di barili 40

Notes

Chapter I

1 AOSMF, Battesimi 4, f. 96.

2 ASF, Sebregondi 2522.

3 ASF, Dec. grand. 3563, f. 61.

4 The two buildings were sold in 1564 (ASF, Dec. grand. 2299, n. 264.) and demolished in 1584 (ibid. 2330, n. 25).

5 ASF, Gherardi-Piccolomini-D'Aragona 324, f. 4.

6 ASF, Catasto 68, ff. 264–5; ibid. 705, f. 96; ibid. 813, f. 444.

7 J. Henderson, *The Renaissance Hospital*, London, 2006, p. 251.

8 For the 'Monte delle Doti', see A. Molho, *Marriage Alliance in Late Medieval Florence*, London 1994, pp. 27ff.

9 Villata, p. 13.

10 ASF, Catasto 1009, f. 3.

11 ASF, Dec. rep. 20, f. 27; ASF, SMN 5745, f. 178.

12 ASF, Notarile 17151, f. 484.

13 Antonmaria described the podere of San Silvesro: 'a farm located in the parish of San Donato in Poggio, the place known as San Silvestro, with its boundaries, consigned to Francesco del Giocondo as the dowry of his daughter Lisa on 6 March 1495 (1494 Florentine style)': ASF, Dec. rep. 20, f. 26v. Indeed, the notarial act for the delivery of the dowry was signed on 5 March 1495.

14 Michelangelo bought the two estates in Chianti in 1549. See ASF, Dec. grand. 3601, f. 41v.

15 For date of birth of Noldo: AOSMF, Battesimi 4, f. 110; Camilla: ibid. f. 132; Giovangualberto: Online Tratte, see 'gherardini'; Francesco: AOSMF, Battesimi 5, f. 65v; Ginevra: ibid. 224, f. 99; and Alessandra: ibid. f. 114v.

16 ASF, Dec. rep. 17, f. 74.

17 ASF, Corp. relig. 78, n. 79, f. 134.

18 AOSMF, Battesimi 2, f. 123.

19 ASF, Catasto 79, ff. 290v–292v.

20 Ibid. 79, ff. 338–42; ibid. 65, f. 81v; ibid. 906, f. 419; ibid. 994, f. 153.

21 ASF, Dec. rep. 28, ff. 407r–408v.

22 In 1472, as Benedetto Dei wrote in his 'Cronica', in Florence there were 270 wool workshops, 83 silk workshops, and 33 large banks. See B. Dei, *La Cronica*, ed. by Roberto Barducci, Firenze, 1984, pp. 84–5.

23 In 1458, the Del Giocondo brothers had debts amounting to approximately 3,500 florins and credits of 2,700 florins which included around 300 florins from Giovanni di Paolo Rucellai and 1,600 from Benedetto di Francesco Strozzi: ASF, Catasto 820, ff. 340, 341v.

24 Bartolomeo bought the two Montughi estates between October 1463 and January 1464: ibid. 820, f. 55.

25 According to the Baptismal Registers and the 1480 tax return, he had nine children: Giocondo who was born in 1457 (AOSMF, Battesimi 1, f. 182), Alessandra in 1459 (ibid. f. 212), Caterina in 1460 (ibid. f. 249v), Giuliano in 1461 (ibid. 2, f. 27v), Gherardesca in 1463 (ibid. f. 85), Francesco in 1465 (ibid. f. 123), Lisa in 1468 (?), Margherita in 1470 (ibid. f. 80v), and Marietta in 1477 (?).

26 AOIF 13147, ff. 2, 7, 20, 21, 27, 34, 42, 47, 51, 53, 58, 64, 123.

27 Ibid. 13149, ff. 1 and 3v; ibid. 13150, f. 10.

28 Hatfield, p. 7.

29 ASF, Notarile 17146, ff. 57, 62v, 64, and 66v.

30 ASF, Dec. rep. 28, ff. 407–8.

Chapter II

1 There is no mention of a woman called Tommasa in the tax returns of the Villani family. This must be one of the many inaccuracies in seventeenth- and eighteenth-century genealogical trees, where names are often confused. His marriage to 'Tommasa Villani' is highly unlikely because in the 'Monte delle Doti' (Dowry Fund) records for the period 1493–4 Francesco del Giocondo was always referred to as Camilla Rucellai's husband: ASF, Monte comune 1397, ff. 32v and 63v.

2 ASF, Grascia 190, f. 241, and also ASF, Corp. relig. 102, Appendix 19, f. 39v.

3 ASF, Catasto 1012, f. 126v; ibid. 820, f. 340; ibid. 1012, f. 126v.

4 On Camilla Rucellai's birth see AOSMF, Battesimi 4, f. 21v.

5 Hatfield, p. 16, n. 47, notes that Camilla Rucellai's tomb is in the vault of the Del Giocondo family in Santa Maria Novella.

6 ASF, Notarile 10584, ff. 248v–249.

7 On marriage in Tuscany see D. Herlihy and C. Klapisch-Zuber, *Les Toscans et leurs familles. Une étude du catasto florentin de 1427*, Paris, 1978 (*I toscani e le loro famiglie*, Bologna, 1988, pp. 533 and ff.); C. Klapisch-Zuber, *La famiglia e le donne nel Rinascimento a Firenze*, Bari, 2004, pp. 112 and ff.; A. Molho, *Marriage Alliance in Late Medieval Florence*, London, 1994, pp. 138 and ff.; D. Lombardi, *Storia del matrimonio*, Bologna, 2008, pp. 21 and ff.

8 ASF, Catasto 1015, f. 11v.

9 Piera, Francesco del Giocondo's mother, died in 1492. See Hatfield, p. 8, n. 18.

10 In 1501, when Francesco and his brother Giuliano were dividing property, the house was described as a building with floors, halls, rooms, land, a porch, a courtyard, and a stable: ASF, Notarile 17146, f. 64v.

11 The Montughi villa and estate were sold by his son Francesco to Bonaccorso Uguccioni in 1516, for 900 gold florins. In the bill of sale it was written that the villa

was located in a place called 'al luogho di Francesco del Giochondo': ASF, Notarile 13593, f. 67.

12 AOSMF, Battesimi 224, ff. 6v, 79v, 92, 138; ibid. 6, f. 126; ibid. 225, f. 285.

13 In his will Francesco made a provision as to Lisa's clothes and jewellery: ASF, Notarile 7799, f. 6.

14 AOIF 13148, ff. 12, 14, 17.

15 Piero was born on 24 May 1496: AOSMF, Battesimi 6, f. 71v.

16 Piera was born on 5 May 1497: ibid. 225, f. 240v, and died on 4 June 1499: ASF, Corp. relig. 102, Appendix 68, f. 8v.

17 Camilla was born on 9 August 1499: AOSMF, Battesimi 225, f. 273.

18 Marietta was born on 11 November 1500: ibid. 225, f. 282v; Andrea on 12 December 1502: ibid. 7, f. 17; Giocondo on 20 December 1507: ibid. f. 102v, died in January 1508. He was buried in the Del Giocondo family vault in the church of Santa Maria Novella: ASF, Corp. relig. 102, Appendix 68, f. 23.

19 ASF, Notarile 7799, f. 268.

20 Ibid. 17147, ff. 440–1.

21 ASF, Otto di Guardia 152 bis, f. 173v.

22 Villata, p. 9.

23 Sister Beatrice died on 9 January 1518: ASF, Corp. relig. 108, 12, f. 204.

24 In 1503 Francesco undertook to provide his daughter Camilla with a dowry of 1,000 florins if she married and 200 if she became a nun: ASF, Notarile 17146, ff. 150–1.

25 ASF, Corp. relig. 100, 89, book 4, f.n.n.

26 N. Lemery, *Pharmacopée Universelle*, Paris, 1738, pp. 757–8.

27 Lisa delivered 95 pounds of cheese to the nuns and their payment was registered on 8 September 1523: ASF, Corp. relig. 100, 89, book 4, f.n.n. One Florentine pound corresponded to around 340 grams.

28 http://www.chnt.at/wp-content/uploads/Battini_etal_2014.pdf. The convent is scheduled to be converted into a cultural centre.

29 For an informative series of account books, see Rogers Mariotti, pp. 80–92.

30 ASF, Corp. relig. 100, 89, books 3, 4 and 5, f.n.n.; ibid. 51, ff. 11 and 32.

31 ASF, Notarile 17146, ff. 62–9; ibid. 17151, ff. 484–94.

32 Ibid. 17146, ff. 150–1.

33 ASF, Dec. rep. 178, n. 346. The house was rather modest; located next to his house, it could not stand comparison with the one where Lisa and Francesco lived. Indeed they never returned there. He bought it in 1503, paying 260 gold florins; in 1507 he resold it for 403 florins. See ASF, Notarile 17146, f. 160 for the purchase, and ibid. 17147, f. 402 for the resale. It has been wrongly suggested that it was Lisa and Francesco's new house and that, as such, it was linked to the commission of the famous portrait.

34 Villata, pp. 166–8.

35 Ibid. pp. 159–61.

36 Hatfield, p. 5, note 11.

37 Online Tratte, see 'delgiocondo'.

38 Rogers Mariotti, p. 94.

39 ASF, MAP 108, no. 144: Hatfield, pp. 129–31. Filippo Strozzi, 26 Sept. 1515 letter to Lorenzo de' Medici:

Francesco del Giocondo was here to see me at home today, and after many words he confided in me that a friend of his had told his son Piero in secret that your Excellency and I were his [Francesco's] enemies and that in every way we will ruin him by means of arbitrary denunciations or in another manner. The cause of the enmity was our having tempted his M. Lisa in her honour, without her consenting, for this reason we were outraged, disregarding his faithfulness to your house, and that he would not refuse to shed his blood for you, but that her honour mattered too much. I liked this pronouncement a lot, and in reply I said that, as far as I was concerned, I had never given any thought to his women, but seeing how confidentially and freely he had proceeded with me, I could not deny to him that I had sooner thought about the males, which was just the normal thing. As far as your Excellency is concerned, I did not know of anything bad whatsoever; on the contrary, I had always heard you count Francesco among your close servants and faithful friends, and that I had never heard you complain about him on account of his women. He replied that he was sure to be in good standing with your Excellency, and that you had already spoken to the woman in a little hut [*capannuccia*]. He departed all content and satisfied. I have not added or left anything out but faithfully recounted everything; and in order that Your Excellency can gain the same pleasure out of this that I did, I did not want to defer telling you until we can speak. [Translation based on Hatfield.]

40 Hatfield, p. 40, suggests that Filippo Strozzi treated Francesco with a degree of scorn, which could have been the result of a business deal that had gone wrong a few months earlier. In August 1514 Pope Leo X awarded Francesco, together with two other Florentine bankers, the contract to administer the customs of Rome and the following year he resold his share to Filippo Strozzi for 1,100 gold florins through a complicated transaction that could have soured their relationship.

41 Ibid. p. 139.

42 ASF, Otto di Guardia 147, ff. 19–20.

43 ASF, Notarile 6679, ff. 320v, 337v, 340v, 342v, 345, 532, 551, 561, 575v, 594.

44 ASF, Libri di commercio 712, f. 7v.

45 ASF, Notarile 6679, ff. 561, 594, 606, 637; ibid. 6680, f. 197.

46 ASF, Corp. relig. 119, 50, f. 109v.

47 AAF, Cause Civili 268, file 3; ibid. 67, file 10.

48 ASF, Notarile 17148, ff. 298–9.

49 Ibid. 17147, f. 141; ibid. 17148, f. 298; ibid. 17150, ff. 130 and 583.

50 ASF, Dec. grand. 3611, f. 162v.

51 ASF, Dec. rep. 28, f. 407; for the workshop located near Piazza Signoria, ASF, Notarile 6682, f. 98v.

52 ASF, Dec. rep. 28, ff. 407v and 409v; ASF, Dec. grand. 3629, ff. 351v–352.

53 ASF, Notarile 6684, f. 433v.

54 In 1532, Francesco had no part in the running of the family workshops. Instead, he owned a large amount of land: ASF, Dec. grand. 3629, ff. 351v–354.

55 ASF, Monte comune, Part I, 990, f. 203.

Chapter III

1 ASF, Corp. relig. 98, 54, f. 105 for Francesco del Giocondo's payment, and f. 173 for Sandro Botticelli's.

2 Vasari, IV, pp. 160 and 611.

3 ASF, Monte comune 965, f. 728.

4 At the beginning of the sixteenth century, the Buonarroti were in dire financial straits and until 1505 they were ineligible to hold public offices because they did not pay taxes. Starting from 1508 they became regularly eligible, presumably because Michelangelo paid their taxes: see Rab Hatfield, *The Wealth of Michelangelo*, Rome, 2002, pp. 211–12.

5 In the 1561 census of houses and workshops, the owner of the house next door to the Palazzo Spinelli in Borgo Santa Croce was named Giorgino d'Arezzo: ASF, Dec. grand. 3781, f. 9. The house was given to him by Duke Cosimo that same year.

6 ASF, Corp.relig. 119, 203, f. 1 and ASF, Arte della seta 13, f. 54.

7 In 1532, Leonardo and Tommaso di Amadio del Giocondo owned the shares which they had inherited from their father as well as half of those inherited by Antonio's (ASF, Dec. rep. 26, ff. 118 and 97) and Francesco's entire share (ibid. 28, f. 407).

8 Vasari, IV, p. 351.

9 G. Gardner, 'The Paintings of Domenico Puligo', PhD dissertation, Ohio State University, 1986. For a good account of Francesco's involvement with art, see Frank Zöllner, 'Leonardo's Portrait of Mona Lisa del Giocondo', *Gazette des Beaux Arts*, CXXI, 1993, p. 124.

10 Vasari, I, p. 250. Vasari considered it to be Puligo's masterpiece: 'the best work ever executed by Domenico was a large painting in which he represented life-size a figure of the Virgin with some Angels and little angels and a figure of Saint Bernard who is writing; this painting is now in the possession of Giovangualberto del Giocondo and Messer Niccolò, his brother, a canon of San Lorenzo in Florence'.

11 Vasari, IV, pp. 250–1: 'For Francesco del Giocondo, Domenico painted a picture of Saint Francis who is receiving the stigmata, on a panel destined for his chapel in the main apse of the church of the Servites in Florence; this work is very soft and gentle in colouring and it is executed with utmost care.' On Francesco's death, his son Bartolomeo placed a different painting in the chapel, which was less beautiful. Vasari's source was the memoir of Father Eliseo Biffoli, a monk of the Annunziata: ASF, Corp. relig. 119, 59, f. 17v.

12 Vasari, IV, p. 514.

13 On 5 July 1558, his mother died (ASF, Grascia 191, f. 230v), and many monks of the Annunziata participated in the funeral which took place in the church of Santa Croce: ASF, Corp. relig. 119, 815, f. 2.

14 Iacopo da Pontormo painted the fresco of the *Visitation* in the *antiporto* (atrium). According to Father Eliseo Biffoli's *Libro di memorie*, the friars paid the young painter the very modest sum of 11 *scudi*, 'se ben Giorgio Vasari dica sedici [even if Giorgio Vasari says sixteen]': ASF, Corp. relig. 119, 59, f. 8v. For the payment see Vasari, V, pp. 314–15. Father Eliseo was well acquainted with Vasari and the artists of the *Accademia del Disegno*. He celebrated Mass at the beginning of their meetings in the Chapter of the Annunziata: ASF, Accademia del Disegno 24, f. 15.

15 Bartolomeo was buried on 11 December 1561 (ASF, Corp. relig. 119, 815, f. 20v); Piero on 28 February 1569 (ibid. f. 72v).

16 ASF, Corp. relig. 119, 52, f. 143; ibid. 65, f. 350; ibid. 815, f. 145v.

17 Archivio di Stato di Arezzo, Archivio Vasari, 30 (Memoirs of Giorgio Vasari, from 1527 to 1572), f. 21v.

18 The position of the house can be deduced from the number it was given in the 1561 'Censimento delle case e botteghe di Firenze'. Starting from Piazza San Marco, the first building was number 1523, Piero's was number 1539, and the one on the corner with Via Alfani was number 1544: therefore, Piero del Giocondo's house stood near this corner. See ASF, Dec. grand. 3783, f. 99v.

19 Vasari, IV, pp. 16, 20, 22.

20 Ibid. pp. 30–1.

21 In January 1537, when Francesco made his will, Andrea was already dead and indeed, he does not feature among his heirs.

22 See ASF, Notarile 6688, ff. 316–17 and 327–30.

23 ASF, Notarile 7799, ff. 5–5v and f. 7.

24 Hatfield, pp. 138–9 expresses serious doubts as to Francesco's sincerity and the parts of the will where he praises his wife.

25 ASF, Notarile 7799, ff. 6–8.

26 Two documents show that Francesco died at the beginning of March 1538. One of them is the acceptance of his inheritance signed by his sons on 1 April 1538, where Bartolomeo and Piero said that he had died a month before. See ibid. 13385, f. 259. The other one is a legal act dated 20 August 1538, in which the notary stated that 'Francesco died in March 1538': ibid. 6689, f. 77v.

27 Ibid. 6689, ff. 286v–290.

28 'Monna Lisa donna fu di Francesco del Giocondo morì addì 15 di luglio 1542 e sotterrossi in Sant'Orsola. Tolse tutto il Capitolo.' See Archivio Capitolare di San Lorenzo 4904, f. 139v.

29 The deed of acceptance of inheritance was signed by her son Piero on 18 July 1542 and the notary stated that Lisa had died on 14 July 1542: ASF, Notarile 2565, f. 81v.

30 Ibid. 6691, ff. 8, 9, 289, and ibid. 21104, f. 221.

31 The agreement between Bartolomeo and Piero was signed on 13 January 1543: ibid. 21104, ff. 347v–349.

32 For the deed of sale and interiors of the house in Via della Stufa, see ibid. 9756, f. 346v.

33 Bartolomeo died on 11 December 1561: ASF, Corp. relig. 119, 815, f. 20v. Piero died on 28 February 1569: ibid. f. 72v. Both were buried in the sepulchre built by their father in 1526.

34 Gaspare was born on 5 September 1533, and he was the first child of Bartolomeo del Giocondo and Maddalena Ricasoli: AOSMF, Battesimi 10, f. 8v.

35 The proceedings started in December 1563 and were over in June 1565: ASF, Mercanzia 10959, f.n.n.

36 ASF, Corp. relig. 119, 53, ff. 106, 152.

Chapter IV

1 At the beginning of the fourteenth century, the members of the family were not known by the surname 'Da Vinci' but rather by their patronymic: in 1412, Ser Piero di Ser Guido, Antonio's father and Leonardo's great grandfather, was registered in the Real Estate Registry as 'Ser Piero di Ser Guido notaio di Vinci e cittadino fiorentino [Ser Piero di Ser Guido notary from Vinci and Florentine citizen]': ASF, Estimo 226, ff. 550 and 569v.

2 ASF, Notarile 16823, ff. 14–44.

3 Ser Piero drew up a legal act in Pisa on 23 January 1452 and the following day he drafted another one in Via Ghibellina in Firenze: ibid. 16823, ff. 80 and 82.

4 Ibid. 16823, ff. 44–5.

5 Ser Piero drew up three legal acts on 7, 15, and 29 July 1451: ibid. 16823, ff. 55–7.

6 In the tax return which Antonio, Ser Piero's father, submitted in 1458, Albiera was said to be 21 years old: ASF, Catasto 795, f. 503. For Ser Piero and Albiera Amadori's house in Borgo dei Greci, see Ulivi, pp. 8–10.

7 ASF, Corp. relig. 78, 79, f. 134.

8 Antonia was baptized on 16 June 1463 (AOSMF, Battesimi 2, 75v) and buried in San Biagio on 21 July 1463 (ASF, Medici e Speziali 245, f. 49v); her mother, Albiera, died on 15 June 1464 (ibid. f. 67).

9 Francesca di Ser Giuliano Lanfredini was born on 5 December 1449. See Ulivi, pp. 12–14.

10 ASF, Medici e Speziali 245, f. 195v.

11 Margherita di Francesco Giulli was baptized on 30 December 1457: AOSMF, Battesimi 1, f. 185v.

12 Antonio was born on 26 February 1476: ibid. 4, f. 39v; Maddalena was born on 4 November 1477: ibid. f. 71 and died on 27 November 1477: ASF, Medici e Speziali 246, f. 27v; Giuliano was born on 31 December 1478: AOSMF, Battesimi 4, f. 88v; Lorenzo on 24 October 1480: ibid. f. 114; Violante on 27 November 1481: ibid. f. 133; Domenico on 21 February 1483: ibid. 5, f. 19v; Bartolomeo was born on 29 June 1485: ibid. f. 55; and died on 19 December 1485: ASF, Medici e Speziali 246, f. 108v.

13 Ser Piero and his family moved to Via Ghibellina on 1 March 1480: ASF, Catasto 1001, f. 124.

14 See Rab Hatfield, *The Wealth of Michelangelo*, Rome, 2002, p. 65.

15 Margherita Giulli died on 26 August 1485: ASF, Medici e Speziali 246, f. 104v.

16 Lucrezia di Guglielmo Cortigiani was baptised on 5 March 1459: AOSMF, Battesimi 1, f. 215v.

17 Guglielmo was born on 21 October 1486: ibid. 5, f. 75v; and died on 5 December 1486: ASF, Medici e Speziali 246, f. 118v; Margherita was born on 16 December 1487: AOSMF, Battesimi 224, f. 89v; and died on 5 May 1490: ASF, Medici e Speziali 247, f. 4v; Benedetto was born on 18 March 1489: AOSMF, Battesimi 5, f. 115v; Pandolfo on 28 July 1490: ibid. 5, f. 137; Guglielmo on 6 June 1492: ibid. 6, f. 4; Bartolomeo on 30 July 1493: ibid. 6, f. 23v; Margherita on 3 January 1496: ibid. 225, f. 219; Giovanni on 9 January 1499: ibid. 6, f. 111.

18 ASF, Notarile 16837, f. 279v.

19 Ibid. 16833, f. 535v; ibid. 16834, f. 413.

20 ASF, Corp. relig. 119, 700, f. 82; ibid. 625, ff. 38v and 95v; ibid. 199, f. 92.

21 The Florentine calendar was known as '*ab incarnatione* [from the Incarnation of Christ]' and it started exactly nine months before Christ's birth.

22 ASF, Corp. relig. 119, 700, ff. 19v, 23 and 24v; ibid. 701, f. 19; ibid. 51, f. 200v.

23 Vasari, IV, p. 347. Friar Mariano performed the duties of a sacristan and sold candles: ASF, Corp. relig. 119, 199, ff. 10 and 254; ibid. 700, ff. 23v, 33, 34. In December 1500, he signed a sale and purchase agreement drafted by Ser Piero da Vinci: ibid. 50, f. 90. He died in 1515: ibid. 52, f. 97v.

24 Ser Piero had known all three of them at least since 1474. See ASF, Notarile 16829, ff. 280 and 282; ibid. 16837, f 279v.

25 The document begins as follows: 'Act formulated on the day of 17 February 1497 in Florence in the quarter of Santa Cecilia in the workshop of the silk merchant Antonio di Zanobi del Giocondo and company. Present, Miniato di Piero Miniati, silk merchant, and Francesco di Piero del Maestro Ugolino, quarter of San Michele Berteldi. Compromise [between the brothers of the Annunziata and Antonio and Francesco del Giocondo].

 Father Stefano di Giuliano da Milano, auditor and procurator of the prior, monks, chapter and monastery of Santa Maria dei Servi in Florence, on one side…and Antonio di Zanobi del Giocondo and Francesco di Bartolomeo del Giocondo, on the other…' The accord concerns a vexing civil dispute in which they were involved with the two merchants: ASF, Notarile 16837, f. 279v.

26 ASF, Corp. relig. 119, 50, f. 109v; ibid. 700, ff. 26, 166v.

27 Ibid. 119, 50, ff. 30v–31.

28 In November 1500, Father Valerio paid 14 *soldi* to the notary Ser Gaspare di Ser Santi della Pieve to prepare the document whereby Friar Zaccaria was to 'poter obrigare il Convento a Lionardo [have the power to obligate the Convent to Leonardo]': ibid. 119, 700, f. 113. For the story of the commissions, see J. Nelson, 'The High Altar-Piece of SS. Annunziata in Florence: History, Form, and Function', *The Burlington Magazine*, CIIIIX, 1997, pp. 84–94.

29 The agreement with Baccio d'Agnolo was signed on 15 September 1500: Friar Zaccaria pledged to pay 150 gold florins and Baccio undertook to finish the woodwork by June

1502: ASF, Corp. relig. 119, 59, f. 210. Filippino Lippi received his commission on 15 September 1503, and the painter undertook to paint the panel by April 1504, for 200 florins. Perugino received three-quarters of the sum which had been promised to Filippino. Another 240 florins were paid to Francesco di Nicolò to gild the altarpiece: ibid. 119, 199, ff. 122, 151, 221.

30 Vecce, p. 230.

31 The arbitration was completed on 15 June 1503 in Francesco del Giocondo's house in Via della Stufa, whose boundaries were listed too. See ASF, Notarile 17146, ff. 176v and 179–80.

32 Father Valerio appointed him his '*mallevadore* [guarantor]' in a legal act dated 26 December 1511: ASF, Corp. relig. 119, 52, f. 80v.

33 Father Valerio died on 4 January 1522: ASF, Corp. relig. 119, 347, f. 188v.

34 Ibid. 119, 52, ff. 107v–108.

35 Arundel, 272r; Villata, p. 173, no. 197.

36 ASF, Notarile 5111, ff. 93–111v.

37 The estate was divided in equal shares: four-ninths went to Margherita's sons; five-ninths to Lucrezia's. See ibid. 18271, ff. 130–1.

38 The inventory was mostly carried out in July, shortly after Ser Piero's death, and was completed on 18 August 1504. See ibid. 5111, ff. 107–110v. By that time the building had already been divided into two houses (ibid. f. 110v). The full inventory is available in the appendix.

39 A comparison on a much grander scale is the Medici inventory of 1482: *Lorenzo de' Medici at Home: The Inventory of the Palazzo Medici in 1492*, ed. R. Stapleford, University Park, 2013 (*Libro d'inventario dei beni di Lorenzo il Magnifico*, ed. M. Spallanzani, G. Bertelà, S. Di Stagio dalle Pozze, Florence, 1992).

40 For a fine account of the terminology of furnishings, see Peter Thornton, *The Italian Renaissance Interior 1400–1600*, London, 1991 (*Interni del Rinascimento Italiano*, Milan, 1992). The 'lettucci' in Ser Piero's house were usually covered with a rug which was about 2.5 metres long: ASF, Notarile 5111, f. 110v.

41 ASF, Notarile 5111, f. 108.

42 On the whole matter, see Ulivi, pp. 42–7.

43 ASF, Dec. rep. 61, f. 677; ASF, Dec. grand. 2983, n. 18.

44 For the sale of the house in 1529: ASF, Notarile 9750, f. 2; for that of 1530: ibid. f. 129v; for its transcription in the land books in 1534: ASF, Dec. grand. 2983, n. 18.

45 Vasari, V, p. 231.

46 ASF, Dec. grand. 3781, f. 46.

47 ASF, Catasto lorenese 293, n. 251.

48 These figures derived from the following sources: ASF, Estimo 216, ff. 88–96 (for 1384); ibid. 226, ff. 494–517v (for 1412); ASF, Catasto 174, ff. 485–535 (for 1427).

49 The data on the families and inhabitants of Vinci in the eighteenth and nineteenth centuries is taken from the 'Lists of Souls' of the church of Santa Croce. See Archivio Chiesa di Vinci, Sez. II, 9 (Stati d'Anime), 1, f. 180 (1750); ibid. 2, f. 10 (1775); ibid. 2, f. 60 (1780); ibid. 3, f. 37 (1790); ibid. 3, f. 134v (1800); ibid. 3, f. 250v (1810); ibid. 4, f. 125 (1820); ibid. 5, f. 69v (1830).

50 This list of professions is derived from the analysis of the tax returns submitted by the inhabitants of Vinci in 1451 (ASF, Catasto 750, ff. 648–958), and in 1459 (ibid. 871, ff. 1–304).

51 The distribution of households by taxable assets, including houses, was as follows: between 0 and 50 florins (those who owned nothing or very small properties), 147 households (69.4%), with the average value of taxable assets being 26 florins, which meant widespread poverty; between 51 and 200 florins (the owners of small and medium-size properties), 56 households (26.4%); between 201 and 600 (wealthy proprietors), nine households (4.2%). For the classification of households by taxable assets, see E. Conti, *La formazione della struttura agraria moderna nel contado fiorentino*, III, Part II, Roma 1965, pp. 11–12.

52 ASF, Catasto 1052, f. 276.

53 ASF, Estimo 226, f. 569 (for the beginning of the fifteenth century) and ASF, Catasto 871, ff. 136, 157, and 200 (for the middle of the fifteenth century).

54 ASF, Catasto 67, f. 158v–159.

55 Antonio recorded the dates of birth of his children and of his grandson Leonardo on the last folio of his father's notarial register. Piero was born on 19 April 1426, Giuliano on 31 May 1428 (and he died soon after his birth), Violante on 31 May 1432, and Francesco on 14 August 1436. See ASF, Notarile 16912, f. 105v.

56 ASF, SMN 70, f. 66–67v, and ibid. 80, ff. 106–7.

57 In 1433, Antonio had to pay the hospital 23 of the 30 florins promised: ASF, Catasto 490, f. 43.

58 ASF, Catasto 795, f. 502.

59 In 1469, Ser Piero and Francesco stated that they used the house as their home, that it was located in the extramural precinct of the castle, with a plot of land and that it was bounded in the following way: on the first side by the street, on the second and third sides by the properties of the Church (with the landholding known as 'in borgo'), on the fourth side by the street, on the fifth side by Papino di Nanni Banti: ASF, Catasto 909, f. 497.

60 The house which Ser Piero bought in 1460 shared a wall with his father's house, which was then inherited by his brother Francesco: ASF, Catasto 1001, f. 124v.

61 Both in 1495 (ASF, Dec. rep. 67, f. 77), and in 1534 (ASF, Dec. grand. 9500, f. 296), the Dean of the Church stated that the lands *in borgo* bordered the houses of Ser Piero and Francesco di Antonio da Vinci.

62 For the descriptions and boundaries of the houses of Ser Piero and Francesco, see ASF, Dec. rep. 9, f. 1161v and ibid. 8, f. 405.

63 The location of the houses in the current Via Roma can also be inferred from deeds of sale, which contain their boundaries, from the parish books of the Vinci church, which list the families and homes in the *borgo*, and from the changes of ownership: the Da Vinci houses were sold in 1548 to Scarpelli family, in 1652 to Baldassini, and in 1810 the Salvi family, as is clear from the Land Registry, in particular from cadastral books of the early nineteenth century.

Chapter V

1 Villata, p. 3, no. 1.

2 On Monday 24 April 1452, Ser Piero is documented in his office in Via Ghibellina: ASF, Notarile 16823, f. 104 (added folio).

3 When Leonardo was born, his grandfather Antonio was around 80 years old, his wife Lucia was 60, their daughter Violante 20 (but it could be that she was already married and no longer lived with her parents), and their son Francesco 16. For Antonio's age and Lucia's age, see ASF, Catasto 795, f. 503; for Violante and Francesco, ASF, Notarile 16912, f. 105v.

4 ASF, Notarile 16912, f. 105v.

5 For the estate managed by Arrigo, see the 1457 Land Registry declaration: ASF, Catasto 793, ff. 511–15. In 1451, many families in Vinci owed money or wheat to Arrigo di Giovanni (for all his debtors, see ibid. 750, f. 746v).

6 Ibid 750, f. 895; ASF, Estimo 216, f. 93v.

7 ASF, Estimo 226, ff. 497, 508, 512v.

8 ASF, Catasto 174, ff. 496, 517.

9 Ibid. 750, f. 743.

10 'nato di lui et della Chaterina, al presente donna d'Achattabrigha': ibid. 795, f. 503.

11 In general, an average dowry was 80 lire, but sometimes it was less than half of this sum: see marriage acts in ASF, Notarile 6173. In 1478, Antonio Buti gave his daughter Maria a dowry of 40 lire, around 10 florins: ibid. f. 237.

12 Antonio Buti's mother was called Piera: ASF Catasto 174, f. 540.

13 Ibid. 132, ff. 219–20; ibid. 174, f. 540.

14 Ibid. 750, f. 721.

15 Caterina and Antonio Buti's children were: Piera, born in 1454, Maria in 1457, Lisabetta in 1459, Francesco in 1561 (killed in the war in Pisa), and Sandra in 1465: ibid. 871, f. 17 and ibid. 1130, f. 29.

16 In 1451, there were twenty-one Caterinas and two Sandras, one of whom was the wife of Orso Lippi (ibid. 750, ff. 648–959); in 1459, there were twenty-nine Caterinas and three Sandras, including Orso's wife (ibid. 871, ff. 1–301).

17 In 1465, Papo was 16 years old, and Sandra and Orso, together with their children, occupied the house next door in Mattoni, as their house in the castle of Vinci was unfit to live in, having become an open-air shack, roofless and without floors: ibid. 871, f. 220.

18 ASF, Notarile 6173, f. 120; ibid. 6174, f. 3; ibid. 6173, ff. 237 and 279v. Maria's dowry was 40 lire, approximately 6 florins.

19 ASF, Catasto 1052, f. 135.

20 The deed was signed in Vinci on 9 August 1480, 'in a place known as the square': ASF, Notarile 6173, f. 279v.

21 In Antonio Buti's tax return, which he submitted in 1487, the Land Registry officials later added that he had died, without giving the year. We can assume, however, that he had passed away shortly thereafter: ASF, Catasto 1130, f. 29. On the marriage of

Caterina and Antonio Buti's third daughter Lisabetta, and her dowry settlement formalized by a legal deed drawn up by Ser Piero on 7 September 1487, see ASF, Notarile 16834, ff. 473v–474.

22 ASF, Catasto 871, f. 234; ibid. 174, f. 496; ibid. 1052, f. 272; ibid. 1130, f. 167.

23 For Lorenza's 1451 tax return, see ibid. 750, f. 843; for Fiore's tax return, ibid. f. 862.

24 ASF, Notarile 6173, ff. 331v–332; ASF, Dec. rep. 9, f. 1163v; ibid. 324, f. 311.

25 Villata, p. 5, no. 2.

26 Ibid. p. 7, no. 3.

27 Vecce, p. 59.

28 Villata, p. 172, no. 195.

29 Ibid. p. 219, no. 252; Vecce, p. 271; Ulivi, pp. 32 and 37.

30 Villata, p. 7, no. 5.

31 Forster III 88r: 'Caterina venne a dí 16 luglio 1493'.

32 Villata, p. 154, note to document IV. 36: Registro dei morti, Archivio di Stato di Milano.

33 Forster II 64v: '*spese per la socteratura di Caterina; in libre 3 di cera; per lo catalecto; palio sopra catalecto; portatura e postura di croce; per la portatura del morto; per 4 preti e 4 chierici; canpana libro spunga; per li socteratori; all'antiano; per la licentia ali ufitiali; in medico; zucchero e candele*'.

Chapter VI

1 Villata, pp. 129–30, no. 134.

2 Amongst the numerous books on the strange history of the painting, see R. McMullen, *Mona Lisa: The Picture and the Myth*, Boston, 1975; A. Chastel, *L'Illustre incomprise. Mona Lisa*, Paris, 1988; and D. Sassoon, *Mona Lisa: The History of the World's Most Famous Painting*, London, 2001.

3 Cicero, *Epistolae ad familiares*, Bologna 1477, Bl. 11a, Heidelberg, Universitätsbibliothek, D 7620 qt. INC: http://diglit.ub.uni-heidelberg.de/diglit/cicero1477?sid=8287842c6716109d2b231e2a21e83a31&ui_lang=eng. Agostino came from Terricciola near Pisa, and was not a member of the same family as the famous Amerigo. See Hatfield, p. 105 n. 270.

4 'N[u]nc ut Appelles Veneris caput & summa pectoris poltiissima arte perfecit: reliquam partecorporis incohatum reliquit.'

5 *Apelles pictor. Ita Leona[r]*

> *dus Vincius facit in o[gn]ib[us] suis*
> *picturis. Ut e[st] Cap[u]t Lise d[el] gio*
> *condo, et anne m[at]ris virginis*
> *videbimus quid facit de aula*
> *mag[ni] consilii, de q[u]a re co[on]venit*
> *ia[m] cum vexill[ari]o. 1503 8.bris*

6 Villata, pp. 166–8, no. 189.

7 Carlo Pedretti, 'La Verruca', *Renaissance Quarterly*, XXV, 1972, pp. 417–25.

8 Richter, II, no. 669; and *Commentary* II, no. 669. For the narrative, see M. Kemp, 'Leonardo's "Most Bestial Madness": His Storyboard for the *Battle of Anghiari*', in *Leonardo da Vinci and the Battle of Anghiari: The Mystery of the Tavola Doria*, Tokyo, 2015, pp. 178–81.

9 Villata, p. 219, no. 252; and Vecce, p. 271.

10 See p. XXX, above.

11 Villata 1999, p. 136, no. 151.

12 Villata 1999, p. 265, no. 316.

13 Vecce, pp. 331–2.

14 The first edition was by Luwig Pastor, *De Reise des Kardinals Luigi d'Aragona…*, Freiburg, 1905. The English edition by John Hale, *The Travel Journal of Antonio Beatis*, trans. J. Hale and J. Lindon, London, 1979, contains much information about the circumstances behind the compiling of the diary.

15 Hale, *The Travel Journal of Antonio Beatis*, pp. 132–3. The translation is modified slightly from Hale.

16 As 's.ra Isabella Gualanda'. Vecce, pp. 334–6 argues ingeniously on the basis of (H) Irpino's poem (see below pp. 161–2, IX, 'Poets look at Leonardo') and Lomazzo's reference (see below, pp. 117–19, VI, 'Artists-authors: Vasari and Lomazzo') that this is the portrait of a woman described by Ambrogio de' Beatis as done at the behest of Giuliano de' Medici, and therefore is what we call the *Mona Lisa*.

17 This portrait was probably obtained by Louis XII when he invaded Milan in 1499: L. Fagnart, 'Leonard de Vinci et la France. Pérégrinations des pientures du maître dans la collection royale au XVIe siècle', *Bulletin de l'AHAI*, X, 2004, p. 121.

18 The list is given by Rogers Mariotti, pp. 92–4.

19 Hatfield, p. 140.

20 See below, pp. 44–5.

21 For earlier suggestions to this effect, see M. Kemp, *Leonardo da Vinci: The Marvellous Works of Man and Nature*, London, 1981, pp. 269–70; and Rogers Mariotti 2009.

22 The Florentine origins of the lady, about which Antonio is clear, eliminates the possibility that the sitter was Pacifica Brandini who died giving birth to Giuliano's illegitimate son, Ippolito. Pacifica was from Urbino. See Roberto Zapperi, *Mona Lisa Addio—la Vera Storia della Gioconda*, Florence, 2012.

23 MS C, 15v: Richter, II, p. 363.

24 Luigi Pulci, *Il Morgante Maggiore*, XXI, 47. Pulci's poem was owned by Leonardo.

25 M. Zecchini, *The Caprotti Caprotti: A Study of the Painter Who Never Was*, Venice, 2013. See more generally for a good account of Salaì.

26 J. Shell and G. Sironi, 'Salaì and Leonardo's Legacy', *The Burlington Magazine*, CXXXIII, 1991, pp. 95–108.

27 Hatfield, pp. 25–6.

28 V. Longoni, *Umanesimo e Rinascimento in Brianza*, Milan, 1998, pp. 170–1; and Villata 1999, nos. 347 and 348.

29 B. Jestaz, 'François Ier, Salaì et les tableaux de Léonard', *Revue de l'Art*, CXXVI, 1999, pp. 68–72.

30 For Francis's extensive collecting of Italian art, see J. Cox-Rearick, *The Collection of Francis I: Royal Treasures*, Antwerp and New York, 1996.

31 L. Fagnart, 'Leonard de Vinci et la France. Pérégrinations des pientures du maître dans la collection royale au XVIe siècle', *Bulletin de l'AHAI*, X, 2004, pp. 121–8.

32 P. Dan, *Le Trésor des merveilles del la maison royal de Fontainbleau*, Paris, 1625, pp. 135–6.

33 P. Rubin, *Giorgio Vasari: Art and History*, London, 1995; and *The Ashgate Research Companion to Giorgio Vasari*, ed. D. Cast, Farnham, 2014.

34 Vasari, IV, pp. 30–1.

35 *Rabisch: Il Grottesco nell'arte del Cinquecento: 'Accademia della Val di Blenio. Lomazzo, and l'ambiente Milanese*, ed. M. Kahn-Rossi and F. Porzio, Milan, 1998. See also M. Kemp, '"Equal Excellences": Lomazzo and the Explanation of Individual Style in the Visual', *Renaissance Studies* (Society of Renaissance Studies Annual Lecture), I, 1987, pp. 1–26.

36 Vecce, pp. 378–9. See also the edition of Lomazzo's writings, *Scritti sulle arte*, ed. R. Ciardi, Pisa, 1973–4.

37 G. P. Lomazzo, *Trattato dell'arte della Pittura*, Milan, 1584, p. 434.

38 M. Kemp, '"Here's Looking at You": The Cartoon for the So-Called Nude Mona Lisa', in *Illuminating Leonardo: A Festschrift for Carlo Pedretti*, ed. C Moffatt and S. Taglilagamba, Leiden and Boston, 2016, pp. 151–68; A. Vezzosi exhibitions of the *'Nude Mona Lisa'* at the Museo Ideale in Vinci (http://www.wix.com/rossylor/gioconde), see below pp. 171–3, IX, 'Painted Poetry', and in the Freedom Tower at Miami Dade College, 'Mona Lisa Unveiled'; and A. Vezzosi and A. Sabato, *Mona Lisa Unveiled*, Vinci, 2011.

39 This suggestion was made by Maria Pavlova: '*e* (&) for *o* is a fairly common error in manuscripts and early printed books and it often results in nonsensical statements. E.g. in the 1516 edition of Ariosto's *Orlando furioso* the Christian paladin Astolfo is told that whoever dares to travel to the lower reaches of the Nile is 'put to death *and* taken prisoner' (XIII 45, 8 A). The printer's error is corrected in the 1521 edition of the poem, where we read 'put to death *or* taken prisoner'. See the critical apparatus in Ludovico Ariosto, *Orlando furioso secondo la princeps del 1516*, ed. by Marco Dorigatti, with the collaboration of Gerarda Stimato, Florence: Olschki, 2006.

40 M. Kemp, '"Equal Excellences": Lomazzo and the Explanation of Individual Style in the Visual Arts', *Renaissance Studies*, I, 1987, pp. 1–26. See also B. Tramelli, 'Artists and Knowledge in Sixteenth Century Milan: The Case of Lomazzo's Accademia de la Val di Blenio', *Art and Knowledge, Fragmenta, Journal of the Royal Netherlands Institute in Rome*, Special Issue, 2011, pp. 121–37.

41 G. P. Lomazzo, *Idea del Tempio della Pittura*, Milan, 1590, pp. 6–7.

Chapter VII

1 Cécile Scailliérez, *Léonard de Vinci: La Joconde*, Musée du Louvre, Paris, 2003.

2 J. Cox-Rearick, *The Collection of Francis I: Royal Treasures*, Antwerp and New York, 1996, p. 153.

3 *The Paper Museum of Cassiano dal Pozzo*, exhibition catalogue London, British Museum, *Quaderni Puteani*, 4, 1993; and http://warburg.sas.ac.uk/research/research-projects/paper-museum-cassiano-dal-pozzo.

4 D. Sparti, *Le collezioni dal Pozzo. Storia di una famiglia...*, Modena, 1992.

5 J. Barone, 'Cassiano dal Pozzo's Manuscript Copy of the Trattato: New Evidence of Editorial Procedures and Responses to Leonardo in the Seventeenth Century', *Raccolta Vinciana*, XXXIV, 2012, pp. 223–86; also more generally for the reception of Leonardo in seventeenth-century France, *Leonardo nella Francia del XVII: Eredità Paradossali*, Lettura Vinciana (2012), Florence, 2013; and 'Seventeenth-Century Transformations: Cassiano dal Pozzo's Manuscript Copy of the *Treatise on Painting*', in *Art as Institution. The Fabrication of Leonardo da Vinci's 'Trattato della Pittura' 1651*, ed. C. Farago, J. Bell, and C. Vecce, Leiden and Boston, 2016, pp. 350–84.

6 Cassiano's account of what he saw in Fontainebleau is in his copy of Leonardo's treatise, the Codex Barberinus Latinus 5688, ff. 192v–195. See Barone, *Leonardo nella Francia del XVII*, p. 8, who also includes Cassiano's accounts of the pictures by Leonardo.

7 See M. Dalivalle, '"Borrowed Comlinesse": Copying from Pictures in Seventeenth-Century England', DPhil thesis, University of Oxford, 2011, p. 157.

8 The relevant inventory is to be cited by Margaret Dalivalle in a forthcoming publication. We are most grateful to her for sharing her unpublished researches.

9 Jonathan Richardson Sr and Jr, *An Account of Some of the Statues, Bas-Reliefs, Drawings and Pictures in Italy, Etc....*, London, 1722, p. 16.

10 Michael Burrell, 'Reynolds's Mona Lisa', *Apollo* (Sept., 2006), pp. 64–71.

11 Christie's, Pall Mall, *A Catalogue of the...Collection of Pictures...of...Sir Joshua Reynolds*, fourth day, 17 March 1795, no. 96.

12 Joseph Pulitzer, *Where Is the Mona Lisa?*, London, c.1966.

13 The Mona Lisa Foundation, *Mona Lisa. Leonardo's Earlier Version*, Zurich, 2012. With a notably un-Leonardesque landscape, lifeless handling, and the widened lateral columns common to many copies, it is related to a finished copy in Oslo, of somewhat lesser quality. It is likely that both are based on an unknown copy.

14 Sassoon, p. 43.

15 Geneviève Bresc, *Mémoires de Louvre*, Paris, 1988, pp. 170–1; trans. Sassoon, pp. 46–7.

16 M. Florisoone and S. Béguin, *Hommage à Léonard de Vinci*, exh. cat., Musée du Louvre, Paris, 1952, which lists twenty-three prints.

17 E. H. Gombrich, 'The Mask and the Face: The Perception of Physiognomic Likeness in Life and Art', in *Art, Perception and Reality*, with J. Hochberg and M. Black, Baltimore, 1972, p. 2.

18 H. Naef, 'Luigi Calamatta', in *Portraits by Ingres: Image of an Epoch*, ed. G. Tinterow and P. Conisbee, London, National Gallery, and New York, Metropolitan Museum of Art, 1999, pp. 312–13.

19 S. Bann, 'Reproducing the Mona Lisa in Nineteenth-Century France', in *Distinguished Images: Prints in the Visual Economy of Nineteenth-Century France*, New Haven, 2013; and *Parallel Lines Printmakers, Painters, and Photographers in*

Nineteenth-Century France, New Haven, 2001; and H. Focillon, 'La Joconde et ses interpretes', in *Technique et sentiment, études sur l'art moderne*, Paris, 1919.

20 Hamid Irbouh, *Art in the Service of Colonialism: French Art Education in Morocco, 1912–1956*, London, 2005, pp. 151–2.

21 S. Aubenas et al., *Gustav Le Gray 1820–1884*, ed. G. Baldwin, Los Angeles, 2002.

22 André Chastel, *L'Illustre incomprise. Mona Lisa*, Paris. 1988, p. 19.

23 A particularly good account of the rise of *Mona Lisa* as a poetic *fèmme fatale* and subsequent literary manifestations is given by Sassoon, pp. 94–172; and less extensively in R. McMullen, *Mona Lisa: The Picture and the Myth*, Boston, 1975, pp. 163–82.

24 T. Gautier, *Les Dieux et les demi-dieux de la pienture*, Paris, 1864, pp. 24–5.

25 W. Pater, *The Renaissance: Studies in Art and Poetry*, London, 1873, pp. 118–19.

26 See particularly, M. Esterow, *The Art Stealers*, London, 1966; and N. Charney, *The Thefts of the Mona Lisa*, New York, 2011.

27 ASF, Tribunale di Firenze, Procedimenti penali risolti con sentenza, anno 1914, fascicolo n. 64, cc. 27–30.

28 H. McLeave, *Rogues in the Gallery: The Modern Plague of Art Thefts*, Raleigh, NC, 2003, p. 25. Geri's own substantial collection was sold in 1930: *Vendita della Raccolta Privata dell'Antinquario Cav. Alfredo Geri*, Florence, 1930.

29 Esterow, p. 151.

30 ASF, Tribunale di Firenze, Procedimenti penali risolti con sentenza, anno 1914, fascicolo n. 64, cc. 66–7.

31 Ibid.

32 Esterow, p. 111.

33 The fullest account of the story is by R. Scotti, *Vanished Smile: The Mysterious Theft of the Mona Lisa*, New York, 2009, pp. 191–207.

34 See N. Charney, *The Thefts of the Mona Lisa*, New York, 2011, pp. 103–6.

Chapter VIII

1 Ovid, *Metamorphoses*, trans. John Dryden et al., book III, http://classics.mit.edu/Ovid/metam.3.third.html.

2 Alberti, para. 26.

3 Pliny, *Natural History*, XXXV, 12: http://www.loebclassics.com/view/pliny_elder-natural_history/1938/pb_LCL394.373.xml.

4 Alberti, para 25.

5 For a telling account of the relationship of poetry to portraiture, see Linda Bolzoni, *Poesia e Ritratto nel Rianscimento*, Roma-Bari, 2008. Also Elizabeth Cropper, 'On Beautiful Women, Parmigianino, Petrarchismo, and the Vernacular Style', *The Art Bulletin*, LVIII, 1976, pp. 374–94.

6 M. Kemp and M. Pagiavla, 'The Master's Shelf' [Leonardo's booklists], *Cabinet*, LII, 2014, pp. 15–19.

7 A telling rebuttal of Leonardo's own claim to be a 'a man without letters' is by C. Dionisotti, "Leonardo uomo di lettere" *Italia Medioevale e Umanistica*' V, 1962,

Milan, 1995, pp. 183–216. For Leonardo's poetic sources, see the fundamental study by E. Solmi, *Fonti dei Manoscritti di Leonardo*, Turin, 1901.

8 *Il codice dell'anonimo Gaddiano (cod. Magliabechiano XVII, 17) nella Biblioteca nazionale di Firenze*, ed. C. von Fabriczy, Firenze 1893, p. 78.

9 Claire Farago, *Leonardo da Vinci's 'Paragone': A Critical Interpretation*, with a new edition and English translation of the text in CU 1270, Leiden, 1992.

10 Urb. 13r: Kemp and Walker, pp. 25–6.

11 Urb. 13v: Kemp and Walker, p. 26.

12 Ubr. 13–14r: Kemp and Walker, pp. 26–7.

13 Urb. 6r–v: Kemp and Walker, p. 28.

14 D. Cast, *The Calumny of Apelles: A Study in the Humanist Tradition*, New Haven and London, 1981; and J.-M. Massing, *De texte à l'image. La calomnie d'Apelle et son iconographie*, Strasbourg, 1990.

15 Urb. 12v: Kemp and Walker, p. 34.

16 For a good discussion and anthology, see Romano, pp. 349–94.

17 Dante, *Vita Nuova*, XXXIV, trans. M. Musa, Oxford, 1992.

18 *Vita Nuova*, XIX.

19 Dante, *Convivio*, II, IX. Unless otherwise stated, all quotations are from *Dante's Il Convivio (The Banquet)*, trans. R. H. Lansing, New York, London, 1990.

20 For this aspect of Dante, see P. Boyd, *Perception and Passion in Dante's 'Comedy'*, Cambridge, 1993. For 'medical' aspects of the temperamental medicine of the poet's passions, see N. Tonelli, *Fisiologia della Passione*, Florence, 2015.

21 Dante, *Vita Nuova*, XXI.

22 Dante, *Vita Nuova*, XXI.

23 Dante, *Convivio*, III, Canzone 2 (authors' italics). Kemp 1981, p. 267.

24 *Convivio*, III, VIII.

25 *Paradiso*, XXIII. All citations of the *Divine Comedy* are from Dante, *The Divine Comedy*, trans. C. H. Sisson with intro and notes D. H. Higgins, Oxford, 1993.

26 *Purgatorio* XXVIII. See M. Kemp, 'Leonardo da Vinci: Science and Poetic Impulse', *Journal of the Royal Society of Arts* (Selwyn Brinton Lecture), CXXXIII, 1985, pp. 196–214.

27 Windsor 12349: 'Passano nostri triunfi, nostre pompe'. Petrarch: 'Passan vostre grandezze e vostre pompe, / passan le signorie, passano i regni [Your grandeur passes, and your pageantry, / Your lordships pass, your kingdoms pass]', *The Triumphs of Petrarch*, trans. E. H. Wilkins, Chicago, London, 1962. See C. Dionisotti, 'Leonardo uomo di lettere', *Italia medioevale e umanistica*, V, 1962, Milan, 1995, p. 193.

28 Windsor 12349v: *La gola e 'l sonno et l'ozioso piume / ànno del mondo ogni vertù sbandita, / ond' è dal corso suo quasi smarrita / nostra natura è vinta dal costum*e. Cf. Petrarch, *RVF*, 7.

29 CA 477v.

30 Triv. 1 b. (1487–90); Richter II, P. 312.

31 Petrarch, *RVF*, 75; *The Canzoniere or Rerum vulgarium fragmenta*, trans. M. Musa, Bloomington, 1999.

32 Petrarch, *RVF*, 123.

33 Milan, Biblioteca Ambrosiana, Ms. S.P. 10.

34 Petrarch, *RVF*, 77.

35 Petrarch, *RVF*, 78.

36 See *The Stanze of Angelo Poliziano*, trans. D. Quint, University Park, PA, 1993.

37 D. Brown, *Leonardo da Vinci: Origins of a Genius*, New Haven and London, 1998, pp. 125–6.

38 Lorenzo de' Medici, *Canzoniere*, XLIX; *Opere*, ed. T. Zanato, Turin, 1992.

39 Lorenzo de' Medici, *Comento de' miei sonetti*, VII, trans. Maria Pavlova.

40 Lorenzo de' Medici, *Comento de' miei sonetti*, VII, trans. Maria Pavlova.

41 Lorenzo de' Medici, *Raccolta aragonese*, V, trans. Maria Pavlova.

42 Giuliano de' Medici, *Poesie*, ed. G. Fantini, Florence, 1939.

43 Based on Hatfield, p. 148.

Chapter IX

1 For the 'academy' see the fine thesis by Jill Pederson, 'The Academia Leonardi Vinci: Visualizing Dialectic in Renaissance Milan, 1480–1499', Johns Hopkins University, 2007, p. 44; and 'Henrico Boscano's *Isola beata*: New Evidence for the Academia Leonardi Vinci in Renaissance Milan', *Renaissance Studies*, XXII, 2008, pp. 450–75.

2 R. Schofield, 'Gaspare Visconti, mecenate del Bramante', in *Arte, committenza ed economia a Roma e nelle corti del Rinascimento, 1420–1530: atti del convegno internazionale*, ed. A. Esch and C. Frommel, Trun, 1995, pp. 297–34.

3 Gaspare Visconti, *I Canzonieri per Beatrice d'Este and per Bianca Maria Sforza*, ed. Paolo Bongrani, Milan, 1979, CLXVIII.

4 Bongrani (ibid. pp. xxiii–xxiv) provides a detailed discussion of the composition and text of the manuscripts.

5 M. Kemp, 'Ogni dipintore dipinge se: A Neoplatonic Echo in Leonardo's Art Theory?', in *Cultural Aspects of the Italian Renaissance: Essays in Honour of Paul Oskar Kristeller*, ed. C.H. Clough, Manchester, 1976, pp. 3, 11–23.

6 Romano, nos. 5–23, conveniently collects Visconti's poems on works of art.

7 Romano, nos. 40–4.

8 Romano, no. 43, trans. Maria Pavlova. Cf. Leonardo, BN 2038 19v; Urb 11r–v: Kemp and Walker, p. 24.

9 Romano no. 40, trans. Maria Pavlova.

10 Angiolillo, pp. 43 For *Paradisi* in Renaissance scene designs, see Alessandra Buccheri, *The Spectacle of Clouds: Italian Art and Theatre*, Farnham, 2014.

11 Villata, p. 76, no. 72c. Translation based on Zöllner, p. 98 and Marani, p. 169. See *Leonardo. La dama con l'ermellino*, exhibition catalogue, ed. Barbara Fabjan and Piero Marani, Rome, Palazzo del Quirinale, 1998.

12 Cambridge, Fitzwilliam Museum: M. Kemp and Juliana Barone, *Leonardo da Vinci. I disegni di Leonardo da Vinci e della sua cerchia. Collezione in Gran Bretagna*, Florence, 2010, no. 3.

13 C. Pedretti, 'La *Dama dell'Ermellino* come allegoria politica', in *Studi politici in onore di Luigi Firpo*, I, Milan 1990, pp. 161–81.

14 P. Cotte, *Lumière on the Lady with the Ermine by Leonardo da Vinci*, Paris, 2014.

15 Villata, pp. 112–15, nos. 129–31.

16 Codice atlantico, 456v. Translation based on Zöllner, pp. 98–9, and Marani, p 177.

17 http://cartelen.louvre.fr/cartelen/visite?srv=car_not_frame&idNotice=13895.

18 Portraits of Casio are in Milan, Pinacoteca Brera, Chatsworth, and San Diego, Timken Museum of Art. For Boltraffio, see M. T. Fiorio, *Giovanni Antonio Boltraffio. Un pittore milanese nel lume di Leonardo*, Milan and Rome, 2000.

19 Vilatta, pp. 289–90, no. 335.

20 Girolamo Casio, *Libro de Fasti*, Bolgna, 1528, CXLIII, in Villata, p. 290, no. 336.

21 A. Venturi, *Storia dell'arte italiana*, IX, 1, *La pittura del Cinquecento*, Milan, 1925, pp. 41ff.; B. Croce, 'Un canzoniere d'amore per Costanza d'Avalos, duchessa di Francavilla', in Id., *Aneddoti di varia letteratura*, I, Bari 1953, pp. 158–65. Villata, pp. 280–2 gives the text of five poems. See also Bolzoni, pp. 184–5; Vecce, pp. 335–6. The dedication of the poems is far from clear and requires further investigation.

22 Both poems tanslated by Maria Pavolva.

23 Joanna Woods-Marsden, 'Portrait of the Lady, 1430–1520', in *Virtue and Beauty: Leonardo's 'Ginevra de' Benci' and Renaissance Portraits of Women*, ed. D. A. Brown, Washington, 2001, pp. 80–1.

24 Vecce, p. 336.

25 See above pp. 107–8, VI, 'Renaissance Records'.

26 For portraits of women, see D. A. Brown, 'Leonardo and the Ladies with the Ermine and the Book', *Artibus et Historiae*, XI, 1990, pp. 47–61; and the National Gallery, Washington, exhibition catalogue, *Virtue and Beauty*, Princeton, 2001; P. Simons, 'Women in Frames: The Gaze, the Eye, the Profile in Renaissance Portraiture', *History Workshop: A Journal of Socialist and Feminist Historians*, XXV, 1988, pp. 4–30, reprinted in N. Broude and M. Garrard, *The Expanding Discourse: Feminism and Art History*, Boulder, 1992, pp. 38–57; and E. Cropper, 'On Beautiful Women, Parmigianino, Petrarchismo, and the Vernacular Style', *The Art Bulletin*, LVIII, 1976, pp. 374–94. See more generally, P. Tinagli, *Women in Renaissance Art: Gender, Representation and Identity*, Manchester, 1997, ch. 2.

27 John Pope-Hennessey, *Italian Renaissance Sculpture*, London 1996, pp. 192, 238–41, 255, 395–7.

28 For a fine overview, see L. Campbell, *Renaissance Portraits: European Portrait-Painting in the 14th, 15th and 16th Centuries*, London and New Haven, 1990 (omitting the *Mona Lisa!*).

29 For the series of profiles, see *Antonio and Piero del Pollaiuolo: 'Silver and Gold, Painting and Bronze…'*, ed. A Di Lorenzo and A. Galli, Milan, 2014, pp. 240–52.

30 For Leonardo and Antonello, see Maria Teresa Fiorio in *Leonardo da Vinci. Il musico*, ed. Pietro Marani, Milan, 2010, pp. 48–59.

31 Ronald Lightbown, *Sandro Botticelli*, London, 1978, II, pp. 28–9. Botticelli's subject is generally identified from the inscription on the ledge as Smeralda Bandinelli, wife

of Viviano Bandinelli and grandmother of the sixteenth-century sculptor Baccio Bandinelli. However, the status of the writing on the ledge of the painted casement is uncertain and the portrait hardly seems to portray a woman over 30 years old, which she would have to be given Smeralda's age. She is listed as 30 years old in her husband's *catasto* in 1469: see L. Waldman, *Baccio Bandinelli and Art at the Medici Court: A Corpus of Early Modern Sources*, American Philosophical Society, Philadelphia, 2004, p. 3.

32 Jennifer Fletcher, 'Bernardo Bembo and Leonardo's Portrait of Ginevra de' Benci', *The Burlington Magazine*, CXXXI, 1989, pp. 811–16.

33 Translation, not in verse form, by John F. C. Richard in John Walker, 'Ginevra de' Benci by Leonardo da Vinci', *Report and Studies in the History of Art*, National Gallery of Art, Washington, 1967, pp. 32–53. Giving her name as 'Bencia' provides a precedent for 'Gioconda' as Lisa's nickname.

34 For the portrait, the attribution of which is much debated, see Martin Kemp and Pascal Cotte, *La Bella Principessa: The Story of the New Masterpiece by Leonardo da Vinci*, London, 2010. See also Martin Kemp, *Leonardo*, rev. edn, Oxford, 2011, pp. 33, 210–11, and 256. For the recent evidence about its origins see Kemp and Cotte, *La Bella Principessa di Leonardo da Vinci. Ritratto di Bianca Sforza*, Florence, 2012.

35 F. Ames-Lewis, *Isabella and Leonardo: The Artistic Relationship between Isabella d'Este and Leonardo da Vinci 1500–1506*, London and New Haven, 2012.

36 Our analysis of the costume is based upon an account specifically provided in November 2105 by Elisabetta Gnignera, the leading historian of dress and hair-styles, to whom we are very grateful. Our argument about the presentation of the sitter has much in common with Joanna Woods-Marsden, 'Leonardo da Vinci's *Mona Lisa*: A Portrait without a Commissioner', in *Illuminating Leonardo: A Festschrift for Carlo Pedretti*, ed. C. Moffatt and S. Taglaigamba, Leiden and Boston, 2016, pp. 169–82, though we see the starting point as a specifically commissioned portrait.

37 In a telling review of portraits of courtesans in the Renaissance, E. R. Kauer makes an ingenious attempt to claim that Lisa's twisted veil is the 'yellow scarf' of a courtesan. However, the argument founders on the absence of any yellow pigment in the veil: 'Leonardo da Vinci's Gioconda and the Yellow Shawl: Observations on Female Portraits in the Renaissance', *Raccolta Vinciana*, XXXIII, 2009, pp. 1–80.

38 See D. A. Brown and K. Oberhuber 'Monna Vanna and Fornarina: Leonardo and Raphael in Rome', in *Essays Presented by Myron P Gilmore*, ed. S. Bertelli and G. Ramakus, I, Florence, 1978, pp. 25–86. Alessandro Vezzosi has organized exhibitions of the '*Nude Mona Lisa*' at the Museo Ideale in Vinci (http://www.wix.com/rossylor/gioconde), and in the Freedom Tower at Miami Dade College, *Mona Lisa Unveiled*, with A. Sabato, Vinci, 2011. I discussed the cartoon briefly in *Christ to Coke: How Image Becomes Icon*, Oxford, 2011, pp. 158–60 and provide a full analysis in '"Here's Looking at You": The Cartoon for the "*Nude Monas Lisa*"', in *Illuminating Leonardo. A Festschrift for Carlo Pedretti*, ed. C. Moffatt and S. Taglialagamba, Leiden and Boston, 2016, pp. 151–68.

39 Sample measurements by Pascal Cotte when we inspected the cartoon together include: the distance between the pupils in the cartoon, 5.9 cm, and in the *Mona Lisa*, 5.1 cm; from the top of the knot of hair above her forehead vertically to the upper contour of her arm in the cartoon, 55.3 cm, and from the top of her hair to her arm in the *Mona Lisa*, 54.2 cm.

40 It features in the Salaì list as a '*quadro cum una meza nuda*'. It is also listed in the 1530 document as '*alius habet figuram unius nude*'. See above VI, note 28.

41 L. de Panthou and B. Peronnet, *Dessins italiens du musée Condé à Chantilly. I, Autour de Pérugin, Filippino Lippi et Michel-Ange*, exh. cat., Chantilly, Musée Condé, 1996, pp. 89–93.

42 The most important is the painting in the Accademia Carrara, Bergamo, generally attributed to Carlantonio Procaccini, on the basis that the flowers resemble those in his still lifes.

43 See D. A. Brown and K. Oberhuber, 'Monna Vanna and Fornarina: Leonardo and Raphael in Rome', in *Essays Presented by Myron P Gilmore*, ed. S. Bertelli and G. Ramakus, I, Florence, 1978, pp. 25–86.

44 *A Woman in her Bath, with a Young Child and a Wet Nurse Suckling a Baby*. A second version of high quality is in the National Gallery, Washington. See H. Zerner, 'Diane de Poitiers, maîtresse de son image', *Acts du Colloque Le Mythe de Diane en France au XVIe Siècle. Albineana*, XIV, 2002, pp. 335–43; and more generally *Renaissance Art in France: the Invention of Classicism*, Paris, 2003.

Chapter X

1 Urb 205r: Kemp and Walker, p. 201.

2 BN 2038 20v; Urb 4v–5r: Kemp and Walker p. 13.

3 Urb 24v–25r: Kemp and Walker, pp. 40–2. For his major declarations of the superiority of painting, see Claire Farago, *Leonardo da Vinci's 'Paragone': A Critical Interpretation*, with a new edition and English translation of the text in CU 1270, Leiden, 1992.

4 BN 2038 19r; Urb 8r: Kemp and Walker, p. 20.

5 Urb 133r–v: Kemp and Walker, p. 16.

6 Urb 2r–v: Kemp and Walker, p. 20.

7 Windsor 12604r; Urb, 219r: Kemp and Walker, p. 92–3.

8 BN 2038 25v; Urb 78 r–v: Kemp and Walker, pp. 80–1.

9 Codex Leicester 36r, translation by Kemp and Domenico Laurenza for forthcoming edition with Oxford University Press.

10 Codex Leicester 12v.

11 For a series of such complications, see Kemp and Walker, pp. 72–4.

12 Urb 87r: Kemp and Walker, p. 72.

13 Urb 68r–v: Kemp and Walker, p.72.

14 E18r; Urb 74r: Kemp and Walker, p. 73.

15 This is discussed by Z. Filipczak, 'New Light on Mona Lisa: Leonardo's Optical Knowledge and His Choice of Lighting', *The Art Bulletin*, LIX, 1977, pp. 518–23.

16 M. Kemp, 'In the Beholder's Eye: Leonardo and the "Errors of Sight" in Theory and Practice' (Hammer Prize Lecture), *Achademia Leonardi Vinci*, V, 1992, pp. 153–62.

17 MS D 6v.

18 MS D 10v.

19 MS A 55v.

20 Codex Leicester 34r.

21 J. Henderson, *The Renaissance Hospital: Healing the Body and Healing the Soul*, New Haven and London, 2006.

22 Windsor 12281r; Pedretti and Keele 122r.

23 Windsor 19027v; Pedretti and Keele 169r.

24 Windsor 19027v; Pedretti and Keele 69r.

25 Windsor 19064v: Pedretti and Keele 157v.

26 Windsor 12281; Pedretti and Keele 122r.

27 Windsor 19102r; Pedretti and Keele 198r.

28 We have followed Pedretti's reconstruction of the damaged note.

29 Codice atlantico 126v.

30 Codex Leicester 10r.

31 The most substantial of the attempts is by S. Albini, *Acque e Monti di Leonardo tra Lago d'Iseo, Valcalepio e Valcamonica*, Rudiana, 2015. Albini produces a good spectrum of the *kinds* of mountainscapes at which Leonardo looked, but the specific matches are generic and rely upon reversals.

32 Richter 1163.

33 Windsor 12579: Pedretti I, 48r.

34 Urb 131r: Kemp and Walker, pp. 226–7.

35 Windsor 12516.

36 BN 2038 17v; Urb 169r: Kemp and Walker, p. 153.

37 Urb 167r–v: Kemp and Walker, p.155.

38 BN 2038 4r; Urb 168v–169r; Kemp and Walker, pp. 157–8.

39 Urb 169v–170r; Kemp and Walker, p. 158.

Chapter XI

1 These and other details of the history of the scientific examinations are drawn from *Inside the Painting*.

2 X-ray emission, using an intense source of X-rays, produces data about the pigments in the paint layers. Differences in the intensity of secondary electrons *emitted from* adjacent colours is recorded on X-ray film.

3 *Inside the Painting*, fig. 43.

4 M. Livingstone, *Vision and Art: The Biology of Seeing*, New York, 2002.

5 M. Kemp, 'Leonardo and the Visual Pyramid', *Journal of the Warburg and Courtauld Institutes*, XXXIX, 1977, pp. 128–49.

6 A valuable compendium of technical studies is provided by *Leonardo da Vinci's Technical Practice: Paintings, Drawings and Influence*, ed. M. Menu, Paris, 2004.

7 L. de Viguerie et al., 'Revealing the *Sfumato* Technique of Leonardo da Vinci by X-Ray Fluorescence Spectroscopy', *Angewante Chemie*, XLIX, 2010, pp. 6125–8.

8 Jacques Franck has ingeniously claimed, using his own painted reconstructions, that Leonardo used a system of 'micro-divisionism', but the small, separate touches have not been disclosed by technical analysis: 'La Pratique de "micro-divisionnisme" dans l'atelier de Léonard de Vinci', *ArtItalies*, Revue de l'Association des Historiens de l'Art Italien, XX, 2014, p. 4–16.

9 A. González Mozo, 'The Copy of the *Gioconda*', and B. Mottin, 'Leonardo's *Mona Lisa* in the Light of its Madrid Copy', in *Leonardo da Vinci's Technical Practice*, pp. 194–222; and https://www.museodelprado.es/aprende/investigacion/estudios-y-restauraciones/recurso/estudio-tecnico-y-restauracion-de-la-gioconda/504eaceo-d54e-49b1-a16b-7afd17f756d3. A very useful comparison of the reflectograms is at http://focus.louvre.fr/en/mona-lisa/compare/infrared-reflectograms-original-and-copy#. I have benefited from correspondence with the late Hasan Niyazi, whose website is still partially accessible (http://www.3pipe.net/2012/03/open-reporting-and-prado-mona-lisa.html), and with Neau Kersing, who has looked at the evidence of the scientific examination in great detail.

10 Windsor 12396 and 12397; Pedretti I 10r and 9r.

11 M. Kemp and T. Wells, *Leonardo da Vinci's Madonna of the Yarnwinder: A Historical and Scientific Detective Story*, London, 2001; and the studies by T. Wells and C. Accidini, R. Bellucci, and C. Frosinini in *Leonardo da Vinci's Technical Practice*, pp. 101–25.

12 P. Cotte, *Lumière on the Mona Lisa: Hidden Portraits*, Paris, 2015. In what follows only a small selection the images from Cotte's examination can be included, and the reader can follow up the points in more detail using his rich set of illustrations.

13 Windsor 12534.

14 Cotte, *Lumière on the Mona Lisa*, figs. 204, 301, 180, and 181.

15 P. Cotte, *Lumière on the Lady with the Ermine by Leonardo da Vinci*, Paris, 2014.

16 Cotte, *Lumière on the Mona Lisa*, figs. 018 and 019.

17 Ibid. figs. 191 and 192.

18 For the emissographs, see *Inside the Painting*, plates 18 and 25.

19 Cotte, *Lumière on the Mona Lisa*, fig. 169.

20 *Inside the Painting*, plate 20.

21 Hatfield, pp. 57–104.

Appendix: Inventory of the late Ser Piero's da Vinci's house in Florence

1 The inventory has been reviewed by Dott. Gabriella Battista, whom we sincerely thank. The first notice of the inventory was given by Louis A. Waldman, 'Leonardo ed i suoi due "padri": l'artista attraverso la lente delle sue opere perdute', Lettura Vinciana, XLIX, Vinci, 8 April 2009.

 a. Added in the left margin.

 b. It appears thus in the text, meaning 'vetri' [glass].

 c. Added in the left margin.

 d. Number illegible due to an ink stain.

e. Added in the left margin.

f. Added in the left margin.

g. Added in the left margin.

h. Added in the left margin.

i. Added in the left margin.

j. Follows, crossed out, 'fratello' [brother].

References Cited in Abbreviated Form

Manuscripts

Leonardo da Vinci: the references to Leonardo manuscripts are given in their standard abbreviated forms (e.g. MsD = the manuscript so designated in the Bibliothèque of the Institut de France). The manuscripts are now conveniently available under these abbreviations at http://www.leonardodigitale.com.

See also the facsimile editions published by Giunti as the Edizione Nazionale dei Manoscritti e dei Disegni di Leonardo da Vinci from 1964 onwards.

Archival Sources:

AOIF	Archivio dell'Ospedale degli Innocenti di Firenze
AOSMF	Archivio dell'Opera di Santa Maria del Fiore
Battesimi	Registri Battesimali
ASF	Archivio di Stato di Firenze
Corp. relig.	Corporazioni religiose soppresse dal governo francese
Dec. grand.	Decima granducale
Dec. rep.	Decima repubblicana
MAP	Mediceo avanti il Principato
Medici e Speziali	Arte dei Medici e Speziali
Notarile	Notarile antecosimiano
Online Tratte	Online Tratte of Office Holders, 1282–1532. Version 1.1. Edited by David Herlihy, R. Burr Litchfield, Anthony Molho, and Roberto Barducci
SMN	Ospedale di Santa Maria Nuova

Printed sources

Alberti: L. B. Alberti, *On Painting*, trans. C. Grayson, London, 1991 (cited by paragraph number).

Bolzoni: Linda Bolzoni, *Poesia e Ritratto nel Rianscimento*, Roma-Bari, 2008.

Dante: *Il Convivio (The Banquet)*, trans. R. H. Lansing, New York, London, 1990.

Dante: *Vita Nuova*, trans. M. Musa, Oxford, 1992.

Dante: *The Divine Comedy*, trans. C.H. Sisson with intro and notes D. H. Higgins, Oxford, 1993.

Esterow: M. Esterow, *The Art Stealers*, London, 1966.

Giuliano de' Medici; *Poesie*, ed. G. Fantini, Florence, 1939.

Hatfield: R. Hatfield, *The Three Mona Lisas*, Milan, 2014.

Kemp 1981: M. Kemp, *Leonardo da Vinci: The Marvellous Works of Nature and Man*, London, 1981 (rev. edn, Oxford, 2007).

Kemp and Walker: *Leonardo on Painting: An Anthology of Writings by Leonardo da Vinci with a Selection of Documents Relating to his Career as an Artist*, ed. M. Kemp, trans. M. Kemp and M. Walker, New Haven and London, 2001.

Inside the Painting: J-P. Mohen, M. Menu, and B. Mottin, *Mona Lisa: Inside the Painting*, New York, 2006.

Lorenzo de' Medici: *Canzoniere* in *Opere*, ed. T. Zanato, Turin, 1992.

Pedretti and Keele: *Leonardo da Vinci, Corpus of Anatomical Drawings in the Collection of Her Majesty the Queen at Windsor Castle*, ed. C. Pedretti and K. Keele, 3 vols, New York, 1979.

Pedretti: C. Pedretti, *The Drawings of Leonardo da Vinci, Landscapes, Plants and Water Studies: Windsor Castle, Royal Library*, 2 vols, New York, 1987.

Petrarch, RVF: *The Canzoniere or Rerum vulgarium fragmenta*, trans. M. Musa, Bloomington, 1999.

Richter: J. P. Richter, *The Literary Works of Leonardo da Vinci*, 2 vols, Oxford, 1970, with the *Commentary* by C. Pedretti, 2 vols, Oxford, 1977.

Rogers Mariotti: J. Rogers Mariotti, *Mona Lisa. La 'Gioconda' del Magnifico Leonardo*, Florence, 2009.

Romano: C. D. Romano, '"Come se fussi viva e pura". Ritrattista e Lirica Cortigiana tra Quattro e Cinquecento', *Bibliothèque d'Humanisme et Renaissance*, LX, 1998, pp. 349–94.

Sassoon: D. Sassoon, *Mona Lisa: The History of the World's Most Famous Painting*, London, 2001.

Ulivi: E. Ulivi, *Per la genealogia di Leonardo*, Vinci, 2008.

Vasari: G. Vasari, *Le vite de' più eccellenti pittori, scultori e architettori nelle redazioni del 1550 e 1568*, ed. Rosanna Bettarini with commentary by P. Barrochi, Florence, 1966.

Villata: *Leonardo da Vinci. I documenti e le testimonianze contemporanee*, ed. E. Villata, presented by P. C. Marani, Raccolta Vinciana, Milan, 1999.

Vecce: C. Vecce, *Leonardo*, Rome, 1998 (new edn, 2006).

Vera Immagine: *Leonardo da Vinci: la vera immagine: documenti e testimonianze sulla vita e sull'opera*, ed. V. Arrighi, A. Belinazzi, and E. Villata, Florence, 2005.

Zöllner: F. Zöllner, with J. Nathan, *Leonardo da Vinci*, Cologne, 2003.

Bibliography

This selection from the vast bibliography of *Mona Lisa* concentrates on works that have a specific focus on *Mona Lisa* or on particularly relevant aspects of Leonardo's art and science. More detailed references for particular topics are to be found in the endnotes.

The annual publication *Raccolta Viciana* provides bibliographic updates.

A valuable service is provided by the Biblioteca Leonardiana at Vinci: http://www.bibliotecaleonardiana.it/bbl/bb-leo/bb-leo-home.shtml.

See also the bibliographies by F. Zöllner and by C. Farago and M. Landrus, at Oxford Bibliographies: http://www.oxfordbibliographies.com.

For the poetry, see the very useful collection and search facility has been created by the Università degli Studi di Roma 'La Sapienza': http://ww2.bibliotecaitaliana.it/presenta.php

J. Ackerman, 'Leonardo's Eye', *Journal of the Warburg and Courtauld Institutes*, XL, 1978, pp. 108–46.

Francis Ames-Lewis, *Isabella and Leonardo: The Artistic Relationship between Isabella d'Este and Leonardo da Vinci 1500–1506*, London and New Haven, 2012.

C. Bambach, 'Leonardo and Raphael in Rome in 1512–16', in *Late Raphael*, ed. M. Falomir, Madrid, pp. 26–38.

C. Bambach et al., *Leonardo da Vinci Master Draftsman*, New York, Metropolitan Museum, 2003.

J. Barone, 'Cassiano dal Pozzo's Manuscript Copy of the Trattato: New Evidence of Editorial Proceedures and Responses to Leonardo in the Seventeenth Century', *Raccolta* Vinciana, XXXIV, 2012, pp. 223–86.

J. Barone, 'Seventeenth-Century Transformations: Cassiano dal Pozzo's Manuscript Copy of the *Treatise on Painting*', in *Art as Institution: The Fabrication of Leonardo da Vinci's 'Trattato della Pittura' 1651*, ed. C. Farago, J. Bell, and C. Vecce, Leiden and Boston, 2016, pp. 350–84.

Antonio de Beatis, *Relazione del viaggio del cardinale Luigi Aragona* (1517–18), ed. L. Pastor, *Die Reise des Kardinals Luigi d'Aragona,* Freiburg, 1905; and J. Hale, *The Travel Journal of Antonio Beatis…*, trans. Hale and J. Lindon, London, 1979.

L. Beltrami, *Documenti e memorie riguardanti la vita e le opere di Leonardo da Vinci,* Milan, 1919.

P. Boyd, *Perception and Passion in Dante's 'Comedy'*, Cambridge, 1993.

S. Bramly, *Mona Lisa*, London, 1996.

S. Bramly, *Mona Lisa: The Enigma*, New York, 2004.

D. A. Brown, 'Leonardo and the Ladies with the Ermine and the Book', *Artibus et Historiae*, XI, 1990, pp. 47–61.

D. A. Brown, *Leonardo Da Vinci: Origins of a Genius*, New Haven, 1998.

D. A. Brown and K. Oberhuber, 'Monna Vanna and Fornarina: Leonardo and Raphael in Rome', in *Essays Presented by Myron P Gilmore*, ed. S. Bertelli and G. Ramakus, I, Florence, 1978, pp. 25–86.

D. A. Brown et al., *Virtue and Beauty: Leonardo's 'Ginevra de' Benci' and Renaissance Portraits of Women*, Princeton, 2001.

G. Brucker, *Florence: The Golden Age, 1138–1737*, London, 1998.

Alessandra Buccheri, *The Specacle of Clouds: Italian Art and Theatre*, Farnham, 2014.

D. Cast et al., *The Ashgate Research Companion to Giogio Vasari*, Farnham, 2014.

N. Charney, *The Thefts of the Mona Lisa*, New York, 2011.

A. Chastel, *L'Illustre incomprise, Mona Lisa*, Paris, 1988.

K. Clark, *The Drawings of Leonardo da Vinci in the Collection of Her Majesty the Queen at Windsor Castle*, 2nd edn with C. Pedretti, 3 vols, London and New York, 1968.

K. Clark, *Leonardo da Vinci*, ed. M. Kemp, London, 1993.

E. Conti, *La formazione della struttura agraria moderna nel contado fiorentino*, III, Parte II, Roma, 1965.

P. Cotte, *Lumière on the Lady with the Ermine by Leonardo da Vinci*, Paris, 2014.

P. Cotte, *Lumière on the Mona Lisa: Hidden Portraits*, Paris, 2015.

J. Cox-Rearick, *The Collection of Francis I: Royal Treasures*, Antwerp and New York, 1996.

E. Cropper, 'On Beautiful Women, Parmigianino, Petrarchismo, and the Vernacular Style', *The Art Bulletin*, LVIII, 1976, pp. 374–94.

M. Dalivalle, '"Borrowed Comlinesse": Copying from Pictures in Seventeenth-Century England', DPhil thesis, University of Oxford, 2011.

B. Dei, *La Cronica*, ed. Roberto Barducci, Firenze, 1984.

Vincent Delieuvin et al., *Saint Anne: Leonardo da Vinci's Ultimate Masterpiece*, Paris, 2012.

C. Dionisotti, 'Leonardo uomo di lettere', *Italia Medioevale e Umanistica*, V, 1962, pp. 183–216.

B. Fabjan and P. Marani, *Leonardo. La dama con l'ermellino*, Rome, Palazzo del Quirinale, 1998.

C. Farago, *Leonardo da Vinci's Paragone: A Critical Interpretation*, New York, 1991.

C. Farago (ed.), *Leonardo's Writings and Theory of Art*, 5 vols, London, 1999.

C. Farago et al., *Art as Institution: The Fabrication of Leonardo da Vinci's 'Trattato della Pittura' 1651*, Leiden and Boston, 2016.

Z. Filipczak, 'New Light on Mona Lisa: Leonardo's Optical Knowledge and His Choice of Lighting', *The Art Bulletin*, LIX, 1977, pp. 518–23.

M. T. Fiorio, *Giovanni Antonio Boltraffio. Un pittore milanese nel lume di Leonardo.* Milan and Rome, 2000.

J. Fletcher, 'Bernardo Bembo and Leonardo's Portrait of Ginevra de' Benci', *The Burlington Magazine*, CXXXI, 1989, pp. 811–16.

M. Florisoone and S. Béguin, *Hommage à Léonard de Vinci*, exh. cat., Musée du Louvre, Paris, 1952.

H. Focillon, 'La Joconde et ses interpretes', in *Technique et sentiment, études sur l'art moderne*, Paris, 1919.

S. Gilson, *Dante and Renaissance Florence*, Cambridge, 2009.

R. Goldthwaite, *The Building of Renaissance Florence: An Economic and Social History*, London, 1980.

J. Greenstein, 'Leonardo, Mona Lisa and *La Gioconda*: Reviewing the Evidence', *Artibus et Historiae*, XXV, 2014, pp. 17–38.

D. Hales, *Mona Lisa: A Life Discovered*, New York, etc., 2014.

R. Hatfield, *The Wealth of Michelangelo*, Rome, 2002.

R. Hatfield, *Finding Leonardo: The Case for Recovering the Battle of Anghiari*, Florence, 2007.

J. Henderson, *The Renaissance Hospital*, London, 2006.

D. Herlihy and C. Klapisch-Zuber, *Les Toscans et leurs familles*, Paris, 1978; *Tuscans and their Families*, London, 1985; *I toscani e le loro famiglie*, Bologna, 1988.

B. Jestaz, 'Francois 1er, Salaì et les tableaux de Léonardo', *Revue de l'Art*, CXXVI, 1999, pp. 68–72.

K. Keele, *Leonardo da Vinci: Elements of the Science of Man*, London, 1983.

M. Kemp, 'Il concetto dell'anima in Leonardo's Early Skull Studies', *Journal of the Warburg and Courtauld Institutes*, XXXIV, 1971, pp. 115–34.

M. Kemp, 'Leonardo and the Visual Pyramid', *Journal of the Warburg and Courtauld Institutes*, XL, 1977, pp. 128–49.

M. Kemp, 'Leonardo da Vinci: Science and Poetic Impulse', *Journal of the Royal Society of Arts* (Selwyn Brinton Lecture), CXXXIII, 1985, pp. 196–214.

M. Kemp, 'In the Beholder's Eye: Leonardo and the "Errors of Sight" in Theory and Practice' (Hammer Prize Lecture), *Achademia Leonardi Vinci*, V, 1992, pp. 153–62.

M. Kemp, *Christ to Coke: How Image Becomes Icon*, Oxford, 2011, ch. 5.

M. Kemp, '"Here's Looking at You": The Cartoon for the So-Called Nude Mona Lisa', in *Illuminating Leonardo: A Feshrift for Carlo Pedretti*, ed. C. Moffatt and S. Taglialagamba, Leiden and Boston, 2016, pp. 151–68.

M. Kemp and Juliana Barone, *Leonardo da Vinci. I disegni di Leonardo da Vinci e della sua cerchia. Collezione in Gran Bretagna*, Florence, 2010.

M. Kemp and P. Cotte, *La Bella Principessa di Leonardo da Vinci. Ritratto di Bianca Sforza*, Florence, 2012.

M. Kemp and M. Pagiavla, 'The Master's Shelf' [Leonardo's booklists], *Cabinet*, LII, 2014, pp. 15–19.

C. Klapisch-Zuber, *La famiglia e le donne nel Rinascimento a Firenze*, Bari, 2004.

E. R. Knauer, 'Leonardo da Vinci's Gioconda and the Yellow Shawl. Observations on Female Portraits in the Renaissance', *Raccolta Vinciana*, XXXIII, 2009, pp. 1–80.

M. Koos, *Bildnisse des Begehrens: Das lyrische Männerporträt in der venezianischen Malerei des frühen 16. Jahrhunderts—Giorgione, Tizian und ihr Umkreis*, Emsdetten, 2006.

G. P. Lomazzo, *Scritti sulle arti*, ed. Roberto Ciardi, 2 vols, Florence, 1973–4.

D. Lombardi, *Storia del matrimonio*, Bologna, 2008.

V. Longoni, *Umanesimo e Rinascimento in Brianza*, Milan, 1998, pp. 170–1.

H. McLeave, *Rogues in the Gallery: The Modern Plague of Art Thefts*, Raleigh, NC, 2003.

R. McMullen, *Mona Lisa: The Picture and the Myth*, London, 1976.

N. Macola, *Sguardi e scritture: figure con libro nella ritrattistica italiana della prima metà del Cinquecento*, Venice, 2007.

E. Maell, *Mona Lisa Reimagined*, New York etc., 2015.

P. Marani, *Leonardo da Vinci: The Complete Paintings*, New York, 2003.

M. Menu et al., *Leonardo da Vinci's Technical Practice: Paintings, Drawings and Influence*, Paris, 2004.

A. Molho, *Marriage Alliance in Late Medieval Florence*, London 1994.

The Mona Lisa Foundation, *Mona Lisa: Leonardo's Earlier Version*, Zurich, 2012.

J. Najemy, *A History of Florence, 1200–1575*, Oxford, 2006.

C. Nicholl, *Leonardo da Vinci: Flights of the Mind*, New York, 2004.

G. Pallanti, *Monna Lisa, mulier ingenua*, Florence, 2004.

G. Pallanti, *Mona Lisa Revealed; La vera identità della Gioconda*, Milan, 2006.

J. Pederson, 'The Academia Leonardi Vinci: Visualizing Dialectic in Renaissance Milan, 1480–1499', PhD thesis, Johns Hopkins University, 2007.

J. Pederson, 'Henrico Boscano's *Isola beata*: New Evidence for the Academia Leonardi Vinci in Renaissance Milan', *Renaissance Studies*, XXII, 2008, pp. 450–75.

C. Pedretti, *Leonardo: A Study in Chronology and Style*, Berkeley and Los Angeles, 1973.

C. Pedretti, ed., *Leonardo da Vinci: Libro di Pittura, Codice Urbinate lat. 1270 nella Biblioteca Apostolica Vaticana*, transcribed by C. Vecce, 2 vols, Florence, 1995.

F. Pich, *I Poeti davanti al Ritratto: da Petrarca a Marino*, Lucca, 2010.

J. Richardson Sr and Jr, *An Account of Some of the Statues, Bas-Reliefs, Drawings and Pictures in Italy, Etc....*, London, 1722.

P. Rubin, *Giorgio Vasari: Art and Hisory*, London, 1995.

C. Scallierez, *Léonard de Vinci: La Joconde*, Paris, 2003.

A. Schelchter, 'Ita Leonardus facit in omnibus suis picturis. Leonardo da Vincis Mona Lisa in der Cicero-Inkunabel aus Florenz und deren Geschichte', in *Leonardo da Vinci und Heinrich Schickhardt*, ed. Robert Kretzschmar and Sönke Lorenz, Stuttgart: Kohlhammer, 2010, pp. 242–84, http://www.iaslonline.de/index.php?vorgang_id=2889.

R. Schofield, 'Gaspare Visconti, mecenate del Bramante', in *Arte, committenza ed economia a Roma e nelle corti del Rinascimento, 1420–1530: atti del convegno internazionale*, ed. A. Esch and C. Frommel, Trun, 1995, pp. 297–334.

R. Scotti, *Vanished Smile: The Mysterious Theft of the Mona Lisa*, New York, 2009.

J. Shell and G. Sironi, 'Salaì and Leonardo's Legacy', *The Burlington Magazine*, CXXXIII, 1991, pp. 93–108.

W. Smith, 'Observations on the Mona Lisa Landscape', *Art Bulletin*, LXVII, 1985, pp. 183–99.

E. Solmi, *Leonardo (1452–1519)*, Florence, 1900.

E. Solmi, 'Le Fonti dei manoscritti di Leonardo da Vinci', *Giornale storico della Letteratura Italiana* (suppl. 10–11), Turin, 1908 and 1911, pp. 312–27.

M. R. Storey and D. Bourdon, *Mona Lisas*, New York, 1980.

L. Syson et al., *Leonardo da Vinci at the Court of Milan*, London, 2011.

P. Thornton, *The Italian Renaissance Interior, 1400–1600*, London, 1991.

P. Tinagli, *Women in Renaissance Art: Gender, Representation and Idenity*, Manchester, 1997.

B. Tramelli, 'Artists and Knowledge in Sixteenth Century Milan: The Case of Lomazzo's Accademia de la Val di Blenio', *Art and Knowledge, Fragmenta, Journal of the Royal Netherlands Institute in Rome*, Special Issue, 2011, pp. 121–37.

A. R. Turner, *Inventing Leonardo*, New York, 1993.

C. Vecce, 'La Gualanda', *Achademia Leonardo Vinci*, III, 1990, pp. 51–72.

B. Vecchietti, *ll codice dell'anonimo Gaddiano (cod. magliabechiano XVII, 17) nella Biblioteca nazionale di Firenze*, ed. C. von Fabriczy, Farnborough, 1969.

A. Vezzosi and A. Sabato, *Mona Lisa Unveiled*, Vinci, 2011.

L. de Viguerie et al., 'Revealing the *Sfumato* Technique of Leonardo da Vinci by X-Ray Fluorescence Spectroscopy', *Angewandte Chemie*, International Edition, XLIX, 2010, 6125–8.

J. Walker, 'Ginevra de' Benci by Leonardo da Vinci', *Report and Studies in the History of Art*, National Gallery of Art, Washington, 1967.

Joanna Woods-Marsden, 'Portrait of the Lady, 1430–1520', in *Virtue and Beauty: Leonardo's 'Ginevra de' Benci' and Renaissance Portraits of Women*, ed. D. A. Brown, Washington, 2001, pp. 80–1.

Joanna Woods-Marsden, 'Leonardo da Vinci's *Mona Lisa*: A Portrait without a Commissioner', *Illuminating Leonardo: A Festschrift for Carlo Pedretti*, ed. C Moffatt and S. Taglilagamba, Leiden and Boston, 2016, pp. 169–82.

Roberto Zapperi, *Monna Lisa addio. La vera storia della Gioconda*, Florence, 2012.

M. Zecchini, *The Caprotti Caprotti: A Study of the Painter Who Never Was*, Venice, 2013.

F. Zöllner, 'Leonardo's Portrait of Mona Lisa del Giocondo', *Gazette des Beaux Arts* CXXI, 1993, pp. 115–38.

F. Zöllner, *Leonardo da Vinci, Mona Lisa, das Porträt der Lisa del Giocondo, Legende und Geschichte*, Frankfurt, 1994.

Index

Figures, plates, and tables are shown in bold. Current street names, where known, are shown in brackets.

Illustration Sources